Fields of Vision

LANDSCAPE IMAGERY AND NATIONAL IDENTITY IN ENGLAND AND THE UNITED STATES

Stephen Daniels

Polity Press

First published in 1993 by Polity Press in association with Blackwell Publishers
First published in paperback 1994

Editorial office:
Polity Press
65 Bridge Street
Cambridge CB2 1UR, UK

Marketing and production:
Blackwell Publishers
108 Cowley Road
Oxford OX4 1JF, UK

ISBN 0 7456 0450-1
ISBN 0 7456 1354-3 (pbk)

A CIP catalogue record for this book is available from the British Library.

Typeset in 10 on 12pt Times by TecSet, Wallington, Surrey

Printed in Great Britain by The Alden Press, Oxford

This book is printed on acid-free paper.

Fields of Vision

Human Geography

Edited by Michael Dear and Derek Gregory

Published
Stephen Daniels, *Fields of Vision*
Michael Dear and Jennifer Wolch, *Landscapes of Despair*
John Eyles and David M. Smith (eds), *Qualitative Methods in Human Geography*
Rebecca Morales, *Flexible Production*
Kevin Morgan and Andrew Sayer, *Microcircuits of Capital*
Allan Pred, *Place, Practice and Structure*
Susan J. Smith, *The Politics of 'Race' and Residence*

Forthcoming
Derek Gregory, *An Introduction to Human Geography*
Susanna Hecht, *Development and Destruction*
Nigel Thrift, *Social Theory and Human Geography*

Contents

List of Illustrations vii
Acknowledgements xii
Introduction 1

1 The Prince of Wales and the Shadow of St Paul's 11

2 Joseph Wright and the Spectacle of Power 43

3 Humphry Repton and the Improvement of the Estate 80

4 J. M. W. Turner and the Circulation of the State 112

5 Thomas Cole and the Course of Empire 146

6 Frances Palmer and the Incorporation of the
 Continent 174

7 John Constable and the Making of Constable
 Country 200

Conclusion 243

Index 247

Illustrations

1 THE PRINCE OF WALES AND THE SHADOW OF
ST PAUL'S

1 Canaletto, *The Thames from the Terrace of Somerset House* 12
2 *The River Thames and the City of London* 12
3 Niels M. Lund, *The Heart of the Empire* 14
4 Christopher Wren, The Great Model 18
5 C. Malapeau and S. Miger, *Voltaire's Remains Transported to
 the Panthéon* 21
6 *A View of London and the Surrounding Country Taken from
 the Top of St Paul's Cathedral* 24
7 Gustave Doré, *Ludgate Hill* 26
8 Gustave Doré, *The New Zealander* 26
9 *Picturesque London: or, Skysigns of the Times* 27
10 Jubilee edition of *Illustrated London News* 30
11 *St Paul's Cathedral during the Blitz,* December 1940 33
12 William Holford, *Plan for the Precinct of St Paul's* 35

2 JOSEPH WRIGHT AND THE SPECTACLE OF POWER

1 Joseph Wright, *Arkwright's Cotton Mills by Night* 45
2 Joseph Wright, *A Philosopher giving that Lecture on the
 Orrery ...* 52
3 Joseph Wright, *An Experiment on a Bird in the Air Pump* 54

4 Joseph Wright, *The Alchymist, in search of the Philosopher's Stone ...* 56
5 Joseph Wright, *Matlock Tor, Moonlight* 58
6 Joseph Wright, *John Whitehurst, FRS* 59
7 Engraving after John Whitehurst, *A Section of the Strata at Matlock High-Tor* 60
8 *St Paul's Cathedral* 63
9 J. R. Smith after Joseph Wright, *Sir Richard Arkwright* 64
10 Philippe Jacques de Loutherbourg, *Coalbrookdale by Night* 69
11 Philippe Jacques de Loutherbourg, *Headpiece of Isaiah* 71

3 HUMPHRY REPTON AND THE IMPROVEMENT OF THE ESTATE

1 Thomas Gainsborough, *Mr and Mrs Robert Andrews* 81
2 Humphry Repton, Main Vista from Armley House 87
3 Humphry Repton, Armley Mill from Kirkstall Road 87
4 Humphry Repton, View of proposed new house at Sheringham 90
5 Humphry Repton, Coursing on sea shore at Sheringham 93
6 Humphry Repton, Main view from proposed new house at Sheringham 93
7 Humphry Repton, 'Improvements' 97
8 Humphry Repton, Views from Repton's house at Hare Street 100
9 A. W. Pugin, *Catholic Town in 1440: The Same Town in 1840* 102
10 Peter Brookes after Thomas Gainsborough, *Mr and Mrs Robert Andrews with Margaret* 105

4 TURNER AND THE CIRCULATION OF THE STATE

1 J. M. W. Turner, *Bridport, Dorsetshire* 116
2 J. M. W. Turner, *Leeds* 118
3 Samuel Buck, *The East Prospect of the Town of Leedes* 120
4 J. M. W. Turner, *Rain, Steam and Speed* 125
5 J. C. Bourne, *Maidenhead Railway Bridge* 129

6 J. M. W. Turner, *The Fighting 'Temeraire'* 131
7 J. M. W. Turner, *The Burning of the Houses of Parliament* 133
8 J. M. W. Turner, *The Burning of the Houses of Parliament* 133
9 Canaletto, *Westminster Bridge, London* 135
10 J. M. W. Turner, *The Sun of Venice Going to Sea* 137
11 The Clore Gallery, London 140

5 THOMAS COLE AND THE COURSE OF EMPIRE

1 Samuel Colman, *Storm King on the Hudson* 147
2 William Guy Wall, *Glens Falls* 148
3 Thomas Cole, *Landscape with Figures and a Mill* 150
4 Thomas Cole, *Falls of Kaaterskill* 153
5 Thomas Cole, *The Oxbow* 154
6 Thomas Cole, *The Course of Empire: The Arcadian or
 Pastoral State* 159
7 Thomas Cole, *The Course of Empire: Consummation* 159
8 Thomas Cole, *View of the Catskill, Early Autumn* 162
9 Thomas Cole, *River in the Catskills* 162
10 Francis Alexander (attrib.), *Globe Village* 166

6 FRANCES PALMER AND THE INCORPORATION
 OF THE CONTINENT

1 Frances Palmer, *Across the Continent* 175
2 Frances Palmer, *Loughborough from Cotes Hill* 177
3 Albert Bierstadt, *The Rocky Mountains – Lander's Peak* 181
4 Emmanuel Gottlieb Leutze, *Across the Continent, Westward
 the Course of Empire Takes its Way* 183
5 Frances Palmer, *The Rocky Mountains* 185
6 Frances Palmer, *The 'Lightning Express' Trains* 186
7 Thomas Nast, Title page to *Beyond the Mississippi* 187
8 A. R. Waud, *Building the Union Pacific Railroad in
 Nebraska* 189
9 T. M. Fowler, *Harvard, Nebraska* 190
10 Thomas Nast, *Railroads and Farmers* 194

7 JOHN CONSTABLE AND THE MAKING OF
 CONSTABLE COUNTRY

1 John Constable, *The Cornfield* 203
2 John Constable, *The Hay-wain* 206
3 John Constable, *Hampstead Heath* 208
4 C. L. Burns, *Willy Lot's House at Flatford* 216
5 C. L. Burns, *The Backwater at Flatford* 216
6 *Willy Lot's Cottage as Found by the Restorers* 218
7 Leonard Squirrell, *Willy Lot's Cottage* 218
8 Sydney Strube, *Had John Constable Lived Today* 221
9 Peter Kennard, *The Hay-wain, Constable (1821)*
 Cruise Missiles, USA (1981) 228
10 John Constable, *London from Hampstead* 231
11 John Constable, *The Opening of Waterloo Bridge* 234

To my Mother and Father
Ellen and Alan Daniels

Acknowledgements

M any people have helped during the research and writing of this
book. For observations and information I am grateful to Nick
Alfrey, Caroline Arscott, John Barrell, Robert Bartram, Ann Bermin-
gham, Louise Crewe, Philip Dodd, Mona Domosh, Felix Driver, Nick
Entrikin, Patricia Fara, Zena Forster, David Fraser, Mike Heffernan,
Andrew Hemingway, Peter Howard, Dick Humphries, Jane Jacobs,
David Lowenthal, John Lucas, Kenneth Maddox, Mandy Morris,
Charles Pattie, Joy Pepe, Michael Pidgely, Hugh Prince, Michael
Rosenthal, Simon Rycroft, Susanne Seymour, Eric Shanes, Alan Wal-
lach and Charles Watkins. The arguments of the book owe much to
conversations with Peter Bishop, Denis Cosgrove, Pyrs Gruffudd and
David Matless. The research was supported with grants from the British
Academy, Economic and Social Research Council, Leverhulme Trust
and University of Nottingham and by a Visiting Fellowship at the Yale
Center for British Art. Parts of chapter 3 appeared in the *Journal of
Historical Geography* and *Journal of Garden History*, of chapter 4 in
Turner Studies and of chapter 7 in *Landscape Research*. Some of the
arguments of chapters 1 and 2 were first set out in articles for *New
Statesman and Society*. Various drafts of the manuscript were typed by
Lorraine Childerhouse, Jenny Heighton and Karen Korzeniewski. The
manuscript was edited for publication by John Banks. The people at
Polity Press, Tony Giddens, Gill Motley, Debbie Seymour and Pam
Thomas, have organized publication with great care and attention. The
book was written with the enormous support of my wife Chrissie; her
love and company, and sense of style, sustained me throughout.

Introduction

I

As I write, in the summer of 1991, a fierce political row rages over an exhibition of American art in Washington, DC. 'The West as America: Reinterpreting Images of the Frontier' at the National Museum of American Art exhibits paintings, engravings and sculpture which portray the nation's expansion across the prairies to the Pacific. Accompanying the art-works are plaques of text which challenge the ideology of the images. 'Images from Christopher Columbus to Kit Carson show the discovery and settlement of the West as a heroic undertaking', says the plaque at the exhibition's entrance,

> A more recent approach argues that these images are carefully staged fiction, constructed from both supposition and fact. Their role was to justify the hardship and conflict of nation-building. Western scenes extolled progress, but rarely noted damaging social and environmental change. Looking beneath the surface of these images gives us a better understanding of why national problems created during the Westward expansion still affect us today.

Some images are described to be less about the West than a projection of social tensions, around immigration and labour unrest, in the eastern cities where many of the art-works were produced and consumed. The exhibition draws parallels between America's conquest of the West and its quasi-imperial role in south-east Asia, culminating in the Vietnam War.

The exhibition has provoked outrage well beyond artistic circles. Western Senators are threatening budgetary retaliation against the

sponsoring Smithsonian Institution, the complex of national museums which receives some $300 million a year in public funds. Galleries in the western cities of St Louis and Denver have now cancelled their plans to show the exhibition. Angry editorials in the national press accuse the exhibition of crimes close to treason. Even the usually liberal-minded *Washington Post* declares that the exhibition 'trashes not only the integrity of the art it presents but most of our national history as well'. The renowned historian Daniel Boorstin writes in one of the Commentary Books at the exhibition: 'Perverse, historically inaccurate, destructive exhibit'. Judging by other entries the exhibition has outraged some of the American public who were flooding into Washington for the Victory Parade of the Gulf War.[1]

This furore echoes another in England in 1982, in the wake of the wave of patriotism awoken by the Falklands War. The exhibition at the Tate Gallery, London, on the eighteenth-century painter Richard Wilson, entitled 'The Landscape of Reaction', showed Wilson's glowing pastoral views of the English countryside. Captions intimated, and the catalogue explicated, how the 'pictures played an active role in the society which witnessed their production', notably in legitimating the conservative mythology of Wilson's landed patrons.[2]

I can't recall if landed Members of Parliament threatened the Tate's budget, but certainly the editorial in *Apollo*, the journal for 'collectors and cognoscenti', demanded that if the Tate could not police its own exhibition, the government should. What provoked *Apollo* still more was the insult to the unwitting sponsors Britoil. The conservative *Daily Telegraph* devoted an editorial to warnings of how 'the idea of eighteenth-century England as a golden era of liberty and calm' was being subverted. The exhibition 'brands our greatest Augustan landscapist as a purveyor of "elite culture" who presents social inequalities in their most flattering light'. Critics in the more liberal press also sprang to the defence of traditional values. 'I don't recall a catalogue which has proved more of a hindrance to the enjoyment of an exhibition', wrote the *Guardian*'s reviewer, 'I found myself wondering if social comment is altogether to the point with Wilson, a gentle landscape painter'.[3]

For every exhibition deconstructing myths of national identity, there have been many others reconstructing them. Since the row over the Richard Wilson exhibition, the Tate Gallery's exhibitions of major English painters have been notably more cautious. The summer 1991 exhibition and catalogue on John Constable wilfully refused sociological readings of the pictures, sticking to traditional connoisseurship or presenting the painter as part of England's 'green' heritage.[4] Such

exhibitions are sometimes part of wider programme of cultural diplomacy. The 1977 'A New World' exhibition of American paintings presented a frontier version of American heritage in Europe, and the 1985 'Treasure Houses of Britain' exhibition marketed a landed, and very English, version of British heritage in the United States.[5]

Poorer nations are having their identities recast in art exhibitions for wealthy consumption, as part of larger cultural festivals, which include films, plays and performances. Shows in the United States include 'Turkey: the Continuing Magnificence' (1987–8), the 'Festival of Indonesia' (1990–2) and the 1991 'Mexico: A Work of Art'. All map out cultural histories and geographies which, in the words of a critic, 'transform negative stereotypes into positive ones and, in the process, improve the political and economic standing of their country'. In the process old stereotypes, like 'orientalist' views of Turkey, are refurbished, and wrenching political upheavals, like revolutionary movements in Mexico, smoothed over. Future national festivals are planned for Brazil, Egypt, Iran and Vietnam.[6]

These exhibitions, and their attendant controversy, are signs of the centrality of 'heritage', that powerful blend of historical and environmental display, to the cultural politics of Britain and the United States since the late 1970s. The American West and the English landed estate are two of the principal symbolic landscapes of national identity. There have been others – textile towns, waterfronts, farming villages, plantations – presented with a mixture of media imagery, conservation, reconstuction and outright invention. The model heritage landscape is the 'theme park' where historical and environmental meanings are comprehensively packaged and programmed.[7]

The devotion to national heritage, evident in the flag-waving politics of the 1980s as well as its theme parks, and the anger when it is put into question, arguably reflects uncertainties about the security of traditional, taken-for-granted, national identities and the durability and effectiveness of the cultures which have sustained them. As the decline of Britain as a world power finally registered on the English public, so did the cultural complications of New Commonwealth immigration, membership of the European Economic Community (including the prospect of a federal Europe), the globalization of institutions, the civil strife in Northern Ireland, the resurgence of Scottish and Welsh nationalism and the regional division between North and South.[8] In the United States, the patriotism of the Reagan and Bush presidencies has been applauded as an antidote to the national self-doubt known as the 'post-Vietnam syndrome', a condition which flared with various

Watergate-style political and financial scandals, the Middle East hostage crisis, the burgeoning National Debt, threats from Europe and the Far East to America's global commercial power, and internal pressures, from various minorities, on the White Anglo-Saxon Protestant culture which has traditionally shaped American national identity.[9]

The rhetoric of national identity has not been given up by those keen to fragment the kind of monolithic, State-sponsored nationalism favoured by dominant élites. Rather they have tried to re-claim and re-formulate it. Caught unaware by the imperial-style patriotism released by the Falklands War, the English Left sought to reclaim patriotism, to promote a metropolitan, multi-ethnic version, even to recover a radical tradition of patriotism which was internationalist in its solidarity against all State oppression. This has involved the restoration of alternative versions of English heritage, some of which, like parish pride, may overlap uncomfortably with conservative versions.[10]

Pressing issues of national heritage and identity are now widespread throughout Europe. The collapse of Soviet power in eastern Europe, and the break-up of the Soviet Union itself, has seen the revival and re-constitution of many ethnic national identities. And with this movement has come an intense debate on how national identities might be conceived, especially in the light of forces and relations of global interdependence which some had presumed would render the nation obsolete as a geo-political formation, even as a form of cultural identity. Far from being a nostalgic trace of former glory, national heritage in eastern Europe has been a driving force of new political and economic alignments.[11] This may be as true in the nation-states of western Europe where heritage now not only has considerable political power in the planning process but great financial power too.[12]

<div align="center">II</div>

National identity can take many forms. If it is inflected by other kinds of cultural identity, of class, gender, race and religion, and by other forms of cultural-geographic identity, of region and locality, national identity is arguably, in A. D. Smith's words, 'the most compelling identity myth in the modern world ... so global a condition and so explosive a force'. Smith discriminates between a predominantly genealogical 'ethnic' national identity, a community of descent, and a predominantly territorial 'civic' national identity, a community, usually a State, of common institutions. But, as he emphasizes, any one national identity is always

consciously characterized by both a historical and a geographical heritage.[13]

National identities are co-ordinated, often largely defined, by 'legends and landscapes', by stories of golden ages, enduring traditions, heoric deeds and dramatic destinies located in ancient or promised home-lands with hallowed sites and scenery. The symbolic activation of time and space, often drawing on religious sentiment, gives shape to the 'imagined community' of the nation. Landscapes, whether focusing on single monuments or framing stretches of scenery, provide visible shape; they picture the nation. As exemplars of moral order and aesthetic harmony, particular landscapes achieve the status of national icons. Since the eighteenth century painters and poets have helped narrate and depict national identity, or have had their work commandeered to do so; scholars and professionals have been enlisted too: historians, map-makers, geographers, engineers, architects and archaeologists. There is seldom a secure or enduring consensus as to which, or rather whose, legends and landscapes epitomize the nation. While most nationalists recognize several representative histories and geographies, all, by definition, reject others, including those of people dwelling within their own national borders. The very process of exclusion is integral to the nationalist enterprise. But even apparently singular histories and geographies may be open to varying interpretation, even appropriation, by those once marginalized in, or excluded from, the dominant national culture.[14]

Imperial nationalists, almost by definition, have been intent to annex the home-lands of others in their identity myths. They have projected on these lands and their inhabitants pictorial codes expressing both an affinity with the colonizing country and an estrangement from it. It is often the very 'otherness' of these lands which has made them appear so compelling, especially as a testing ground for imperial energy and imagination. Nineteenth-century Russian nationalists envisaged the expenses of taiga, tundra and steppe in Siberia as an 'Asian' periphery to a 'European' core, a vast field for the realization of Russian material and spiritual development which was explicitly modelled on the American construction of its continental frontier.[15] The endeavour to remake other lands in an exotic image was made easier by their location overseas. Paintings of the deserts of North Africa, their subjects steeped in the discourse of 'orientalism', helped to frame the cultural imagination of France's Second Empire. Images of barrenness and ruins activated histories of past prosperity under ancient empires. Under the mantle of a modern empire, and its material power, the desert might be

redeemed, restored to its former civilized glory. But, no less, the very wildness of the desert, its silences and vast horizons, might redeem the very materialism of modern France, its spiritual decay. This ambiguity, as Michael Heffernan points out, was seldom a source of confusion or compromise, rather one of soaring confidence.[16]

Heroic European visions could come aground. If grandiose French schemes collapsed in the sands of the Sahara, British ones broke up on the ice of the polar regions. News of the remains of Franklin's ill-fated search for a North West Passage came as a profound shock to national confidence, especially as it came the same week in 1858 of news of the ill-fated Charge of the Light Brigade. Landseer's painting *Man Proposes, God Disposes* shows the wreckage of Franklin's ship in an ice floe, one polar bear shredding a Union Jack, another gnawing a human rib-cage, an allusion to the cannabalism which overcame the crew, to the undertow of cultural regression in a voyage of civilization. It was consoling that a similar defeat for the Scott expedition in the 1910 race to the South Pole should be accompanied by the highest ideals of English pluck and self-sacrifice, and useful too a few years later to encourage a similar spirit on the battlefields of Flanders.[17]

The very global reach of English imperialism, into alien lands, was accompanied by a countervailing sentiment for cosy home scenery, for thatched cottages and gardens in pastoral countryside. Inside Great Britain lurked Little England. At the same time in the 1880s as Greenwich was taken as the Prime Meridian, as the British public gazed at global maps centred mathematically on Britain, with dominions coloured red to show an empire on which the sun never set, and margins illustrated with exotic human figures, fauna and flora, so the very picture of rustic England, Constable's *Hay-wain*, entered the National Gallery and, through reproduction, the national imagination. By the First World War, the *Hay-wain* was upheld as an epitome of the country it was worth dying to defend.[18]

For every magnificent, even multi-cultural, prospect of national identity, there is a more homely ethnic enclosure. Reformulating Marian iconography, the English Tudor state was envisaged as an enclosed garden walled off from its enemies. In the Ditchley portrait of the Elizabeth I the virgin queen is shown standing upon a map of England, symbolizing, as she is symbolized by, the island which resists all foreign bodies. If the English were, in poet Spenser's words, an 'Inclosure of the best people', their identity was also fashioned by those beyond the pale: vagabonds, gypsies and – the richest, and most enduring, source of nationalist demonology – the Irish.[19]

Protective images of landscape have played a role in cultural resistance to outside aggression. The ethnic nationalism fuelling the dissolution of the Soviet Union has been codified by pictorial images of independent homelands. In their drive for independence Latvians have looked back to nineteenth-century landscape paintings from a previous era of national awakening, to images of well-cared-for family farmsteads in a setting of fields, birch groves and fir forests. The physical landscape which inspired these paintings was left derelict under Soviet occupation, with emigration, taxation and a new régime of settlement; but, as Edmunds Bunkśe shows, the moral sensibility which informed this landscape survived in more private life, in various activities from the raising of children to the design and care of graveyards, now to be reactivated in a wider, more public, world.[20]

The very images of dominion, of power in the land, may be identified as such, then reclaimed or reconstituted. Since the eighteenth century woodland has proved a complex symbolic terrain for rival definitions of Englishness.[21] Aristocratic preserves of moorland were opened up to working-class ramblers between the wars, and moorland became, with due organization for good behaviour, the defining landscape of the new National Parks.[22] Now a countryside predominantly colonized by white residents and visitors is subject to campaigns for access by Black and Asian minorities. Images like Ingrid Pollard's photographs of Black figures in 'traditional' English countryside put complacent views of national landscape into question. Other landscapes may be culturally re-cast. A day's pony trekking for Muslim girls in the Brecon Beacons 'reminded everyone of Kashmir and Mirpur where they used to live. The small villages, the streams, the green fields ... sometimes it leaves you lost: you feel just like you're home'.[23]

III

In this book I will examine how landscapes, in various media, have articulated national identities in England and the United States from the later eighteenth century. I will concentrate on the work of painters and designers which has featured in exhibitions in the last decade and which has been a focus of heritage debate. There is a decidedly English emphasis to the book. All the artists I discuss were born in England, even the two who made their career representing American landscape. One of the issues in the chapters on the United States is how codes of landscape representation developed in England were deployed in an

American setting. In the chapters on England, I address the issue of returning American influence, often in the form of symbolism which is seen to disrupt the integrity of English national identity.

In a book on landscape and national identity an English emphasis is perhaps unavoidable. 'Nowhere else is landscape so freighted with legacy', observes David Lowenthal, 'nowhere else does the very term suggest not simply scenery and *genres de vie*, but quintessential national virtues.'[24] Landscape in England is conventionally regarded as denoting rural scenery, but I will extend the term to cover urban and industrial sites artists depicted. Indeed one of the principal themes of the book is how landscapes were composed to comprehend urban and industrial subjects. My eyes will not be fixed to the ground. I want to show how landscape intersects with other forms of representation, verbal as well as visual, and other subject matter, such as genre scenes and portraiture. The depiction of national identity in landscape negotiates many other forms of identity: local, regional and international; social, religious and familial. Above all I want to demonstrate the relation between landscape depiction and historical narration, including narratives which put national identity into doubt.

Landscape imagery is not merely a reflection of, or distraction from, more pressing social, economic or political issues; it is often a powerful mode of knowledge and social engagement. Running through many of the images I discuss is a variety of discourses and practices, from engineering to political economy. Not all of them were put there by the artists. They are often activated, or introduced, by the various contexts in which the images are displayed, reproduced and discussed. My intention in this book is not iconoclastic, to smash the aesthetic surface of landscape images to describe some deeper, more authentic world of social relations. Rather I wish to amplify the eloquence of these images, if this means rendering their meaning more mutable and ambiguous than their nationalist admirers might allow. I will emphasize the fluency of landscape, not its fixity, its poetics as well as its politics. An apparently simple picture of a country scene may yield many fields of vision.[25]

NOTES

1 This account is abstracted from Martin Walker, 'How the West was won, or was it?', *Guardian*, 13 June 1991. Some, but not all, of the catalogue entries

and essays develop the ideological critique expressed on the captions. William T. Truettner (ed.), *The West as America: Reinterpreting Images of the Frontier* (Smithsonian Institution Press, Washington, DC, 1991).

2 David H. Solkin, *Richard Wilson: the Landscape of Reaction* (Tate Gallery, London, 1982).

3 This account is abstracted from Neil McWilliam and Alex Potts, 'The landscape of reaction: Richard Wilson and his critics', *History Workshop Journal* 16 (1983), pp. 171–5.

4 On this see John Barrell, 'Constable's plenty', *London Review of Books*, 13 August 1991 and the last part of the final chapter of this book.

5 David Cannadine, 'Brideshead re-visited', *New York Review of Books*, 19 December 1985, pp. 17–21; 'Cultural diplomacy: Britain's Washington coup', *The Economist*, 2 November 1985.

6 Brian Wallis, 'Selling nations', *Art in America*, September 1991, pp. 85–91.

7 Patrick Wright, *On Living in an Old Country: the National Past in Contemporary Britain* (Verso, London, 1985); Robert Hewison, *The Heritage Industry: Britain in a Climate of Decline* (Methuen, London, 1987); Robert Lumley (ed.), *The Museum Time Machine: Putting Cultures on Display* (Routledge, London, 1988); Colin Shaw and Malcolm Chase, *The Imagined Past: History and Nostalgia* (Manchester University Press, 1989); Stephen Daniels and David Matless, 'The new nostalgia', *New Statesman and Society*, 19 May 1989, pp. 40–1.

8 Raphael Samuel, 'Exciting to be English' in Raphael Samuel (ed.), *Patriotism: the Making and Unmaking of British National Identity* (3 vols, Routledge, London, 1987), vol. 1, *History and Politics*, pp. xviii–lxviii.

9 See the 'United States' Special Issue of the *Times Literary Supplement*, 31 May 1991, especially the review essays by Joseph Epstein, 'An endangered species', pp. 3–4 and George Walden, 'Isolationists and interventionists', p. 9.

10 Stephen Daniels 'Envisioning England', *Journal of Historical Geography* 17 (1991), pp. 95–9.

11 Neal Ascherson, 'Why the future waves a flag', *The Independent on Sunday*, 8 September 1991.

12 Daniels and Matless, 'The new nostalgia'.

13 Anthony D. Smith, *National Identity* (Penguin, Harmondsworth, 1991) pp. 1–18, 71–8.

14 Anthony D. Smith, *The Ethnic Origins of Nations* (Blackwell, Oxford, 1986), pp. 174–208; Colin Williams and Anthony D. Smith, 'The national construction of social space', *Progress in Human Geography* 7 (1983), pp. 507–18. Recent detailed discussions of landscape, history and national identity in various places and periods, focusing on various discourses, include Prys Morgan, 'From a death to a view: the hunt for the Welsh past in the Romantic period' in Eric Hobsbawm and Terence Ranger (eds.), *The Invention of Tradition* (Cambridge University Press, 1983), pp. 43–100; Pyrs Gruffudd, ' "Uncivil engineering": nature, nationalism and hydro-electrics

in North Wales' in Denis Cosgrove and Geoff Petts (eds.), *Water, Engineering and Landscape* (Belhaven, London, 1991), pp. 159–73; Josef Konvitz, *Cartography in France 1660–1848: Science, Engineering and Statecraft* (University of Chicago Press, 1987); Trevor Pringle, 'The privation of history: Landseer, Victoria and the Highland myth' in Denis Cosgrove and Stephen Daniels (eds.), *The Iconography of Landscape* (Cambridge University Press, 1988), pp. 142–61; Brian S. Osborne, 'The iconography of nationhood in Canadian art', *ibid.*, pp. 162–78.

15 Mark Bassin, 'Inventing Siberia: visions of the Russian East in the early nineteenth century', *American Historical Review* 96 (1991), pp. 763–94.

16 Michael Heffernan, 'The desert in French orientalist painting during the nineteenth century', *Landscape Research* 16 (2) (1991), pp. 37–42.

17 Trevor Pringle, 'Cold comfort: the polar landscape in English and American popular culture 1845–1900', *Landscape Research* 16 (2) (1991), pp. 43–48.

18 On images of global imperialism see Denis Cosgrove, 'Looking in on our world: images of global geography' in Paul Wombell (ed.), *The Globe: Representing the World* (Impressions Gallery of Photography, York, 1989). On Constable's *Hay-wain* see chapter 7 below.

19 Peter Stallybrass, 'Time, space and unity: the symbolic discourse of *The Faerie Queen*', in Samuel (ed.), *Patriotism*, vol. 3, *National Fictions*, pp. 199–214.

20 Edmunds Valdermārs Bunkśe, 'Landscape symbolism in the Latvian drive for independence', *Geografiska Notiser* 4 (1990), pp. 170–178.

21 Stephen Daniels, 'The political iconography of woodland in later Georgian England' in Cosgrove and Daniels (eds), *The Iconography of Landscape*, pp. 43–82.

22 Marian Shoard, 'The lure of the moors' in John R. Gold and Jacquelin Burgess (eds), *Valued Environments* (Unwin Hyman, London, 1982), pp. 55–73.

23 Graham Coster, 'Another country', *Guardian Weekend*, 1–2 June 1991, pp. 4–6.

24 David Lowenthal, 'British national identity and the English landscape', *Rural History* 2 (1991), pp. 205–30, quotation on p. 213.

25 These methodological points are developed in the conclusion to this book.

1

The Prince of Wales and the Shadow of St Paul's

———◦◉◦———

THE ROYAL TOUCH

I would suggest that most of us are probably very proud of our country and feel there is something rather special about Britain, about our landscape, about our villages and our towns, and about those aspects of our surroundings which provide us with what we rather loosely call character.

S o begins the text of the Prince of Wales's best-selling *A Vision of Britain* (1989), opposite a photograph of lush green fields and above one of the Prince's own watercolours of country houses.[1] What provoked this vision was the 'terrible damage' inflicted on the landscape by 'planners, politicians and architects' since the Second World War, damage illustrated by grim 1960s tower blocks of flats in inner cities and giant cranes looming over central London during the office building boom of the 1980s.[2] But *A Vision of Britain* is no rural retreat. If the city is here the source of destruction, it is the source of redemption too. The vision is civic: Glasgow, Cardiff, Leeds, Birmingham and, at the centre, energizing the whole, London.

This is London restored, re-visioned as landscape, framed by lavish reproductions of eighteenth- and nineteenth-century oil paintings, 'the London that slowly evolved after the Great Fire [which] took more than three hundred years to build' and which took an unholy alliance of 'planners, politicians and architects' a mere 'fifteen years to destroy'.[3]

London used to be one of the architectural wonders of the world, a city built on the water like the centre of another great trading empire, Venice. And when Canaletto painted it in the 18th century, it was no less beautiful.[4]

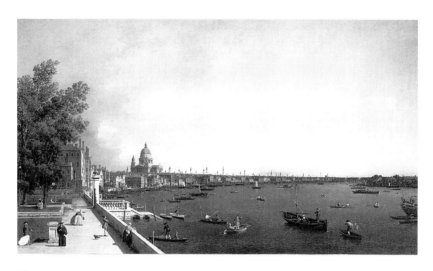

Figure 1 Canaletto, *The Thames from the Terrace of Somerset House, the City in the Distance*, 1746–51, Royal Collection, St James's Palace. © 1991 Her Majesty The Queen

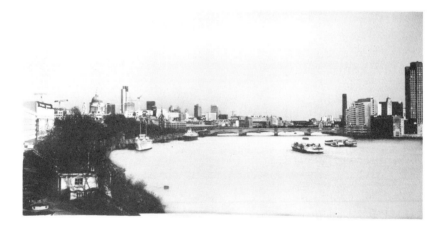

Figure 2 *The River Thames and the City of London*, Associated Design Consultants

Canaletto's view from Somerset House (Figure 1), purchased by George III in 1762 and still in the Royal Collection, renders London as Venice,

the very image of a patrician, mercantile city-state. Under a sunny Venetian sky, the Thames recalls the Grand Canal, thronged by boats working from the warehouses lining the banks, by pleasure craft, a State Barge, even a gondola. St Paul's Cathedral, not long completed, rises above the water like the great Venetian church of Santa Maria della Salute. The skyline is seen by the Prince to evoke British sea-power, Wren's City churches surrounding 'the glorious dome of St Paul's, like so many yachts riding at anchor around a great ship.[5]

To illustrate the destruction of London Canaletto's painting is contrasted with a modern photograph (Figure 2) taken from the same vantage point. The warehouses are gone; a few boats dock where scores had plied. On the skyline St Paul's sinks below the office blocks of the City and the Nat West tower now rises impiously above it: 'the soul of the City has been conquered by hovering hordes of giants'. While other European cities have maintained their distinctive skylines, London has traded hers: 'There is no need for London to ape Manhattan', the Prince declares, 'We already possessed a skyline. They had to create one'.[6]

Much of the power of this contrast is its insistence on the primacy of painterly vision, its elision of eighteenth-century London with Canaletto's picture, in all its inventiveness, its allusions, shifts in perspective and tricks of lighting. The modern photograph has had to be carefully construed to approximate the painting's apparent vantage point. In its telephoto compression it makes the City appear a deadening mass, and St Paul's, notwithstanding its modern surroundings, so much squatter than the soaring cathedral in Canaletto's painting. In the photograph London has lost not just a skyline but the theatricality Canaletto gave it.

While hostile to the towers of modern finance, *A Vision of Britain* is not resistant to commercial enterprise. Rather it seeks to consolidate commerce in a monumental landscape of civic virtue, one dominated by St Paul's. Commercial institutions have long contributed to the finance and fabric of the Cathedral and, in turn, used St Paul's as a trade-mark of their probity and reliability.[7] Some still do. But in the absence of effective building restrictions, increasingly international, and foreign-owned, financial institutions saw no need to defer to the dominion of St Paul's. Nor did they. What their towers disrupt is the symbolic exchange between St Paul's and the City, the solid image of a community of interest which framed London's supremacy as a centre of world trade.

This image is enshrined in another key painting of *A Vision of Britain*, Niels Lund's 1904 *The Heart of the Empire* (Figure 3). From a viewpoint on the Royal Exchange, the painting looks down to the bustling Bank junction around the Mansion House and across over a panorama of

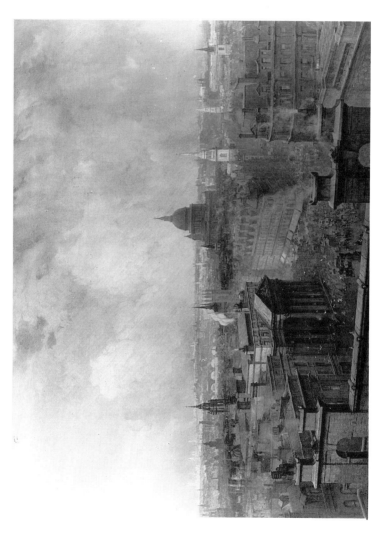

Figure 3 Niels M. Lund, *The Heart of the Empire*, 1904, Guildhall Library, London

London stretching to the horizon. This is not the calm Georgian vision of Canaletto, classically clear and sparkling, but the more gothic, dynamic image of the Victorian city, smoking with power. Still it pivots on St Paul's. The Cathedral commands the City like a great observatory. This is 'a painting that says everything about the harmony and scale of the City of London', the Prince declares, 'where the Lord Mayor's Mansion House and the houses of God were given appropriate prominence – all finding their place comfortably within the landscape'.[8]

The Heart of the Empire had already achieved the status of a conservationist icon. It hung in the Livery Hall during the public enquiry there in 1988 on plans to develop Bank Junction with modernist blocks. Later that year it was displayed in the crypt of St Paul's itself during the 'Aspiring Visions' exhibition celebrating the dissolution of the 'tyranny of the Modern Movement' and the revival of a nineteenth-century 'Battle of Styles'.[9] As Jane Jacobs points out, *The Heart of the Empire* offered a dual image of civic virtue. It was appealed to by those who wished to re-affirm the grandiloquence of the landscape around St Paul's, its monumentality and vast horizons. It also appealed to those who found a more picturesque intimacy in the landscape, a sense of locality, the nation gathering around a cathedral close. For both interests it projected that combination of environmental character and business efficiency which defines the English heritage industry.[10]

If, as Raphael Samuel maintains, the resurgence of national feeling in the 1980s was a response to the de-centring of national institutions, of an Anglican Church taking its lead from a worldwide communion, of a City abandoning sterling and turning itself into 'a staging post between Tokyo and New York',[11] then *A Vision of Britain*, pivoting on St Paul's, offers precisely a re-centring of national identity. Before the Great Fire of 1666, when the ruinous old cathedral still bore the marks of damage and desecration by Cromwell's troops, Wren pledged a new St Paul's to Charles II as 'an ornament to His Majesty's most excellent reign, to the Church of England, and to the Great City'.[12] The prospective Charles III seems intent on having the pledge re-honoured. In *A Vision of Britain* St Paul's Cathedral is restored as an *axis mundi*, linking the spheres of the local, national, global and celestial.[13] This is not seen as an insular strategy; the Prince connects it to the revival of sacred architecture in the Islamic world.[14] St Paul's is revived as a radiant centre for the new Royal Touch, the Prince's attempt to heal and revive a nation, to re-enchant it with beauty, harmony, hierarchy, community, spirituality, above all with vision.

THE PACT WITH THE PAST

The culmination of four years' speech-making and lobbying, prepared by a team of advisers, previewed by a BBC film, and launched by an exhibition at the Victoria and Albert Museum, *A Vision of Britain* was carefully orchestrated and brilliantly timed. It appeared at the end of a decade dominated by issues of national renewal and identity.[15] The Thatcher government played the patriotic card in a variety of issues, both international and domestic, from the Falklands War to the Miners' Strike, from New Commonwealth immigration to European monetary union. Yet they stood accused of surrendering the defence of the realm to the United States, of mortgaging the nation's finance to multinational companies, of isolating England from the rest of the United Kingdom, and dividing Britain into 'two nations' of North and South. In contrast the Royal Family's consensual image became politically charged. In that charismatic mixture of aloofness and ordinariness which British royalty have long cultivated, and eschewing the niceties of democratic or professional accountability, the Prince of Wales came forward as a spokesman for the silent majority, referring to G. K. Chesterton's 'people of England, that have never spoken yet', a people the Prince is quick to identify as not just English but British.[16]

No less than Prime Minister Margaret Thatcher, the Prince of Wales offered a vision of cultural renewal after the Dark Ages of the 1960s and 1970s. But it was a public rather than populist vision. It evoked a world of institutional authority and loyalty, stately and hermetic, a world Thatcherism affected to explode.[17] In emphasizing such virtues as community, conservation, tradition and religion the vision proved historically more conservative than that officially on offer from the Conservative Party. It specifically appealed to Edmund Burke's idea of genealogical pact between past, present and future. 'When the past feeds and sustains the present and the future you have a civilized society', the Prince declares, 'It was only this century that we broke the pact with the past and tried to obliterate its meanings and messages ... when a man loses contact with the past, he loses his soul.'[18]

Above all, *A Vision of Britain* harnessed the resurgence of landscape aesthetics in explorations of cultural identity.[19] The very idea of landscape, its aesthetic integration of people and environment, offered an antidote to the fragmentation and alienation so often seen as uniquely modernist. *A Vision of Britain* shifted the locus of national identity from rural landscape imagery, too easily identified with an

affluent, white middle class who were increasingly colonizing the countryside, to a seemingly more representative metropolitan land-scape, one which offered the social range a patrician vision demands. Constable and Wordsworth are enlisted in *A Vision of Britain* but not for their images of Suffolk meadows and Cumbrian fells, rather for their lesser known, civic scenes of London and the Thames.[20] London played a spectacular, if not always orderly or esteemed, role in the culture of the 1980s, in issues as varied as high finance, ethnicity, homelessness, postmodernism and community politics. Indeed, during the decade, the very term *culture* took on a pronounced metropolitan meaning.[21] It was one of those periodic moments when London epitomized the nation; when the capital became, in the words of a seventeenth-century writer, 'our England of England, and our Landskip and Representation of the whole Island'.[22]

A Vision of Britain restores London as the nation's landscape and representation. Centrally it projects St Paul's in a series of historical tableaux. In the rest of this chapter I will explore the myths and images of St Paul's which *A Vision of Britain* has activated, and some which it has suppressed.

PHOENIX PAULINA

The dispute between the Prince of Wales and modernist architects has reactivated accounts of the design and building of St Paul's. Richard Rogers, architect of the avant-garde Lloyds Building in the City, has reclaimed Wren as a daring modernist. He draws attention to the severely classical design for St Paul's embodied in the Great Model (Figure 4) (currently in the crypt of the Cathedral) and its rejection by a conservative clergy.[23] In its uncomfortably close echoes of St Peter's in Rome, the Great Model was seen at the time as too radical and papal a departure from the gothic tradition of cathedral building in England.[24] The eventual building is an often illusory combination of classic and gothic styling.[25] This combination came to characterize much English patrician landscape design, signifying a distinctively national synthesis of northern and southern European culture.[26] Classical authority com-bines with gothic liberty, classical enlightenment with gothic supersti-tion, classical order with gothic energy. The very fabrication of St Paul's has helped generate multiple interpretation.

Most accounts of the building of the Cathedral plunge it in the purging imagery of the Great Fire of 1666. In *Parentilia* (1750) Wren's

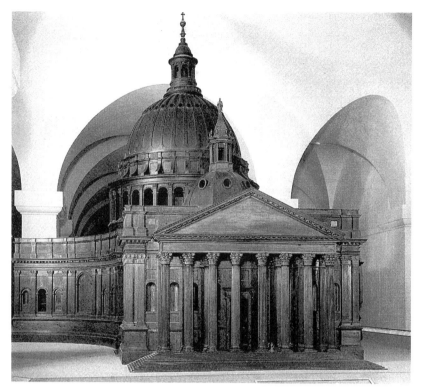

Figure 4 Christopher Wren, The Great Model, 1673–4, St Paul's Cathedral

son described his father's laying of the first stone in 1675 on the ruins of the old cathedral as 'a memorable omen'.

> When the SURVEYOR in Person had set out, upon the Place, the Dimensions of the great Dome, and fixed upon the centre; a common Labourer was ordered to bring a flat stone from the Heaps of Rubbish ... to be laid for a Mark and Direction to the Masons; the Stone happened to be a Piece of Grave-stone, with nothing remaining of the Inscription but this simple word in large capitals, RESURGAM ['I Rise Again'].[27]

The word RESURGAM was emblazoned on the south transept of the new Cathedral above the figure of a phoenix rising from the ashes.

Launched by the united efforts of Crown, Church, City and Parliament, the Cathedral was, from the beginning, seen as a symbol of

national as well as civic renewal and ascendancy.[28] *Parentilia* describes how Wren probed for firm foundations which stretched well beyond the City: 'He continued boring until he came to hard Beach, and still under that until he came to the natural hard Clay which lies under the City and Country and Thames also far and wide'. Shells in the strata showed 'it was evident the Sea has been where now the Hill is, on which PAUL'S stands'.[29] So was launched the Cathedral's image as a Ship of State.

When Wren's son, his father watching, laid the last stone on the lantern on the summit of the dome in 1710, St Paul's, in contrast to the slow accretion of other cathedrals, had taken a mere thirty-five years to build. But its construction was steeped in political controversy. Conflicts between Crown, City, Church and Parliament, focusing on disputes over revenues for building, slowed down construction severely in the 1670s and 1680s. It took the accession in 1701 of Queen Anne, an ardent supporter of the Church and a friend of the Tories (always more sympathetic than the Whigs to the royalist associations of St Paul's) to restore the supply of money and materials.[30] From her coronation the Queen activated the Cathedral as a symbol of State. To strengthen this symbolism the Queen's Tory suppporters invented a plot they attributed to the Whigs to remove the screws and bolts holding the roof of the Cathedral so that it would collapse on the Queen and her ministers.[31] Queen Anne's statue was erected in the forecourt of St Paul's. In the robes of State she holds the orb and sceptre, around her pedestal four female figures representing Britain, Ireland, France and North America.[32] The ageing barrister poet James Wright, who had written a lament, *The Ruins*, for old St Paul's in 1668, took up his pen again upon completion of the new cathedral for eighty-six verses of *Phoenix Paulina*. He praised porticoes, pediments, carvings and towers until he reached

> The CUPOLA, that mighty orb of stone,
> Piercing the clouds in figure of a crown
> A diadem that crowns not Paul's alone
> But the whole Island, plac'd on her head stone.[33]

Wren's plan to redevelop the City comprehensively in an image of imperial grandeur were not realized, perhaps fortunately for St Paul's because it would have been upstaged by a massive Roman-style Exchange in its own oval piazza. It was the Cathedral, and its flotilla of City churches, which made London look a world power. Canaletto and his many imitators evoked Venice in their views of the new city, but

Venice in Roman dress, more classic than gothic, not so much an image of republican liberty as of imperial authority.[34]

The transcendental image of St Paul's has been shadowed by darker undercurrents. These have usually gathered around the antiquity of its hallowed ground and its use for burials or pagan worship. Wren's son was pleased to report that his father's excavations of Roman remains revealed no traces of temples[35] but stories of even earlier sites have survived as a subtext to the usual triumphal narratives. An 1872 history of royal occasions at St Paul's opened with 'traditional fables' that 'ages before the genius of Sir Christopher Wren designed the present magnificent edifice, it was an oak-crowned height in the depths of which Druid priests performed their sanguinary rites', fables the history was eager to dismiss.[36] This was not just an injection of gothic horror. Since the later eighteenth century historians had debated whether ancient Britons were bloodthirsty savages deserving extinction or, in opposing the Romans, were primitive patriots resisting a foreign aggressor.[37] Mindful of its imperial theme the 1872 catalogue reported the finding of only Roman remains.[38] But the myth of a prehistoric site has persisted, in a terrestrial, not maritime, vision of Britain, one which links the site of St Paul's to a network of earth mounds and stone circles, ultimately to Stonehenge.[39]

HOLY WAR

Death and glory in St Paul's quickly became affairs of State. Before the Cathedral was completed Queen Anne instituted a series of Services of Thanksgiving for victorious battles against France.[40] At the end of the eighteenth century, during hostilities with Napoleonic France, the Cathedral was renewed as a belligerent patriotic spectacle. This was largely in response to the spectacle of French nationalism. The Panthéon, in Paris, was secularized as a national shrine, dedicated to the great men of modern revolutionary France (Figure 5). While the gothic in France was associated with royalty and religion, the domed Panthéon, modelled on the Roman original, enshrined the classical humanism favoured by representatives of the Revolution.[41] In their organization, splendour and solemnity, the festivals which culminated there contrasted with the slovenly ceremonial of London. When war was declared there was an upsurge of British nationalist spectacle in major cities and most majestically in London. In contrast to France it blended patriotic with royal and religious iconography. After years of

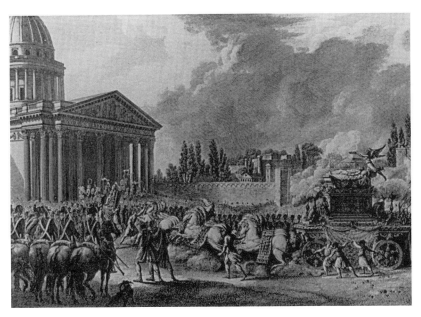

Figure 5 C. Malapeau and S. Miger, *Voltaire's Remains Transported to the Panthéon* 1791, Bibliothèque Nationale, Paris

derision, the monarchy enjoyed a face-lift. George III was transformed, elevated into a figure of national unanimity, 'a precursor of that curious blend of assiduous domestic cosiness interspersed with occasional bouts of public splendour which is the current royal trademark in Britain'. After a period of sharp Protestant Dissent the authority of the Anglican Church was enhanced.[42]

Westminster Abbey was the traditional, gothic, shrine for national figures, but the Abbey was overcrowded with an accumulated mixture of memorials, not all of them fit to inspire a fight with the French, and it was moreover an unruly, even irreverent, place, full of gullible tourists and unscrupulous guides.[43] St Paul's was more chaste. Virtually empty, it was filled with State-sponsored sculpture and monuments to war heroes.[44] In 1789 at the outbreak of the French Revolution, in the first official royal visit for seventy-five years, the King went in State to St Paul's for a Service of Thanksgiving for his recovery from illness. The precincts of the Cathedral were a blaze of illuminations. That on the Bank showed Britannia seated in Roman chariot bearing on a staff the Cap of Liberty.[45] The King was responsible for a procession to St Paul's

for a Naval Thanksgiving in 1797. This aped Revolutionary French precedent not just because it was a victory parade but because it included in its ranks 250 ordinary sailors and marines. The opposition paper, the *Morning Chronicle*, dismissed it as 'Frenchified farce'.[46]

It is instructive to compare the development of St Paul's as a site of patriotic display with Trafalgar Square. The Cathedral already offered a coherent, transcendent image of authority, which the State harnessed, but the attempt to redevelop the area around Charing Cross proved more difficult. Trafalgar Square was long planned as an emblem of empire but took years to realize, and then in a piecemeal way; the National Gallery was not built until the late 1830s, Nelson's Column was not completed until 1843. The problems were not just material ones of money and property rights. As the traditional gateway by road to the seat of government and monarchy it had long been the site for the people to show their support or disaffection for the State. And, even when complete, it long continued to be a place of popular revelry and protest. Moreover Nelson was a figure of libertarian patriotism, expressed in the song 'Rule, Britannia!', whose subjects 'never, never, never shall be slaves' ('God save the King', the national anthem, expressed the official State view). Throughout the nineteenth century Nelson was a radical hero. If he is entombed in St Paul's, his apotheosis is at the summit of the column during a demonstration against State power. If St Paul's became a sacred monument, Trafalgar Square, though always carefully managed, became a profane area.[47]

This is not to say that St Paul's remained inviolate. In the eighteenth century its precincts harboured a reputation as a place of idle, salacious resort. The statue of Queen Anne was continually vandalized until its safe removal in 1884 to the grounds of a girl's school in Sussex.[48] The Cathedral has on occasion been subject to mass assault. In February 1887 socialist demonstrators turned their attention from Trafalgar Square to St Paul's, occupying the Cathedral and the area around, demanding to be preached to by the Bishop of London or Archbishop of Canterbury. With the constabulary in the crypt, the resident canon tried a sermon on class consensus 'to the accompaniment of booing, hissing, and occasional cheering'.[49] The City's gift of bells to the Cathedral in 1878 succeeded in attracting unruly crowds to hear the New Year rung in. After unsuccessful attempts to preach from the steps, the chimes at midnight were stopped and eventually the revellers transferred their attention to Trafalgar Square.[50]

COLOSSAL CIRCULATION

As London expanded and infilled through the nineteenth century, so St Paul's was used to compose its development, to make it seem a stately city, not a sprawling, congested emporium.[51] The Cathedral was a visual focus of civic improvements, either in vistas or in panoramas. A 360-degree panorama of London from the summit of St Paul's, in the purpose-built Colosseum, Regent's Park, was opened in 1829. It claimed 'to unfold the vast resources of empire, in the countless traces of its commerce, its manufactures and trade; to exhibit the productiveness of its public revenues, through the grand national spirit of industry and enterprise'.[52] The panorama was the model for a series of images, in a variety of media, placing the dome at the centre and in orbit the rest of London with the latest signs of improvement from public buildings, like the new Houses of Parliament to new bridges, factories and railway stations (Figure 6).[53]

This centrifugal image of St Paul's plays a key role in the self-realization of Lucy Snowe, the heroine of Charlotte Brontë's novel *Villette* (1853). Travelling from a country parish, Lucy arrives at a London inn one wet February night, and takes to her bed, distressed, disorientated.

> What was I doing here alone in great London? What should I do on the morrow? What prospects had I in life? What friends had I on earth? Whence did I come? Whither should I go? What should I do?

When she has just extinguished her candle, 'a deep, low mighty tone swung through the night ... and at the twelfth colossal hum and trembling knell, I said: "I lie in the shadow of St Paul's" '.

Rising next day she opens her curtain to see the sun rising above the fog:

> Above my head, above the house-tops, co-elevate almost with the clouds, I saw a solemn, orbed mass, dark-blue and dim – THE DOME. While I looked, my inner self moved; my spirit shook its always fettering wings half loose; I had a sudden feeling as if I, who had never yet truly lived, were at last to taste life: in that morning my soul grew ...

Lucy Snow enters the Cathedral and climbs to the summit of the dome:

Figure 6 *A View of London and the Surrounding Country from the Top of St Paul's Cathedral*, c. 1845. Private Collection

> I saw thence London, with its river, and its bridges, and its churches ... I like the spirit of this great London which I feel around me. Who but a coward would pass his whole life in hamlets, and forever abandon his faculties to the eating rust of obscurity?[54]

St Paul's and the smoke of London were found mutually enhancing. In 1840 the painter B. R. Haydon reported that the sight of London smoke 'always filled my mind with feelings of energy such as no other spectacle could inspire ... often I have studied its peculiarities from the hills near London, whence in the midst of its drifted clouds you catch a glimpse of

the great dome of St Paul's announcing at once civilization and power'.[55] A standard view was from Greenwich, the dome in the smoky distance framed by the twin towers of Wren's naval hospital. Closer in, the standard view was along Fleet Street up Ludgate Hill, St Paul's looming over all. In 1882 Samuel Butler found 'nothing in any foreign city equal to the view'.

> It is often said that this has been spoiled by the London, Chatham and Dover railway bridge over Ludgate Hill; I think, however, the effect is more imposing now than before the bridge was built. Time has already softened it; it does not obtrude itself; it adds greatly to the sense of size, and makes us doubly aware of the movement of life, the colossal circulation to which London owes so much of its impressiveness ... vast as is the world below the bridge, there is a vaster still on high, and when the trains are passing, the steam from the engine will throw the dome of St Paul's into clouds, and make it seem as if there was a comingling of earth and some far-off mysterious place in dreamland.[56]

The best-known illustration of this view is Gustave Doré's (Figure 7) for his 1872 book of engravings *London* with text by Blanchard Jerrold. A smoking train crosses the bridge and below a tumult of London traffic funnels up and down Ludgate Hill – carts, barrows, carriages, an omnibus, a hearse, a flock of sheep. Advertising hoardings for newspapers – *The Daily News*, *The Standard* and *Lloyds News* – announce this as the nerve centre of the metropolis. St Paul's looms above the tumult below. 'The grand dome of St Paul's has unwonted grandeur in the blue, unblurred light' runs Jerrold's accompanying text, 'and the dreamer's fancy may people the cross with angels spreading radiant wings to travel over the mightiest city of the earth, and protect the unknown heroes and heroines who every day toil and moil under deadening loads of trouble'. Jerrold's text to *London* is often more optimistic than Doré's pictures, and the passage here runs counter to Doré's view of Ludgate Hill. Doré's sky is in fact overcast, the dome of St Paul's less central than in most views, and Ludgate Hill compressed to a groaning chasm. Readers versed in Doré's illustrations to Milton and Dante would have recognized its darker, apocalyptic register and had it confirmed in the last engraving of the book (Figure 8). Here in the future a tourist from the farthest reach of the Empire, a New Zealander, looks at the ruins of London, centrally the shattered dome of St Paul's, 'contemplating something matching "The glory that was Greece – The grandeur that was Rome" '.[57]

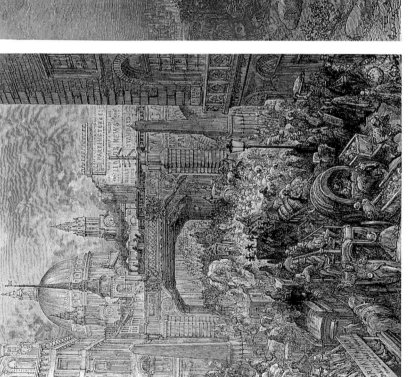

Figure 7 Gustave Doré, *Ludgate Hill*, from Gustave
Doré and Blanchard Jerrold, *London*, 1872

Figure 8 Gustave Doré *The New Zealander*, from Gustave
Doré and Blanchard Jerrold, *London*, 1872

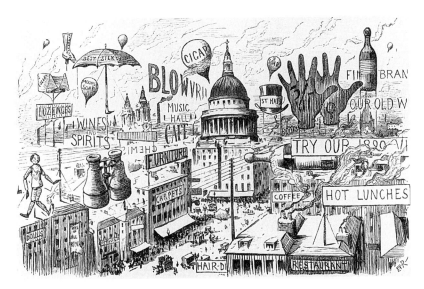

Figure 9 *Picturesque London: or, Skysigns of the Times*, *Punch*,
6 September 1890

The consumer culture of Victorian London was not easily contained
by the St Paul's image of civic virtue. In 1890 *Punch* published a cartoon
of the Cathedral surrounded by the vulgarities of department stores and
giant airborne advertisements (Figure 9). The accompanying verse
described how 'Boetian Commerce' displaced 'Urban beauty from its
last frail hold, / On a Metropolis given up to Gold'.

> But now the 'swinging signs' of ogre Trade,
> Even the smoke-veiled vault of heaven invade,
> And Sprawling legends of the tasteless crew
> Soar to the clouds and spread across the blue.
> See – if you can – where Paul's colossal dome
> Rises o'er realms that dwarf Imperial Rome.
> Cooped, cramped, half-hid, the glorious work of WREN
> Lent grandeur once to huckstering haunts of men,
> Though on its splendour Shopdom's rule impinged,
> Not these sky-horrors, huge and noisy-hinged ...
> Unmoved by civic pride, unchecked by taste,
> They'd smear the general sky with poster's paste.[58]

DOME OF ENLIGHTENMENT

Through the nineteenth century St Paul's had become such a scenic spectacle that its function as a cathedral was brought into question. When in 1850 the new Dean described St Paul's as 'the most magnificent of Protestant Cathedrals' a leader in *The Times* countered it was 'nothing more nor less than a pompous sham'. The admission price only purchased a view of tombs and monuments in a very small space, and what few services there were could be accommodated in 'a church of moderate size'.

> So long as you have not the free range of it, you might just as well see it from the turnabout in the Diorama, or through the lens at the Cosmorana-rooms, or any other respectable peep-show. How is one to be sure it is real? Perhaps the nave of St Paul's after all, is a spectacle of the same class as the Swiss mountain at the Colosseum.

Even as a mausoleum it was about as penetrable as the Pyramid of Cheops. Some explorer should 'force an entrance into it'.

> This is an age of adventure. We are excavating the site of Nineveh, trying to cut the Isthmus of Panama, to discover a north-west passage, and to remove every other obstruction that presumes to interfere with our freedom of movements. We recommend St Paul's to the Geographical Society ...[59]

A rejoinder in the radical *Cooper's Journal* found a use for the Cathedral. 'It is a national property . An enlightened government would provide for its being used to enlighten and elevate the people'. It would 'sweep out the monuments of great murderers' and fill it 'with such productions of Art as could not but be beheld without the purest and best emotions'. And the building would resonate in public lectures with the living memory of enlightened Englishmen: 'the eloquence and philosophy of Fox ... the genius and patriotism of Milton – the wisdom and goodness of Newton', a tradition embodied in Wren himself and his 'noble masterpiece'.[60] St Paul's would become one of those 'domes of enlightenment' like William Hunter's Museum, and the newly domed British Museum library, in which élite and populist educational conventions converged.[61]

CROWN IMPERIAL

Doubts about London which had surfaced in the 1870s, especially the darker, more volatile side of the city depicted by Doré, were eclipsed by the end of the century by a brilliant display of civic splendour. The capital and its region, the 'Home Counties', came to provide the dominant definitions of national identity. For much of the century other, more conspicuously industrial, cities and their regions had offered other versions of the nation which London had to accommodate; but with the evident loss of their industrial power and cultural independence, and the ascendancy of London as a self-consciously financial, imperial and regal capital, so they were reduced to provinces of a metropolitan core. This core was soft and rustic on the outside, in the Home Counties where the City slept, but hard and civic within.[62] The financial district was rebuilt with new offices and monumental headquarters. Some of Wren's churches were demolished in the process. But the stature of St Paul's was enhanced.[63] In *Imperial London* (1901) Arthur Beaven observed that whereas in Tudor times St Paul's had stood on the margins of the city, it was now 'all but the exact middle of Greater London ... the centre of the world's capital'.[64] The Cathedral took on the Crown-Imperial image of the mother country, 'a mighty mothering dome', declared E. V. Lucas in 1906, 'it broods over the greatest city in the world'.[65]

St Paul's was again charged with reviving the reputation and visibility of the monarchy, which since the death of George III had suffered another severe decline. From the Service of National Thanksgiving in December 1871 for the Prince of Wales's miraculous recovery from deathly illness to the Service of National Thanksgiving for the Queen Victoria's sixty-year reign in June 1897 the regal lustre of the Cathedral was restored. The Diamond Jubilee Service was the culmination of a brilliant imperial procession through the capital. The area around the west entrance of St Paul's was turned into an elaborate theatre with grandstands, flags and illuminations. Here the service was held, the aged Queen Victoria in her carriage before a new statue of Queen Anne in State, the steps crammed with clergy and choristers. The entire Anglican communion of bishops was in attendance. For the first time in two hundred years the clergy wore capes and coloured stoles, a sign of how the pageantry of the Church as well as the Crown had been dramatically enhanced.[66] The Jubilee edition of the *Illustrated London News* displayed on its front page a montage of the Queen enthroned

with orb and sceptre, surrounded by loyal colonial subjects, the dome of St Paul's shining above (Figure 10). And it included some verse:

> Hush, hush – the Nations, come from overseas,
> Attend, with trumpets blown and flags unfurled
> To swell thy Jubilee of Jubilees
> Heart of the World![67]

Such pageantry was not for the eyes of British subjects alone. At this time all leading nation-states were competing to make their capital cities

Figure 10 Front cover of Jubilee edition of
Illustrated London News, 26 June 1897.

pompous theatres of national identity, whether royal or republican, in layout, buildings, monuments and ceremonial.[68] Restored with royal and religious lustre, St Paul's offered a parallel spectacle to the secular enlightenment projected by the Eiffel Tower. Erected in 1889 for the Exposition commemorating the centennial of the Revolution, the Eiffel Tower transmitted the Third Republic's industrial might, commercial enterprise and engineering skill.[69] Both monuments affirmed the centrality of capital cities to each nation's imperial destiny.

Purchased for Lord Mayor Sir William Treloar and donated by him to the Corporation of London, Lund's 1904 painting *The Heart of the Empire* (Figure 3), projects the power of the City and the crowning glory of St Paul's.[70] Its title alludes to contemporary geo-political theories of imperial destiny. These envisaged the nation as a living, growing organism which had begun its expansion in the Elizabethan age of royal-sponsored sea-powered imperialism and was coming to maturity. London was the 'heart' of the imperial organism. As H. J. Mackinder put it:

> The life of the great metropolis at the beginning of the twentieth century exhibits the daily throb of a huge pulsating heart. Every evening half a million men are sent in quick streams, like corpuscles of blood the arteries, along the railways and the trunk roads outward to the suburbs. Every morning they return, crowding into the square mile or two wherein the exchanges of the world are finally adjusted.[71]

In re-energizing the roads, the motor car was seen to enhance the City's dominion, to realize it once more as a new Rome. In 1906 E. V. Lucas described the view from the summit of St Paul's, tracing the 'great roads' which converged on the Cathedral, 'for it is pleasant to think that all the roads even of the crowded business centre take one in time into the country, into the world, right to the sea'. It wasn't so much the speed of the car that was important as its 'enlargement of vision', its 'quickening of the imagination'. 'The motor's great achievement is the gift of England to the English, the home counties to the Londoner'.[72]

Rural writers dilated on the City's potential for reviving a decaying countryside. Richard Jefferies called London 'the vortex, the whirlpool, the centre of human life today on earth'.[73] Such vitalist views persisted in writing concerned with the countryside. A 1932 book on conserving Constable Country looked to the new arterial road from London to invigorate the 'living organism' around Flatford Mill in Suffolk, in a transfusion from Bank Junction, 'the vortex that whirls before my Lord Mayor's Mansion House in London'.[74]

RUINS OF EMPIRE

After the slaughter of the First World War, many spokesmen for England struck a less heroically imperial pose. The English were not a master race, they declared, but a domestic people, kindly, tolerant, somewhat old-fashioned, slightly at odds with the modern world. They were to be found more in the country, or at least in gardens, not in cities, least of all in London.[75] Between the wars London doubled in size, but its increasingly cosmopolitan character, especially the conspicuously American-style cinemas, department stores and cocktail bars of the West End, made it no longer a city of which conservative nationalists felt positively proud. Thus London found no place in Stanley Baldwin's *England*, in which 'England is the country and the country is England'. The Dean of St Paul's, W. R. Inge, looked outside his parish. Weary of both the capital's 'romantic imperialism' and 'theoretical socialism', he 'endorsed the notion that the comradeship of the trenches had been that between "the aristocrat" and the "ploughman", and considered that 'the "people who know London and do not like it are a very large proportion of Londoners" '.[76]

It took World War II to redeem the civic reputation of London and St Paul's figured centrally in the process. During the Blitz Churchill ordered the Cathedral to be saved at all costs. St Paul's was badly bombed but an Allied Watch of firefighters helped save it from critical damage. During the incendiary bombing raid of 29 December 1940 the Cathedral stood while all buildings around were consumed by fire. The most famous image of the Blitz is the *Daily Mail* photograph of this night (Figure 11) showing St Paul's rising miraculously above the smoke and flames, the phoenix rising again.[77]

Throughout the War and shortly after, St Paul's in a variety of settings – haloed by fire, floodlit on VE Day, rising above ruins – was a key image of national survival and renewal.[78] The Royal Academy's 1942 Plan for London envisaged clearing more than the 160 acres of rubble around the Cathedral and having St Paul's stand triumphally alone in a piazza approached by broad radiating boulevards. Updated in 1944 and published as *Road, River and Rail* in London, the plan was part of a general overhaul of the capital's infrastructure. Authored by Britain's grandest establishment architects, notably Sir Edwin Lutyens (a self-styled 'Wrenaissance' architect) and Sir Giles Gilbert Scott, the plan evoked the High Imperialism of the turn of the century.[79]

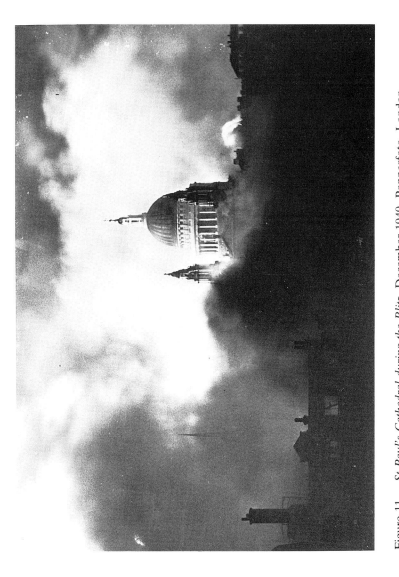

Figure 11 *St Paul's Cathedral during the Blitz*, December 1940. Popperfoto, London

Resurgent socialism claimed St Paul's too. The Cathedral became a recurrent image in the work of Humphrey Jennings, in his patriotic documentary films and in *Pandaemonium*, his filmic sequence of texts and images of the English industrial revolution. St Paul's here does not stand for a regal, religious past but for the progressive, humanistic currents of English culture. If for Blake the dome of St Paul's recalled the head of Newton, for Jennings it recalled that of Darwin. In Jennings's futurist images, the Cathedral assumes the Eiffel Tower's image of an Enlightenment transmitter.[80]

But a clear civic vision for St Paul's, of whatever kind, did not last long. Around it crumbling bombsites were colonized by wild flowers, by rosebay willowherb and Oxford ragwort, and by country birds, by mallards and redstarts.[81] The persistent ruins of the City, the dereliction of the docks, and a growing pessimism about the capital's commercial revival, encouraged a picturesque, almost rustic reconstruction of London in a range of novels, paintings, magazine articles and films.[82] Still in 1965, in the essay by Lowenthal and Prince on English landscape tastes, London 'above all is conceived as essentially rural', 'the prime example of the picturesque as of the bucolic'. They note that the Royal Academy's grand plan for rebuilding around St Paul's was rejected, so that the Cathedral might be glimpsed more picturesquely 'in a hundred different views'. They describe how proposals in the early 1960s to restore the stonework of the Cathedral to its pristine whiteness were vigorously challenged. Even though it spoiled the configuration of the building, the grime was seen as no less organic a deposit than the deep sediment of English history post-war writers on landscape saw in the countryside. Removing it would 'rob St Paul's of the weight of history'.[83]

This post-war picturesque was given a modernist mandate in William Holford's 1956 scheme for Paternoster Square on the site of the bombed precincts of the Cathedral (Figure 12). A mixture of high and low buildings and of building uses, Pevsner called it 'a brilliant essay in the English tradition of informal planning, translated boldly into a twentieth century language'.[84] The important quality of Holford's proposal was its 'essential Englishness', declared the *Architectural Review* in 1956 ,

> [its] infinitely varied approach most notably expressed by the English landscape garden ... the picturesque tradition cultivated in England in the eighteenth century and symbolising all the qualities the English had in mind when they gave their allegiance to freedom and liberty, as opposed to the absolutism and dictatorship of the French ... Holford's design is rightly in the English landscape tradition.[85]

Figure 12 William Holford, *Plan for the Precinct of St Paul's*, 1956. Maxwell Business Communications Ltd

Such sentiments have not survived the recent blanket attacks on the Modern Movement. For the *Architectural Journal* in 1988 Holford's scheme was symptomatic of the 'failings of post-war architecture'. For the Prince of Wales that year it did its best 'to lose the great dome in a jostling scrum of office building ... like a basketball team standing between you and the Mona Lisa'.[86]

As Patrick Wright has pointed out, the Prince was not the first to enlist paintings by Old Masters to indict the modernist precincts of St Paul's. In the early 1970s, Poet Laureate John Betjeman published 'Meditation on a Constable Picture', on Constable's view from Parliament Hill of the city dominated by the Cathedral, a poem dwelling lovingly on the 'steeple surrounded' dome and challenging the reader to keep 'what is left of the London we knew ... Ere slabs are too tall and we Cockneys too few'. In a 1978 BBC documentary, *City of Towers*, Constable's painting, along with Canaletto's view from Somerset House, was deployed by Christopher Booker in an assault on high-rise architecture. Nine years later, in a Royal Academy exhibition, Theo Crosby added Turner's view from Greenwich to the gallery of reproach.[87]

The revival of royal pageantry in the 1970s helped restore the lustre of St Paul's, notably the Queen's Silver Jubilee of 1977 with its logo of a crown enclosing the dome, and the Prince of Wales's own wedding in the Cathedral in 1981. While they shifted attention from the deepening recession of these years, and had the media babbling about the brilliance of British tradition, these were, in their modest scale and splendour, tastefully post-imperial celebrations.[88]

Meanwhile it was becoming apparent that the old imperial practices of the City of London, especially various forms of financial protectionism, were threatening to strangle its competitiveness in world markets. The revolution in City trading, encouraged by a fiercely free-market Thatcher government, culminated in the Big Bang of 1987. This phrase encapsulated the apocalyptic rhetoric of the time. The mushrooming of financial institutions and the associated building boom in the City offered a spectacular image of cultural renewal. The cover of G. H. Webb's book *The Bigger Bang* has a Blitz-like image of St Paul's surrounded by tower blocks rising out of smoke and flames.[89] This imagery was deployed by the Prince of Wales when he compared property developers unfavourably with the Luftwaffe: 'When it knocked down buildings, it didn't replace them with anything more offensive than rubble'.[90] The precincts of St Paul's became a battleground for a variety of civic interests.

A new urban gothicism gathered around this cultural unrest. Set during the rebuilding after the Great Fire of 1666, 1985's best-selling novel *Hawksmoor* finds St Paul's built upon the ruins of a pagan temple, its 'Lighth and Easinesse' anchored in a nether world of occult forces. On an excursion to the West Country, searching for bright stones to set into the Cathedral, Wren is pulled into 'the shaddowe of Stone-henge'.[91]

STARLET

In 1991, after the collapse of the financial boom, after the deposal of Margaret Thatcher, and on the slide into recession, the Prince of Wales and his allies seemed, for the time being, to have triumphed in the struggle for St Paul's. The Cathedral promises to stand in more splendid isolation. The Victorian bridge across Ludgate Hill is now demolished. The 1960s office towers of Paternoster Square will fall to be replaced by neo-classical shops and offices. There are plans to reduce motor traffic from the Cathedral and to build a new processional way. A team of architects is working on a face-lift for the Cathedral's precincts. 'When the ensuing surgery is carried out', noted *The Independent* in July 1990, 'it seems likely that St Paul's will be more visible than it has been at any time in its 300 year history'. But perhaps at a cost. 'In clearing away the urban clutter around St Paul's, will the intimate link between Cathedral and City be lost?' Controversy seems integral to the Cathedral's glamour. 'St Paul's is the Princess Diana, Jerry Hall or Madonna of architecture', the *Independent* declares, 'It is photographed from every angle and discussed endlessly. We worry about the way it is seen from every angle as if it were an over-exposed starlet'.[92]

NOTES

1 HRH the Prince of Wales, *A Vision of Britain* (Doubleday, London, 1989), p. 17. Some of the issues I address in this chapter were raised in Stephen Daniels, 'Battle over Britain', *New Statesman and Society*, 12 January 1990, pp. 30–2.
2 Prince of Wales, *Vision of Britain*, p. 21.
3 ibid., p. 58. The architectural interventions of the Prince have been debated in Maxwell Hutchinson, *The Prince of Wales: Right or Wrong?* (Faber &

38 *The Prince of Wales and the Shadow of St Paul's*

Faber, London, 1989); 'Prince Charles and the architecture debate', *Architectural Design* Profile 79 (1989); Patrick Wright, 'Re-enchanting the nation: Prince Charles and architecture', *Modern Painters* (1989), pp. 26–35.

4 Prince of Wales, *Vision of Britain*, p. 58.

5 ibid., p. 55. On the importance of Canaletto to a developer the Prince approves, see John Simpson, 'Canaletto', *Modern Painters* (1989), pp. 76–7. On the example of Venice to the Windsor monarchy see Tom Nairn, *The Enchanted Glass: Britain and its Monarchy* (Hutchinson, Radius, London, 1988), pp. 151–6.

6 Prince of Wales, *Vision of Britain*, p. 59.

7 Frank Atkinson, *St Paul's and the City* (Park Lane Press, London, 1985), p. 7.

8 Prince of Wales, *Vision of Britain*, p. 69.

9 The Georgian Group, *Aspiring Visions: a Planning History of the St Paul's Area from 1666 to the Present Day* (The Georgian Group, London, 1988), p. 2.

10 Jane M. Jacobs, 'Serious conservation/serious money: discourses of historicity in London', unpublished paper given to Annual Conference of Institute of British Geographers, Glasgow, 1990. On this issue see also Stephen Daniels and David Matless, 'The new nostalgia', *New Statesman and Society*, 19 May 1989, pp. 40–1.

11 Raphael Samuel, 'Exciting to be English' in *Patriotism: the Making and Unmaking of British National Identity* (3 vols, Routledge, London, 1989), vol. 1, *History and Politics*, p. xxxii.

12 Jane Lang, *Rebuilding St Paul's after the Great Fire of London* (Oxford University Press, London, 1956), p. 214.

13 On the *axis mundi* of domed buildings see E. Baldwin Smith, *The Dome: a Study in the History of Ideas* (Princeton University Press, 1950) and Yi Fu Tuan, *Topophilia* (Prentice Hall, Englewood Cliffs, N J, 1974), pp. 169–70.

14 Prince of Wales, *Vision of Britain*, p. 11.

15 On the issue of English and British national identity in the 1980s see Patrick Wright, *On Living in an Old Country* (Verso, London, 1985); Anthony Barnett, *Iron Britannia* (Alison and Busby, London, 1982) and Raphael Samuel's introductions to the three volumes of *Patriotism* (Routledge, London, 1989).

16 Prince of Wales, *Vision of Britain*, p. 13.

17 Samuel, 'Exciting to be English', *Patriotism*, vol. 1, *History and Politics*, p. xxix.

18 Prince of Wales, *Vision of Britain*, pp. 155, 10.

19 On the resurgence of landscape aesthetics see Stephen Daniels and Denis Cosgrove, 'Iconography and landscape' in Denis Cosgrove and Stephen Daniels (eds), *The Iconography of Landscape* (Cambridge University Press, 1988), pp. 1–10; Denis Cosgrove, 'Landscape Studies in geography and cognate fields of the humanities and social sciences', *Landscape Research* 15

(3) (1990), pp. 1–6; Stephen Daniels, 'Landscape' in Gary S. Dunbar, *Modern Geography: an Encyclopedic Survey* (Garland, New York, 1991), pp. 101–3.

20 Prince of Wales, *Vision of Britain*, p. 45.

21 David Feldman and Gareth Stedman Jones (eds), *Metropolis, London: Histories and Representations since 1800* (Routledge, London, 1989), pp. 1–7.

22 Quoted on p. 290 of James Turner, 'Landscape, and the "Art Prospective" in England, 1584–1660', *Journal of the Warburg and Courtauld Institutes* 42 (1979), pp. 290–3.

23 Richard Rogers, 'Pulling down the Prince', *Architectural Design* Profile 79 (1989), pp. 66–9.

24 Kerry Downes, *The Architecture of Wren* (Granada, London, 1982), pp. 18–19.

25 Kerry Downes, *Christopher Wren* (Allen Lane, London, 1974), pp. 178–9.

26 Denis Cosgrove, *Social Formation and Symbolic Landscape* (Croom Helm, London, 1984), p. 203.

27 Christopher Wren, *Parentilia, or Memoirs of the Family of Wrens* (1750) reprinted (Gregg Press, Farnborough, 1965), p. 292.

28 Downes, *Christopher Wren*, p. 134.

29 Wren, *Parentilia*, p. 285.

30 Lang, *Rebuilding St Paul's*, pp. 122, 214–22.

31 W. R. Matthews and W. M. Atkins (eds), *A History of St Paul's Cathedral* (Phoenix House, London, 1957), p. 211.

32 Atkinson, *St Paul's and the City*, p. 74.

33 Quoted in Lang, *Rebuilding St Paul's*, p. 243.

34 ibid., p. 23; Brian Allen, 'Topography or art: Canaletto in London', pp. 29–48 of Barbican Art Gallery, *The Image of London: Views by Travellers and Emigrés, 1750–1920* (Barbican Art Gallery, London, 1987).

35 Wren, *Parentilia*, p. 285.

36 *The History of all Royal Thanksgiving Days at St Paul's Cathedral* (Henry Vickers, London, 1872), p. 3.

37 Sam Smiles, 'Nationalism and the poetics of prehistory', *Landscape Research* 16 (2) (1991), pp. 3–7.

38 *Royal Thanksgiving Days*, p. 3.

39 E. O. Gordon, *Prehistoric London: Its Mounds and Circles* (Covenant, London, 1932).

40 *Royal Thanksgiving Days*, pp. 10–11; Lang, *Rebuilding St Paul's*, p. 223.

41 Robert C. Herbert, *David, Voltaire, 'Brutus' and the French Revolution* (Allen Lane, London, 1972), pp. 80, 86, 142n; Mona Ozouf, 'Le Panthéon: L'École normale des morts', in Pierre Nora (ed.), *Les Lieux de Mémoire, tome 1, La République* (Galliard, Paris, 1984), pp. 140–66.

42 Linda Colley, 'The apotheothis of George III: loyalty, royalty and the British nation, 1760–1820', *Past and Present* 102 (1984), pp. 94–129, quotation on p. 108.

43 Ian Ousby, *The Englishman's England: Travel, Taste and the Rise of Tourism* (Cambridge University Press, 1990), pp. 23–32.
44 Atkinson, *St Paul's and the City*, pp. 23–6.
45 *Royal Thanksgiving Days*, p. 111.
46 Colley, 'George III', pp. 109–10.
47 Rodney Mace, *Trafalgar Square: Emblem of Empire* (Lawrence & Wishart, London, 1976); Colley, 'George III', pp. 103–4.
48 *St Paul's Church, or the Protestant Ambulators* (John Morphew, London, 1716); Atkinson, *St Paul's and the City*, p. 74.
49 Matthews and Atkins, *History of St Paul's*, p. 279.
50 *Illustrated London News*, 2 January 1897; Atkinson, *St Paul's and the City*, p. 72.
51 Alex Potts, 'Picturing the modern metropolis', *History Workshop* 26 (autumn 1988), pp. 28–56; Donald Gray, 'Views and sketches of London in the nineteenth century'; Will Vaughan, 'London, topographers and urban change' in Ira Nadel and F. S. Schwarzbach (eds), *Victorian Artists and the City* (Pergamon, New York, 1979), pp. 43–58, 59–76.
52 Thomas Hornor, *Prospectus: View of London and the Surrounding Country* (Thomas Hornor, London, 1825), p. 25.
53 Ralph Hyde, *Gilded Scenes and Shining Prospects* (Yale Centre for British Art, New Haven, 1985), pp. 128–65; Ralph Hyde, *Panaoramania!* (Trefoil, London, 1988), pp. 79–107. Both these books discuss Hornor's Panorama from St Paul's.
54 Charlotte Bronte, *Villette* (1985) (Penguin, Hamondsworth, 1979) pp. 107–9.
55 Quoted in Humphrey Jennings, *Pandaemonium 1660–1886: The Coming of the Machine as seen by Contemporary Observers* (Picador, London, 1987), p. 125.
56 Quoted in ibid., p. 343.
57 Gustave Doré and Blanchard Jerrold, *London* (1872) reprinted (David & Charles, Newton Abbot, 1971), pp. 118, 190. On Doré's apocalyptic images of London see Barbican Art Gallery, *The Image of London*, pp. 163–8.
58 *Punch*, 6 September 1890, p. 11. I owe this reference to Felix Driver.
59 *The Times*, 19 April 1850.
60 *Coopers Journal*, 4 May 1850, pp. 277–88. I owe this reference to Caroline Arscott.
61 Thomas Markus, 'Domes of Enlightenment: two Scottish university museums', *Art History* 8 (1985), pp. 158–77.
62 Raymond Williams, *The Country and the City* (Chatto & Windus, London, 1972), pp. 281–2; Martin Wiener, *English Culture and the Decline of the Industrial Spirit 1850–1980* (Cambridge University Press, 1981), pp. 41–6, 81–8; Alun Howkins, 'The discovery of rural England' in Robert Colls and Phillip Dodd (eds), *Englishness: Politics and Culture* (Croom Helm, London, 1986), pp. 62–88.
63 Georgian Group, *Aspiring Visions*, p. 5.

64 Arthur H. Beaven, *Imperial London* (J. M. Dent, London, 1901), p. 63.

65 E. V. Lucas, *A Wanderer in London* (Methuen, London, 1906), p. 125.

66 *Royal Thanksgiving Days*, p. 12; *Illustrated London News*, 26 June 1897; David Cannadine, 'The context, performance and meaning of ritual: the British monarchy and the "invention of tradition" c. 1820–1977' in Eric Hobsbawn and Terence Ranger (eds), *The Invention of Tradition* (Cambridge University Press, 1983), pp. 101–64, esp. pp. 120–32; Thomas Richards, 'The image of Victoria in the year of the Jubilee', *Victorian Studies* 31 (1987), pp. 7–32.

67 *Illustrated London News*, 26 June 1987. The verse is by Cosmo Monkhouse.

68 Eric Hobsbawm, 'Mass producing traditions: Europe 1870–1914' in Hobsbawm and Ranger, *Invention of Tradition*, pp. 263–308; Wilbur Zelinsky, 'The imprint of central authority' in Michael Conzen (ed.), *The Making of the American Landscape* (Unwin Hyman, London, 1990), pp. 311–34, esp. 318–24.

69 Joseph Hariss, *The Eiffel Tower: Symbol of an Age* (Paul Elek, London, 1976). On a conservative symbol of the age in Paris, the Basilica of Sacré Coeur, see David Harvey, 'Monument and myth', *Annals of the Association of American Geographers* 69 (1979), pp. 362–81.

70 Provenance of N. Lund, *The Heart of the Empire*, Guildhall Art Gallery.

71 H. J. Mackinder, *Britain and the British Seas*. Second edition (Clarendon Press, Oxford, 1915), pp. 257–8.

72 Lucas, *Wanderer in London*, pp. 125–6.

73 Quoted in Potts, 'Constable Country', p. 173.

74 Herbert Cornish, *The Constable Country* (Heath Cranton, London, 1932).

75 Raphael Samuel, 'Exciting to be English' in *Patriotism*, p. xxv. From this period dates the present Prince of Wales *persona* as a patron of such 'homely causes as community architecture and alternative medicine'. Raphael Samuel, 'Patriotic fantasy', *New Statesman*, 18 July 1986, pp. 20–2, quotation on p. 20. This homely version of the Prince of Wales has beguiled a number of recent commentators, even Patrick Wright, 'Re-enchanting the nation', *Modern Painters* 2 (3), August 1989, pp. 26–35.

76 Gareth Stedman Jones, 'The "cockney" and the nation 1780–1988', in Feldman and Stedman Jones, *Metropolis*, pp. 272–324, quotation on p. 311. W. R. Inge, *Diary of a Dean: St Paul's 1911–34* (Hutchinson, London, 1935), p. 223.

77 W. R. Matthews, *Saint Paul's Cathedral in Wartime 1939–1945* (Hutchinson, London, 1946).

78 Atkinson, *St Paul's and the City*, pp. 38–41; *The British People at War* (Odhams, London, n.d.).

79 Georgian Group, *Aspiring Visions*, pp. 6–8.

80 Anthony W. Hodgkinson and Rodney E. Sheratsky, *Humphrey Jennings – More than a Maker of Films* (Hanover and London, University of New England Press, 1982), pp. 29, 55–7. Mary Lou Jennings, *Humphrey Jennings, Film Maker/Painter/Poet* (British Film Institute, London, 1983), p. 49.

81 Angus Calder, *The People's War: Britain 1939–45* (Jonathan Cape, London, 1969), p. 44.
82 David Mellor, *A Paradise Lost: the Neo-Romantic Imagination in Britain 1935–55* (Lund Humphries, London, 1987), pp. 64–5.
83 David Lowenthal and Hugh C. Prince, 'English landscape tastes', *Geographical Review* 55 (1965), pp. 189, 193, 218.
84 Nikolaus Pevsner, *The Buildings of England: London. Volume I: the Cities of London and Westminster* (Harmondsworth, Penguin, 1957), p. 243.
85 Editorial, *Architectural Review*, June 1956, pp. 295–8, quotations on pp. 298, 295.
86 Quoted in Georgian Group, *Aspiring Visions*, p. 11.
87 Patrick Wright, *A Journey through Ruins: the Last Days of London* (London, Radius, 1991), p. 241.
88 Cannadine, 'The context of ritual', p. 160.
89 George H. Webb, *The Bigger Bang: Growth of a Financial Revolution* (Waterloo, London, 1987), esp. pp. 10–13.
90 Speech at the Mansion House 1 December 1987, quoted on front page of *The Times*, 2 December 1987.
91 Peter Ackroyd, *Hawksmoor*, paperback edition (Abacus, London, 1986), quotations on pp. 7, 57. See also Jeanette Winterson, 'The architecture of unrest' *Granta* 28 (autumn 1989), pp. 177–86; Robert Hewison, *Future Tense: a New Art for the Nineties* (Methuen, London, 1990), pp. 98–101.
92 *Independent*, 28 July 1990, p. 32.

2
Joseph Wright and the Spectacle of Power

T he 1990 exhibition on Joseph Wright (1734–97), 'Wright of Derby', held in London, Paris and New York, sought to enhance the international stature of a reputedly provincial painter. Joseph Wright was initially called Wright of Derby by critics early in his career, to distinguish him from a Richard Wright from Liverpool. But long after all other Wrights have been forgotten, the label has stuck, and in a way which has marginalized Joseph Wright, which has enclosed him in his native Derbyshire. The 1990 exhibition both acknowledged Wright's regionalism and sought to make it less restrictive. It expressed the Tate Gallery's new policy in the re-hanging of its permanent collection, of elevating the role of 'regional voices' in an emphatically British contri-bution to the international mainstream of modern art.[1]

ART AND THE INDUSTRIAL REVOLUTION

The exhibition sought to revise Wright's reputation as a painter of scientific and industrial scenes. Over half the 150 exhibits were portraits, and the rest of the show revealed Wright's range of subjects from literary and mythological scenes to Italian landscapes. But it still grouped well-known paintings like *The Orrery*, *The Air Pump*, *The Iron Forge* and *Arkwright's Cotton Mills by Night* along with portraits of Midlands merchants and industrialists in a sequence which did little to disperse the received image of Wright's art. Most reviewers focused upon these pictures and many rehearsed the received wisdom of Wright as a painter of and for a solid, provincial, utilitarian bourgeoisie, expressing 'a North Midlands belief in knowledge rather than fashion', replacing 'religious

faith with a new reverence for reason and scientific enquiry', expressing 'the spirit of the Industrial Revolution'.[2]

This provincial–industrial view of Wright dates from the later nineteenth century, and Wright's rediscovery, after a century of neglect, in his home town of Derby. Derby corporation built up an unrivalled collection of his work. Exhibitions displayed his work with scientific apparatus and industrial products. Local authors heralded Wright's honest, hard-headed realism. The painter's decision to live and work in Derby was upheld as a reproach to the luxury and corruption of London and Bath. Wright and his work became a monument to provincial civic pride.[3]

The provincial–industrial view of Wright was given an internationalist dimension in Francis Klingender's *Art and the Industrial Revolution*, first published in 1947. Like other socialist documentaries of the period this book constructed a heroic scientific and industrial heritage for the nation. Klingender's text was consciously provincial. 'The most progressive currents of thought were no longer emerging in the metropolis but in countless provincial areas, where mining, industry and farming were being remodelled on scientific lines'. And Wright was 'the first professional artist to express the spirit of the industrial revolution'.[4] Much of the preparation for *Art and the Industrial Revolution* was done in the Midlands; the book is dedicated to the 'students and tutors of the North Staffordshire Workers' Educational Association'. Here in difficult wartime conditions Klingender discovered some of his most original sources. In two Nottinghamshire country houses he found 'in a ruinous condition' two versions of a hitherto little-known painting by Wright *Arkwright's Cotton Mills by Night* (Figure 1). Reproduced for the first time, the picture is placed at the centre of Wright's work in *Art and the Industrial Revolution*, indeed at the pivot of the book. Klingender dated the paintings 1789, the year of the French Revolution, when 'new energies were bursting like buds through the soil of an age old civilization'. There is nothing parochial about the Wright of *Art and the Industrial Revolution*. Klingender connects Wright's work to currents of progressive culture throughout Europe. Wright is upheld as a prophetic painter in a book which sought to establish a parallel between British enthusiasm for industrialization in the nineteenth century and Soviet enthusiasm a century later.[5]

When Wright was rediscovered a decade later by Benedict Nicolson, first in a 1958 exhibition at the Tate Gallery, ultimately in a 1968 monograph, the painter's provincial – industrialization was constructed

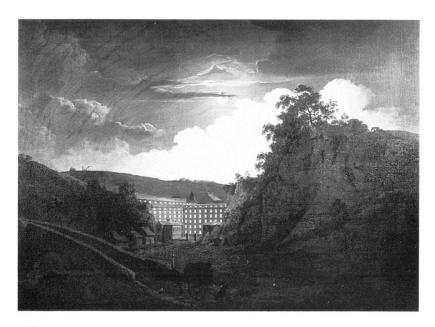

Figure 1 Joseph Wright, *Arkwright's Cotton Mills by Night*, c. 1782–3.
 Private Collection

from a perspective that was more English, patrician and metropolitan.
The 'new bourgeois civilization' of Wright's region 'lacked a cultural
history, had nothing to refine on but was starting from scratch',
announced Nicolson, 'what it lacked in sophistication, this society made
up for in seriousness of purpose, and Wright transmits this seriousness
to us'. Nicolson esteemed the scenes of scientific demonstration most
highly; in contrast he regarded the industrial scene of *Arkwright's Cotton
Mills by Night* as representing a coarsening of what culture the Midlands
possessed, and to be an omen of moral decline: 'nowhere in England
was the future being plotted with such devastating accuracy ... the
countryside going to rack and ruin under the scourge'. Nicolson
regionalized Wright in a restrictive way. He would 'not claim Wright as
a major figure ... the word "provincial" should remain attached to him
in a derogatory as well as in the flattering sense'.[6] Wright emerges from
Nicolson's work, and its reviews, as an example of the provin-
cial–industrial genre of the time, along with the novels of Alan Sillitoe
and the painting of L. S. Lowry. Nicolson left others to pursue more of
Wright's works 'among the factories of the Midlands and the North'.[7]

Many factories of the Midlands and the North were then facing redundancy. Scores were demolished as part of wholesale clearances of nineteenth-century landscapes. As industrial production fell steeply, as industrial structures decayed and collapsed, so industrialization began to be reclaimed as a national heritage. Klingender's *Art and the Industrial Revolution* was re-issued in 1968 to coincide with an exibition on the subject in Manchester. The book was heavily revised, extended and edited by Arthur Elton. It emerged a more elaborate book, a work of connoisseurship, losing much of its theoretical precision and drive.[8] The year 1968 also marked the opening of a seminal site of industrial heritage. The derelict valley of Coalbrookdale in Shropshire was reclaimed as an industrial museum. This wasn't merely nostalgic; it was intended to give the new town of Telford a sense of identity and through tourism contribute to the economic regeneration of the region.[9]

Since then scores of industrial museums have been established. These are often part of broader regenerative schemes which include the adaption of old factories for suave new uses like luxury apartments, advertising agencies or information technology firms. Textile mills in particular are losing their dark, satanic image. They have become as much an emblem of national heritage as country houses.[10]

Arkwright's Mills at Cromford have been restored with the support of the government agency English Heritage. They are part of a tourist trail which extends from the new Joseph Wright Gallery in Derby (opened with the 'Joseph Wright Cosmic Roadshow', 'an exciting multi-media event for the whole family') leading up the Derwent valley, eventually to the stately mansion of Chatsworth. The mill complex at Cromford combines industrial archaeology with audio-visual presentations, historical tableaux, and shops selling a variety of souvenirs, not all of them with obvious industrial associations. A morning at the mill can be conveniently combined with an afternoon at the 'American Adventure' theme park nearby.

As this patently consumerist heritage industry has multiplied, so it has been subject to increasing criticism. Solemn social theorists and historians attack an illusory heritage world of 'spectacle', 'fantasy' and 'landscape' in the name of a real historical world of 'political economy', 'critical analysis' and 'social relations'. The glamorous reconstruction of industrial heritage, with its panoply of postmodern techniques, is seen as a multi-national, corporate travesty of sturdy English industrial history.[11]

In this chapter I will argue for the integrity of spectacle, fantasy and landscape in industrial history by situating the work of Joseph Wright in

the consumer culture of his time, in its theatrical environment of performance and display. In the process I hope to dissolve the narrowly provincial, materialist version of culture which has congealed around Wright's painting. The consumer culture of Wright's time was consciously metropolitan as well as regional, internationalist as well as patriotic, playful and magical as well as serious and scientific. It was a forum for displaying and exchanging a variety of ideas and practices, some of which may seem to us now rational and useful, others unruly and arcane. Here Wright's pictures are flanked by steam engines and prison reform on one hand, alchemy and Hebrew prophecy on the other.[12] In order to re-vision Wright's pictures, I will first survey some of the key co-ordinates of consumer culture in Wright's time.

SPECTACLE

Like a Wedgwood vase or a Boulton clock, a Wright picture was part of a fashionable market which advertised and sold not just material artefacts but also scientific theory, scenic beauty, social morality, religious doctrine and political allegiance. Indeed such notions were inscribed on or in such artefacts themselves, in the mechanism of the clock, in a cameo on the vase, in the symbolism of the painting. For specific campaigns there was a vigorous market in souvenir ceramics (painted or transfer printed with emblems and mottoes), also bunting, transparency prints and bundles for more public festivities.[13]

These were props in the highly, and self-consciously, theatrical environment of polite culture. Indoors and out, every aspect of this culture, from tourism and social assemblies to medicine and the law, had its purpose-built arenas and codified, sometimes scripted, performances.[14] The visual register of polite culture was high, often brilliant. The theatre itself provided a model, with productions given over largely or completely to scenery and dramatic effects of light and colour. Established playhouses were redesigned to this end and new structures of all sizes were built, from peep-show boxes to panorama towers. Show business reached into most serious pursuits. Some lecturers in natural philosophy toured with apparatus fit for a fairground, incorporating planetaria, air-pumps and steam-engines augmented by paintings, sculpture, automata, barrel organs and fireworks.[15]

Rugged regions like Snowdonia and the Lake District, hitherto avoided by polite society, were packaged as scenic attractions with guidebooks, marked paths and viewpoints. A range of optical gadgets

was on sale for tourists to enhance their view.[16] Industrial districts were tourist attractions too. At fiery Coalbrookdale guidebooks gave performance times for coke making and iron smelting. For a mass circulation print the ironmasters of Coalbrookdale commissioned a London scene painter to depict the Iron Bridge framing the Severn Gorge like a theatre's proscenium arch.[17]

Spectacle was harnessed for expressly patriotic purposes. Looking at English scenery, rather than the more vaunted landscape of the Roman campagna or the Alps, was itself esteemed as a patriotic act.[18] Scientific and industrial performances confirmed the nation's power. National events, like military victories or royal occasions, were celebrated with firework displays, illuminations on public buildings and processions with large transparencies.[19] The Battle of the Nile was celebrated in Norwich in 1798 with a range of emblematic transparencies, one in the style of a celestial diagram, another showing Orus, the God of the Nile, holding a laurel crown over the head of Nelson.[20]

POTTERY AND PAINTING

The work of Josiah Wedgwood provides a precise co-ordinate in this consumer culture to that of Joseph Wright. Wedgwood set out to secure royal and aristocratic patronage to establish the social cachet of his wares. He sold successfully to a broad market, not because he sold cheap, quite the opposite: his quality control was rigorous and he kept prices high. He employed leading artists, including Wright, to provide designs for his wares and to paint pictures which included his products or allusions to his enterprise.[21] He commissioned Wright to paint *The Corinthian Maid*. This painting depicts the story from Pliny of a potter's daughter who keeps a record of her departing lover by tracing the outline of his shadow on the wall. The potter is so impressed he fills the outline with clay and bakes it as a relief. In the painting Wright shows the two lovers in cameo relief, as on Wedgewood ware, next to them two vases and in the distance a flaming kiln. It is a picture not just about pottery but about the very themes of representation and reproduction which defined consumer culture.[22]

Wedgwood staged spectacular promotions at his London warehouses in Pall Mall which became as fashionable a meeting place as many theatres. 'I want to ASTONISH THE WORLD ALL AT ONCE', he told his partner, 'For I hate piddleing you know.' The exhibition of his tea service for Catherine the Great, with admission by ticket only,

would 'fully compleat our notoriety to the whole Island'. Wedgwood staged similar promotions in other provincial cities and at his own factory Etruria near Burslem. Like his sometime collaborator, sometime competitor, Matthew Boulton at Soho, he made a spectacle of the factory itself, giving it a classical façade and landscaping the grounds to flatter patrician clients.[23]

Wedgwood's ambitions extended abroad, especially to the home of European porcelain. 'Do you really think we can make a *compleat conquest* of France?' he asked in 1771, '*Conquer France in Burslem?*' – the prospect made his 'blood move quicker'. Wedgwood struck two commemorative medallions to celebrate the commercial treaty between Britain and France in 1786, the figure of Mercury uniting the hands of the two nations, and three years later adapted the design for another to celebrate the French Revolution. When Britain declared war on France, Wedgwood's export drive in Europe was seen as part of the nation's armoury. Cartoons show John Bull with a pottery face on a body of English cotton, or in more fleshy form, skimming plates of Wedgwood and hurling Sheffield cutlery into the terrified ranks of Napoleon's army.[24]

MASONRY AND MAGIC

If the aristocracy were influential in setting or endorsing standards of fashion and style, those who designed, produced and sold commodities were not simply, in John Brewer's words, 'a service sector for the aristocracy, a "client economy" catering to the whims of the rich'.[25] They catered for an increasingly large and heterogeneous market among the middling sort, the men of movable property: entrepreneurs, professionals, tradesmen. Joseph Wright counted aristocrats among influential patrons, but was not tied to their coat-tails. The very range of Wright's clientèle from Midlands aristocrats to Liverpool merchants to foreign monarchs is representative of consumer culture. Most of his paintings were exhibited for sale in London. He was well known throughout Europe through reproductions, fine and expensive ones, of his work in mezzotint.[26]

The middling sort were, and had to be, highly organized, if only to protect themselves from the arbitrary behaviour of the super-rich, either aristocrats reluctant to pay their bills or financiers exacerbating economic fluctuations with their speculations. Most tradesmen, artisans and professionals were members of various associations which protected

their members against the vicissitudes of the open market and helped to establish, in both a moral and financial sense, their credit-worthiness.[27] In London Wright was a member, along with engravers of his work, of the Society of Artists. Many of Wright's circle, including Wedgwood and Erasmus Darwin, were freemasons and it is probable that Wright was too.[28]

Freemasons were the most powerful of fraternities. They boasted of how they united tradesmen, merchants and squires, Anglicans and Dissenters, Whigs and Tories. In their opposition to royal and religious tyranny and corruption everywhere they united all men of liberal persuasions, from St Petersburg to Philadelphia. The very range of Wright's clientèle bears the hallmark of masonic networking.

Masonic lodges were not just a form of personal insurance; they promoted and financed a variety of public improvements, including street lighting, theatres, hospitals, schools, turnpikes and bridges. With a commercial vision of social improvement and unanimity, freemasons became a consciously patriotic force in polite society, taking a leading role in sponsoring and organizing patriotic festivities. In the era of the American Revolution, which was seen as an exemplary declaration of masonic ideals, this patriotism had a radical, anti-statist edge. But as Liberty and Independence were successfully appropriated by the British State, notably in hostilities with Napoleonic France, and as the court and Crown became more visible patrons of freemasonry, so lodges in Britain became more loyal to King and country.[29]

The progressive outlook promoted by freemasonry was not narrowly materialist. It drew on speculative alchemy to promote what Frances Yates has called the 'Rosicrucian Enlightenment'.[30] The appeal of alchemy for progressive minds was its re-visioning of Christian and classical iconography (so often part of narrow, repressive ideologies in Europe) within a more comprehensive, more materialist philosophical system. Many of Wright's scientific and industrial scenes re-work biblical scenes, the forge scenes the Nativity (the glowing ingot in place of the Holy Byre), *The Alchymist* (in his gesture of prayer upon discovering phosphorus) the magi at the manger, the white bird of *The Air Pump* the Holy Spirit. They present what Rosicrucians called a 'chemical theatre' in which the spiritual and material rituals of enlightenment are enacted and witnessed.[31]

Freemasonry was not a monolithic movement. During Wright's career there developed a schism between official, court-sponsored masonry and a more dissident, subversive form emerging from revolutionary circles in France. This is evident in their respective forms and

performances of Rosicrucian knowledge. Official freemasonry inclined to a sober, deistic, epistemology of rational reform; dissident masonry embraced an hermetic, apocalyptic epistemology of revolutionary transformation. So-called 'illuminist' lodges staged sensational rituals, with fiery displays and mesmeric seances.[32] These contrasting forms of freemasonry institutionalized a controversy in the polity of natural philosophy, between conservatives who maintained that scientific performance should describe a divine, hierarchial order culminating in the Divine Architect, and radicals who maintained that performance should express nature's active, volatile powers. Display was crucial in securing the status of natural philosophy, but conservative critics argued that radical performances subverted it. They confused lecturing with conjuring, bedazzling audiences, not enlightening them, stirring up active powers in society as well as nature.[33]

ORDER AND POWER

Wright's interior scientific and industrial scenes dramatize the issue of divine order and active power. *A Philosopher giving that Lecture on the Orrery* (1766, Figure 2) shows a lecturer demonstrating to a small audience of adults and children some feature of the solar system, perhaps an eclipse or the transit of a planet across the sun. Orreries were used to demonstrate Newtonian ideas, particularly the theory of universal gravitation which was seen to reveal nature as an ordered, harmonious, divinely designed system. The machine Wright depicts is a Grand Orrery; its armillary hemispheres had no function other than to enhance the spectacle of interplanetary space. Like the cosmic tourists in contemporary poems on extra-terrestial space, the audience, orbiting like planets, contemplate the vastness of the solar system and the divine light which articulates it. It is a serious, even solemn scene, set in a library, and as such set against the more flamboyant performances by travelling showmen on portable equipment in playhouses and coffee houses.[34]

No less than landscapes, machines in the eighteenth century modelled a polity of harmony and proportion.[35] The precise State apparatus might vary. Wright's *Orrery* might be geared to the British system of limited monarchy celebrated in masonic tracts on Newtonian principles of attraction.[36] Alternatively, it might be geared to republican polity being designed at the time by leading freemasons in America. Newtonian laws

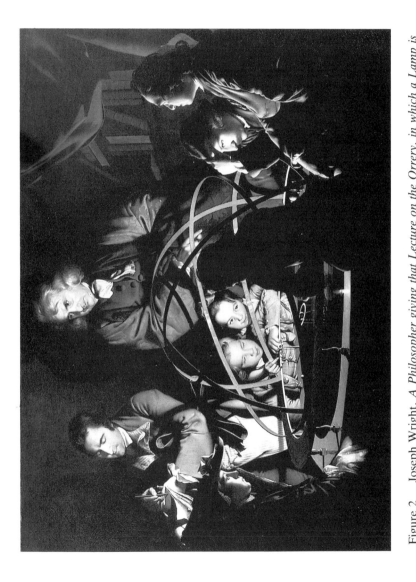

Figure 2 Joseph Wright, *A Philosopher giving that Lecture on the Orrery, in which a Lamp is put in place of the Sun*, 1766. Derby Museum and Art Gallery

of motion and revolution were inscribed into many representations of the United States, notably the Declaration of Independence. The orrery designed in Philadelphia by David Rittenhouse was hailed by Jefferson as a patently 'American Production'. As much as the Natural Bridge or Niagara Falls, this orrery was regarded as a showpiece of the new republic and its designer, a clockmaker by trade, promoted as a patriotic hero.[37]

An Experiment on a Bird in the Air Pump (1768) (Figure 3) depicts a demonstration which by Wright's time was something of a parlour trick. But again Wright has made it into an image of high seriousness. To show the nature of a vacuum a bird has been placed in a sealed jar from which air has been expelled. The bird lies apparently lifeless, a horror-struck girl shielding her eyes from the spectacle of death. The lecturer's hand is poised at the stopcock about to release air into the jar to dramatically revive the bird. Other instruments on the table show that the experiment is part of a general demonstration on pneumatics.[38]

Unlike demonstrations of mechanics, those of pneumatics were seen not just to describe the principles of nature but to tap its active powers. Joseph Priestley declared that

> works of fiction resemble those features which we contrive to illustrate the principles of philosophy, such as globes and orreries, the use of which extend no further than the views of human ingenuity, whereas real history resembles experiments by the air pump, condensing engine and electrical machine which exhibit the operation of nature, and the God of nature himself. The English hierarchy (if there be anything unsound in its constitution) ... has reason to tremble even at an air pump or an electrical machine.

The theory of pneumatics, with its key terms of aspiration, inspiration and combustion, became closely identified with the radical politics Priestley promoted. It helped to tilt the term 'revolution' from its regular orbit, of a return to first principles, to an irreversibly progressive trajectory, onward and upward. Priestly's great antagonist Edmund Burke spoke of 'The wild gas, the fixed air' which 'had plainly broke loose' in the French Revolution.[39]

While pneumatic performances were often lampooned in cartoons as an occasion for intellectual hot air, belching and farting,[40] Wright regulates his painting within a serious Rosicrucian framework. The bird in the jar is not the expendable sparrow or lark mostly used in such demonstrations, but an expensive white cockatoo. Hermetically sealed in jars, such birds were a standard pictorial allegory for the albedo, or phoenix, stage of alchemical transmutation.[41] As such *The Air Pump* is a

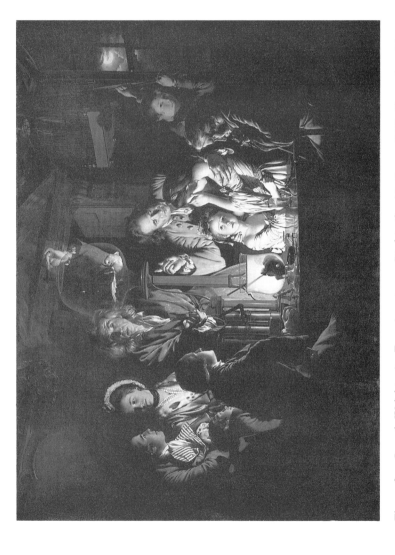

Figure 3 Joseph Wright, *An Experiment on a Bird in the Air Pump*, 1768. Reproduced by courtesy of the Trustees, The National Gallery, London

companion for Wright's *Alchymist* (Figure 4) who, in another pneuma-
tic performance, beholds a jet of phosphorus issuing from a retort, the
penultimate stage before the discovery of the philosopher's stone.[42] In
its rarity the cockatoo of the *Air Pump* functioned like phosphorus in
displays of natural philosophy; it affirmed in every way the credit, even
nobility of the performance.[43] The lecturer of *The Air Pump* and
Wright's alchymist are not base showman or conjurers mongering
worldly wonders and riches to an unruly crowd, nor are they lofty
preachers or monks mongering heavenly wonders and riches; they are
progressive, even utopian philosophers enacting for a select and sub-
missive audience the esoteric and exoteric rituals of enlightenment.[44]

The Orrery and *The Air Pump* depict the kind of performances staged
by provincial convivia of natural philosophy like the Lunar Society,
which included Wedgwood, Boulton and Erasmus Darwin among its
members and the Philosophical Society Darwin established when he
moved to Derby. Indeed *The Orrery* can be situated with some
precision.

The painting was sold to and probably commissioned by a local
squire, Lord Ferrers. Ferrers was elected to the Royal Society on the
basis of a paper he wrote on the transit of Venus in 1761 and had his own
orrery constructed to go along with the other observational instruments
in his country house. The notetaker in the picture is a portrait of Peter
Perez Burdett, then resident of Ferrers's estate, who was joint signatory
of the bond of sale of the painting. Printmaker, pottery designer,
cartographer, shuttling between English cities and the courts of Europe,
Burdett was one of those versatile figures who characterized Wright's
progressive circle of friends and patrons. He literally put Derbyshire on
the map with his county survey of 1767. The lecturer in *The Orrery*
combines the features of Newton with those of another of Wright's
progressive circle, John Whitehurst, maker of astronomical clocks in
Derby, author of a pioneering treatise on geology, and appointed to a
special post in London at the Mint.[45]

POWER IN THE LAND

Until his sojourn in Italy in 1774–5 Wright's depiction of the outside
world was limited to backgrounds to portraits or interior scenes. In Italy
Wright turned to exterior scenes, to the civic theatre of Rome, notably
firework displays and illuminations, and to the natural theatre of
volcanic terrain, notably the eruptions of Vesuvius, the caverns around

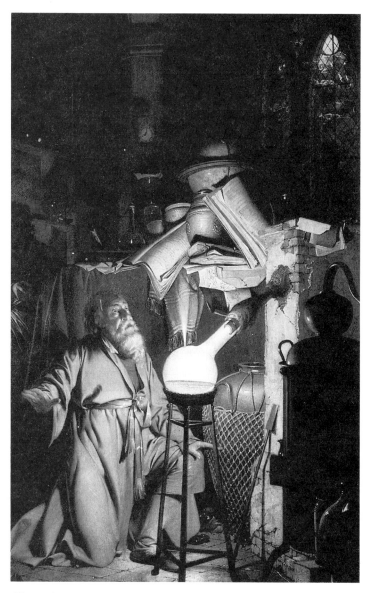

Figure 4 Joseph Wright, *The Alchymist, in search of the Philosopher's Stone, discovers Phosphorus and prays for the Successful Conclusion of his Operation, as was the Custom of the Ancient Chymical Astrologers*, 1771, reworked 1795 (detail). Derby Museums and Art Gallery.

the Gulf of Salerno and the crater lakes of Albano and Nemi.[46] From the 1780s Wright painted a series of sites in the Derbyshire Dales which display a similar sense of voluminous, often volatile force. Along with portraits of prominent local figures, these views add up to an album of regional and national power.

Wright depicts local figures with emblems of their enterprise: Erasmus Darwin with his quill pen, geologist John Whitehurst with a section of rock strata, cotton spinner Richard Arkwright with a model spinning frame, lead-mining squire Francis Hurt with a lump of galena, dilettante Brooke Boothby with a volume of Rousseau. Wright also painted renowned sites in the valley of the main river of the county, the Derwent, and its tributaries, including views of Dovedale, a series of studies of the gorge overlooked by the towering cliff Matlock High Tor, and a set of views around Arkwright's cotton mills at Cromford.[47] Wright and many of the figures he portrayed helped to define the Derwent valley, throughout its forty-mile length, as a spectacular region, linking cavernous mines, aristocratic estates, ancient castles, rocky gorges, lush meadows, mineral springs, cotton mills and industrial towns. An *Address to the River Derwent* of 1792, dedicated to Darwin, traced the 'radiant state' of the river valley from the 'glow of Chatsworth' through the 'new-found art' of cotton mills to 'Derby's towered vale'.[48] 'Perhaps no country ... can boast of finer scenes', declared James Pilkington's *View of the Present State of Derbyshire* (1789). This volume broadcast the enterprise of many of the figures Wright portrayed, praising Wright's 'sweet and magic pencil' for confirming the scenic reputation of the county. Its opening sentence located the county in every way: 'Derbyshire lies nearly in the middle of England'.[49]

In Wright's work, no less than in that of the figures he portrayed, the 'radiant state' of the region projects many and far-reaching currents of progressive culture. Wright's glowing paintings of the gorge of Matlock High Tor (Figure 5) are connected to his paintings of Vesuvius in eruption through the geological theory of his friend John Whitehurst. After his trip up Vesuvius during an eruption in 1774, Wright wrote home that he wished he had enjoyed the company of Whitehurst: 'his thoughts would have center'd in the bowels of the mountain'.[50] Whitehurst was then preparing his seminal *Inquiry into the Original State and Formation of the Earth*, first published in 1778. With a blend of Newtonian theory and Biblical revelation supported by observations of volcanoes, industrial furnaces and Derbyshire rock strata, Whitehurst argued that 'subterraneous fire' was the main agent shaping present landforms. As water during the Noachian flood seeped down fissures in

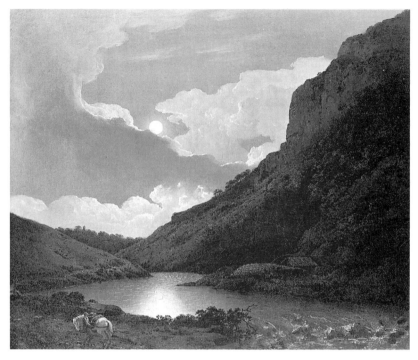

Figure 5 Joseph Wright, *Matlock Tor, Moonlight*, c. 1780. Yale Center for
British Art, Paul Mellon Collection, New Haven, Connecticut

the earth's crust, so it was vaporized, causing a cataclysmic explosion,
throwing rock strata into the dramatic forms seen in the Derwent valley.
Some of Whitehurst's evidence was taken from reports on continental
earthquakes and volcanoes, especially of Vesuvius, but the crucial field
reports were from Derbyshire. 'The book of nature is open to all men,
and perhaps no part of the world more so than Derbyshire'.[51] On the
basis of observations from mine-shafts, quarries and surface exposures,
Whitehurst prepared pioneering transverse sections of local rock strata.
Wright's portrait of Whitehurst shows a smoking volcano through the
window and his sitter holding the geological section of the gorge at
Matlock High Tor, the keystone of the *Inquiry* (Figures 6, 7). This
section shows volcanic toadstone interleaved with limestone and, below
the bed of the Derwent, a rubble-filled fissure reaching down, White-
hurst presumed, into the subterranean sea of fire. Whitehurst was
confident that fellow earth scientists could extrapolate from the section

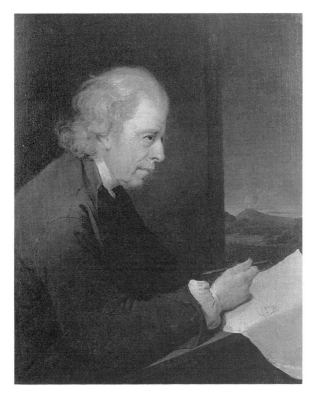

Figure 6 Joseph Wright, *John Whitehurst, FRS*, c. 1782–3.
Private Collection

to anywhere on earth. More immediately, he hoped that the local industrial interests who had provided information would, in turn, use his sections to prospect for greater wealth still.

A year after Whitehurst's *Inquiry* was published, the Derwent Valley was further publicized in London by a scenic pantomime staged at Drury Lane, *The Wonders of Derbyshire*. This was designed by the mercurial Philippe de Loutherbourg: stage machinist, alchemist, mesmeric healer, painter and book illustrator. Loutherbourg was praised in Britain for patriotic displays of his adopted country, from scenes of military might to celebrations of native landscape and occupations.[52] The *Wonders of Derbyshire* presented a series of tableaux, including views of Dovedale, Chatsworth House, the lead mines at Castleton and the great cavern of Peak's Hole (including a group of rope-spinners who

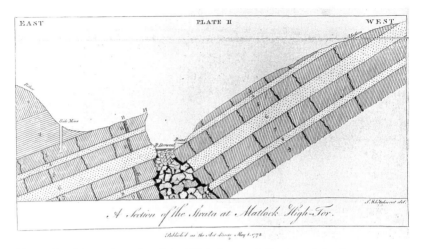

Figure 7 Engraving after John Whitehurst, *A Section of the Strata at Matlock High-Tor*, from John Whitehurst, *An Inquiry into the Original State and Formation of the Earth*, 1778

worked in there). The opening scene, a view of Matlock High Tor, was used as standard drop at Drury Lane and became the trademark of the theatre. *The Wonders of Derbyshire* was a magical, specifically Rosicrucian production. The Genius of the Peak, a fire-spirit or Salamandore, rises from his 'haunts profound' below Matlock Tor to endow miners with supernatural gifts to prospect for mineral riches. In spectacular transformation scenes, the Salamandore conjures from a gloomy cave a brilliant palace and gardens.[53]

There are, as contemporaries noted, evident exchanges between Loutherbourg's stagecraft and Wright's painting.[54] These are part of a larger genre of Rosicrucian theatre which includes works like John Sargent's dramatic poem *The Mine* (1785) which Wright made detailed plans to paint.[55] *The Mine* incorporated various up-to-date theories of natural philosophy, including Whitehurst's geology and Priestly's pneumatics, in a story of enlightenment set in an Idrian mercury mine. The mine is a terrible prison for an innocent Viennese nobleman, condemned to labour until death. His release is effected by 'beams of mercy' from gnomic 'spirits of the earth'. These spirits perform their 'high alchymy', brewing various metals, ultimately spiritual gold, bidding 'the imperial Lord of Metals Blaze'. When hapless miners appear the scene is dark; when gnomic spirits enter they transform this 'gloomy

prison house' into a radiant landscape of mountains, meadows, lakes and waterfalls. 'In earth's brute caverns we can wake delight / And gild with rapture the dark brow of night.'[56] The drama bears many of the features of masonic rites of passage practised in illuminist lodges.[57] It also echoes the tourist trails organized in the mines of Derbyshire themselves. In 1795 a minister from Perthshire described how he was taken, dressed as a miner, through gloomy passages into a vast limestone cavern brilliantly illuminated with candles. One guide 'had ingeniously withdrawn himself on purpose to surprise us; he was standing on a pinnacle of rock where I could not conceive it possible for a human being to stand; and therefore his appearance struck me at first with the idea of some supernatural being inhabiting a region of enchantment'.[58]

Upon his move to Derby, to a house by the river Derwent, in 1783, the polymathic Erasmus Darwin – physician, inventor, natural philosopher, poet – further raised the reputation of the county town and the Derwent Valley. Wright portrayed him twice, around 1770 when he was a leading figure of the Lunar Society and then again in 1792–3 when he had just published his long poem *The Botanic Garden*.[59] Running to four editions by 1799, *The Botanic Garden* was a critical and popular success: 2,400 lines long, with lengthy footnotes, pictures and diagrams, it amounted to a compendium of progressive knowledge, ranging from prison reform to geology, water-pumps, electrical machines, the abolition of slavery, canals, coinage, Wedgwood's pottery works and the 'patriot flame' of political revolution. This phosphorescent flame spread quickly over America – 'Hill lighted hill, and man electrified man' – then underground to ignite the revolutionary spirit chained in the dungeons of the Bastille.[60]

The Botanic Garden is a highly visual, pictorial poem written 'for the eye' but not, its author emphasised, a narrowly naturalistic one. 'Nature may be seen in the market place, or at the card table; but we expect more than this in the play-house or picture-room'. What Darwin expected was not a financial form of speculation but a Rosicrucian one: 'The Rosicrucian doctrine of Salamanders, Gnomes, Sylphs and Nymphs was thought to offer a proper machinery' for the poem, Darwin declared. Darwin traced this elemental machinery of fire, earth, air and water back to the alchemical wisdom of the ancient Egyptians, the 'hieroglyphic paintings' which expressed their 'many discoveries in philosophy and chemistry'. Geographically *The Botanic Garden* ranges from African deserts to Arctic icefields but the locus of the work is vested in the sites and heroes of enlightened Britain. The river Derwent

is upheld as a modern Nile. If flax and papyrus were the fibres of ancient civilization, cotton was now. The 'curious and magnificent machinery' of Arkwright's Mills revolves 'where Derwent rolls his dusky floods / Through vaulted mountains and a night of woods'.[61]

ARKWRIGHT'S MILLS

Wright's painting *Arkwright's Cotton Mills by Night* (Figure 1) has a complex genealogy. In its conjunction of cool moonlight and fierce industrial light, it echoes Wright's forge scenes, the mills glowing like molten ingots of iron. The transverse view of the valley, the mills contained in a crater-like hollow, recalls Whitehurst's geological sections of the gorge at Matlock High Tor.[62] The picture also adapts the conventions of those country house portraits which show brilliantly sunlit stately mansions settled in the centre of their parks. From this perspective it offers a version of what Mundy in his poem on the 'radiant state' of the Derwent called 'the glow of Chatsworth'.[63] If the Duke of Devonshire's Chatsworth was the power house of upper Derwent, the centre of an extensive estate with industrial, urban and farming interests, the cotton mills at Cromford, at the centre of Arkwright's estate, were the power house downstream. Promoters of county culture publicized both landmarks. The makers of Derby porcelain had both Chatsworth and Cromford Mills emblazoned on their tableware.[64] With its compositional structure of wings and backlighting, *Arkwright's Cotton Mills by Night* deploys spectacular stagecraft. It puts into an exhibition-sized oil painting the conventions of cheap peep-show prints of famous public buildings like St Paul's Cathedral (Figure 8). Lit from the front such prints presented day scenes, and from the back night scenes, with perforations for brightly lit windows, the moon and stars.[65] No less than St Paul's Cathedral, Arkwright's Cotton Mills were a national monument worthy of display.

Cromford was the centre of a cotton-spinning empire. Arkwright owned or controlled mills along the Derwent and its tributaries and further afield in Staffordshire, Lancashire and in Scotland. From Cromford, his carriage drawn by four horses and at rapid speed, Arkwright shuttled both north to his other mills and warehouses and south to the financial and political forum of London.[66] Although not unprecedented in particulars, the systematic combination of architecture, machinery and management at Cromford enterprise was seen as exemplary. The long, narrow, multi-storeyed mills, probably modelled

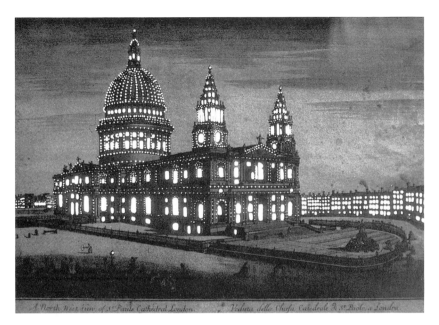

Figure 8 *St Paul's Cathedral*, perforated transparency print, n.d. Bill
Douglas and Peter Jewell Collection

on the earlier silk mill in Derby, became the template for textile mills
throughout the world. The strict discipline at Cromford, refined from
the regimes of other large institutions, including other factories, prisons
and hospitals, took Arkwright's name. The water-spinning frame, the
technical mainspring of Arkwright's success, was much copied. Despite
testimony by Wedgwood and Darwin, Arkwright failed to protect his
patent to the water-spinning frame. Piqued, he threatened to publish all
technical details of his machinery'. 'that it might be known to foreign
nations as well as our own'. Placated, perhaps by Wedgwood's encoura-
gement to adapt the frame for wool spinning, Arkwright had Joseph
Wright portray him boldly displaying a model of the frame he still
claimed to have invented (Figure 9). Like his hero George III (whose
portrait hung in his London mansion) Arkwright is portrayed in the
sturdy image of John Bull. Circulating widely, the engraving fixed
Arkwright's image and reputation.[67]

The Arkwright empire did not always run smoothly. Blaming
Arkwright's machines for their unemployment in 1779, rather than the
strangling of Britain's sea power when Spain and France declared war,

Figure 9 J. R. Smith after Joseph Wright, *Sir Richard
 Arkwright*, mezzotint of 1789–90 oil painting. Derby
 Museum and Art Gallery

handworkers marched on one of Arkwright's mills at Birkacre, Lanca-
shire with firearms and set it ablaze. Josiah Wedgwood, who happened
to be in the area, found that 'their professed design was to take Bolton,
Manchester and Stockport on their way to Cromford, and to destroy all

the engines, not only in these places, but throughout England'. The mayor of Derby appealed to the Secretary of War for military assistance. Cromford Mills were defended with a battery of canon and small arms. As it turned out, the Lancashire crowd did not get within fifty miles of Cromford but the siege mentality there served to underline the esteem of the mills as bulwarks of national survival. The role of the cotton industry in Britain's post-war commercial recovery made them a shining example of national renewal.[68]

Wright's painting *Arkwright's Cotton Mills by Night* seems to combine a number of viewpoints at the site. In shadow, above the illuminated mills in the background, is another building which may be Arkwright's house which was positioned strategically on a rocky cliff, or one of the large warehouses in the mill yard. In front of the mills, flanking the road to their gate, are some outbuildings. In the foreground, almost lost in shadow, is a horse and cart crossing a bridge, probably loaded with bales of cotton thread.

Arkwright's Cotton Mills by Night is one of a series Wright painted of the Cromford estate. There are two versions of the picture itself. Its pendant is a (now lost) view around Cromford Bridge, an area of lead smelters and forges. Wright also painted a view of the mills by day around 1790, paying particular attention to recent additions to the works and the improvements to the watercourses, with a companion picture of Arkwright's recently completed gothic mansion and park on the opposite bank of the Derwent.[69] At this time too Arkwright commissioned Wright to do his portrait but did not purchase the views of his mills. *Arkwright's Cotton Mills by Night* and its companion painting of Cromford Bridge were purchased by Daniel Parker Coke, Member of Parliament for Derby from 1776–1780 and thereafter for Nottingham. Coke had family connections with local landed and commercial interests (he appears in a group portrait by Wright casting a critical eye over a drawing of his cousin's park), he was a staunch defender of the factory system and, like Arkwright, fiercely loyal to the King.[70]

By the end of the 1780s Arkwright employed over eight hundred people of Cromford, housing some in a newly built town. The mills were a new focus for the region's labour market. Arkwright brought in clockmakers and blacksmiths to design, make and maintain the machinery, swearing them to secrecy on their indentures. To work the machines Arkwright imported men, women and children from scattered leadmining communities. It was the labour supply as much as the water supply which attracted Arkwright to the Derwent Valley.[71] If Wright's nocturnal forge scenes project a heroic image of individualized artisans,

Arkwright's Cotton Mills by Night projects a heroic image of mass, semi-skilled labour. The mills reminded more than one observer of the only structures to rival them in concentrated, twenty-four-hour, patriotic man-power: British battleships. 'These cotton-mills, seven stories high and fill'd with inhabitants remind me of a first rate man of war', noted Viscount Torrington in 1790, 'and when they are lighted up on a dark night, look most luminously beautiful.'[72]

The mills and warehouses were not just illuminated for work. The rosy lighting of the outside of the mills in Arkwright's painting may refer to the illumination of the works during the annual festive procession at Cromford each September. On this occasion Arkwright dispensed meat and ale to his workers and they in turn regaled their employer in song, praising 'The Matchless Inventor of this Cotton Mill' to the tune of the 'Roast Beef of Old England'. Such a festivity, one observer noted, 'makes them industrious and sober all the rest of the year'.[73] There were other festivities too. George III's recovery from serious illness in 1789 was celebrated 'in a style of superior elegance to anything ever exhibited in that part of the country', reported the *Derby Mercury*.

> During the day a large bonfire blazed ... at night a transparency was exhibited, the whole length of the semi-circular building [a warehouse], with the motto, in large characters – 'Rejoice all men for the King liveth;' which, with the brilliant display of lights, in the building [the mills] on each side, had a very magnificent and striking appearance.[74]

It is not incidental that about the same time as he was working on *Arkwright's Cotton Mills by Night*, Wright was completing the (now lost) *View of Gibraltar during the Destruction of the Spanish floating Batteries*. The successful defence of Gibraltar, under siege from 1779 to 1783, captured the nationalist imagination, helping to restore some of the esteem lost with the American colonies, and enlisting the support of radical patriots against a rival, Catholic colonial power. Before the assault by the batteries, publicists for the Spanish and French courts had marketed prints of the planned destruction of the British garrison and mounted a moving-panorama of the spectacle in Paris. Tourists journeyed to the site, taking their seats in the natural amphitheatre of the Sierra Carbonara, to see the real thing. What they saw in September 1782 was the British garrison firing red-hot shot into the batteries, blowing up four and scattering the rest. In prints and reports British patriots quickly publicized the victory of what one poem called the 'British Salamanders'.[75] Wright drew on these for a painting he completed after the Peace of 1783 which left Gibraltar in British hands. Purchased by the

wool merchant John Milnes, it fetched the largest price of any of Wright's paintings during his lifetime.[76] By all accounts it was a spectacular scene. In *The Botanic Garden* Darwin coupled it with Wright's view of Vesuvius erupting.[77] Wright himself described how the burning batteries in his picture 'make a fine blaze, and illuminate in a striking manner the noble Rock of Gib ... '.[78] In some verse for the catalogue to the painting's London exhibition, William Hayley spoke for the Rock:

> With patriotic pride and national delight,
> Ye Briton's view me in the tints of night ...
> This miracle of art a Briton wrought
> Painting as boldly as his country fought.

In an ode to Wright, Hayley praised the painter for giving 'to our view our favourite scene of Fame / Where Britain's genius blazed in glories brightest Flame'![79]

The glamour of Arkwright's Mills, and their role in galvanizing the culture of the Derwent Valley, did not long survive Arkwright's death in 1792. The local cotton industry soon experienced the first contraction of what was to prove terminal decline. Arkwright's son shifted his investment and energy to money and land.[80] The mills had never been a securely reassuring sight for tourists. Viscount Torrington's patriotic enthusiasm for the spectacle of the night-shift in 1790 was tempered by his patrician foreboding at the energies Arkwright has released.

> Speaking as a tourist, these vales have lost their beauty; the rural cot has given way to the lofty red mill ... the simple peasant ... is changed to an impudent mechanic ... the steam perverted from its course by sluices and acqueducts ... the woods find their way into the canals and the rocks are disfigured for limestone ... a fear strikes me that this (our over stretch'd) commerce may meet a shock; and then what becomes of your rabble of artisans!![81]

Two years later he was reminded of Arkwright when he came across 'a great flaring mill' in the 'pastoral vale' of Aysgarth:

> All the vale is disturb'd; treason and levelling systems are the discourse; the rebellion may be near at hand ... Sir Rd. Arkwright may have introduced much wealth into his family and into the country, but as a tourist I execrate his schemes ... if men thus start into riches, or if riches from trade are too easily procured, woe to us men of middling income and settled revenue.[82]

Picturesque tastes of landscape appreciation, increasingly codifying agrarian or landed ideologies, defined mills as eyesores. Uvedale Price's 1810 edition of his *Essay on the Picturesque* registered his disgust at Arkwright's mill at Matlock: 'these monstrous lumps ... are so placed they contaminate the most interesting views: and so tall there is no escaping from them in any part'.[83] In *The Excursion*, written between 1810 and 1814, Wordsworth's discussion of the 'darker side' of the factory system, 'England's bane', is prompted by the sight of an illuminated cotton mill in a Derbyshire dale: An 'unnatural light', 'Prepared for never-resting Labour's eyes / Breaks from a many windowed fabrick huge'. 'Fled utterly' for Wordsworth 'the old domestic morals of the land.' Only on a gentleman's estate nearby is there 'harmony serene ... diffused / around the mansion and its whole domain'.[84] Many local promoters of tourism in the Derwent Valley in the early nineteenth century endorsed this reductive vision. They dilated on Chatsworth and marvelled at Matlock High Tor, but either passed over cotton mills in embarrassed silence or briefly registered their disgust.[85] The cultural enlightenment of the Derwent Valley which Wright and his circle had defined was, in the space of twenty years, extinguished.

IRON BRITANNIA

The cultural resonance of *Arkwright's Cotton Mills by Night* did not fade with the decline of Arkwright's enterprise. Its conventions were redeployed by Loutherbourg in *Coalbrookdale by Night* (1801) (Figure 10).[86]

Loutherbourg depicts the principal iron works of the Severn Gorge, Madely Wood or Bedlam Furnaces, blazing in a crater-like hollow under a night sky lit by a full moon. In the foreground a horse-drawn cart, loaded with pig iron, pulls away from the site. At the time Bedlam Furnaces were the leading iron-works in Britain, producing pig iron, a local guide declared, 'of superior quality to any other in the Nation' and also large castings like pipes and cylinders for steam engines and cannon which are shown in the picture scattered about the site.[87]

Bedlam Furnaces were the centre of an industrial empire around the Severn Gorge, which included coalmines, chemical works, potteries, glassworks, wharves, bridges, inclined planes and canals. It was run by the region's most enterprising figure, William Reynolds. Reynolds was nationally esteemed as a speculative as well as a practical industrialist, keen to transfer laboratory experiments on geological samples into the

Figure 10 Philippe Jacques de Loutherbourg, *Coalbrookdale by Night*, 1801. Trustees of the Science Museum, London

theatre of industrial operations on, or below, the ground. The workmen he asked for these samples suspected conjuring for gold. The transformations Reynolds envisaged were altogether more dramatic. In ironstone, he announced, 'lay coiled up a thousand conveniences of mankind: that in that ore lay concealed the steam-engines, the tramways, the popular and universal metal that in peace and war should keep pace with, and contribute to, the highest triumphs of the world'.[88] At the time of Loutherbourg's painting, Reynolds's enterprise was firmly aligned to the British martial spirit of the Napoleonic Wars. Spectators at the Royal Academy would have recognized the parallels with Loutherbourg's painting of British fire-power the previous year, *The Battle of the Nile*, showing the French flag-ship being blown up by British men-of-war.[89]

Compared to *Arkwright's Cotton Mills by Night*, *Coalbrookdale by Night* is an evidently more energetic, even volatile, spectacle. An incandescent cloud erupts from the coke hearths into the night sky. Figures hurry to feed the coke into the blast furnaces to the right. The loaded cart, pulled by two horses on rails, rushes urgently away, the figures in front whipping the leading horse, the figure behind gesticulating dramatically and bawling above the din. This is an infernal, even apocalyptic scene. If

many pictures of the English countryside during the Napoleonic Wars offered reassuringly sturdy, earthy images,[90] *Coalbrookdale by Night* expresses a more martial, less stable view of the nation and its destiny. The picture captures what E. P. Thompson calls the 'climate of expectant frenzy' at the turn of the century when 'Napoleon [was seen] in the Book of Revelation ... the lost tribes of Israel were discovered in Birmingham and Wapping ... and the British Empire was regarded as "the peculiar possession of the Messiah and his promised naval dominion" '.[91] The grandeur of such visions was shadowed by an imminent sense of collapse, of the present into the ruins of past empires. Moreover the forces of corruption were seen to be Satanic, in a wordly rehearsal for Armageddon. The forces of redemption promised a new era of social and spiritual regeneration, a 'Third Age' or 'Age of Gold'. Such millennialism was broadcast by a variety of groups, from Methodists and mystically inclined Anglicans to the Behmenist and Swendenborgian circles in which Loutherbourg moved.[92]

Coalbrookdale was conventionally described and depicted as a shudderingly demonic place, reminiscent of various hellish set-pieces in the Bible and classical myths and their retelling in popular English writings like Milton's *Paradise Lost*.[93] The region's apocalyptic reputation was established by the vicar of the parish in which the Bedlam works was situated, John Fletcher. Born Jean Guilaume de la Fléchère, of a Swiss noble family, Fletcher was internationally renowned as the leading theologian of Methodism; his millennial prophecies and faith healing made him a cult figure in Behmenist and Swedenborgian circles. Fletcher regarded Madely as an ideal parish because its world seemed prophetic of the world to come.[94] In his sermons Fletcher seized upon local scenes of sulphurous mines, forges and furnaces. Here the 'Sons of Vulcan' laboured in a

> confused noise of water falling, steam hissing, fire-engines working, wheels turning, files creaking, hammers beating, ore bursting and bellows roaring ... while a continual irruption of flames ascending from the mouths of their artificial volcanoes, dazzle their eyes with a horrible glare ... Our earth's the bedlam of the universe, where reason (undiseas'd in heaven) runs mad.[95]

If there was gloom in Coalbrookdale, there were intimations of glory too. Thanking a parishioner who sent him a print of the Iron Bridge while on a sojourn in Switzerland, Fletcher hoped that 'the word and the faith that works by love will erect a more solid and durable bridge to unite those who travel towards Zion'.[96]

Figure 11 Philippe Jacques de Loutherbourg, *Headpiece of Isaiah Chap. II* for Macklin Bible, 1796. Bolton Public Library

Loutherbourg had already stoked up a taste for the infernal atmosphere of *Coalbrookdale by Night* in the 1782 run of his miniature stage spectacle, *The Eidophusikon*. The finale was a furnace-like scene of Satan's Palace of Pandemonium from *Paradise Lost*, the palace rising from a fiery lake surrounded by burning hills to the accompaniment of peals of thunder and bolts of lightning.[97] The imagery of Loutherbourg's illustrations of the end of the century for the prophetic books of the Bible is implicated in the picture's features too. The foreground carthorse is crossbred with the flying stallion in *The Vision of the White Horse* (1798) from the Book of Revelation. The flaming coke hearths echo the volcanic hills, inscribed with the seven planetary metals, flanking the shining Temple of Zion from Loutherbourg's headpiece to the Book of Isaiah in the Macklin Bible (Figure 11).[98] Loutherbourg deployed such special effects and alchemical imagery in his pictures of the various 'philosophical operations' for the illuminist Egyptian Rite of Freemasonry, designed to hang in the vestibule of the lodge for

apprentices to contemplate before their rite of passage. The Rite had apprentices descend into an underworld to be met by trials of air, fire and water, in an infernal atmosphere of steam, smoke and noise. After performing the various operations they emerged to behold a brilliant vision of the Temple of Zion.[99]

The apocalyptic, industrial vision of *Coalbrookdale by Night* is paralleled by a passage from Blake's *Milton* (1804) which is now often understood in a way contrary to the spirit in which it was written.[100] The verses of *Jerusalem*, set to elegiac music in the early twentieth century by Sir Charles Hubert Parry, and since sung as a patriotic hymn by socialists and conservatives alike, are often seen as a defence of a rustic, anti-industrial England, a 'green and pleasant land' defiled by 'satanic mills'. In Blake's poem, the satanic power of those mills is not unEnglish; it is the shadow of the fire-power which will forge the New Jerusalem, in what is a spectacular, urban-industrial vision:

> Bring me my Bow of burning gold
> Bring me my Arrows of desire
> Bring me my Spear: O clouds unfold
> Bring me my Chariot of Fire!
>
> I will not cease from Mental Fight
> Nor shall my Sword sleep in my hand:
> Till we have built Jerusalem,
> In England's green and pleasant land.[101]

ICONOCLASM

By the beginning of the nineteenth century the spectacular theatricality of polite culture was coming under increased moral attack, charged with superficiality, deceit and instability. Depth, truth, stability were grounded in more naturalistic views of the world, in the organic world of countryside, in texts rather than images.[102] Edmund Burke linked the dangers of theatre and theory, spectating and speculation in his diatribes against the ideology of the French Revolution. He described a sermon by the radical Richard Price:

> There must be a great change of scene; there must be a magnificent stage effect; there must be a grand spectacle to rouse the imagination ... the Preacher found them all in the French Revolution. This inspires a juvenile warmth throughout his whole frame. His enthusiasm kindles as he advances; and when he arrives at his peroration, it is in full blaze ... [103]

Other English writers, from a variety of political perspectives – William Cobbett, Jane Austen, William Cowper – looked to deep-rooted rurality as a critique of specualtion and theatricality. Urban corruption and the malignant glamour of money were seen to be spreading into rural areas, putting the whole idea of landscape into question. 'Estates are landscapes' complained Cowper, 'gaz'd upon awhile, then advertised and auctioneered away'.[104] Landscape was reclaimed as a key term of English identity by representing the organic virtues of rural communities and the soil. The civic, internationalist, republican patriotism represented by Joseph Wright and his circle came under challenge from a more vernacular, insular patriotism represented by painters and poets of the English countryside.[105] After a visit in 1823 to a Diorama in London, John Constable reported

> It is a transparency, the spectator in a dark chamber ... it is without the pale of Art because its object is deception – the style of the pictures is French which is decidedly against them. The place was full of foreigners – and I seemed to be in a cage of magpies.[106]

NOTES

1 Judy Edgerton, *Wright of Derby* (Tate Gallery, London, 1990), esp. pp. 9–14; Tate Gallery, *Preview*, January–April 1990, pp. 1–7.
2 Tim Hilton, 'The white heat of reason', *Guardian*, 14 February 1990, p. 41; Richard Dormant, 'The enlightened world of Wright of Derby', *Daily Telegraph*, 6 February 1990, p. 14; *In Britain*, February 1990, p. 42. My review of the exhibition, 'Voices from the regions', *New Statesman and Society*, 23 February 1990, pp. 40–41, sketches some of the arguments I develop in this chapter.
3 William Bemrose, *The Life and Works of Joseph Wright ARA* (Bemrose & Sons, London, 1885); Midland Counties Exhibition, *Catalogue of Works of Art and Industrial Products*, May 1870; Derby Corporation Art Gallery, *Joseph Wright* (Derby, 1883); F. W. Shurlock, 'The scientific pictures of Joseph Wright', *Science Progress* 17 (1923), pp. 432–8.
4 Francis D. Klingender, *Art and the Industrial Revolution* (Noel Carrington, London, 1947), pp. 39–57, quotations on pp. 21, 46. Other writings of the time promoting a similar view include Ruthven Todd, *Tracks in the Snow: Studies in English Science and Art* (Grey Walls Press, London, 1946) and Humphrey Jennings, *Pandaemonium 1660–1886: the Coming of the machine as seen by Contemporary Observers* (Picador, London, 1987).
5 Klingender, *Art and the Industrial Revolution*, pp. v, 49, 177, 37.

6 Benedict Nicolson, Introduction to *Joseph Wright of Derby 1734–1797* (Arts Council of Great Britain for the Tate Gallery, London, 1958), pp. 5, 7; Benedict Nicolson, *Joseph Wright of Derby: Painter of Light* (2 vols, Routledge & Kegan Paul, London, 1968), quotations in vol. 1, pp. 166–7. It should be said that many of Nicolson's research findings cut across the grain of his thesis.

7 Nicolson, *Joseph Wright*, p. 7. Horace Shipp, 'Joseph Wright of Derby', *Apollo*, April 1958, pp. 118–25.

8 Francis D. Klingender, *Art and the Industrial Revolution*, edited and revised by Arthur Elton (Adams & Dart, London, 1968).

9 Robert Hewison, *The Heritage Industry* (Methuen, London, 1987), pp. 91–3.

10 Marcus Binney, *Satanic Mills* (SAVE Britain's Heritage, London, 1979). As this exhibition catalogue shows, the model for many regenerative schemes is the National Park at Lowell, Massachussets, opened in 1978.

11 Hewison, *The Heritage Industry*, pp. 83–106; Bob West, 'The making of the English working past: a critical view of the Ironbridge Gorge Museum'; Tony Bennett, 'Museums and "the people" ' in Robert Lumley (ed.), *The Museum Time Machine: Putting Cultures on Display* (Routledge, London, 1988), pp. 37–62, 63–85, quotations on pp. 37, 53, 74.

12 Among the more recent writings on Wright I have found useful are Ronald Paulson, *Emblem and Expression* (Thames & Hudson, London, 1975), pp. 185–247; Frederick Cummings, 'Folly and mutability in two romantic paintings: The Alchemist and Democritus by Joseph Wright' *Art Quarterly* 33 (1970), pp. 247–71; David Fraser, '"Fields of radiance"; the scientific and industrial scenes of Joseph Wright', in Denis Cosgrove and Stephen Daniels (eds), *The Iconography of Landscape* (Cambridge University Press, 1988), pp. 119–41. Also I have benefited from a new historiography of the Enlightenment which is breaking up the idea of a forward march from superstition to utility. See especially Roy Porter, 'The Enlightenment in England' in Roy Porter and Mikulas Teich (eds), *The Enlightenment in National Context* (Cambridge University Press, 1981), pp. 1–18; Roy Porter, 'Science, provincial culture and public opinion in Enlightenment England', *British Journal for Eighteenth Century Studies* 3 (1980), pp. 20–46; Clarke Garrett, 'Swedenborg and the mystical enlightenment in England', *Journal of the History of Ideas* 45 (1984), pp. 67–81. My approach to Wright has some parallels with Nicholas Green's to French painting in, *The Spectacle of Nature: Landscape and Bourgeois Culture in Nineteenth-century France* (Manchester University Press, 1990).

13 John Brewer, 'Commercialization and politics' in Neil McKendrick, John Brewer and J. H. Plumb, *The Birth of a Consumer Society* (Europa, London, 1982), pp. 197–262.

14 Stephen Daniels and Susanne Seymour, 'Landscape design and the idea of improvement', 1730–1900, in R. A. Dodgshon and R. A. Butlin (eds), *An Historical Geography of England and Wales*, second edition (Academic

Press, London, 1990), pp. 457–520.
15 Richard D. Altick, *The Shows of London* (Belknap Press of Harvard University Press, Cambridge, Mass., 1978).
16 Esther Moir, *The Discovery of Britain: English Tourists 1540–1840* (Routledge & Kegan Paul, London, 1964); Malcolm Andrews, *The Search for the Picturesque: Landscape Aesthetics and Tourism in Britain, 1760–1800* (Scolar Press, London, 1989).
17 Barrie Trinder, *'The Most Extraordinary District in the World': Ironbridge and Coalbrookdale* (Phillimore, London, 1977); Stuart Smith, *A View from the Ironbridge* (Ironbridge Gorge Museum Trust, Ironbridge, 1979).
18 Michael Rosenthal, *British Landscape Painting* (Phaidon, Oxford, 1982), pp. 44–72.
19 Linda Colley, 'The apotheosis of George III: loyality, royalty and the British nation, 1760–1820', *Past and Present* 102 (1984), pp. 94–128.
20 Trevor Fawcett, 'Patriotic transparencies in Norwich 1798–1814', *Norfolk Archaeology* 34 (1968), pp. 245–52, esp. pp. 246–7.
21 Neil McKendrick, 'Josiah Wedgwood and the commercialization of the potteries', in McKendrick et al., *The Birth of a Consumer Society*, pp. 100–45; Albert Boim, *Art in an Age of Revolution, 1750–1800* (University of Chicago Press, 1987), pp. 87–93, 371–7.
22 Edgerton, *Wright of Derby*, pp. 133–4.
23 McKendrick, 'Josiah Wedgwood', quotation on p. 121. Jennifer Tann, *The Development of the Factory* (Cornmarket, London, 1970), p. 153.
24 McKendrick, 'Josiah Wedgewood', p. 121; Boim, *Art in an Age of Revolution*, pp. 374–5.
25 Brewer, 'Commercialization and politics', p. 197.
26 Edgerton, *Wright of Derby*, pp. 25–9.
27 Brewer, 'Commercialization and politics', pp. 219–21.
28 Marsha Keith Manatt Schuchard, *Freemasonry, Secret Societies and the Continuity of the Occult Tradition in English Literature* (unpublished Ph.D. dissertation University of Texas at Austin, 1975), p. 447. For information on Wright's freemasonic connections I am indebted to David Fraser.
29 Brewer, 'Commercialization and politics', pp. 220–1; Colley, 'Apotheossis of George III', p. 118.
30 Frances Yates, *The Rosicrucian Enlightenment* (Routledge & Kegan Paul, London, 1972); Schuchard, 'Freemasonry', pp. 220–33.
31 Charles Nicholl, *The Chemical Theatre* (Routledge & Kegan Paul, London, 1980).
32 Schuchard, 'Freemasonry', pp. 166–229; Margaret Jacob, *The Radical Enlightenment: Pantheists, Freemasons and Republicans* (Allen & Unwin, London, 1981); Clarke Garrett, *Respectable Folly: Millenarians and the French Revolution in France and England* (Johns Hopkins University Press, Baltimore, 1975), pp. 97–120.
33 Simon Schaffer, 'Natural philosophy and public spectacle in the eighteenth century', *History of Science* 21 (1983), pp. 1–43.

34 Edgerton, *Wright of Derby*, pp. 1, 54–5; Fraser, 'Fields of radiance', pp. 121–4; Henry C. King, *Geared to the Stars: the Evolution of Planeteriums, Orreries and Astronomical Clocks* (Adam Hilger, Bristol, 1975); Marjorie Hope Nicolson, *Newton Demands the Muse* (Princeton University Press, 1936), pp. 20–113.

35 John Barrell, *English Literature in History 1730–1830: an Equal Wide Survey* (Hutchinson, London, 1983), pp. 29–35.

36 J. T. Desaguliers, *The Newtonian System of the World* (J. Roberts, London, 1728); Jacob, *The Radical Enlightenment*, pp. 136–7.

37 J. R. Pole, 'Enlightenment and the politics of American nature' in Porter and Teich, *The Enlightenment in National Context*, pp. 192–214, esp. pp. 194–6; Garry Wills, *Inventing America: Jefferson's Declaration of Independence* (Athlone Press, London, 1980), pp. 93–110, 100–14; John F. Kasson, *Civilizing the Machine: Technology and Republican Values in America, 1776–1900* (Penguin, Harmondsworth, 1977), pp. 12–14.

38 Edgerton, *Wright of Derby*, pp. 58–61.

39 Schaffer, 'Natural philosophy and public spectacle', quotations on pp. 1, 10, 25; James Hillman, 'The imagination of air and the collapse of alchemy', *Eranos Yearbook* 50 (1981), pp. 273–333.

40 Altick, *The Shows of London*, p. 367.

41 See especially the pictures from Solomon Trismosin, *Splendor Solis* reproduced in C. A. Burland, *The Arts of Alchemists* (Weidenfeld & Nicolson, London, 1967) and E. J. Holmyard, *Alchemy* (Penguin, Harmondsworth, 1957).

42 John Read, *The Alchemist in Life, Literature and Art* (Thomas Nelson & Sons, London, 1947), pp. 88–90.

43 J. V. Golinski, 'A noble spectacle: phosphorus and the public cultures of science in the early Royal Society', *Isis* 80 (1989), pp. 11–39.

44 Schaffer, 'Natural philosophy and public spectacle', p. 15.

45 David Fraser, 'Joseph Wright of Derby and the Lunar Society' in Edgerton, *Wright of Derby*, pp. 15–24; Edgerton, *Wright of Derby*, pp. 54–5, 87–90. J. B. Harley et al., *Burdett's Map of Derbyshire 1791* (Derbyshire Archaeological Society, Derby, 1975); King, *Geared to the Stars*, p. 141.

46 Nicolson, *Joseph Wright*, pp. 75–86; Edgerton, *Wright of Derby*, pp. 158–80.

47 Nicolson, *Joseph Wright*, pp. 87–94, 158–69; Edgerton, *Wright of Derby*, pp. 181–212.

48 F. N. C. Mundy, 'Address to the River Derwent' (1792), in *The Poetical works of Erasmus Darwin* (3 vols, J. Johnson, London, 1806), vol. 1, pp. xii–xiii.

49 James Pilkington, *A View of the Present State of Derbyshire* (Derby, 1789), quotations on pp. 9, 25–6, 1.

50 Quoted Fraser, 'Fields of radiance', p. 125. I am greatly indebted to the section on landscape and geology in Fraser's article, pp. 124–8.

51 John Whitehurst, *An Inquiry into the Original State and Formation of the*

Earth (W. Bent & J. Cooper, London, 1778). On Whitehurst's geology see Roy Porter, *The Making of Geology: Earth Science in Britain 1660–1815* (Cambridge University Press, 1977); Martin Rudwick, 'The emergence of a visual language for geological science 1760–1840', *History of Science* 14 (1976), pp. 149–55.

52 Rudiger Jöppien for the Greater London Council, *Philippe Jacques de Loutherbourg, RA 1740–1812* (Greater London Council, London, 1973).

53 Ralph G. Allen, 'The *Wonders of Derbyshire*: a spectacular eighteenth-century travelogue', *Theatre Survey* 2 (1961), pp. 54–6. Loutherbourg's show drew on a travelogue tradition which reached back to Thomas Hobbes's *De Mirabilis Pecci* (William Crook, London, 1636) and latterly Charles Cotton, *The Wonders of the Peak* (John Collyer, Nottingham, 1681, 1725).

54 Benedict Nicolson, 'Wright of Derby: addenda and corrigenda', *Burlington Magazine*, October 1988, p. 757 n. 39.

55 Nicolson, *Joseph Wright*, p. 125.

56 John Sargent, *The Mine: a Dramatic Poem* (T. Cadell, London, 1785), quotations on pp. 8, 61.

57 Anthony Vidler, 'The architecture of the lodges: rituals and symbols of freemasonry', in *The Writing of the Walls: Architectural Theory of the late Enlightenment* (Princeton Architectural Press, 1987), pp. 83–102.

58 William MacRitchie, *Diary of a Tour through Great Britain in 1795* (Elliott Stock, London, 1987), pp. 56–60.

59 Edgerton, *Wright of Derby* pp. 220–1.

60 *Poetical Works of Erasmus Darwin*, vol. 1, quotation on p. 105.

61 Ibid., vol. 1, pp. xvii–xviii, vol. 2. pp. 80–8; Klingender, *Art and the Industrial Revolution*, first edition, pp. 30–8.

62 Fraser, 'Fields of radiance', p. 136.

63 Mundy, 'Address to the River Derwent', p. xiii.

64 Fraser, 'Joseph Wright and the Lunar Society', p. 23.

65 Ralph Hyde, *Panoramania* (Trefoil, London, 1988), p. 115.

66 R. S. Fitton, *The Arkwrights: Spinners of Fortune* (Manchester University Press, 1989), pp. 50–89, 182–223.

67 Ibid., pp. 91–183, quotation on p. 142.

68 Ibid., pp. 51–4, quotation on p. 33.

69 Nicolson, *Joseph Wright*, pp. 164–9. David Fraser, curator at Derby Art Gallery, thinks one of the versions of *Arkwright's Mills by Night* may be a copy by another hand.

70 Ibid., p. 125; Edgerton, *Wright of Derby*, pp. 199–200, 217–18.

71 Fitton, *The Arkwrights*, p. 30.

72 *The Torrington Diaries*, ed. C. Bryn Andrews (Eyre & Spottiswoode, London, 1935–6), vol. 2, pp. 194–5. See also Fitton, *The Arkwrights*, p. 152.

73 Fitton, *The Arkwrights*, pp. 232–4.

74 Quoted in ibid., p. 186.

75 George Hills, *Rock of Contention: a History of Gibraltar* (Robert Hale and Son, London, 1974), pp. 336–9. The poem to British Salamanders is reproduced in Jack Russell, *Gibraltar Besieged 1779–83* (Heinemann, London, 1965), p. 274.
76 Nicolson, *Joseph Wright*, p. 16.
77 Darwin, *Poetical Works*, vol. 2, pp. 24–5.
78 Quoted in Nicolson, *Joseph Wright*, p. 160.
79 Quoted in William Bemrose, *Joseph Wright*, p. 59.
80 Fitton, *The Arkwrights*, pp. 254–96.
81 *Torrington Diaries*, vol. 2, pp. 194–5.
82 Ibid., vol. 3, pp. 81–2.
83 Uvedale Price, *Essays on the Picturesque* (3 vols, London, 1810), vol. 1, p. 198.
84 William Wordsworth, 'The excursion', in *Wordsworth: Poetical Works* (Cambridge University Press, 1969), quotations on p. 683.
85 E. Rhodes, *Peak Scenery, or the Derbyshire Tourist* (Longman, London, 1824), pp. 250–1.
86 The argument of this section is expanded and fully illustrated in my essay 'Loutherbourg's chemical theatre: *Coalbrookdale by Night*' in John Barrell (ed.), *Painting and the Politics of Culture* (Oxford University Press, 1992) pp. 195–230.
87 Barrie Trinder, *Bedlam* (Ironbridge Gorge Museum Trust, Ironbridge, 1984).
88 Barrie Trinder, *The Industrial Revolution in Shropshire* (Phillimore, London and Chichester, 1981), pp. 36–7, 43–4, 116–17, 138–9; *Coalbrookdale 1801: a Contemporary Description*, ed. Barrie Trinder (Ironbridge Gorge Museum Trust, Ironbridge, 1979), pp. 16–17.
89 Monika Wagner, *Die Industrielandschaft in der Englischen Malerei* (Peter Lang, Frankfurt, 1977).
90 John Barrell, *The Dark Side of the Landscape: the Rural Poor in English Painting, 1730–1840* (Cambridge University Press, 1980), pp. 116–17.
91 E. P. Thompson, *The Making of the English Working Class* (Allen Lane, London, 1963), p. 382.
92 Garrett, 'Swedenborg and the mystical Englightenment'.
93 Klingender, *Art and the Industrial Revolution*, first edition, pp. 71–3; Trinder, 'The Most Extraordinary District'.
94 Barrie Trinder, *John Fletcher* (Ironbridge Gorge Museum Trust, Ironbridge, n.d.); Desirée Hirst, *Hidden Riches: Traditional Symbolism from the Renaissance to Blake* (Eyre & Spottiswoode, London, 1964), pp. 242, 263.
95 John Fletcher, *Works* (T. Allman, London, 1836), vol. 1, pp. 4–162, quotations on pp. 20, 31, 99.
96 Quoted in Trinder, *The Industrial Revolution in Shropshire*, p. 112.
97 Altick, *The Shows of London*, pp. 117–27.

98 Morton Paley, *The Apocalyptic Sublime* (Yale University Press, New Haven and London, 1986), pp. 51–70.

99 Henry Ridgley Evans, *Cagliostro and his Egyptian Rite of Freemasonry* (New York, 1933), pp. 340–2, 375.

100 Boim, *Art in an Age of Revolution*, pp. 349–67.

101 William Blake, *Writings*, ed. G. E. Bentley (Clarendon Press, Oxford, 1978), p. 318.

102 On this issue see Stephen Daniels and Denis Cosgrove, 'Spectacle and text: landscape metaphors in cultural geography', in James Duncan and David Ley (eds), *Place/Culture/Representation* (Routledge, 1993) pp. 57–77.

103 Quoted in W. J. T. Mitchell, *Iconology: Image, Text, Ideology* (University of Chicago Press, 1986), p. 144.

104 Daniels and Seymour, 'Landscape design and the idea of improvement', pp. 497–99, 501, quotation on p. 501.

105 Stephen Daniels, 'The political iconography of woodland in later Georgian England', in Cosgrove and Daniels (eds), *The Iconography of Landscape*, pp. 43–82.

106 John Constable's *Correspondence*, ed. R. B. Beckett (Suffolk Records Society, Ipswich, 1968), vol. 12, p. 134.

3

Humphry Repton and the Improvement of the Estate

The landed gentry ruled Georgian England and their country seats were the main focus of their authority. No longer restrained by Church or Crown, progressively less so by common right and custom, the gentry assembled large, consolidated estates and took a keen personal interest in their planning and management. They displayed their power in the land by building, extending and refashioning mansions and grounds. Some of this construction was paid for by rural revenue – by agricultural rents, or the sale of parkland produce – but the most grandiose schemes were funded by other, often more lucrative sources – urban ground rents, mineral leases, stocks and bonds, dowries, governments sinecures, the spoils of war, overseas plantations, overseas trade. The very attention lavished on mansions and grounds, both on the ground, and written and pictorial representations of polite society, helped obscure the gentry's involvement in a diverse and dynamic economy. Estate portrayal and design did not eclipse the gentry's economic interests; rather they codified these interests in terms of landscape. Scenes of flourishing plantations, pasture and tillage displayed the economic, social and patriotic virtues of progressive estate management[1] (Figure 1).

The idea of 'improvement' was central to landed culture. Initially used to denote profitable operations in connections with land, notably aristocratic enclosure, by the end of the century 'improvement' referred to a range of activities. It denoted the moral and aesthetic dimensions or implications of estate design and management; furthermore it referred to a broad range of conduct, from reading to statecraft. The classic statement on improvement is Edmund Burke's. 'To improve', declared Burke, 'is to treat the deficient or corrupt parts of an established order

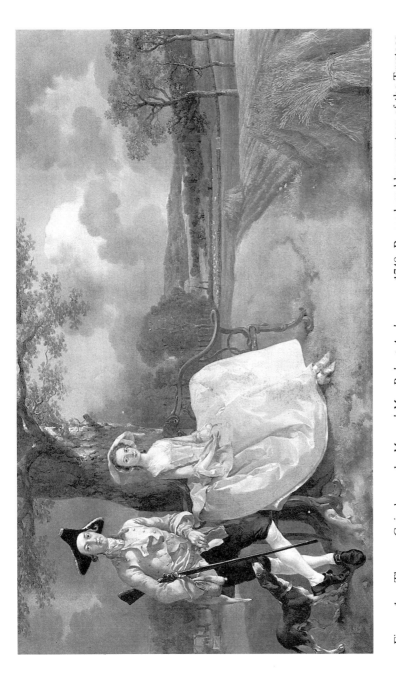

Figure 1 Thomas Gainsborough, *Mr and Mrs Robert Andrews*, c. 1748. Reproduced by courtesy of the Trustees, The National Gallery, London

with the character of the whole in mind.' The established order was presided over by the gentry, who had the statesman's advantage of envisaging society as a 'whole', much as they could envisage their estates as a whole, in paintings and maps as well as on the ground. Burke's idea of improvement was attuned to commercial enterprise. He saw capitalist exchange, 'the great wheel of circulation' he called it, as providing the momentum, without which the State, or a particular estate, would stagnate. If the idea of improvement implied a progressive, stable polity, the very power and range of its uses in an increasingly complicated society tended to disperse and destabilize its meaning. By the beginning of the nineteenth century the word 'improvement' in connection to estate design was being used to signify the corruption of landed society; and in the domain of middle-class reform it was deployed against landed power and privilege.[2]

In this chapter I examine the issue of estate improvement in the work of Humphry Repton (1752–1818), the leading landscape designer in later Georgian England. I will concentrate on his later career, in the early nineteenth century, when estate improvement was a particularly complex, contentious issue, one that was held to have serious implications for the condition of the country as a whole. This was one of the many crises of the aristocracy which have characterized English history, or rather certain narrations of it. Like many commentators, before and since, Repton was convinced of the decline and imminent fall of landed culture. Writing two centuries later I am struck by its resilience. In an epilogue to this chapter I consider the changing fortunes and iconography of landed culture in the twentieth century, especially its place in views of national heritage.

HUMPHRY REPTON

After the death of Lancelot 'Capability' Brown in 1783, Humphry Repton became England's leading designer of landscape parks. While Repton claimed some pedigree in Brown's style, there are important differences between the two figures. Brown lived and worked under the patronage of the large aristocracy, landscaping their vast parks in a style which expressed their supreme self-confidence and also his. Repton's career lasted from 1789 to 1818, a more changeful and often turbulent period. He worked, more circumspectly, for a range of clients, from dukes to lawyers, at a more modest scale and with an attention to detail which betrays acute anxieties about the status of his clients, the role of

his art and condition of society. The vehicles of Brown's designs were large maps; Repton prepared volumes of meticulous watercolours and text, leaving little to chance. While Brown described his work emphatically as 'place-making', Repton preferred the more temperate term 'landscape gardening'.[3]

After his death in 1783, Brown and his style came under increasing censure by conservative moralists. They were alarmed at the scale of Brownian parks and their disconnection from the humbler side of the English countryside. In an age of sharpening social disaffection, such parks presented too indelicate a display of wealth and prestige. Speaking for the local attachments of the middling gentry, the picturesque theorist Uvedale Price described the Brown style as 'levelling', 'a principle, when made general, or brought into action by any determined improver either of grounds or governments, occasions such mischiefs, as time slowly, if ever, repairs'.[4] Speaking for the steady rhythms of nature and husbandry, the poet William Cowper called 'improvement' in the Brown style 'the idol of the age', 'fed with many a victim'. For Cowper, Brown's parks were a form of conspicuous consumption which shone with the malignant glamour of money: 'Estates are landscapes ... gaz'd upon awhile and auctioneer'd away'.[5] As a professional landscape gardener convinced of the social responsibility of his art, Humphry Repton was continually negotiating the demands of money and morality which framed the discourse of estate improvement.

For the first decade of his career Repton was optimistic. He cultivated a broad network of clients and saw his art as mediating the great range of, potentially hostile, social interests and attitudes of the time. But Repton's anxieties increased after the turn of eighteenth century.

The first years of the nineteenth century

> excited such alarm through all ranks of people that I felt as my profession was becoming extinct ... the whole nation was aroused to self-defence ... nothing was heard but the dread of Bonaparte and the French invasion! Beacons, Martello Towers, Camps, Depots, and every species of self-defence occupied all minds – and everyone trembled for the safety for old England.[6]

Repton's fears for old England were provoked as much by the economic and social effects of the wars at home: the disaffection of the poor, the pressure of war taxes on the established gentry and on his own profession, and the ascendancy of a new moneyed interest. While 'the title of an English merchant has always been and ever will be honourable', commerce was being corrupted by finance.[7] Repton accused the

government of encouraging this by failing to regulate the increase in paper money and offering huge war contracts to unscrupulous entrepreneurs. A contractor for tents and bedding had moved into the manor in Repton's own village and was busy grinding his tenants (including Repton) for rent.[8] 'In France they're all beggars, marauders and robbers', wrote Repton, 'In England Directors, contractors, Stock Jobbers ... Our glory and pride with the stocks rise and fall.'[9] In contrast to land, paper money seemed to provide a baseless source of wealth and political power. With Burke, Repton feared the displacement of the accumulated, unwritten wisdom of the nation-estate with 'A paper circulation and stock-jobbing constitution'.[10]

Demand for Repton's talents decreased. While his career had been launched on the patronage of the aristocracy and some of England's leading statesmen, those who did commission him after the turn of the century seemed to be upstarts with neither pedigree nor taste. 'In two or three years the same person who lived in a hired workshop must inhabit a house of his own in the country, so a field is bought – and a villa is to be built and Mr Repton must come to fix the spot'. These brief and mercenary transactions contrasted with 'the society I used to keep'. They brought home to Repton a fact which aristocratic patronage obscured: he was a commercial artist. 'I can picture their calculators thus talking of me – landscape gardening is a good line, no risk of capital, all profit, no loss! a very pretty morning work'.[11] But even the English aristocracy were now infected by finance, sacrificing all for money in estate improvements. In 1816 Repton recalled a time when his art 'seemed likely to extend its influence till all England would become one landscape garden'; 'but eager pursuit of gain has, of late, extended from the new proprietor, whose habits have been connected with trade, to the ancient hereditary gentleman'.[12]

The decline in Repton's fortunes was not unremitting. He enjoyed a brief respite during 1809 and 1812 and I will now discuss the major commission from each of these periods, to see how Repton struggled to fashion landscapes in a world which seemed hostile to his art, and how he strove to maintain an aristocratic politics of landscape, before finally admitting defeat.

LANDSCAPING FOR A MANUFACTURER

Repton's ten recorded commissions for 1809 were the highest annual total for fifteen years. They are scattered widely throughout England,

from Cornwall in the west to Norfolk in the east and at the northern extremity of Repton's field of work in Yorkshire.[13] It is a sign of Repton's driving desire for work that Christmas 1809 found him not with his family in Essex but staying with a Yorkshire client, the Leeds woollen manufacturer Benjamin Gott. Gott commissioned Repton to landscape his estate on the outskirts of Leeds, concentrating on the view towards the city in which his woollen mills were the focus of attention.[14]

This was not Repton's first commission to landscape an industrial view. Four months before he had visited the Wingerworth estate in Derbyshire, owned by the Hunlokes, the kind of the old titled family Repton respected. Repton always sanctioned the combination of commerce with ancestral pride, as long as this was not too conspicuously displayed. But the Hunlokes were quite unlike the southern aristocrats or smaller gentry with whom Repton was familiar. The Hunlokes enjoyed the bulk of their income from exploiting their estate for minerals – coal, iron ore, building stone, lead and clay – and had done so for almost three hundred years. At the time of Repton's visit industrial production at Wingerworth, especially of iron, was at a peak and the coke-fired furnace, linked to collieries by a pioneering railway, was working full blast. The furnace dominated the middle distance of the principal vista from the house. In the unimproved view from his Red Book Repton shows its burst of flame and plume of white smoke. He made no attempt to screen it in the improved view, rather he attempted to create a more relaxed, sophisticated landscape for it. He did so by proposing a lake in the valley and a balustraded terrace in front of the house, creating a sequence of horizontal bands which inhibited the eye from plunging down the prospect to the foundry as on 'an inclined plane'. Where in the unimproved view servants swept up horse droppings in front of the house, in the improved view Sir Windsor Hunloke and his wife promenade on the terrace, he gesturing towards the flaming furnace, the main source of his wealth.[15] Repton was to use a similar strategy for the main vista from Benjamin Gott's house at Armley.

The context for the Armley commission is quite different from that for Wingerworth. Gott began his career as a successful cloth merchant in Leeds, and became an even more successful cloth manufacturer. This was unusual. In Leeds selling cloth was considered gentlemanly, making it was not. When cloth merchants had made their fortune it was customary for them to retire to a country estate, well away from the city. Gott acquired an estate with a 73-acre park just over two miles from Leeds, with a view of his steam-powered cloth factory in the city and, on the estate itself, his water-powered woollen mill. At the time of the commission Gott's business was booming, partly due to his contract to

supply the government with army blankets and uniforms. It was not just the demands of monitoring his business which kept him close to Leeds; he was committed to the city's growing literary and artistic culture, patronising exhibitions and stocking his house at Armley with paintings and sculpture. If Repton barely understood Hunloke, a titled industrial squire, he must have been bewildered by Gott, a city merchant, manufacturer, government contractor and connoisseur. In his Red Book of designs for Armley Repton made no secret of the difficulties he faced.[16]

Repton divided the main vista from Gott's house into three painterly planes: offskip, landscape and foreground (Figure 2). In the distant offskip, the smoke from Gott's factory in Leeds blended with that of its neighbours, announcing the city but obscuring it too. Repton observed that Leeds was currently 'softened by its misty vapour' but might well come into sharp focus 'as the increasing prosperity of the town daily increases its dimensions and brings it nearer and nearer'.[17] He advised Gott to use his estate as a buffer to the urban expansion his own enterprise had encouraged. Gott probably appreciated a softened image of the city. Not only had his factory aroused middle-class complaints about the nuisance of smoke and invasion of housing for its workers (a nuisance their spokesman said Gott had taken care to escape), but small clothiers and cloth finishers saw it as a serious threat to their livelihood, petitioning Parliament and threatening Gott's life and property.[18]

In its organization and appearance the 'landscape' of the middle distance of the vista from Armley house presented a very different industrial environment to that of Leeds. The focus of attention was Gott's water-powered woollen mill. If local clothiers resented Gott's enterprise in Leeds, they welcomed it on his own estate. For the mill at Armley was not technically a factory, engrossing all the stages of production; rather it was used to prepare yarn for a host of small clothiers and to process their cloth which Gott, in his capacity as merchant, purchased in large quantities. Armley Mill dovetailed into the domestic system and arguably energized it. This is not to say that it represented a disinterested benevolence. Gott made three times as much money selling the cloth of others as making it himself. Nor was the mill archaic. When Gott showed Repton over his park he pointed out the most powerful, technically advanced and safety-conscious mill in the country; it was gas-lit, steam-heated, fire-proof and spacious. Unlike the massive bulk of Gott's factory in Leeds, Armley Mill was as well proportioned as a country house. A contemporary chronicle called it 'the most elegant pile of buildings devoted to the manufacture of cloth

Figure 2 Humphry Repton, Main vista from Armley House. Red Book
 for Armley, 1810. Oak Spring Garden Library, Upperville,
 Virginia

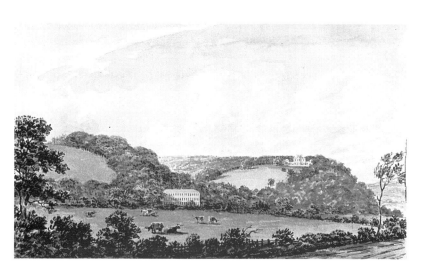

Figure 3 Humphry Repton, Armley Mill from Kirkstall Road. Red
 Book for Armley, 1810. Oak Spring Garden Library,
 Upperville, Virginia

in the neighbourhood of Leeds'. Moreover beyond the choked streets of Leeds it sat prettily in water meadows (Figure 3).[19]

Clearly Gott appreciated the view. Just before Repton's visit he had Armley Mill gas-lit, 'and a beautiful and interesting object it is' he told his son, 'the shade of light so pure – and the quantity so great and at so small a price'. At this time the word 'interesting' still resonated with connotations of financial interest and with a sense of moral involvement. Repton echoes Gott in his Red Book. 'The prominent feature of this scene is that large building which at such a distance, and so accompanied by trees, can never fail to be an interesting object by daylight and at night presents a most splendid illumination by gaslight'. For Repton the setting of the mill tempered its impact, but there was no mistaking its function: 'I must here compliment the good taste of the proprietor on the unaffected simplicity of this large building which looks what it is – a Mill and Manufactory, and is not disguised by Gothic Windows or other architectural pretensions too often misapplied by way of ornament.'[20]

Repton seems to have had some appreciation of the role of the mill in supporting the small clothiers who were scattered on the neighbouring hillsides: 'it is a proud consideration to reflect, that instead of adjoining landed property being appropriated to the feeding of a few sheep or cattle almost every acre supports hundreds of human beings, whose labour and ingenuity are usefully directed to the aggrandizement of the country.' Not that we see them in Repton's views; indeed he was intent to maintain a sense of 'quiet and seclusion' screening any scene 'that is too populous'. The mill at Armley was the only one Gott owned outright and Repton wanted him to look upon it with undivided pride of possession, incorporating it in an idea of landscape whose basis was 'appropriation', 'the *exclusive right* of enjoyment with the power of refusing that others should share our pleasure'.[21]

To this end Repton proposed a balustrade terrace before the house which, as at Wingerworth, controls the scene, preventing the gaze plunging down the prospect and being seized too rapidly by the industrial features there. A new plantation and the presence of sheep on the lawn arrest the gaze, formally and with their languid pastoral associations. But it would not have been lost on either Repton or Gott that the sheep in the foreground symbolized with their fleece the first stage in the process of production which continued in the middle distance at Armley Mill and was completed in Leeds with the finishing and sale of cloth. Repton fashioned a landscape which vested this process in private ownership, but which at least alluded to its public,

patriotic character. As the nation's most valuable industry, and one which linked agriculture, manufacture and trade, the woollen industry had long provided a paradigm of the nation's well-being.[22] When Napoleon's troops were finally defeated Gott's workers paraded through Leeds with emblems of the woollen trade after feeding on roast beef and ale, and the front of Gott's mill was illuminated by lamps forming a crown and anchor.[23]

LANDSCAPING FOR A COUNTRY SQUIRE

Upon his return home early in 1810, Repton was reported 'very hard at work' making the Red Books for the 1809 commissions but 1810 was to bring just three new commissions, and the following year proved even worse. Repton's financial problems were compounded by a spinal injury suffered in a carriage accident from which he never fully recovered and which contributed to the world-weary tone of his writings. In 1812 he did enjoy a remission from his injury and in the second half of the year his business, like that of the nation generally, picked up.[24] In June 1812 he visited Sheringham in Norfolk for what was to prove his last major commission, but his favourite one.

This area of north Norfolk had long enchanted Repton. Over thirty years before, when he had lived there as a small squire, he described it as the 'Garden of Norfolk' because of its fertility and subtly varied scenery.[25] The Sheringham estate stretched down from wooded hillsides to cultivated valleys then to the sea (Figure 4). Repton was also enchanted by his client, Abbot Upcher, a Norfolk squire who, unusually among Repton's later clientèle, shared his own view on improvement. If the Armley Red Book testifies to the tensions between Repton and his client, that for Sheringham, as Repton emphasized, was a report of congenial minds in congenial country. It is significant that in his last publication Repton reprinted the Red Book for Sheringham almost in full but made not the slightest mention of Armley.[26]

What makes the Red Book for Sheringham such an eloquent document, with resonances well beyond the estate itself to the country at large, is its context of social tension and disorder. In 1803, with Napoleon's troops massed for invasion at Boulogne, a signal station was erected at the top of the oak wood at Sheringham. If by 1812 Napoleon had turned his attention to Moscow, the station was still in place, and Repton picks it out prominently in his sketch of the site for the new house, a flagpole at one corner, and a flag (probably the Union Jack)

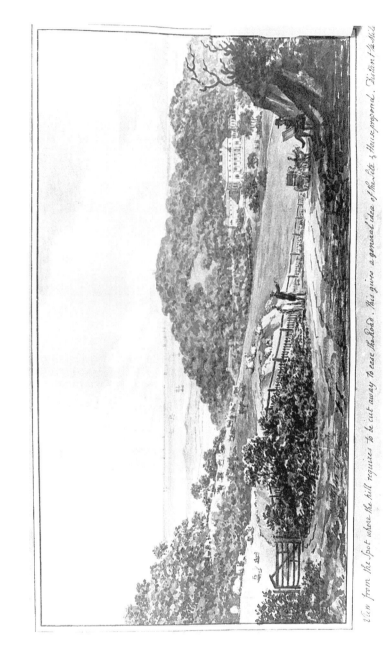

View from the Spot where the hill requires to be cut away To ease the Road. This gives a general idea of the Site of House proposed. Distant the Sea

Figure 4 Humphry Repton, View of proposed new house at Sheringham. Red Book for Sheringham, 1812. Private Collection

flying proudly. The North Sea beyond is shown thronged with sturdy British shipping. In his text Repton fastens on the naval associations of the wood the station was placed in: 'England's combined oaks resist the Sea / Emblem of Strength, increased by unity'.[27]

At this time the unity of England was precisely in question. The nation seemed ripe for insurrection. Luddism flared in industrial districts of the midlands and north (Leeds was effectively under martial law), and Repton voiced his concern about radical Norfolk weavers ten miles inland at Aylsham.[28] He was relieved for his client that at Sheringham 'There are no manufactories near'.

> This is of far more importance to the comfort of Habitation, than is generally supposed. The manufacturer [Repton means industrial worker] is a different species of animal to the husbandman the Sailor or even the Miner, not to mention their difference in Religion and Morality. The latter from being occupied in employments requiring bodily exertion, look for their Relaxations in the society of their families with whom they are shared – but the manufacturer leads a sedentary life, always working at home and looking for Relaxation in the Society of his Club – that birthplace and cradle of discontent and of Rebellious principles.[29]

But there were problems enough in agriculture. The time was one of peak prosperity for Norfolk farmers, taking full advantage of the high price of wheat, and one of chronic distress for farm labourers, scarcely able to buy bread.[30] Repton complained that farmers who once worked alongside their men were now living in style apart from them and driving their labourers for the profit to support it. 'And whether the poor slave be driven by the Lash of the Whip or the dread of Confinement in a Workhouse, he must feel that men are not all equal although he may be taught to read that they are so'. Small wonder that 'in some places I hear that all the neighbouring poor are idle thieves or active poachers'.[31] At Sheringham it was imperative for the squire to intervene to restore the balance of rural society, and if he could not fully restrain his tenant farmers (after all they funded the estate) at least he could alleviate the lot of the labouring poor. Upcher and his wife were exemplary. At their previous estate they had read the Bible to their servants and invited the destitute to dine in their kitchen, and when they purchased Sheringham they resolved to thank God by 'doing all the good which lies in our power to the poor and needy of Sheringham and by setting a virtuous example to all around us'.[32]

In a highly inflationary year, Upcher purchased Sheringham at the top of the market, paying 50,000 guineas. Repton intended to improve

its value but not just financially, to satisfy 'those who know no standard of value but Gold and its flimsy representatives'. He wished to restore a sense of community. Although he planned a new mansion, in a new park, further from the village of Sheringham, he was intent to disting-uish this from 'the modern fashion of placing a house detached from the haunts of men', opening up too dangerous a space between gentry and commonality. He was confident that 'The proximity of the village may be made a source of interest more interesting than the interest upon interest of the Usurer'. The village of Sheringham was unfortunately dominated by a new Union workhouse, a distasteful reminder of the breakdown of landed paternalism. 'The workhouse instead of being an object of disgust to the Rich and of terror to the Poor, might be made to look more like a hospital or Asylum and less like a Prison', suggested Repton, and 'by removing the high wall the street might be converted into a neat *Village green* with its benches and *May pole*; *that* almost forgotten Emblem of rural happiness and festivity'.[33]

Repton specified other arenas on the estate for rebuilding social confidence. Instead of forbidding access to the woods, it would be prudent 'one day in the month or oftener if necessary' to admit the poor 'under the eye of a keeper' to pick up dead sticks for firewood, for where this was done 'no wood is stolen, no trees are lop'd or disfigured'. The issue of game might be a source of confidence rather than suspicion if Upcher organized coursing matches on the beach at low tide, which, like games of cricket, would attract all ranks (Figure 5). 'This promotes a mutual intercourse between the Landlord, the Tenant and labourer, which is kept up at little expense, and secures the ready and reciprocal assistance of each of the other.' Such an arena offered a stable vision of England threatened neither by the oppressive arrogance of the nation's élite nor by the subversive forces threatening from abroad:

> Smooth as the Level Sand Twixt Cliff and Sea
> So may our middle course of life run free
> Twixt overwhelming Power, and mad Equality.

In such places the poor 'would rise at night to serve their Liberal patron' not rise at night to steal his wood, shoot his game or worse.[34]

The valley in which the new house was to be set had been given over mainly to crops, principally wheat. To create a more gentlemanly purview Repton suggested turning much of it into parkland pasture (Figure 6). His proposals for the main view across the valley offer a sweeping panorama variegated with pasture for sheep and cattle and

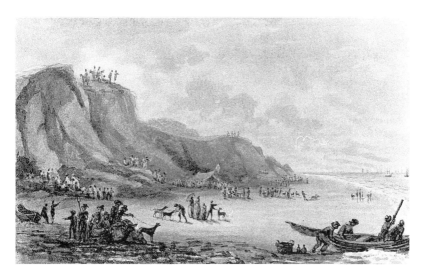

Figure 5 Humphry Repton, Coursing on sea shore at Sheringham. Red
 Book for Sheringham, 1812. Private Collection

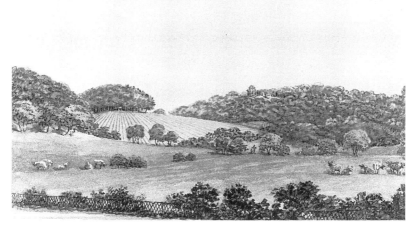

Figure 6 Humphry Repton, Main view from proposed new house at
 Sheringham (detail). Red Book for Sheringham, 1812. Private
 Collection

bounded by the wooded hills. But contrary to the kind of fastidious connoisseur who 'shudders at a crop of wheat' (and this had included Repton himself a few years before), Repton included a ploughed field as the main feature in the view. Given the high price of wheat in 1812, and the high price he paid for his estate, Upcher would have been foolish to empark the whole valley. Repton could easily, as he had often done, screen such ploughed land, but here he drew attention to it, framed by trees and signalled by a temple. In wartime cornfields were now a 'dig-for-victory' symbol, in places eclipsing even the patriotic virtues of oak groves which were grubbed up to make way for them.[35] Moreover the sight of the cornfield fitted with the scheme to have the squire monitor his men, for 'at seed time and at harvest it may be enlivened by Men, as well as beasts – If I might be permitted to indulge in my favourite propensity for *humanising*, as well as animating beautiful scenery'.[36]

TRAFALGAR

There is a sub-text to the Sheringham commission, rather less high-minded than the exchanges between Repton and Upcher, but no less implicated with the question of the condition of England. Repton's son William, a lawyer at Aylsham, had acted as steward for the Sheringham estate under its previous owner, Cook Flower, and overseen the enclosure bill which preceded the sale. Repton's correspondence with his son reveals that in 1809 he had seized upon Sheringham as a candidate for the country seat to go with the new Nelson peerage settled on Horatio's brother (a clergyman who had never been to sea in his life) after the Battle of Trafalgar. Repton had been privy to the scheme when staying with the Speaker of the House of Commons who told him that the estate 'must be in a Maritime County and ought to have a house on it fit for a Nobleman to be called Trafalgar'. The Speaker preferred an elevated site which could be crowned with a commemorative tower or flag and which overlooked the sea. As Nelson was born and raised just up the coast Sheringham seemed highly appropriate. Its choice whould not only secure Repton the national esteem he coveted but, as Parliament had voted £90,000 for the purchase, would more than ease his financial troubles. Hearing of the impending enclosure, Repton asked his son to 'send me all you can – with the present and suppose improved rents' to pass on the Speaker. The Speaker was not persuaded, thinking the value of the estate too low and objecting to the lack of mansion. Two

years later Sheringham was sold to Upcher for a little over half of what was set aside for the Trafalgar estate, but this did not put an end to Repton's hopes of securing the Nelson commission.[37]

In October 1812 Upcher moved into the farmhouse at Sheringham, enchanted with Repton's advice and ready to realize it. Just two months later Repton wrote to William in a fever of excitement: 'Mr Upcher is gone mad – entirely owing to the Estate for which he gave 50 thous'd & has offered it to sale & nobody will give more than 30 thous'd'. Repton approached Upcher's physician who diagnosed depression and through him offered to find a purchaser for Upcher. This Upcher accepted. The purchaser Repton had in mind was the Nelson Trust which had still to buy an estate. Repton suggested to William that they should reopen negotiations with the Speaker. Repton now knew from his own survey the potential value of the estate and what a bargain it had proved to be. He had made copies of some of the illustrations in the Red Book which showed features the Speaker desired: the proposed mansion in a landscape that Repton had exaggerated, enlarging the hill that sheltered it and expanding the views of the sea. Repton asked William to find out whether the estate had in fact depreciated, and, if the Speaker objected to its size, whether it would be possible to enlarge or consolidate it by purchasing land from the adjacent property of the Walpoles, clients of William's and relations of Lord Nelson: '*perhaps* it might *suit* your noble client to *accommodate* a Relation to accomplish a National purpose – It is a fair Stalking horse'. Repton also inquired whether there was any chance of Cook Flower

> Letting Upcher off his bargain & upon what terms – that I may have two strings to my bow if I fail with the Speaker ... I think it is possible I may still have some benefit from building the house and you from sale and resale etc. etc. etc. But I hope you will make Flower pay well for your agency and consider on the Sale of such an estate you ought to have a percentage. Your advice added 2500 Slap & the odd 500 should be yours – ha! Slap.

It is hard to imagine a greater contrast to the rhetoric of the Red Book which expressly censured such speculative relish. Four days later Repton wrote again to William saying that the speaker wanted a 'full acc. of Value present and improvable with price and full particulars'. In an inversion of his public pronouncements on improvement Repton suggested his son should 'set the woods and Game and improvement for Inclosure pretty high – then add so much for situation and beauty'.[38]

Throughout his career Repton had been negotiating opinions he found unpalatable, making adjustments which eased strains between his commercial, artistic and moral commitments. By 1812, these adjustments had lost their delicacy. Repton lurched between condemning financial obsession and endorsing it. As it turned out Upcher recovered from his depression, refused to sell and began implementing the suggestion of the Red Book. Repton continued his search for an estate for Lord Nelson who in 1814 was settled, but without Repton's advice, at Stanlych Park in Wiltshire.[39]

IMPROVEMENT IN QUESTION

Repton's revival of 1812 was short-lived. The profit from a month's work on the road in November was wiped out by the bankruptcy of a client owing him £2000. In the rest of his career he had little business and large debts and he grew steadily more gloomy about his health, that of his profession and that of the nation. Repton's world was falling apart. From 1814 he put much of his time into preparing his last published work entitled (perhaps significantly after the breakdown of his career) *Fragments on the Theory and Practice of Landscape Gardening*. It is a valedictory work, preserving the memory of an art which had declined under wartime conditions, and which Repton saw little prospect of reviving in peacetime.[40]

The key Fragment in the book, 'Concerning Improvements', is a homily on the delinquency of landed culture.

> I have frequently been asked, whether the Improvement of the Country in beauty has not kept pace with the increase of its wealth; and perhaps have feared to deliver my opinion to some who have put the question. I now may speak the truth, without fear of offending, since time has brought about these changes which I long ago expected. The taste of the country has bowed to the shrine which all worship; and the riches of individuals have changed the face of the country.[41]

Repton illustrated these changes with a parody of his own technique, contrasting a recent 'improved' view of an estate with an unimproved from the same spot when he was passing ten years earlier (Figure 7). During this time the estate had been sold by an aristocratic 'ancient proprietor'' to a 'very rich man' (by implication a newly and suddenly rich one) who had transformed its organization and appearance. Repton

IMPROVEMENTS

Figure 7 Humphry Repton, 'Improvements'. From *Fragments on the Theory and Practice of Landscape Gardening*, 1816

points out that the estate is in 'a distant country', meaning that the trail of finance had spread well beyond London. The contrasting views and accompanying text do have an ancestry in conservative polemics on estate improvement, but also some basis in fact in the sale of Lord Essex's estate at Hampton Court in Herefordshire to Sir Richard Arkwright, son of the cotton spinner and the wealthiest financier in England.[42]

The unimproved view is stately and kindly. On the left is a park full of 'venerable trees', in the foreground an 'aged beech' which shades the road, its branches pointing to a family resting on a thoughtfully placed bench. A ladder stile by its trunk indicates a public footpath through the park. On the right is a wooded common. Divisions between the park, the road and the common are not clearly marked and the effect of the rich woodland is to soften them further. The effect for the spectator is to be taken into, not past, the estate, into an arena of landed benevolence.

The changes made by the new owner, for whom 'money supersedes every other consideration' destroy this landscape. Repton heard about them from 'an old labourer'.

> By cutting down the timber and getting an act to enclose the common, [the new owner] had doubled all the rents. The old mossy and ivy-covered pale was replaced by a new and lofty close paling; not to confine the deer, but to exclude mankind, and to protect a miserable narrow belt of firs and Lombardy poplars: the bench was gone, the ladder-stile was changed to a caution about man-traps and spring-guns, and a notice that the footpath was stopped by order of the commissioners. As I read the board, the old man said 'It is very true, and I am forced to walk a mile further round every night after a hard day's work'.[43]

The new régime is as uninviting for the spectator as it is for the labourer. No longer is our gaze dispersed gently into the landscape but is driven rapidly through it. The alignments of straightened road, new palings, conifers and ploughed field form a streamlined vista which conducts the eye abruptly to the horizon. Here we see a figure (the new owner?) pointing to (directing?) a ploughman, the conventional figure of rural toil. The landscape is, in every way, so severe, so ruthlessly mobilized for money, as to be for Repton scarcely a landscape at all.

Repton's loss of confidence in landed culture at this time was widely shared. If Repton still clung conservatively to his memory that 'all England would become one landscape garden', radicals abandoned the entire image. In an address to the 'People of the United States of

America' on the famine and incendiarism in the southern counties in May 1816, William Cobbett recalled

> a book that we used to look at a great deal entitled 'A Picture of England'. It contained views of Country Seats and of fine hills and valleys ... Alas! this was not a picture of *England*, if by England, we mean anything more than a certain portion of houses, Trees and Herbage. If, by England, we mean the English *nation*; and if, by the nation we mean the *great* body of the people.[44]

At the end of his career Humphry Repton concentrated not on parks but on gardens and their moral virtues. In his last published writing he upheld his own front garden at Hare Street as a refuge from 'pomp and palaces, the elegance of fashion or the allurements of dissipation'. Here he enjoyed a view of 'the cheerful village ... which I would not exchange for any of the lonely parks I have improved for others'.[45] Repton's illustrations (Figure 8) of his improvements to the view intimate less cheerful conditions. His garden now obscures most of the village, including livestock, a butcher's shop, a passing carriage, and, leaning cap-in-hand on Repton's fence, a crippled beggar, evidently a veteran of the Napoleonic Wars. Repton's private correspondence of the time confirms a troubling view. The post-war depression had left the village 'desolate and depopulated'. 'Premises empty – untenanted & dilapidated – no chaises or State coaches which used to enliven our scene', he wrote to his son, 'now all a blank'.[46]

GARDEN AND CITY

The darker side of Repton's art was largely eclipsed after his death. When J. C. Loudon republished Repton's works in 1840, in a cheap edition for a largely middle-class audience, he incorporated Repton's style as a precursor to his own idea of the 'gardenesque'.[47] This was both more scientifically exact than Repton's horticulture and unambiguously charming. And it provided a model for all classes of polite society, from suburban villa owners to landed aristocrats who dug up parkland in front of their mansions for elaborate gardens.[48]

Parkland did not contract in Victorian England; indeed it seems to have increased appreciably. Until late in the century landed estates and their owners prospered. But the Victorian countryside seemed no

Figure 8 Humphry Repton, Views from Repton's house at Hare Street.
From *Fragments on the Theory and Practice of Landscape
Gardening*, 1816

longer fraught with social energy and tension and the landed estate loosened its grip on the political imagination.[49] This was not because of any sudden dampening of rural disaffection – conditions in the 1840s were especially severe – but because the burgeoning industrial cities now seemed to epitomize the condition of England. When A. W. Pugin depicted the cultural degradation of the nation in 1841 he deployed Repton's contrast of a benevolently old and brutally modern landscape in an urban setting (Figure 9). A gorgeously gothic medieval city, with soaring spires and charitable institutions, is transformed into a bleak utilitarian city of smoking chimneys, factories, warehouses, nonconformist chapels, a new jail and lunatic asylum, and a 'Socialist Hall of Science'.[50]

DECLINE AND FALL

The Second World War seemed to spell the end of aristocratic England. The erosion of the aristocracy's political and economic power had long been under way, notably since the later nineteenth century, but now the very emblems of their culture, their country houses and parks, were visibly disintegrating. Mansions were requisitioned by the military, gardens and parkland lay untended or suffered under army encampment, farmland fell under the control of the government, servants were scarce.[51] The patriotic *Recording Britain* project, intended to depict buildings threatened by enemy invasion or commercial development, concentrated on vernacular architecture; what country houses it did record looked mere shells, drained and exhausted.[52] The post-war prospects of aristocratic England looked bleak. Charting the decline and fall of a great house in *Brideshead Revisited*, Evelyn Waugh saw in 1944 the coming 'Age of Hooper', the bleak age of the Common Man.[53]

As it turned out in the Age of Hooper the aristocracy fared better than it had dared imagine. Its mansions and grounds found support from the Labour government's Historic Buildings Councils and National Land Fund and from the National Trust (which transformed itself from a radical campaigner for rural access to a conservative custodian of country houses and their inhabitants). Under the architectural editorship of Christopher Hussey, the magazine *Country Life* played a vigorous role in promoting country houses as national heritage. In 1955–8 Hussey issued articles from *Country Life* in a three-volume work on *English Country Houses* of the Georgian period. If 'many of these houses can no longer be regarded primarily as family houses in a continuing way of life [they] have come to be recognised as national and

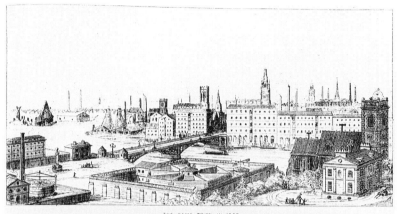

THE SAME TOWN IN 1840

1. St Michael's Tower, rebuilt in 1750. 2. New Parsonage House & Pleasure Grounds. 3. The New Jail. 4. Gas Works. 5. Lunatic Asylum. 6 Iron Works. 7. Ruins of St Mary's Abbey. 7. St Evans' Chapel. 8. Baptist Chapel. 9 Unitarian Chapel. 10. New Church. 11 New Town Hall & Concert Room. 12. Wesleyan Centenary Chapel. 13. New Christian Society. 14 Quakers Meeting. 15. Socialist Hall of Science.

Catholic town in 1440.

1 St Michaels on the Hill. 2. Queens Cross. 3. St Thomas's Chapel. 4. St Maries Abbey. 5. All Saints. 6. St Johns. 7. St Peters. 8. St Alphage. 9. St Maries. 10. St Edmunds. 11 Grey Friars. 12. St Cuthberts. 13. Guild Hall. 14. Trinitys. 15. St Olaves. 16. St Botolphs.

Figure 9 A. W. Pugin, *Catholic Town in 1440: The Same Town in 1840*. From *Contrasts*, 1841

historic works of art'. Hussey presented Georgian England not as overbearingly aristocratic but as a picturesque age of equipoise, perhaps an exemplar for the so-called post-war consensus. 'During this [eighteenth] century the newly United Kingdom, with its mixed climate, geographical and cultural affinities, attained political and economic maturity.' And 'the period's greatest contribution to the visual arts' was 'the synthesis of classical mansion and park landscape'.[54] A rise in the value of land and country house contents (furniture, art-works) from the mid-1950s to mid-1960s, and the willingness of the car-owning middle class to pay to see them, further enhanced the prospects of country house culture.[55] Introducing a revised version of *Brideshead Revisited* in 1959 Waugh wrote:

> It was impossible to foresee, in the spring of 1944, the present cult of the English country house. It seemed then that the ancestral seats which were our chief national artistic achievement were doomed to decay and spoilation like the monasteries of the sixteenth century. Brideshead today would be open to trippers, its treasures rearranged by expert hands and the fabric better maintained ... And the English aristocracy has maintained its identity to a degree that then seemed impossible.[56]

Writings on country house culture, on paintings, architecture and landscape gardening, sharply increased, in guidebooks, monographs, magazine articles, newspapers. A lost world was being recovered. The National Gallery's purchase in 1960 of Gainsborough's *Mr and Mrs Robert Andrews* (Figure 1) was a major news story and the painting quickly became an icon of landed culture.[57] The trim, brightly confident look of figures and landscape reflected well an era of rising expectations. These were not enervated grandees in luxurious surroundings but a young squire and his wife displaying their enterprising estate management. Here was the dandyish modernity which became the trademark of the mid-1960s, the 'New Aristocrats' of 'Swinging London', 'clean, crisp, straightforward'.[58]

By the mid-1970s lamentations for aristocratic culture echoed again. Rising costs of insurance, staffing and security and the prospect of a swingeing Wealth Tax on capital and assets by the newly returned Labour government mobilized campaigners for country house culture. They invoked the idea of 'danger' to define the idea of 'heritage'. The 1975 exhibition 'The Destruction of the Country House' opened with a roll-call of the thousand houses demolished in the previous hundred years. With the success of the National Trust Country House Scheme,

country house culture was now perceived to be less about private ownership than public trusteeship. As Roy Strong put it in the exhibition catalogue, 'the historic houses of this country belong to everybody who cares about this country and its traditions'. Especially to those, like Strong, of modest beginnings. 'We glimpse the park gates as we hurtle down a road, or we sense behind some grey, mouldering wall, the magic of a landscape painting', a glimpse, Robert Hewison comments, of 'a lover locked out'. Such voyeurism was broadcast in the 1976 television version of *Brideshead Revisited*. With plangent theme tune and soft-focus camera-work it had viewers aching for a vanished culture.[59]

Stories of decline and fall, whether told tragically or not, are part of the mythology of the English aristocracy, perhaps aristocracies everywhere. In 1990, not with a misty regret, but with batteries of statistics and iconoclastic relish, David Cannadine again charted the aristocracy's demise. They are, he declares, an absurd anachronism in the 'rampantly petty bourgeois world of Thatcher', their momentous loss of real power disguised by the enduring façade of aristocratic imagery, especially its use in the heritage industry.[60] Cannadine's book *Decline and Fall* was largely researched and written in the early 1980s.[61] Upon publication in 1990 some reviewers demanded a second opinion on the death of the aristocracy. The *Daily Telegraph* published a full-page riposte by Hugh Montgomery-Massingbird who declared that 'Our Dave' (as he called him) had got it wrong, that, with nearly two thousand family seats, the aristocracy was not only alive but, with its vigorous connections with business and the professions, fully capable of renewing itself.[62]

Such stories of resilience and renewal are no less part of the mythology of the English aristocracy than those of crisis and decay, and since the mid-1980s they have been told, from both Right and Left, with rising voices. In 1987 Robert Hewison pointed out that many great estates were prospering and that new country houses were being built, many for established dynasties.[63] The same year Marion Shoard declared that large-scale private owners still controlled much of the British countryside, a 'hard core' of titled families owning nearly a third. The difficulty of assessing precisely how much land they owned (property passed through inheritance is not registered nationally) itself testified to the enduring mystique of the aristocracy. 'The dominance of traditional aristocratic landowners has *not* faded away', Shoard maintained. It persisted not just because they still owned much of the land but also 'because they have succeeded in instilling their attitudes and habits into newer kinds of rural landowner'.[64]

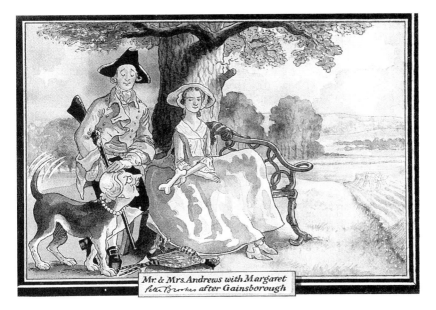

Mr. & Mrs. Andrews with Margaret
Peter Brookes after Gainsborough

Figure 10 Peter Brookes after Thomas Gainsborough, *Mr and Mrs Robert
Andrews with Margaret. The Spectator*, 22 October 1988

On 22 October 1988 the front cover of the *Spectator* showed a
pastiche of Gainsborough's *Mr and Mrs Andrews* (Figure 10) with Mrs
Thatcher's head transplanted on to the dog, the squire patting her head,
his wife tossing her a bone. In the accompanying article Nicholas
Coleridge suggested 'the aristocracy will be marked out by history as
Mrs Thatcher's greatest allies and beneficiaries'. 'Many superficially
benign peers like to put in a "hard man" as land agent, and this is what
they have in Mrs Thatcher', one 'who does the dirty work and gets
defaulting tenants out of tied cottages'. While the common rights of the
Welfare State were being extinguished, the halving of taxation, the
spiralling value of works of art and the financial boom in the City
stimulated a resurgence of aristocratic confidence. The mood of owner-
ship was no longer furtive, Coleridge observed, it was brazen and
businesslike. Estates were developing, not just with tourist facilities
near the house but with a range of lucrative enterprises from housing
and office parks to golf courses and 'leisure complexes'.[65] Encouraged
by the government agency English Heritage, landowners used such
developments to raise money for restoring the historic fabric of houses

and parks. Landscape architects profited from both initiatives. Country house culture seemed fully attuned to the enterprise culture. In 1989 a series of advertisements in Sunday magazines for stock-brokers Capel-Cure Myers used Capability Brown's maps and contracts for landscaping country houses as a vehicle to promote their investment plans.[66] Few country houses were now in 'danger'. In a 1989 book on businesslike conservation David Pearce observed that many country houses were in better shape than for at least a century. And he quoted Margaret Thatcher in aristocratic mode: 'We are no more than life tenants of our heritage and we have a duty to pass it on in as good a condition as that in which we received it'.[67]

The soaring inflation in the art market in the 1980s funded extensive aristocratic building and rebuilding. At least three new country houses were paid for out of proceeds of private treaty sales of paintings to the National Gallery.[68] Promoted by the British Council, sponsored by the Ford Foundation and opened by the Prince and Princess of Wales, the 1985-6 'Treasure Houses of Britain' exhibition at the National Gallery, Washington, DC was a polite sales pitch for country house culture. With ravishing paintings and exquisite china, but without the stuffed birds, stags' heads and elephants' feet which decorate so many mansions, British country houses were presented as 'vessels of civilization'.[69] The catalogue luxuriated in a painterly image of mansions 'rising out of a mist ... seen across a lake at sunset'. 'A deeply romantic picture this may be ... but it shows what a central place the country house still holds in the British national consciousness, and what dreams of Elysium it continues to offer in an egalitarian twentieth century'. One of the exhibition's sponsors also declared it no bad thing for NATO 'to be reminded occasionally of the civilization more directly at risk to Russia's SS-20s'.[70]

The financial boom in the City broadened the appeal of country house culture, not so much for land as for mansions. In 1987, in his new journal *Landscape*, the heritage campaigner Marcus Binney told of the 'new nabobs' flocking back to enterprising Britain from Hong Kong and the Middle East to purchase manor houses in Somerset and Devon. Fast trains and portable telephones kept them in touch with the City, but now 'that so many firms have hard American and Japanese masters the Square Mile is not the same clubbable place' and the nabobs preferred to get away quickly and go deep into the shires. 'They are not simply weekenders', Binney declared, 'In many cases they are genuinely intending to make the country the centre of their family and social lives'.[71] The spectre of 'danger' did not entirely recede in ideas of

country house heritage. In October 1987 it came out of the skies. Reports on the Great Gale which swept through south-east England focused on the damage done to landscape parks and gardens. 'Nearest to a nuclear war' declared the *Observer*'s 'Gale 87' supplement next to a photograph of an uprooted oak tree in front of a country house.[72]

REPTON RESTORED

If the paucity of published works is a reliable guide, Repton was neglected for much of the nineteenth century. He was rediscovered as a minor figure in the aesthetics of 'the Picturesque' in Christopher Hussey's 1927 book of that name.[73] Nikolaus Pevsner enlisted Repton in his post-war valorization of the English picturesque, quoting Repton's comments on the precincts of St Paul's Cathedral as a mandate for William Holford's post-war designs.[74] In 1961 *Country Life* published Dorothy Stroud's monograph on Repton which re-established Repton's reputation within a grand tradition of English landscaping. This was the authoritative word until the catalogue of the 1982–3 exhibition on Repton in which, in a guest essay, I raised some of the issues I have addressed here.[75]

Since that exhibition Repton's work on the ground has received more care and attention. In particular Repton's favourite landscape at Sheringham has been taken into the custody of the National Trust. A 1988 article in *Landscape* describes how it was saved for the nation.

Before his death in 1986, the last Upcher heir expressed a wish for Sheringham to pass to the National Trust but left no financial provision for this. The trustees of the estate decided to sell on the open market but gave the National Trust first refusal and six months to find the necessary funds. It wasn't the house or its contents which were at stake (they were sold separately), but the parkland and grounds. The success of the Trust's appeal for £200,000 'may be seen as a turning point in the protection of historic landscapes'. It was planned to restore Repton's vistas by re-introducing pollarding, by removing a modern garden of golden cypresses and flowering cherries, and by replanting some of the oaks blown down in the Great Gale of October 1987. One of the first acts was to restore the look-out tower at the top of the oak wood. In November 1987 a new frame was flown in by helicopter from 202 Squadron based at Coltishall, as part of the RAF's contribution to the Trust's appeal. It was opened in January 1988 by the appeal patron the Prince of Wales who broke the Trust's flag on the masthead. 'As in

Repton's watercolour of 1812', announced *Landscape*, 'so this year, the flag is flying at the crest of Oak Wood'.[76]

NOTES

1 Stephen Daniels and Susanne Seymour, Landscape design and the idea of improvement 1730–1900', in R. A. Dodgson and R. A. Butlin (eds), *An Historical Geography of England and Wales*, second edition (Academic Press, London, 1990), pp. 487–520.

2 Ibid., quotation on p. 488.

3 Dorothy Stroud, *Capability Brown* (Country Life, London, 1950). Dorothy Stroud, *Humphry Repton* (Country Life, London, 1961). George Carter, Kedrun Laurie and Patrick Goode, *Humphry Repton Landscape Gardener 1752–1818* (Sainsbury Centre for the Visual Arts, Norwich, 1982).

4 Uvedale Price, *Essays on the Picturesque* (London, Mawman, 1796), pp. 261–2.

5 William Cowper, *The Task* (1785), book III, lines 755–66.

6 Humphry Repton, *Memoir*, part 2, n.d., p. 169. British Museum Add MS 62112.

7 Stephen Daniels, 'The political landscape' in Carter et al., *Humphry Repton*, pp. 110–21, esp. pp. 112–18.

8 For a full discussion of this see Stephen Daniels, 'Cankerous blossom: troubles in the later career of Humphry Repton documented in the Repton correspondence in the Huntington Library', *Journal of Garden History* 6 (1986), pp. 146–61.

9 Humphry Repton, *Odd Whims and Miscellanies* (London, T. Cadell, 1804), vol. 2, pp. 163–4.

10 Stephen Daniels, 'The political iconography of woodland in later Georgian England' in Denis Cosgrove and Stephen Daniels (eds), *The Iconography of Landscape* (Cambridge University Press, 1988), pp. 43–82, esp. pp. 68–9.

11 Repton *Memoir*, pp. 169n., 169c, 202–4.

12 Humphry Repton, *Fragments on the Theory and Practice of Landscape Gardening* (London, T. Bensley & Sons, 1816), p. 192.

13 Information from the gazeteer in Carter et al., *Humphry Repton*, pp. 147–65.

14 Stephen Daniels, 'Landscaping for a manufacturer: Humphry Repton's commission for Benjamin Gott at Armley in 1809–10', *Journal of Historical Geography* (1891), pp. 379–96. This article provides an extended discussion of some of the issues addressed in the following part of this chapter.

15 Tim Warner, 'Combined utility and magnificence: Humphry Repton's commission for Wingerworth Hall in Derbyshire', *Journal of Garden History* 7 (1987), pp. 271–301.

16 Daniels, 'Landscaping for a manufacturer', pp. 383–5.

17 Humphry Repton, *Armley House near Leeds in Yorkshire* (1810), Oak Spring Garden Library, Upperville, Virginia, Mrs Paul Mellon Collection.
18 Daniels, 'Landscaping for a manufacturer', p. 388.
19 Ibid., p. 389.
20 Ibid., quotations on pp. 389–90.
21 Ibid., quotations on p. 391.
22 John Barrell, *English Literature in History 1730–1830: an Equal Wide Survey* (Hutchinson, London, 1983), pp. 90–102.
23 *Leeds Intelligencer*, 23 April 1814.
24 Daniels, 'Cankerous blossom', p. 147.
25 Stephen Daniels, 'Humphry Repton at Sustead', *Garden History* 11 (1983), pp. 57–64 (p. 61).
26 Repton, *Fragments*, pp. 195–212. I discuss the Sheringham commission at greater length in Stephen Daniels, 'Humphry Repton and the morality of landscape' in John C. Gold and Jacqueline Burgess (eds), *Valued Environments* (Allen & Unwin, London, 1982), pp. 124–44, esp. pp. 131–8.
27 Humphry Repton, *Plans for Sheringham* (1812). Reprinted in Edward Malins (ed.), *The Red Books of Humphry Repton* (Basilisk Press, London, 1976).
28 Daniels, 'Cankerous blossom', p. 149.
29 Repton, *Plans for Sheringham*, n.p.
30 Daniels, 'Humphry Repton and the morality of landscape', p. 132.
31 Repton, *Plans for Sheringham*, n.p.
32 Daniels, 'Humphry Repton and the morality of landscape', p. 134.
33 Ibid., pp. 136–7.
34 Repton, *Plans for Sheringham*, n.p.
35 Daniels, 'The political iconography of woodland', p. 48.
36 On this see Daniels, 'Humphry Repton and the morality of landscape', pp. 134–6.
37 Daniels, 'Cankerous blossom', p. 150.
38 Ibid., p. 151.
39 Ibid., p. 153.
40 Ibid.
41 Repton, *Fragments*, p. 191.
42 Daniels, 'The political iconography of woodland', pp. 70–2. See also Stephen Daniels and Charles Watkins, 'Picturesque landscaping and estate management: Uvedale Price at Foxley, 1770–1828', *Rural History* 2 (1991), pp. 141–70.
43 Repton, *Fragments*, p. 193.
44 *Cobbett's Weekly Political Register*, 18 May 1816.
45 Repton, *Fragments*, pp. 232–8.
46 Daniels, 'Cankerous blossom', pp. 153–8.
47 John Claudius Loudon, *The Landscape Gardening and Landscape Architecture of the late Humphry Repton Esq* (Longman, London, 1840).
48 Daniels and Seymour, 'Landscape design', pp. 501–3.

49 Ibid., p. 504.
50 A. W. Pugin, *Contrasts* (Dolman, London, 1841).
51 David Cannadine, *The Decline and Fall of the British Aristocracy* (Yale University Press, New Haven and London, 1990), pp. 606–30.
52 David Mellor, Gill Saunders and Patrick Wright, *Recording Britain: a Pictorial Survey of Pre-War Britain* (David & Charles, Newton Abbot, 1990).
53 Robert Hewison, *The Heritage Industry* (Methuen, London, 1987), p. 51.
54 Christopher Hussey, *English Country Houses: Early Georgian 1715–60* (Country Life, London, 1955), pp. 7, 9–10.
55 Hewison, *The Heritage Industry*, pp. 56–68.
56 Evelyn Waugh, *Brideshead Revisited* (Chapman and Hall, London, 1960), p. 10.
57 Cuttings file, June 1960, National Gallery, London.
58 On the pictorial details of Gainsborough's *Mr and Mrs Andrews* see Daniels and Seymour, 'Landscape design', p. 493. On the 'New Aristocrats' (and their connections with the old ones) see Christopher Booker, *The Neophiliacs: a Study of the Revolution of English Life in the Fifties and Sixties* (Collins, London, 1969), p. 23.
59 Hewison, *The Heritage Industry*, pp. 51–79, quotations on p. 53. See also Patrick Wright, *On Living in an Old Country* (Verso, London, 1985), pp. 33–56.
60 Cannadine, *Decline and Fall*, p. 638.
61 Ibid., p. xiii.
62 *Daily Telegraph*, 20 October 1990.
63 Hewison, *The Heritage Industry*, p. 73.
64 Marion Shoard, 'Pursuit of the gentry', *Times Higher Education Supplement* 7 August 1987, p. 11. For a fuller statement see Marion Shoard, *This Land is Our Land: the Struggle for Britain's Countryside* (Paladin, London, 1987).
65 Nicholas Coleridge, 'Why the Lords love the Lady', *Spectator*, 22 October 1988, pp. 9–10.
66 The advertisement appeared showing Sherbourne Castle in the magazine of the *Sunday Correspondent*, 29 October 1989. Another version shows Audley End.
67 David Pearce, *Conservation Today* (Routledge, London, 1989), pp. 123–46, quotation on p. vii. This book is discussed in Stephen Daniels and David Matless, 'The new nostalgia', *New Statesman and Society*, 19 May 1989, pp. 40–1.
68 Hewison, *The Heritage Industry*, p. 73.
69 David Cannadine, 'Brideshead Re-revisited', *New York Review of Books*, 19 December 1985, pp. 17–21. 'Cultural diplomacy: Britain's Washington coup', *The Economist*, 2 November 1985.
70 Quoted Hewison, *The Heritage Industry*, p. 52.
71 Marcus Binney, 'New nabobs go west', *Landscape*, October 1987, pp. 22–3.

72 On this see Stephen Daniels, 'Wooden heart', *New Statesman and Society*, 18 August 1989, pp. 33–4.

73 Christopher Hussey, *The Picturesque* (E. T. Putnams, London, 1927), pp. 162–6.

74 Nikolaus Pevsner, 'Humphry Repton', *Architectural Review* CII (1948) revised for *Studies in Art, Architecture and Design* (2 vols., Thames & Hudson, London, 1968), vol. 1, pp. 138–55.

75 Daniels, 'The political landscape'.

76 Merlin Waterson, 'Repton recognized', *Landscape*, April 1988, pp. 63–7.

4

J. M. W. Turner and the Circulation of the State

J M. W. Turner (1775–1851) is popularly thought of as 'a painter of lurid sunsets, indistinct landscapes and storms at sea', an artist grappling with the forces of nature and pushing his style and colouring to the limits to do so.[1] Based on Turner's later oil paintings, this impression obscures an aspect of Turner's art which I will examine in this chapter, his detailed depiction of mundane activities in particular places, especially the working of land, river and sea. This aspect has come into focus with the recent study of Turner's earlier sketches and watercolours, but is discernible too in the later, more abstract-looking, oils.[2]

Turner's pictures of places are not merely local in their meaning. They situate places in regional, national and international contexts. Nor are such pictures merely factual. Some are hyper-factual, showing a wealth of detail designed to tax the comprehension of the most informed local observer. Moreover such detail is informed by a complex iconography designed to tax the comprehension of the most sophisticated connoisseur. Turner's imagery is galvanized by a range of cross-currents from classical mythology to political economy.[3] For an audience used to poring over pictures, of concentrating on this then that feature, Turner laid a series of trails. Above all Turner was intent to endow landscape painting with extensive power, to concentrate issues of history and historical destiny in an apparently momentary view of a particular place, to intersect the epic with the everyday.[4]

In this chapter I will look in detail at the extensive power of two of Turner's pictures, the watercolour *Leeds* (1816) and the oil painting *Rain, Steam and Speed* (1844). I will consider Turner's representation of the nation in the light of his view of contemporary historical events and

long-term historical change. In conclusion I will consider how the nation has represented Turner.

CIRCULATION

Turner's field of work was extensive, international in scope. He filled hundreds of sketchbooks with views of his tours throughout England, Scotland and Wales, in France, the Low Countries, Switzerland, Germany and Italy. Mobility shaped Turner's work. He relished travel, taking fast roads, steam boats, later steam trains. His technique kept pace, in a rapid, shorhand sketching style or in the shifts in perspective of watercolours and oils which give the spectator the experience of moving, sometimes rapidly, through the picture.[5]

Routeways feature prominently in the pictures – turnpikes, drove-roads, railways, rivers, canals, sea lanes – and often organize the composition. Vehicles throng these routeways: packhorses, various wagons and carriages and all kinds of barge, boat and ship. Turner often depicts the conjunction of routeways, and hence a good deal of infrastructure: bridges, aqueducts, tunnels, causeways, locks, wharves and piers. Routeways in Turner's art are not just lines of linkage, but arenas of bustling activity.

It was circulation rather than property which shaped Turner's landscape imagery, even in depictions of landed estates. In a view of the park at Harewood for his early patron Edward Lascelles, Turner concentrated on the timber economy of the park, showing labourers resting after uprooting a tree and transporting it to the sawmill.[6] For his later patron Lord Egremont he painted the park at Petworth filled with signs of progressive management as one of a series of pictures displaying Egremont's portfolio of financial investments, including the Chichester Canal and the Chain Pier at Brighton.[7]

Born the son of a London barber, and trained as an architectural draughtsman, Turner quickly joined the enterprise culture of his time. As well as securing the patronage of enterprising aristocrats, he sold paintings on the open market to merchants and manufacturers and prepared watercolours for engravings directed at the professional classes. He made a fortune. This was more by investments than selling pictures. By 1810 his ownership of stock amounted to several thousand pounds and many payments for his pictures were invested directly in funds.[8]

Turner didn't sell all his pictures. Resisting lucrative offers, and buying back some pictures at higher prices than he had sold them, Turner conserved in his studio 370 oils, some unfinished, and over 95,000 watercolours, sketches and engravings. These he bequeathed to the nation, maintaining that the works should be seen together. The nation might then study the growth, development and working of the artist's imagination as the artist had studied the growth, development and working of the nation.[9]

PATRIOTIC TOPOGRAPHY

Early in his career Turner developed a dynamic topographic style. This departed from the prevailing antiquarian focus on enduring landmarks to concentrate on human activity and enterprise. When castles and abbeys and country houses are shown by Turner they are incorporated in scenes of present circumstances, placed firmly within a course of events, not standing aloof from them.[10] Intended to illustrate albums of views, or books on localities, they catered for a rising market for British scenery at a time when the Continent was closed to travellers by the Napoleonic Wars.[11] Like the contemporary Reports of the Board of Agriculture, and the maps of the Ordnance Survey, they survey the character of the country.[12]

Turner's excursion in 1811 to gather material for *Picturesque Views of the Southern Coast of England* was conceived as 'a commentary on the political and moral state of this bulwark of the nation at the height of the struggle against Napoleon'.[13] As well as sketching his observations in the field, Turner made notes on geology, history, agriculture, engineering and manufactures. These topics were included in a long poem Turner intended to be the basis of the book's text. Among drawings of warships in the sketchbook are some lines on Bridport in Dorset, a centre for the manufacture of sailcloth and cordage for the navy. Turner champions the mobilizing of the population for the war effort, beginning with the 'breaking' (crushing) of flax in a mill.

> Here roars the busy mill called breaks
> Through various processes o'ertakes
> The flax in dressing, each with one accord
> Draw out the thread, and meet the just reward.
> Its population great, and all employed,
> And children even draw the twisting cord

Behold from small beginnings, like the stream,
That from the high raised downs to marshes breem[?]

First feeds the meadows where grows the line,
That drives the mill that all its powers define,
Pressing ...
On the peopled town who all combine
To throw the many strands in lengthened twine;
The onward to the sea its freight it pours,
And by its prowess holds the distant shores,
The straining vessel to its cordage yields:
And Britain floats the produce of her fields.
Why should the Volga or the Rubicon
Be coveted for Hemp? why such supply'd
The sinew of our strength and naval pride ...

Plant but [?] the ground with seed instead of gold
Urge all our barren tracts with agricultural skill,
And Britain, Britain, British canvas fill;
Alone and unsupported prove the strength
By her own means to meed the direful length
Of Continental hatred called blockade[14]

Turner's picture of Bridport, (Figure 1) does not show all the activity described in the verse. It focuses on a throng of figures warping a brig into the harbour, a reference to the line 'the straining vessel to its cordage yields', which is the bridge in the poem between the lines of flax manufacture and those on British naval power. And visually the straining rope acts as a bridge too, between the towering bulwark-like cliffs of Dorset and the English Channel. The verse was intended by Turner to enhance the range of his picture. Turner brings together, at a bridging point, two trails of associations which stretch far beyond its frame. In so doing he extends the scope of landscape as a genre.

As the threat of invasion receded, and as hostilities came to a close, Turner's patriotism became more qualified, more ambiguous. He represented the role and fate of Britain less in terms of a momentary, insular struggle and more in terms of its long-term, global destiny. In his long poem *The Fallacies of Hope*, which he began around 1813, and quoted from in lines to his pictures for the rest of his career, imperial power is constantly undercut by corruption in a cyclical theory of history. Turner made cautionary analogies between Britain in its ascendancy and past empires which had been ruined by decadence, empires in antiquity like that of Carthage, and more recent empires

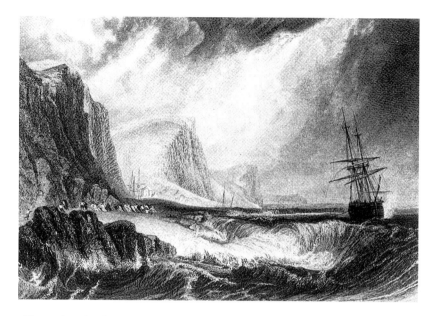

Figure 1 J. M. W. Turner, *Bridport, Dorsetshire*, c. 1813–17. Bury Art
Gallery and Museum

whose ruin he had witnessed on his tours through Europe, notably that
of Venice.[15] As a companion picture to his 1835 view of Venice for the
Manchester cotton spinner Henry McConnel, which showed luxurious
citizens lounging in gondolas, Turner painted a view of Shields on the
River Tyne, showing keelmen shovelling coal from barges to collier
brigs. Turner contrasts the 'sunlit indolence' of Venice with the 'smoke,
bustling activity carried on even by night in the industrial north of
England ... a warning to Britain that she must strive to maintain both
her naval supremacy and her industrial expansion, lest, she, too, suffer
the same fate as Venice'.[16] While Venice and its citizens stagnate, the
keelmen of Tyneside, loading coals for London, help to keep Britain's
energy circulating.

LEEDS

Throughout the first half of his career Turner frequently toured the hills
and dales of northern England. He enjoyed the patronage and hospit-

ality of two leading Yorkshire figures, Edward Lascelles at Harewood until 1808 and then, until 1825, Walter Fawkes at Farnley Hall. Many of Turner's watercolours of scenes in the dales were intended for books, a number to illustrate T. D. Whitaker's seven-volume *History* of the county of York. What is striking about Turner's views of the dales is their representation of energy: strong winds, plunging waterfalls, bursts of sunlight, energy embodied in textile mills and in hurrying figures. Turner drew his sketches for the watercolour of Leeds (Figure 2) in the autumn of 1816, at the end of a tour collecting material for the *History of York*. It was probably commissioned as a frontispiece for the volume on Leeds.[17]

Turner depicts Leeds from Beeston Hill, about a mile and half south of the city. It is instructive to compare the sketches with the finished picture. The main sketch for the middle distance and background is a sharply drawn, meticulously detailed and annotated panorama extending over three pages. On the finished picture the view is cropped and compressed, the road severely foreshortened, the slope of the hill steepened, so connecting foreground and middle distance more suddenly. The watercolour is more selective in its detail. The smoke and mist obscure many buildings and what emerge prominently are the large textile mills and churches, picked out by the colouring of their respective materials, red brick and pale stone. The emphasis on these features is reinforced by the realignment of the road to lead directly to the mill in the centre and by the placement of two figures in the left foreground to frame the mill at the left. In the freer foreground sketches there is just shorthand indication of some of the human activity which appears in the finished picture. What we see in the watercolour is not a simple transcription of what Turner saw that day from the hilltop; it is an amalgam of visual evidence, some from the sketchbook, some, as I will show, from already published views, maps and illustrations. And the visual evidence is intersected by evidence from written sources, especially poetry. It adds up to a complex, searching and highly resonant image.

Turner's sketch is not itself a simple transcription of what he saw but a series of observations organized according to the conventions of the panorama, a popular entertainment of the time. Indeed in the scope of the sketch and the atmosphere of the watercolour, Turner's view of Leeds owes much to panoramas of London. The breadth of the view, and its detailed itemization of buildings, echoes a new map of Leeds published a year before Turner's visit. Like a panorama, this map was not just a record of Leeds as a place but a record of its expansion, a

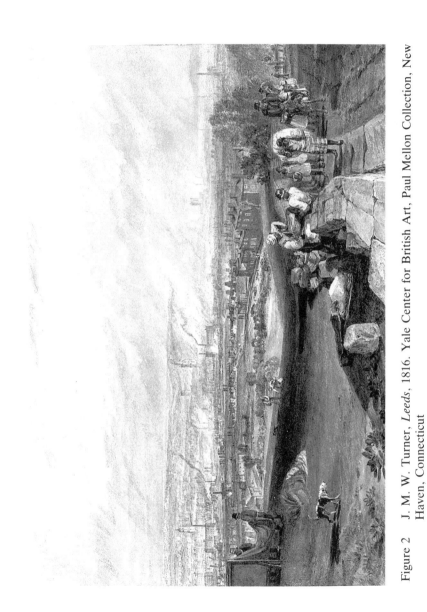

Figure 2 J. M. W. Turner, *Leeds*, 1816. Yale Center for British Art, Paul Mellon Collection, New Haven, Connecticut

document of civic pride. Turner's view is part of a long tradition of prospects celebrating the city of Leeds and its commercial power.[18]

On the left foreground two men are hanging cloth to dry on a tenter frame, on the evidence of the pile cloth still to be hung, at the end of a line of tenter frames crowning the crest of Beeston Hill. The two tentermen frame Benjamin Gott's steam-powered woollen factory, the largest in the world and one of the main sights of the city. It is the kind of morning, sunny and breezy, which local millowners and clothiers welcomed for the drying of cloth. At the right of the picture people make their way uphill. On the road are two milk carriers returning from an early morning delivery to the city. Next to them on the causeway are two factory workers returning from a night shift in one of the spinning mills, perhaps the one at the centre of the picture which had just been gas-lit. We can identify their occupations precisely because they are modelled on the figures in George Walker's *The Costume of Yorkshire*, published in Leeds and London in 1813 and 1814. In cataloguing occupations *The Costume of Yorkshire* depicted the concerted effort of the county and its importance for the nation. Walker linked his milk carriers to the quickening expansion of industrial towns and placed his factory workers in front of one of the mills which 'are essentially requisite for the widely extended commerce of Britain, and furnish food and raiment to thousands of poor industrious individuals'. The figure in front is a cloth worker shouldering a roll of cloth, perhaps coming from the row of buildings down the hill (which appear to have weaving chambers in their top story) and about to turn into the tenter field. He updates the figures on the right of a prospect of Leeds by Samuel Buck (Figure 3), first published in 1720, but reissued as late as 1813. These carry cloth towards the left of the picture where two men hang cloth on tenter frames.[19]

Although the main concentration of industrial building is in the valley there is nothing bucolic about the foreground. The stone causeway and the rebuilding of the wall by the two masons confirm that we are looking down an important artery. Such walled roads were 'a proper approach to a great town' declared the picturesque theorist William Gilpin, 'as it is a kind of connecting thread with the country'.[20] At the time of Turner's visit the fields in this area had been turned over to paddocks for grazing cows to supply the city with milk or to tenter grounds for drying cloth. Indeed so valuable was land for these purposes that it inhibited building. Thus what Turner depicts is not a contrast between urban and rural scenes but an integrated, wholly industrialized landscape. He shows various processes, some mechanized, some not, from

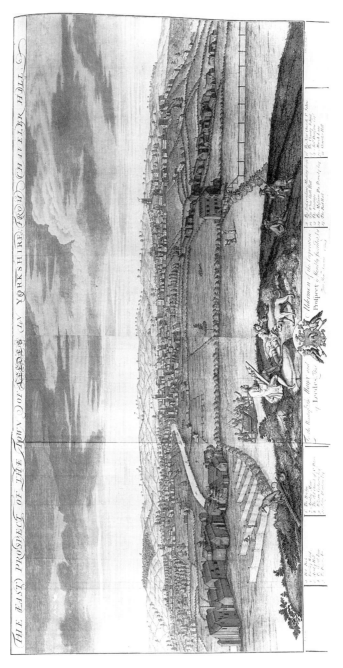

Figure 3 Samuel Buck, engraved I. Harris, *The East Prospect of the Town of Leedes*, 1720. Society of Antiquaries of London

the spinning of yarn in the valley to the tentering of cloth on the hill. It is a scene of energy – signified by steam, sun, wind and human labour – co-ordinated to industrial expansion.[21]

Long established as the nation's main centre for wool, Leeds had recently become the main centre for flax spinning. When a Prussian factory inspector visited the city in 1814 he reported that Napoleon's Continental Blockade had stimulated the production of yarn and the building of six new mills. One of the most advanced is the central focus of Turner's *Leeds*. Many workers had been taken on, it was reported, and employers and employees were prospering. The yarn from the flax mills was turned locally into rope and canvas. There were weaving sheds attached to the mills in the valley but yarn was also put out to domestic weavers in the suburb from which Turner depicts the city. What the tentermen are raising to billow in the wind may then be sailcloth. In overcoming the Continental Blockade, the flax manufacturers of Leeds had not only supplied the navy, but themselves achieved a victory of naval proportions. Given Turner's view that British identity was ultimately realized in sea power, and his fixation with ships as vehicles of industrial advance, it is tempting to see maritime allusions in the landscape of Leeds, in the textile mills which, by their bulk and blazing power, were often likened to warships, and in the tenter ground, where cloth, perhaps canvas, is being unfurled like a sail. As Turner declared in his lines on the flax industry of Bridport: 'Britain, Britain, British canvas fill'.[22]

A poem which is echoed in much of Turner's own verse, including that on Bridport, and which informs much of the iconography of his view of *Leeds*, is *The Fleece* by John Dyer. In the tradition of Virgil's *Georgics*, *The Fleece* is an instructive poem, prescribing the most advanced procedures for the production and distribution of cloth. It does so as it traces the progressive transformation of 'Britannia's fleece' into cloth 'uphung / On rugged tenters, to the fervid sun ... it expands / Still bright'ning in each rigid discipline and gathered worth'. It is a process which takes the poem from the hills of Herefordshire to the Yorkshire Dales to the port of London, connecting all ranks and a variety of workers from artisans to factory hands. Having pictured Britain as a nation united through industry, Dyer goes on to chart its influence overseas. Taken by 'tall fleets into the widening main ... every sail unfurled', the cloth carries the benevolence of

> Britain's happy trade, now spreading wide
> Wide as the Atlantic or Pacific Seas,
> Or as air's vital fluid over the globe.

The city of Leeds occupies a key position in the argument of *The Fleece*. Dyer builds up an image of Leeds that raises its status beyond any other city in the nation, to the point where it stands as the exemplar of British dominion. Some of the features in Turner's picture of Leeds develop Dyer's description, from a similar, perhaps the same vantage point:

> And ruddy roofs, and chimney-tops appear,
> Of busy Leeds, up-wafting the clouds
> The incense of thanksgiving: all is joy;
> And trade and business guide the living scene

Dyer emphasizes the activity of workers 'O'er high, or oe'r low, they lift, they draw, they haste' in the expansion of Leeds and the work of masons in transforming 'heaps of stone' into buildings and 'new streets ... in the neighbouring fields'. So also appear

> Th' increasing walls of busy Manchester,
> Sheffield, and Birmingham, whose redd'ning fields
> Rise and enlarge their suburbs

But there is a cautionary analogy in *The Fleece* for the expansion of Leeds and other British cities. For

> Such was the scene
> Of hurrying Carthage, when the Trojan chief
> First view'd her growing turrets.

And the poem goes on to observe 'the dust of Carthage' in a survey of ancient cities ruined by luxury, monuments 'to those who toil and wealth exchange for sloth and pride'. The resonance of *The Fleece* in Turner's *Leeds* infuses his view of the city with the gravity of the oil painting he did a year before of the building of Carthage and the one he did a year after of its ruin.[23]

 We may now compare Turner's view of Leeds from the south of the city with the one by Humphry Repton I discussed in the previous chapter (Chapter 3, Figure 2), made seven years earlier from Benjamin Gott's park at Armley to the west of Leeds. In contrast to Repton's complacement, proprietorial view for a private client, Turner offered a more public view. Gott's woollen mill to the left is but one feature in a view that also focuses on the ascendancy of the flax industry against a background of many other industrial enterprises. We see plebeian figures as well as the buildings of factory owners. And we look, not from

the leisurely foreground of a park, but from a public road passing through industrialized fields. Rather than looking down upon the city, the city appears to advance up the road towards us. As the masons lift the slab into place so figures on the road come to the crest of the hill, hard on each other's heels. The view is not framed by a repoussoir of trees; indeed the feature occupying the conventional position of a repoussoir, the tenter frame, only serves to confirm that the scene extends far beyond us. Turner is less intent to display the look of the land than to trace the circulation of energy.

Turner's view of Leeds may have been too progressive for the text it was intended to illustrate, for, although later lithographed, it was not in fact published in Whitaker's volume on Leeds. Whitaker's text deplores the effect of industrialization on the landscape and the culture of Leeds and its environs. It yearns for the more polite régime of the cloth industry a generation before when it was controlled and largely financed by Tory 'gentleman merchants'. Turner's picture more clearly expresses the rising power of the Whig manufacturing interest in the city. It is the figurehead of this interest, John Marshall, whose flax mill is at the centre of the picture.[24]

Turner's *Leeds* is not an entirely cheerful celebration of commercial progress and civic pride. Compared to their prototypes in *The Costume of Yorkshire*, the foreground figures do not show off their role in the prosperity of Leeds. They do not regard the spectator at all; each is absorbed in the effort of their occupation. This is evidently hard work which takes its toll of those who do it as it enhances the fortunes of those who do not. There is something troubling too about the conjunction of church towers and smoking mills in the background when we look at them in the light of some verses Turner wrote a few years earlier:

> The extended town far stretching East and West
> The high raised smoke no prototype of Rest
> Thy dim seen spires rais'd to Religion fair
> Seen first as moments thro that World of Care
> Whose Vice and Virtue so commixing blends
> Tho one returns while one destruction sends.[25]

This was probably written with London in mind, for Turner appended his 1809 prospect painting of London from Greenwich with similar lines:

> Where burthen'd Thames reflects the crowded sail,
> Commercial care and busy toil prevail,
> Whose murky veil, aspiring to the skies,
> Obscures thy beauty, and thy form denies,

Save where thy spires pierce the doubtful air,
As gleams of hope amidst a world care.[26]

If Leeds has assumed the prestige of the nation's capital, it has also taken on its burden. There is then material for John Ruskin, towards the end of the nineteenth century, to enlist Turner in his disquiet about urban industrialism. Ruskin saw a smoke-shrouded church spire in another of Turner's industrial views (of Dudley) as a premonition of 'what England was to become'.[27] Turner's view of Dudley shows a much smokier, more infernal scene than his view of Leeds. By the mid nineteenth century, when Leeds itself became choked with smoking factories, Turner's view seemed refreshing. Commenting on the picture in the Art Treasures Exhibition at Manchester in 1857, the *Manchester Guardian* found it 'a revelation of unsuspected beauty'. 'How Turner knew and loved England! ... The Yorkshireman never thought Leeds would be so lifted out of her smoke cloud, and made so brave as she shows here'.[28]

RAIN, STEAM AND SPEED

Rain, Steam and Speed – the Great Western Railway (Figure 4) may seem a very different picture to *Leeds*. It is an exhibition piece, painted in oils in the less detailed, more abstract manner of Turner's late style. If features stand out, are objectified in *Leeds*, in *Rain, Steam and Speed* most are reduced to pictograms and dissolve into flux. Such stylistic differences between the two pictures should not obscure the correspondences of subject and symbolism.

Both pictures feature the main icons of industrial advance of their time, textile mills in 1816, the railway in 1844. And in Leeds and the Great Western Turner shows the most powerful corporate organization of those two industries. As industrial Leeds advances towards us along the roadway, so does the Great Western's train from London along the railway, striking a similar diagonal. Both emerge from an atmosphere of smoke, moisture and sunlight, if in *Rain, Steam and Speed* this is the effect of the train travelling through a storm and is more turbulent and enveloping.

The train and railway bridge are the darkest and most impressive features of *Rain, Steam and Speed*. Less apparent are the old road bridge over the River Thames at the far left of the picture, a boat floating on the river, a group of figures on the bankside and, at the far

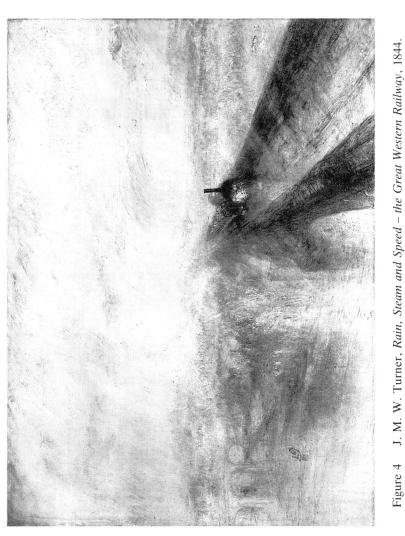

Figure 4 J. M. W. Turner, *Rain, Steam and Speed – the Great Western Railway*, 1844.
Reproduced by courtesy of the Trustees, The National Gallery, London

right of the picture, a plough team. The difficulty of recognizing anything but the traces or notations of objects in an evanescent landscape was one described by early rail travellers who tried to adhere to old painterly ways of seeing when looking out from trains.[29] But Turner is making more than a phenomenological observation about rail travel. In travelling through a landscape rather than upon it the railway confirmed visually what Turner had been doing conceptually with his topographical style, notably in his view of Leeds: breaking the traditional frame of visibility to co-ordinate features as part of a larger network of space and time.

In showing the Great Western Railway crossing the Thames, Turner marks the conjunction of major routeways. Neither was merely a line of linkage, but a system with regional, national and international dimensions. The Thames was long established as the main artery of State power, and is affirmed as such in Turner's art; the Great Western offered a new prospect of State power. I will now consider how Turner represents these two arteries and their conjunction in the rainstorm on Maidenhead Bridge.

THE GREAT WESTERN

The great railway companies were seen to represent a new political-economic order. For better or worse this new order would vanquish the power of the landed gentry, and the inequalities of a property-based culture. The levelling of railway track was a frequent metaphor for the levelling of class distinctions and the fast flow of the railway network was conventionally contrasted with the insular and languid landscape of country estates. The old régime did not yield easily to railway building; it was, said John Francis in his promotional *History of the English Railway* (1851), 'the warfare of the monied with the landed interest'. But railway supporters had to recognize that the landed interest were not entirely resistant to the railway. Many were shareholders, some welcomed the railway on their estates, if not in their parks, and many who did object did so only initially, as a ploy to raise the price of their land. 'Fancy prices for fancy prospects', sneered Francis, upholding in contrast the more public-spirited vision of the Great Western's shareholders (who included Turner), beholding 'Titanic arches and vast tunnels; magnificent bridges and fine viaducts'.[30] In their organization and control of territory, goods and people the railway companies became seen as sovereign States and, as the railway system began to articulate the development of Victorian society as a whole, as a new,

more republican, metaphor of the nation State and its ambitions.[31] Francis dilated on the imperial role of the railways, 'the glorious prospect which will be opened to the world, if merely the vast and important works now in progress – works with which the useless Egyptian pyramids or the vaunted remains of the old Rome's extravagance, will not endure comparison – be carried into execution'.[32]

When Turner painted *Rain, Steam and Speed*, the Great Western was the nation's largest railway and the most glamorous, 'the most gigantic work' declared Francis, 'not only in Great Britain, not only in Europe, but in the entire world'. It was easily the longest, stretching over 200 miles from London to Exeter, and with its broad gauge, even grading, gentle curves and series of spectacular tunnels and bridges, was built to be the fastest, smoothest and most direct. Its reputation reflected that of its designer, Isambard Kingdom Brunel, the most daring of the engineer-heroes of the time. Attending to every detail, Brunel conceived the *Great Western* as an extensive enterprise, stretching from Britain to the United States. When the first stretch of broad gauge was completed in 1837 the company's revolutionary steamboat, designed by Brunel and named the *Great Western*, docked triumphantly in New York. In Bristol, according to a city newspaper, her return from the maiden voyage was greeted with the 'joy and pleasure' of 'the tidings from the Nile, Trafalgar Bay and the plains of Waterloo'. The imperial stature of the Great Western was sealed by the Crown. In a modern version of the procession of the State Barge down the Thames, Queen Victoria and Prince Albert made their first train journey from London to Windsor, and Albert travelled by train to Bristol to launch Brunel's ironship *Great Britain*.[33]

For Turner it was the maritime extension of the railway, the impetus it gave to the nation's power, which raised its status as a subject. When the line from Bristol to Exeter was opened, shortly before Turner exhibited the picture, a fast link was forged between the great naval regions of the east coast and west coasts. Steamships, often battling through stormy weather, are an important subject of Turner's later painting. Like Brunel's ships, designed to cleave through Atlantic storms, the locomotive in *Rain, Steam and Speed* glides smoothly through the storm over the Thames, its wheels scarcely seeming to engage the rails.

Turner uses a number of devices to express the power of the railway and to probe its cultural implications. Following the style of promotional prints for the railway he sets up a series of contrasts: new railway bridge and old road bridge, speeding train and drifting boat, steam driven locomotive and horse drawn plough, direct track and meandering

river. Many prints, while affirming the triumph of the railway over slower-rhythmed ways, tried not to make this seem too overbearing, and in some cases strove to harmonize old and new. They were particularly concerned to counter anti-railway imagery which showed the railway as a volatile spectacle, destabilizing the world it rushed through. Much of Turner's imagery seems to hover between these views. He shows the locomotive with its firebox visible through the front. On one hand this alludes to such firebreathing monsters as Cruikshank's *Railway Dragon*, a caricature of the voracious financial speculation in railways; on the other it alludes more coolly and affirmatively to drawings in popular books on engineering which displayed blazing fireboxes in cross- sections of locomotives as part of their demonstration of how the engine worked.[34]

Maidenhead Bridge was as spectacular an example of engineering as the locomotive crossing it, but Turner's depiction is not easily aligned with the declarations of either its supporters or its detractors. Having been ordered by the Thames commissioners to leave the navigation channel and towpaths unimpeded, Brunel spanned the 300-foot-wide river with just two semi-eliptical arches, the longest then built. Even voices within the Great Western company predicted that the bridge would collapse when the timber centrings were removed, as they were, by force of nature, in a storm. But the bridge stood. J. C. Bourne's illustration from the 1846 official guidebook (Figure 5) to the railway shows the bridge side-on from the river, looking both sturdy and graceful, easily supporting a diminutive train. Bourne shows how Brunel accommodated his bridge to establishd interests, to the river commissioners, and also, in his accompanying text, to the great estates along this stretch of the river which could be seen from the train. Turner's depiction of the bridge is less stable. The suspended viewpoint and foreshortening render the bridge more precipitous, the central pier seems to bulge under the weight of the train and dissolve in the river. If Bourne conclusively resolves the various interests at the site, Turner seems to re-open disputes about the bridge, not to show that the bridge itself would fall (it had stood for five years when Turner painted it) but perhaps to offer a commentary on the ambition, financial as well as technological, it represented.[35]

Maidenhead Bridge was, declared the 1851 *History of the English Railway*, 'a monument to what an engineer of genius can do with shareholders' money'.[36] As a monument to money, not painted during the stable year of 1851, but during the overheated speculation of the mid-1840s, the railway in Turner's picture comes into focus as the

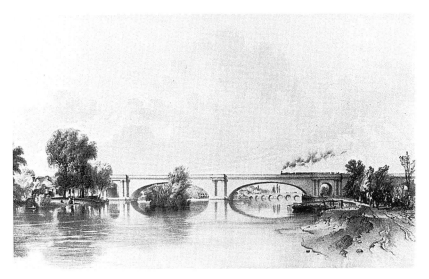

Figure 5 J. C. Bourne, *Maidenhead Railway Bridge* from *The History and Description of the Great Western Railway*, 1846

traditional riverside scenery dissolves. It was scenery to which Turner had long been attached. There may be some grounds for saying that Turner is expressing pictorially in *Rain, Steam and Speed* the sort of sentiments Wordsworth did later in 1844 in verse and correspondence to the *Morning Post* about proposals for a line through his beloved Lake District: 'Is then no nook of English ground secure / From rash assault?'[37] But Turner makes no attempt to reconstruct any picturesque nook of English ground from which we might stare appalled at the assault of the railway. Rather, we vault the river with Brunel.[38]

The most obvious viewpoint in *Rain, Steam and Speed* is across the bridge, along the railway, but there is another from the river, which suggests that Turner did not see this stretch of the Thames as a haven from material progress, rather an avenue of it. The boat drifting on the river has a figure sitting sideways, as though fishing or sketching, sheltering from the storm under an umbrella. This surely represents Turner, lifelong fisherman as well as sketcher, and famously inseparable from his faded umbrella.[39] On the cover of one of Turner's early sketchbooks is a poem 'written at Purley on Thames rainy Morning no Fishing'. The poem describes a boy dropping a paper boat into the rain-filled ruts left by a cart going to market, a scene which magnifies in the following lines as the watery ruts are transformed into a great

waterway flowing to distant markets across the high seas.[40] It is a transformation of scale and register typical of Turner's painting, not least *Rain, Steam and Speed* in which the lack of clear spatial co-ordinates makes it extremely difficult to gauge the precise size or position of features. With the poem in mind, and the shifting perspective of the picture, we can see the boat on the water as a second viewpoint in the picture, both a boat from which the artist sees, and a toy boat in a rain-filled rut transmuting into a great vessel which plies a great waterway. And this is the viewpoint I will now take in considering the role of the River Thames in *Rain, Steam and Speed*.

THE THAMES

It is hard to overestimate the significance to Turner of the River Thames. Throughout his life he resided in various places by it and throughout his career depicted various scenes along it, from its upper reaches to its mouth. In these pictures Turner explicated the activity and associations of the river at such sites as Windsor, Richmond, Westminster, Greenwich and, at the confluence with the Medway, the Nore of Sheerness, Britain's busiest anchorage. In English writing and painting the Thames and its scenery had long signified the nation's condition and power. The Thames is the main thread of the most popular of eighteenth-century poems, James Thomson's *The Seasons*. With its painterly images, it proved an enduring influence on Turner's art. The poem traces a prospect of 'Happy Britannia' along the Thames valley from Richmond Hill, taking in Windsor Castle, various aristocratic seats, the 'Power of Cultivation' on the hills, and eventually 'Commerce' and 'Industry' in the port of London, with the 'sooty hulk', 'splendid barge' and the building and launching of a ship of the line 'To bear the British thunder, black and bold'.

I will consider *Rain, Steam and Speed* in terms of three of Turner's later Thames pictures which address the issue of State power and do so in images which concentrate on the power of fire: *The Fighting 'Temeraire'* (1839), set off Sheerness, and, set at Westminster, the two views of *The Burning of the Houses of Parliament* (1835). It will be necessary to make two meanders in my argument, outlining the circumstances of each painting, before I can bring them directly to bear upon *Rain, Steam and Speed*.

The Fighting 'Temeraire', Tugged to her Last Berth to be Broken up (Figure 6) proved from its first exhibition at the Royal Academy in 1839

Figure 6 J. M. W. Turner, *The Fighting 'Temeraire' Tugged to her Last Berth to be Broken up*, 1838, 1839. Reproduced by courtesy of the Trustees, The National Gallery, London

to be one of Turner's most popular works. It seemed more legible than many of his later works. The *Temeraire*, a First Rate battleship which distinguished itself at the Battle of Trafalgar, is shown being towed towards the breakers' yard at Rotherhithe. Reviewers at the time made much of the setting sun, seeing the picture as an image of fading glory. There was at the time a general mood of elegiac patriotism formulated by the many pictures and reports of the ruin and destruction of old sailing ships from the Napoleonic Wars. Reviewing *The Fighting 'Temeraire'*, the novelist Thackeray caught the mood when he contrasted the majestic ship with the 'little, spiteful diabolical steamer' tugging it spewing 'foul, lurid, red-hot, malignant smoke'. But he found the picture overall a moving one, a 'magnificent national ode or piece of music' which he likened to a performance of *God Save the Queen*.[41]

If most reviewers' sympathies were with the *Temeraire* as opposed to the tug, it is not clear where Turner's lay. The sun is painted in the same pigments as the plume of smoke and fire from the tug and the sun ray sweeping the sky strikes the same diagonal. The sunset may then not be seen as elegiac, but energetic, even explosive. If, in fact, the sun is setting. For if the *Temeraire* is being tugged to Rotherhithe it is going *up* the Thames, westward, and the sun low in the sky is in the east, *rising*. Is the tug and the era it represents then rising with the sun and assuming its power and majesty?[42]

Whatever view may be taken, *Rain, Steam and Speed* may be seen to continue the trajectory of *The Fighting 'Temeraire'*. The locomotive advances upon the spectator like the steam tug but unburdened by any symbols of past era, just pulling a train of carriages at speed from the metropolis. The old road bridge on the Thames is pallid and finely proportioned like the *Temeraire* but is a more marginal feature, disconnected from the onward rush of the train over the new railway bridge. Rather than trying to determine whether Turner was for or against steam power, we might recognize in both pictures the dialectic of national destruction and renewal which is pronounced in Turner's paintings of *The Burning of the Houses of Parliament* (Figures 7, 8).

On the night of 15–16 October 1834 a great fire destroyed both Houses of Parliament. The fire focused many issues of political reform. With memories still vivid of the incendiarism which accompanied the Lords' rejection of the Reform Bill to extend the franchise, and with newly elected radicals campaigning for the abolition of the House of Lords, many suspected arson. As it turned out, the fire was started accidentally but its cause was seen to be no less symbolic. A store of wooden tally sticks, which had been used to keep Exchequer accounts

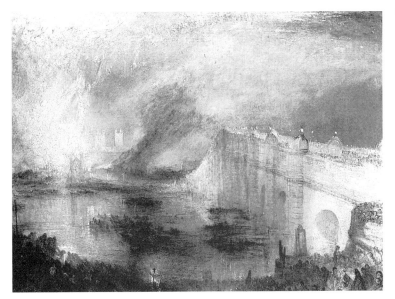

Figure 7 J. M. W. Turner, *The Burning of the Houses of Parliament*, 1835. Philadelphia Museum of Art, John H. McFadden Collection

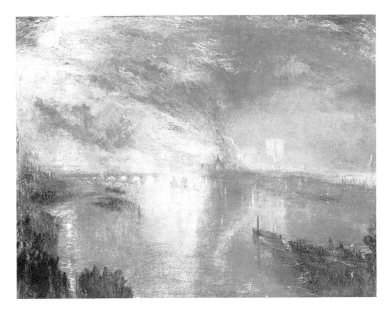

Figure 8 J. M. W. Turner, *The Burning of the Houses of Parliament*, 1835. The Cleveland Museum of Art, Bequest of John L. Severance, 42.647

before the change eight years before to modern bookkeeping, was carelessly burnt in the Old Palace Yard and fire spread rapidly through the labyrinthine complex of medieval buildings. Too long a regard for the relics of the Middle Ages, it was thought, had brought about destruction. The magnitude of the fire, and its location, also exposed the issue of urban reform, in the chaotic attempts of the brigades of private insurance companies to deal with the conflagration. Recalling the Great Fire 1666 and its aftermath, that of 1835 was seen to portend the emergence of a new civic order.[43]

Turner joined the crowds who converged on the Thames to view the spectacle, sketching the fire from various vantage points and producing two oil paintings he exhibited the following year. One painting views the fire directly across the river from near Westminster Bridge, the other, downstream from near Waterloo Bridge, views it along the river. One offers a populist, perhaps radical view of the fire and its political implications, the other a patrician, perhaps conservative view.

The view from near Westminster Bridge shows (Figure 7) an early stage in the fire, during or just after the explosive crash when the roof of the Commons fell in. The explosion was thought at the time to be the work of some modern-day Guy Fawkes and was greeted with cheers by the crowd, which were widely reported to be politically motivated. Using the conventions of the theatre Turner shows the spectators ranked in a circle, one waving a hat, another brandishing a sign on which a large 'NO' is emblazoned, a reference, it has been suggested, to protests among the crowd that night to the New Poor Law.[44]

The view downstream from near Waterloo Bridge (Figure 8) shows a later stage in the fire when Westminster Hall was spared by a sudden shift in the wind. A smaller and more solemn crowd look at the silhouette of Westminster Hall against the flames and, to the right, and now clear of the fire, the twin towers of Westminster Abbey. If the House of Commons had collapsed, Westminster Hall, the most important monument to constitutional tradition, was saved. No less than his subject, Turner's viewpoint affirms tradition. Unlike that from near Westminster Bridge, it did not appear in any of the popular prints of the fire and it is unlikely that Turner himself sketched it, for it is, and was then, practically impossible to stand at this viewpoint. But the viewpoint had been established by Canaletto in his stately views of Westminster, celebrating the conjunction of city and nation and the new Westminster Bridge (Figure 9). While Canaletto's Westminster is clearly drawn, finely detailed and sparkling in sunshine, Turner's dissolves into a nocturnal maelstrom of fire and water.[45]

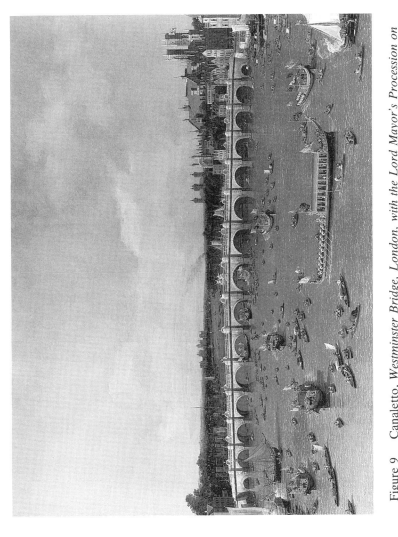

Figure 9 Canaletto, *Westminster Bridge, London, with the Lord Mayor's Procession on the Thames*, 1747. Yale Center for British Art, Paul Mellon Collection, New Haven, Connecticut

To move upstream to *Rain, Steam and Speed*. First, there are striking compositional correspondences with the two paintings of the burning of the Houses of Parliament. Looking along Maidenhead Bridge we observe the incandescent collapse we see along Westminster Bridge. The side-on view of Westminster Bridge, with its nostalgic associations of eighteenth-century classicism, is repeated in the view of the old bridge at Maidenhead. The dark gable of Westminster Hall emerges from the fire, trailing smoke, its interior aflame like the firebox visibly blazing within Turner's locomotive. At least formally, features of modernity elide with features of tradition. But there are compelling, iconographic reasons for discerning the skyline and atmosphere of London in *The Burning of the Houses of Parliament* in *Rain, Steam and Speed*.

LONDON

The railway system which radiated from London was seen to be accelerating the capital's nodal power and expansive influence. In *Dombey and Son* Dickens makes the railway system and its construction a metaphor for the metropolis and its energy, in its continual reduction of the landscape to 'dire disorder' to make way for the 'mighty course of civilization'; the railway is both the 'life blood' of the capital and nation and 'the triumphant monster Death'. If a similar dialectic is discernible in *Rain, Steam and Speed*, vested in the power of fire, it is one which Turner had expressed thirty years before in his verse on 'the extended town'.

> Far stretching East and West
> The high raised smoke no prototype of Rest ...
> Whose Vice and Virtue so commixing blends
> The one returns while one destruction sends
> Oer children's children whateer low & great
> Debase or noble here together meet
> To a concentred focus hope together draws.[46]

It was the railway which most dramatically expressed this vision of London as an epicentre of energy, both explosive and implosive, creative and destructive, noble and base, and in *Rain, Steam and Speed* Turner shows the exact place at Maidenhead Bridge where the capital's main arteries can be seen 'far stretching East and West', the 'concentred

focus' of 'hope' for Turner a driving but duplicitous force of history.[47]

The year before he exhibited *Rain, Steam and Speed* at the Royal Academy Turner appended some lines from his poem *The Fallacies of Hope* to his painting *The Sun of Venice Going to Sea* (Figure 10). The picture shows a fishing boat gliding out from Venice, emerging from the mist of the lagoon. On its sail is inscribed the skyline of the city, the orb of the sun and the words 'Sol del Venezia'. The verse in the catalogue to the exhibition made it clear that despite its swelling sail, the Venetian ship of state is doomed:

> Far Shines the morn, and soft the zephyrs blow,
> Venezia's fisher spreads his painted sail so gay,
> Nor heeds the demon that in grim repose
> Expects his evening prey.[48]

If we can see London similarly inscribed in *Rain, Steam and Speed*, parallels between the two pictures emerge, although conclusions from them are not easy to draw. The train from London rushes towards us from the storm, its source of energy emblazoned on its front, like the

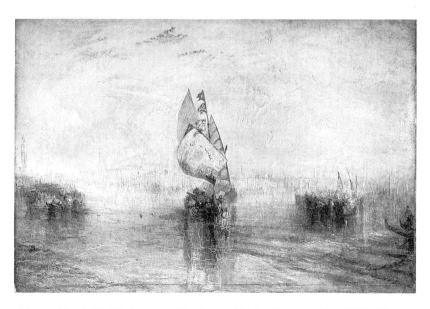

Figure 10 J. M. W. Turner, *The Sun of Venice Going to Sea*, 1843. The Clore Gallery for the Turner Bequest, London

sun on the sail of Venice. Is *Rain, Steam and Speed* merely an accelerated, more violent version of *The Sun of Venice*? Is the British State doomed to repeat the fate of the Venetian? Or does Turner's coal-fired train, this modern ship of State, look forward to an inexhaustible empire on which the sun never sets?[49]

TURNER COUNTRY

Turner was born, he claimed, on 23 April 1775, St George's Day and Shakespeare's Birthday. There is no independent evidence for this and Turner may well have decided on the date himself. He died in December 1851, an official national hero. After lying in state in his studio, Turner's body was taken in a splendid, crowd-lined, funeral cortège to St Paul's Cathedral to be buried there in the crypt.[50]

But Turner's stature as a national painter has seldom been secure. Brilliantly successful in his own right he exerted relatively little influence on subsequent English landscape art. Through a mixture of bungling and neglect Turner's bequest of his works to the nation was not honoured until the twentieth century, and there was little resistance to greedy relatives challenging his will to appropriate Turner's generous fund for indigent artists.[51]

The indifference and sometimes ridicule of the English art world made John Ruskin champion Turner all the more fiercely, notably in *Modern Painters* (1843–60). Ruskin upheld Turner both as a universal artist and as a characteristically English one, conditioned by his feeling for native scenery, especially of the hills and dales of northern England:

> Other artists are led away by foreign sublimities and distant interests; delighting always in that which is most markedly strange, and quaintly contrary to the scenery of their homes. But Turner evidently felt that the claims upon his regard possessed by those places which first had opened to him the joy and the labour, of his life, could never be superseded; no Alpine cloud could efface, no Italian sunbeam outshine, the memory of the pleasant dales and days of Rokeby and Bolton; and many a simple promontory, dim with southern olive, many a low cliff that stooped unnoticed over some alien wave, was recorded by him with a love, and delicate care, that were shadows of old thoughts and long-lost delights, whose charm yet hung like morning mist above the chanting waves of Wharfe and Greta.[52]

Ruskin attended to the subjects of Turner's art and expounded on the symbolism of the pictures, though Ruskin's interpretations tended to project his own moral strictures on the condition of England. Especially in writings towards the end of the century Ruskin used Turner's art to illustrate his own critique of industrialism, of the smoke-darkened skies which symbolized the nation's corruption. 'Much of the shadow against which Turner's light defined itself seemed a product of the mechanical greed which he saw as invading the spirit of the nation'. Ruskin defined Turner's Englishness as elegiac, a record of vanished glory.[53]

The Victorian distrust of Turner is revealed in the summary of the artist by P. G. Hamerton in his *Life of Turner* (1879):

> The qualities of Turner's art are so various and so great, that there is some danger, especially with the influence of Mr Ruskin's eloquence and frequent use of hyperbole, of a national idolatry of Turner, like the Roman idolatry of Raphael or the French idolatry of Claude. Such a result would be a great evil to landscape painting in England, and to the aesthetic culture of Englishmen who are not practical artists. Even as it is, the fame of Turner is injurious to English landscape painters of merit who, inferior to him in range of study or strength of imagination, are often in some respects his superiors, and able to render what they love best in nature with a degree of affectionate fidelity which he certainly could not have equalled ... An uncritical adoration of Turner might narrow and falsify English landscape painting if the natural vigour and independence of the English race did not continually reassert itself.[54]

Shunned in late Victorian Britain, Turner was taken up enthusiastically in France. After an etching of *Rain, Steam and Speed* was exhibited at their first exhibition in 1874 the picture became an icon for the Impressionists. Turner, the proto-Impressionist, was esteemed for his technique rather than his subjects or symbolism. After a pilgrimage to the National Gallery to see *Rain, Steam and Speed*, Signac concluded 'These are no longer *pictures*, but aggregations of colours ... *painting* in the most beautiful sense of the word'. This notion of pure painterly values largely conditioned Turner's reputation until the 1970s. It made him an international modernist, able to speak directly to French impressionists of the 1870s on one hand and on the other to American abstract expressionists of the 1960s.[55]

It took the bicentenary exhibition at the Royal Academy in 1974–5 to reaffirm Turner's nationalism. Poet Laureate John Betjeman and the sculptor Henry Moore, president of the newly formed Turner Society, urged Turner's will to be honoured and a permanent gallery to be found

for the works in the Turner Bequest. Somerset House, on the banks of the Thames, was rejected by the trustees of the Tate Gallery, who had taken custody of most of the oil paintings in the Bequest. A new gallery was eventually approved in 1980 to be built next to the Tate. The shoe shop entrepreneur Charles Clore provided the money, and the design was entrusted to James Stirling, Britain's leading international architect.[56]

The Clore Gallery (Figure 11) was opened by the Queen in 1987, at a time of intense architectural debate in London, and to a chorus of controversy. Postmodernists dilated on the 'contextualism' of the gallery, its self-conscious dialogue with various aspects of the site, especially the neo-classical frontage of the Tate next door and the River Thames over the road.[57] The architect Stirling declared, ' it's like an extension of an English country house ... it's a garden building'.[58] The art critic Richard Cork fastened on the Turnerian associations of 'a triangular green window jutting out like the prow of a ship advancing on the Thames'.[59] Many critics, especially those of the Prince of Wales's persuasion, were more hostile, seeing the building as too frivolous for Turner's new national stature.[60] At the time Paul Barker suggested that

Figure 11 The Clore Gallery, London

'this hostility may even have been a factor in the City of London planners' decision to say "No" to Peter Palumbo's proposal for a new Stirling building at Mansion House'.[61] While most art critics were unhappy with the hanging of Turner's picture against pale hessian walls (deep red was seen to show Turner at his best), they did applaud the groupings of pictures according to subject matter and theme and the provision of a study for looking at the sketchbooks. The new contextual paradigm of Turner Studies was cast in contextual concrete, brick and stucco.

But there were dissenting voices. At the opening of the Clore Gallery a group of demonstrators declared that the Turner Bequest had been betrayed. Their spokesman, Al Wein, a long-time campaigner from the Turner Society, feared for a People's Turner. He distrusted the continuing custody of Turner by the English art establishment, an establishment which, under the influence of the, now unmasked, Soviet spy Anthony Blunt, had betrayed English art, notably Turner. 'Turner left his art to the people of England – not to the National Gallery or the Tate'. Wein argued for an independent Board of Trustees for the Turner Bequest and its tour through Britain in a series of exhibitions. Otherwise 'the bequest will remain in the hands of those academics whose writings on Turner seem to be addressed to other scholars rather than to the general public'.[62]

Downstream in Docklands, Turner was enlisted in the making of London's Thameside heritage. In 1987 the architect Theo Crosby proposed a Battle of Britain monument on what he called the 'Turner axis', the view in Turner's 1809 prospect of London from Greenwich Park across the smoky docks culminating in St Paul's Cathedral. Cleansed of its industrial implications, Turner's painting is used to frame a post-industrial future for London:

> The Thames is deindustrializing fast and if Crosby has his way it will soon be restored to its proper pride of place as the capital's most significant thoroughfare. Busy with upgraded tourist amenities, the river will become a primary source of meaning again.[63]

A more smoky Turner country was discovered in tours of the remains of old Docklands, among warehouses, engine houses and piers redolent of Empire. In a feature for the *Independent*'s 'Traveller' section, Dymphna Byrne described her walk through Rotherhithe

> along a sinister narrow path past tall warehouses and public gardens to Cherry Garden Pier, where Turner painted *The Fighting Temeraire* – the

sailing ship, back from Trafalgar, on its way to be broken up at Rotherhithe. I'd noticed in St Mary's that the communion table was made from Temeraire oak ... The blue pier, old and creaky with a walkway leading out to it, was, on the surface, nothing special ... But evocation and association are powerful ... Turner, and all that Trafalgar means, crept into my perceptions that misty afternoon.[64]

NOTES

1 David Hill, *In Turner's Footsteps* (John Murray, London, 1984), p. 10.
2 There is a burgeoning literature on this. See especially the journal *Turner Studies*, also the following books: Hill, *In Turner's Footsteps*; Eric Shanes, *Turner's Human Landscape* (Heinemann, London, 1989); Eric Shanes, *Turner's England 1810–1838* (Cassell, London, 1990); John Gage, *J. M. W. Turner: 'a Wonderful Range of Mind'* (Yale University Press, New Haven and London, 1987); Andrew Wilton, *Turner and his Times* (Thames & Hudson, London, 1987); Martin Butlin and Evelyn Joll, *The Paintings of J. M. W. Turner*, revised edition (Yale University Press, New Haven and London, 1984).
3 Sam Smiles, 'Picture notes', *Turner Studies* 8 (1988), pp. 53–7; Andrew Wilton, 'Turner and the sense of place', *Turner Studies* 8 (1988), pp. 26–32.
4 Nicholas Alfrey, 'Turner and the cult of heroes', *Turner Studies* 8 (1988), pp. 34–44; Sam Smiles, 'Turner in the West Country: from topography to idealization', in J. C. Eade (ed.), *Projecting the Landscape* (Canberra, Australian National University: Humanities Research Centre Monograph no. 4, 1987), pp. 36–53.
5 Gage, *Turner*, pp. 39–74.
6 Hill, *In Turner's Footsteps*, p. 14.
7 Alun Howkins, 'J. M. W. Turner at Petworth: agricultural improvement and the politics of landscape' in John Barrell (ed.), *Painting and the Politics of Culture* (Oxford University Press, 1992) pp. 231–52.
8 Gage, *Turner*, p. 171.
9 Jack Lindsay, *Turner: the Man and his Art* (Granada, London, 1985), pp. 163–8.
10 Smiles, 'Picture notes'.
11 Hill, *In Turner's Footsteps*, p. 10.
12 Nicholas Alfrey, 'Landscape and the Ordnance Survey 1795–1829' in Nicholas Alfrey and Stephen Daniels (eds), *Mapping the Landscape* (University of Nottingham, 1990), pp. 23–7.
13 Gage, *Turner*, pp. 42–4.
14 Turner Bequest CXXXIII ff. 102v, 105v, 110v, The Clore Gallery, London.
15 Lindsay, *Turner*, pp. 73–93.
16 Butlin and Joll, *Turner*, pp. 210–11.

17 Stephen Daniels, 'The implications of industry: Turner and Leeds', *Turner Studies* 6 (1986), pp. 10–17. This is a more detailed and fully illustrated version of the following section on Turner's *Leeds*. I have slightly revised my interpretation of the picture, bringing out its ambivalence. Some of my revisions are made in the light of a description of the picture in Maurice Beresford, *East End, West End: the Face of Leeds during Urbanization* (The Thoresby Society, Leeds, 1988), being *Publications of the Thoresby Society* 60–1 (1985–6), pp. 365–6. An interesting essay which places Turner's *Leeds* in the context of other nineteenth-century views of the city is Caroline Arscott, Griselda Pollock with Janet Wolff, 'The partial view: the visual representation of the early 19th century city', in Janet Wolff and John Seed (eds), *The Culture of Capital* (Manchester University Press, 1988), pp. 227–9.

18 Daniels, 'The implications of industry', p. 16, no. 8, *Plan of Town of Leeds and Environs*, surveyed by Netlam and Francis Giles (London, 1818), reproduced in 'A "Waterloo" Map of Leeds', *Publications of the Thoresby Society*, 11 (1904), pp. 281–8.

19 Daniels, 'The implications of industry', pp. 11–12.

20 William Gilpin, *Observations on the River Wye* (Blamire, London, 1789), p. 91.

21 Daniels, 'The implications of industry', p. 12.

22 Ibid., pp. 12–13, 16.

23 Ibid., pp. 14–16.

24 Ibid., pp. 12, 16.

25 Jack Lindsay (ed.), *The Sunset Ship: the Poems of J. M. W. Turner* (Scorpion Press, Lowestoft, 1966), p. 99.

26 Butlin and Joll, *Turner*, p. 69.

27 William S. Rodner, 'Turner's *Dudley*: continuity, change and adaptability in the Black Country', *Turner Studies* 8 (1988), pp. 32–40, quotation on p. 32.

28 *A Handbook to the Water Colours, Drawings and Engravings in the Art Treasures Exhibition* (Bradbury & Evans, London, 1857), pp. 15–16.

29 Wolfgang Schivelbusch, *The Railway Journey: Trains and Travel in the 19th Century* (Basil Blackwell, Oxford, 1986), esp. pp. 118–26.

30 John Francis, *A History of the English Railway*, two vols (Longmans, London, 1851), quotations from vol. 2, p. 245, vol. 1, pp. 217, 220. Turner's shareholding in the Great Western is mentioned in Eric Shanes, *Turner: the Masterworks* (Studio Editions, London, 1990), p. 126.

31 George Revill, *Paternalism, Community and Corporate Culture: a Study of the Derby Headquarters of the Midland Railway Company and its Workforce 1840–1900* (unpublished Ph.D. thesis, Loughborough University of Technology, 1989), pp. 82–98.

32 Francis, *History of the English Railway*, vol. 2, p. 139.

33 Ibid., vol. 1, p. 213; John Pudsey, *Brunel and his World* (Thames & Hudson, London, 1974), quotation from *Bristol Mirror* on p. 81; Derrick Beckett, *Brunel's Britain* (David & Charles, Newton Abbot, 1980).

34 The points in this paragraph are expanded and fully illustrated in Stephen Daniels, 'Images of the railway in nineteenth century paintings and prints' in Castle Museum Nottingham, *Trainspotting: Images of the Railway in Art* (Castle Museum, Nottingham, 1985), pp. 5–9.

35 My argument about *Rain, Steam and Speed* mediates the optimistic view of the picture in John Gage, *Turner: Rain, Steam and Speed* (Allen Lane, London, 1972) and the pessimistic view in John McCoubrey, 'Time's railway: Turner and the Great Western', *Turner Studies* (6) (1986), pp. 33–7.

36 Francis, *History of the English Railway*, vol. 1, p. 222.

37 As McCoubrey argues in 'Time's railway'.

38 There is something bizarre, even comic about this image, perhaps influenced by contemporary cartoonists. See Lionel Lambourne, 'Railways in caricature and illustration', in Castle Museum, Nottingham, *Trainspotting*, pp. 37–41.

39 McCoubrey, 'Time's railway', pp. 38–9.

40 Lindsay, *The Sunset Ship*, pp. 91–2.

41 Butlin and Joll, *Turner*, pp. 229–31, quotation on p. 230. Louis Hawes, 'Turner's *Fighting Temeraire*', *Art Quarterly* 35 (1972), pp. 23–48.

42 Michael Serres, 'Turner translates Carnot', *Block* 6 (1982), pp. 23–48.

43 Katherine Solender, *Dreadful Fire! Burnings of the Houses of Parliament* (Cleveland Museum of Art in association with Indiana University Press, Bloomington, Ind., 1984); Gage, *Turner*, p. 233.

44 Solender, *Dreadful Fire!*, pp. 39–40.

45 Malcolm Warner, *The Image of London: Views of Travellers and Emigres 1550–1920* (Barbican Art Gallery in Association with Trefoil, London, 1987), p. 33.

46 Lindsay, *The Sunset Ship*, p. 99.

47 Lindsay, *Turner*, pp. 73–93.

48 Butlin and Joll, *Turner*, p. 251.

49 Parallels between the perceptual register of *Rain, Steam and Speed* and that of the Crystal Palace are suggested in Schivelbusch, *The Railway Journey*, pp. 50–6. It would be worth exploring the symbolic parallels on the issue of modernity and empire. In the last year of his life Turner keenly observed the progress of the building of the Crystal Palace, especially the chromatic south transept, contemporary descriptions of which recall late Turner paintings, especially *Rain, Steam and Speed*. See Wilton, *Turner and his Times*, p. 238. After *Rain, Steam and Speed*, the railway passed out of nineteenth-century English landscape art. On this see Gage, *Rain, Steam and Speed*, pp. 65–76.

50 Lindsay, *Turner*, p. 157.

51 Ibid., pp. 163–8.

52 Quoted in Hill, *In Turner's Footsteps*, p.13.

53 Gage, *Turner*, pp. 5–6; Dinah Birch, *Ruskin on Turner* (Cassell, London, 1990).

54 Quoted in Lindsay, *Turner*, p. 159.

55 Gage, *Turner*, pp. 8–17.

56 Tate Gallery, *The Clore Gallery* (Tate Gallery, London, 1987), pp. 1–38.
57 Ibid., p. 57.
58 Ibid., p. 57.
59 Richard Cork, 'Showing too much respect', *The Listener*, 9 April 1987.
60 See Cuttings File on Clore Gallery, Tate Gallery Archives.
61 Paul Barker, 'Taken by the Clore', *London Evening Standard*, 23 July 1987.
62 Al Weil, 'Turner round', *New Statesman*, 10 April 1987, p. 36; *Independent*, 3 April 1987.
63 Patrick Wright, *A Journey Through Ruins: the Last Days of London* (London, Radius, 1991), pp. 159–60.
64 Dymphna Byrne, 'The Holy Grail of Docklands', *Independent*, 9 February 1991.

5

Thomas Cole and the Course of Empire

———————⊲•◉•⊳———————

HISTORY ALONG THE HUDSON

The Hudson River flows 300 miles from its headwaters in the Adirondack Mountains to the Bay of New York. From the 1820s it was nothing less than a national duty for Americans to admire the river and its scenery and to show it off to visiting Europeans. Several times a day steamboats, emblazoned with patriotic motifs, left New York to make the twelve-hour, 150-mile, trip up the broad tidal waters to Albany. Barges plied a further 50 miles through locks to Glens Falls. Hardier tourists could trek or canoe further on the river's headwaters. The Hudson Valley was a cultural declaration of independence. In scenic grandeur and commercial power (Figure 1), the Hudson Valley surpassed European river valleys with nationalist associations, over-shadowing those of the Thames and Seine, even that of the Rhine. And it had a history to match.[1]

The Hudson Valley had long been a leading avenue for developing the interior and with its tributary areas was an important economic region, notably in its lower reaches producing wheat. From the 1820s there was a marked quickening of its commercial power and a steep rise in its nationalist register. This was prompted by the development and, in 1825, the official opening of the 363-mile Erie Canal from Albany to the Great Lakes. The Hudson Valley was now seen to be more firmly aligned to an epic, imperial trajectory of national development. As the locus of wheat production shifted west, so the Hudson Valley was mobilized as a more diversified and evidently industrialized region. Iron

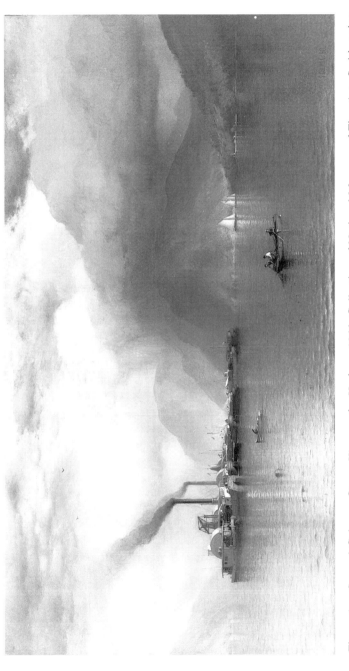

Figure 1 Samuel Colman, *Storm King on the Hudson*, 1866. Collection of National Museum of Fine Art, Smithsonian Institution, Washington DC, Gift of John Gellatly

Figure 2 William Guy Wall, *Glens Falls*, 1820–5, from *The Hudson River Portfolio*. Private Collection

from the Adirondacks and leather from the Catskills were shipped west along the Erie Canal or south to New York. Smoking steamboats linked flourishing shoreline towns. The great mills at Glens Falls (Figure 2) sawed logs, carded wool, spun cotton, crushed limestone, and drove the trip-hammers to make a variety of iron goods from nails to scythes.

Flourishing sites of trade and manufacture along the Hudson, in often spectacular settings, helped to activate a linear, forward-looking pageant of national history. The pageant was also plotted backwards, through sites of the Revolutionary War, Dutch colonization and Indian legend, further still to the primordial wilderness. There was room for such ancient associations in undeveloped areas, or in areas which seemed so. But they were found also in evidently industrialized sites, sometimes with expressions of regret about developments which had overridden them, sometimes not. Various mixtures of nostalgic or progressive sentiment, in varying degrees of harmony, could be incorporated in the course of history which was charted along the Hudson Valley. Its destiny was a matter of dispute. Did these scenes offer a vision of sustained national development, or did some foreshadow the collapse which had afflicted empires in the Old World?[2]

In 1825 Thomas Cole (1801–48) made his first sketching trip up the Hudson. The resulting paintings were a brilliant success in New York and helped to promote Cole's reputation as a distinctively American artist. Cole was taken up enthusiastically by a New York cultural establishment preoccupied with the issue of national landscape and history. Throughout his career Cole explored this issue in a variety of works, in pictures from allegorical scenes to topographical views, in writing from essays to verse. In this chapter I will consider Cole's negotiations of a national style for American scenery. I will focus on two of Cole's paintings of Catskill Greek, a tributary of the Hudson River, paintings in which local and national issues of landscape and history are intertwined.

EUROPE AND AMERICA

In 1818, aged 17, Thomas Cole emigrated, with his parents and siblings, from England to the United States, arriving in Philadelphia. His father's woollen manufacturing business in Lancashire had failed and over the next six years Cole accompanied his father's attempts to make a success of manufacturing, first in Philadelphia, then in Pittsburgh, then in Steuben, Ohio. Cole had trained as a calico designer in England and in America did a variety of jobbing and often itinerant graphic work, including art teaching, wood engraving, textile designing, portraiture, scene painting for theatres and genre scenes for bars and barber shops. Cole's early, nationalist, biographers made much of his early life, smoothing the movements of his family into a linear westward progression, and emphasizing Cole's youthful self-reliance.[3]

Cole's enthusiasm for fine art was shaped by his study of pictures at the Pennsylvania Academy of Art. The Academy was then in the forefront of debates about a national style for American landscape painting. These pivoted on an issue which was to preoccupy Cole. How, and to what extent, should painters of American scenes deploy European conventions of style and subject matter? Or, to put it more exactly, was it possible to raise the dignity of local, topographical traditions of view painting, with their clear delineations of vernacular enterprise, without compromising their national character?[4] Cole's only surviving landscape painting from this period (Figure 3) shows him wrestling with the issue. To the right of the picture is a pastoral, park-like scene, with grazing cattle and a man resting with a dog. To the left is a vigorous working scene, an axeman with a cut stump, and below him in the gorge

Figure 3 Thomas Cole, *Landscape with Figures and a Mill*, 1825. The Minneapolis Institute of Arts. Bequest of Mrs Kate Dunwoody

of a rushing creek a saw-mill, with a churning mill-wheel and smoking chimney.[5] The axeman, cut stump and mill were established icons of American enterprise and can be found in many named, recognizable views of localities.[6] But in Cole's picture, titled generally *Landscape with Figures and a Mill*, they are placed awkwardly in a landscape somewhat reminiscent of parts of western Pennsylvania, but largely organized in terms of rules of picturesque composition developed by English connoisseurs.

When Cole moved to New York in 1825 authors like Washington Irving, William Cullen Bryant and James Fenimore Cooper were developing distinctively American epic historical themes and narratives. Landscape was integral to their work, not just as a setting for events but as a vehicle to articulate social and moral issues.[7] Late in 1825 an Address to the American Academy of Art in the city called upon landscape painters to 'adorn houses with American prospects': 'the Genius of your country points you to its stupendous cataracts, its highlands intersected with the majestic river, its ranging mountains, its softer and enchanting scenery'. The exemplars for American landscape painters were to be European Old Masters: 'let the new Titian touch his pencil on the Catskill Mount; or let him, another Claude Lorrain, look upon its laughing scenes of plenty' or if 'his half-savage spirit like Salvator Rosa's' delighted in savage scenes there were abundant cascades and deep glens, where he might plant not Italian *banditti* lurking in caverns but 'the brown Indian, with featured crest and bloody tomahawk, the picturesque and native offspring of the wilderness'.[8]

There was, as Alan Wallach has described, a distinctly aristocratic strain to the nationalist culture of New York's cultural élite. While many benefited materially from the economic boom of the mid-1820s they distanced themselves from its more vulgar, explicitly modern, manifestations. Their federalist code of property and privilege had lost much of its party-political force, but it still retained considerable cultural power as a conservative criticism of rougher Jacksonian democracy, as an affirmation of republican virtue against the prospect of populist disorder. Landscape painting, in approved Old Master styles, was part of this culture's armoury, offering a repertoire of images of social order and refinement. Most of Cole's early patrons were drawn from this federalist culture. Its members were largely bankers, lawyers and merchants, most of whom owned rural villas, but its aristocratic image was conferred by those members who were great landowners in upstate New York, descendants of Dutch *patroons* or of patricians of English pedigree. While Cole's patrons wished for elegiac scenes, and often

couched their landscape preferences in the language of European painting, they distrusted anything which reeked of Old World decadence. They demanded realistic scenes which were freshly, energetically, American. Cole responded with Rosa-like compositions of sublime grandeur, of steep gorges and plunging waterfalls. Stripped of the industrial and tourist apparatus which then surrounded the site, Cole's *Falls of Kaaterskill* (1826) (Figure 4) appears almost untouched, witnessed by a solitary Indian at its edge.[9]

After a sojourn in Europe from 1829–1832, Cole's style shifted. In England he was impressed by the cultivated, garden-like look of the southern countryside, but disappointed by the messiness of English landscape painting. To Cole's conservative eye this painting seemed to sacrifice subject to style, 'design' to 'dazzling display'; it was 'full of sound and fury signifying nothing'. He may have had in mind Constable's pictures of the time; certainly he was thinking of Turner's. 'Considered separately from the subject, they are splendid combinations of colour', Cole declared, 'but they are destitute of all appearance of solidity: all appears transparent and soft'. Cole admired Turner's earlier paintings of the building and ruin of Carthage. This is because they were explicitly modelled on the highly designed, explicitly subject-centred compositions of Claude Lorrain.[10]

Upon his move to France and Italy, Cole, like scores of English artists and connoisseurs before him, fell under Claude's spell. In contrast to the compressed, turbulent landscapes of Salvatore Rosa, which had conditioned Cole's early style, Claude's serene, stretching, sunlit landscapes provided an image of beneficient order. Their setting of historical or mythological scenes in panoramic compositions offered a model for Cole's artistic ambitions. 'He had now reached an elevation in the great ascent', wrote his friend and biographer Louis Noble, 'from which he could survey both man and the visible world in vast, moral perspective'.[11]

Claude's influence on Cole, upon his return to the United States, is evident in *The Oxbow* (1836) (Figure 5). This is a view from Mount Holyoke of the oxbow bend in the Connecticut River. The left side of the picture is a Rosa-like image of tangled wood and blasted trees under a stormy sky. The right side is a sunlit Claudian panorama.[12] There are no scenes from classical antiquity here, rather the vernacular world of the Connecticut River Valley, its gleaming meadows, orchards, fields, farmhouses, villages and churches. The scene is no less mythological than those of classical antiquity. In contrast to the bustling Hudson

Figure 4 Thomas Cole, *Falls of Kaaterskill*, 1826. The Warner Collection of Gulf States Paper Corporation, Tuscaloosa, Alabama

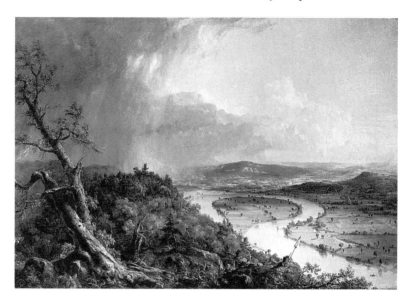

Figure 5 Thomas Cole, *The Oxbow, or View from Mount Holyoke,*
 Northampton, Massachusetts, after a thunderstorm, 1836.
 Metropolitan Museum of Art, New York City. Gift of Mrs
 Russell Sage

Valley further west the Connecticut Valley was esteemed as a slower-
rhythmed, more settled, comely landscape. Timothy Dwight observed

> The towns in the [Connecticut] valley are not like those along the Hudson,
> mere collections of houses and stores clustered around a landing, where
> nothing but mercantile business is done; where the inhabitants appear to
> form no connection to habits besides those which naturally grow out of
> bargains and sales.[13]

Writing to her grandfather Thomas Jefferson in 1825, of the view from
Mount Holyoke, Ellen Randolph Coolidge described the scene as 'one
vast garden divided into parterres':

> The windings of the Connecticut are everywhere marked, not only by its
> clear and bright waters, but by the richness and beauty of the fields and
> meadows, and the density of population along its banks. The villages
> themselves have an air of neatness and comfort that is delightful. The
> houses have no architectural pretensions, but they are almost all painted

white ... and the Churches with their white steeples, add not a little to the beauty of the landscape.[14]

The brightness, and especially the highlights of whiteness insisted upon here, were seen to mark the scene as patently American. 'Along with a new flag, new currency, and a new ordering of land, white lead paint announced a new country and a new political philosophy grounded in liberalism', notes John Stilgoe. It underlined 'the meaning of every farmhouse to the national policy'.[15] So while Cole used Claudian devices to organize the 'moral perspective' of the Connecticut River Valley, he was careful not to overburden it with associations of the Old World, and careful to explicate associations of the New.[16]

Cole did not neglect the Hudson Valley. In 1835 he made 'an excursion in search of the Picturesque on the Headwaters of the Hudson'. This was in response to a commission from the English publisher of Turner's *Picturesque Views in England and Wales* for 'a series of views of the noble Hudson, which are to be engraved by the most eminent English artists'. The engravings were never done (the publisher's bankruptcy put an end to the project) but Cole's sketches show the commission's concern to display the commercial activity of the river, its steamboats, sloops, docks and warehouses. Cole also sketched the region's industrial activity, including iron works in the Adirondacks and tanneries in the Catskills, along with the forest clearance which fuelled them.[17]

AMERICAN SCENERY

Cole set out in writing his views of national landscape and history in his *Essay on American Scenery*, first published in 1836 when he presented it as an Address to the New York Lyceum.[18]

Following the English theorist of the Picturesque, Uvedale Price, Cole singled out trees and water as the key components of landscape.[19] But the very amplitude of American waters and forests needed a more powerful American version of the Picturesque to comprehend them. This version was not a radical departure from the original; indeed Cole implies that only in America was the Picturesque fully realized.

'For variety, the American forest is unrivalled', declared Cole, 'in some districts are found oaks, elms, birches, beeches, planes, pines, hemlocks, and many other kinds of trees commingled'. In autumn 'the American forest surpasses all the world in gorgeousness ... the artist

looks despairingly upon the glowing landscape, and in the old world his truest imitations of the American forest, at this season, are called falsely bright, and scenes in Fairy Land'. Cole singled out certain species: the elm, like its European counterpart a 'paragon of beauty and shade', and the peculiarly American hemlock, 'the sublime of trees, which rises from the gloom of the forest like a dark and ivy mantled tower'. And he remarked on the social character of trees: settled and uniform in 'sheltered spots, or under the influence of culture', but in 'exposed situations, wild and uncultivated', exhibiting an heroic, pioneer version of the Picturesque, 'battling with the elements and with one another for the possession of a morsel of soil ... they exhibit striking peculiarities and sometimes grand originality'.[20]

America had water in abundance, and in striking formations, from vast lakes, to majestic rivers to stupendous waterfalls. In contemplating a great waterfall like Niagara 'our conceptions expand ... in its volume we conceive immensity; in its course everlasting duration; in its impetuosity, uncontrollable power'. The 'river scenery of the United States' was 'a rich and boundless theme'. That of the Hudson was unrivalled in 'natural magnificence', in legendary associations and in 'an unbounded capacity for improvement' either by 'neat villas' or by 'flourishing towns'. In contrast the Connecticut River offered an agrarian vision. Beginning in 'wild mountains',

> it soon breaks into a luxuriant valley, and flows for more than a hundred miles, sometimes beneath the shadow of wooded hills, sometimes glancing through the green expanse of elm-besprinkled meadows ... its villages are rural places where trees overspread every dwelling, and the fields upon its margin have the richest verdure.[21]

Cole countered those who found a 'grand defect of American scenery' its 'want of associations', 'the gigantic associations of a storied past' that fill a spectator's mind on looking from Mount Albano upon the ruins of ancient Rome. While Cole was proud to uphold the primordial grandeur of American scenery – 'the sublimity of a shoreless ocean un-islanded by the recorded deeds of men' – he found American scenes 'not destitute of historical and legendary associations: the great struggle for freedom has sanctified many a spot, and many a mountain stream and rock has its legend'. But unlike Europe, 'American associations are not so much of the past as of present and the future'.[22]

Cole's landscape of present associations is not scarred or stained by the crimes of history; it has 'no ruined tower to tell of outrage – no gorgeous temple to speak of ostentation; but freedom's off-

spring – peace, security and happiness'. Cole's description of this landscape evokes his view of the Connecticut River Valley in *The Oxbow*:

> Seated on a pleasant knoll, look down into the bosom of that secluded valley, begirt with wooded hills – through those enamelled meadows and wide waving fields of grain, a silver stream winds lingeringly along – here, seeking the green shade of trees – there glancing in the sunshine: on its banks are rural dwellings shaded by elms and garlanded by flowers – from yonder dark mass of foliage the village spire beams like a star.[23]

The landscape of future associations offers a mixed promise. One aspect is an extension of the settled valley described in the passage above; another is more energetic, even showing the signs of potential despotism (temple and tower) the valley is spared:

> And in looking over the yet uncultivated scene, the mind's eye may see far into futurity. Where the wolf roams, the plough shall glisten; on the grey crag shall rise temple and tower – mighty deeds shall be done in the now pathless wilderness; and poets yet unborn shall sanctify the soil.[24]

Cole makes explicit his ambivalence about the prospect of development in the next paragraph of the *Essay*. It was his original intention to 'attempt a description of several districts remarkable for their picturesqueness and truly American character' but he goes on to

> express my sorrow that the beauties of such landscapes are quickly fading away – the ravages of the axe are daily increasing – the most noble scenes are made desolate, and often with a wantonness and barbarism scarcely credible in a civilized nation. The wayside is becoming shadeless, and another generation will behold spots, now rife with beauty, desecrated by what is called improvement.

This is an improvement of 'meagre utilitarianism', which Cole likens to a railroad: 'its march makes us fear that the bright and tender flowers of the imagination shall all be crushed beneath its iron tramp'. But for Cole, 'This is a regret rather than a complaint; such is the road society has to travel'.[25]

In the *Essay* Cole is caught between two conceptions of American destiny: a millennialist belief in a unique, progressive, increasingly democratic future for the nation and a more pessimistic, cyclical conception of the rise and fall of civilizations to which America would be subject, no less than was Europe. The tension is clear in the

paragraph comparing the Rhine and Hudson Valleys. Here Cole begins by making the landscape of the Hudson a radical departure from that of the Rhine, but ends by forecasting the building of the towers and temples that both express the climax and spell the ruin of its culture:

> The Rhine has its castled crags, its vine-clad hills, and ancient villages; the Hudson has its wooded mountains, its rugged precipices, its green undulating shores – natural majesty, and an unbounded capacity for improvement by art. Its shores are not besprinkled with venerated ruins, or the palaces of princes; but there are flourishing towns, and neat villages, and the hand of taste has already been at work. Without any great stretch of the imagination we may anticipate the time when the ample waters shall reflect temple, and tower, and dome, in every variety of picturesqueness and magnificence.[26]

THE COURSE OF EMPIRE

According to the cyclical theory of civilization, wealth gives rise to avarice, while political liberty leads to overbearing ambition. Corruption sets in and civilization collapses. Centuries pass and new civilizations arise to begin the cycle over again. Cole spelled out the theory in *The Course of Empire*, a series of five paintings completed a year after his *Essay on American Scenery*. Each painting shows a stage in the cycle set in the same valley in classical antiquity: *The Savage State*; *The Arcadian or Pastoral State*; *The Consummation of Empire*; *Destruction*; *Desolation*. Cole knew Turner's Carthaginian pictures on the same theme and the motto for his own is a quotation from Byron's *Childe Harold*: 'First Freedom, and then Glory; when that fails, wealth, vice, corruption'. Like Turner and Byron, Cole meant his series to have a contemporary resonance. *The Course of Empire* is, in Wallach's words 'an imaginative paradigm of American history'.[27]

Cole's title is perhaps taken from Bishop Berkeley's famous phrase 'Westward the course or empire takes its way', fast becoming a catchphrase of American expansionist ideology. While many of the motifs in the series are sampled from European painting, prints, books and sculpture, a few are patently American, for example in *The Pastoral State* (Figure 6), a cut stump, the conventional sign of frontier enterprise. In his commentary on the paintings, Cole singles out American allusions. In *Consummation* (Figure 7) Cole depicted in his words 'a magnificent city', an architectural mixture of various classical cities, but

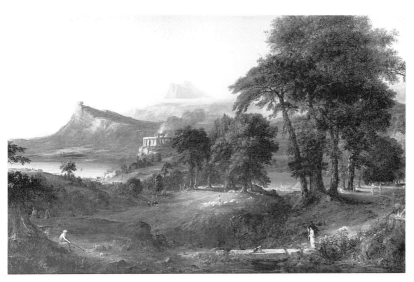

Figure 6 Thomas Cole, *The Course of Empire: The Arcadian or Pastoral State*, 1836, Courtesy of The New York Historical Society, New York City

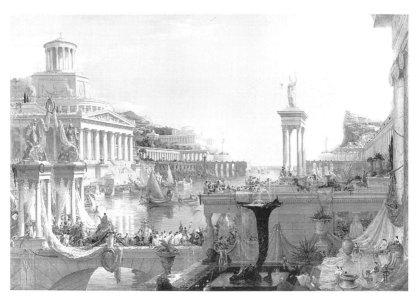

Figure 7 Thomas Cole, *The Course of Empire: Consummation*, 1836. Courtesy of The New York Historical Society, New York City

one which was 'a la mode N. York'. The scene shows a busy harbour around which 'piles of architecture ascend – temples, colonnades and domes'. Signs of corruption are evident not only in the conspicuous wealth and luxury but in its vast crowds hailing the triumphant return of a popular hero. Wallach suggests this may be 'Jackson in antique garb' and the scene suggestive of what all conservatives feared, 'democracy sliding into demagogy and mob rule'.[28]

In upholding the spectacle of classical history for American eyes, Cole seemed to challenge those who believed in unlimited, upward progress. But some critics found their progressive views endorsed. The *New York Mirror* had recognized *The Savage State* and *The Pastoral State* as 'truly American scenes' but resisted any implication that *Consummation* was a projection of American destiny:

> The climax of the course of man's progress, which Mr Cole has here represented is *that* which *has been*, and was founded on the usurpation of the strong over the weak: the perfection which man is hereafter to attain, will be based upon a more stable foundation: political equality; the rights of man; the democratick principle; the *sovereignty of the people*.[29]

The Course of Empire was a popular success if some misunderstood, or chose to misrepresent, its message. The series was sympathetically received by the *patroons* of the federalist élite. Cole was commissioned by William P. Van Rennsselaer and Peter G. Stuyvesant to paint narratives on the same theme. But Cole received no initial patronage for *The Course of Empire* from the ranks of the establishment whose ideology it seemed to articulate.[30]

The federalists had maintained their power as an establishment by being flexible in the face of changing circumstances. If initially they saw industrialism as a threat, the prospect of making enormous financial dividends from manufacturing from the later 1820s made them rather less sympathetic then they had been to a pessimistic view of American development. Cole eventually found a patron in a less established figure, Luman Reed, a wholesale grocery merchant who had risen from the position of a store clerk and who chose art collecting as his entrée to polite society. The trajectory of Reed's career parallel's Cole's own, and Reed's frequent letters to Cole are full of a 'sort of closeness and bonhomie [which] would have been unimaginable in Cole's more aristocratic patrons'. The commission for *The Course of Empire* was 'a minor tragedy', one in which, comments Wallach, 'ideology takes its usual revenge', 'for what else are we to say of a situation in which a self-made merchant paid a small fortune to a self-taught artist for

paintings that elaborately mourn the passing of an aristocracy to which both merchant and artist aspired and to which neither could ever belong'.[31]

ON CATSKILL CREEK

In 1835 Cole was commissioned by Luman Reed's business partner Jonathan Sturges to paint a pastoral view of the valley of Catskill Creek, entitled *View on the Catskill, Early Autumn* (Figure 8), a picture he completed in 1837. Five years later he painted the site again, in a picture entitled *River in the Catskills* (Figure 9), but now showing signs of improvement, including felled forest, farmland and a railroad. I will now compare their iconographies.[32]

The valley of Catskill Creek joins that of the Hudson River at the Port of Catskill about forty miles south of Albany. In Cole's time it was an area richly associated with memories of the Mohawk Indians and the dynasties of Dutch *patroons*. Cole had helped to bring its scenic beauty to public attention. After spending each summer here, Cole moved permanently from New York in 1836. But the time proved a troubling one. Cole was depressed by his lack of progress on *The Course of Empire*. The death of Luman Reed in early June deepened his despondency; two months later he confided to his disciple Asher Durand that 'the dark view of things is the true one'. The recent 'ravages of the axe' in Cole's own neighbourhood had done much to discompose him. In March 1836 he had told Reed of how 'The copper hearted barbarians are cutting *all* the *trees* down in the beautiful valley on which I have looked so often with a loving eye. This throws quite a gloom over my spring anticipations'.

The trees were being felled to clear a path for a portentous sign of 'improvement', the Canajoharie & Catskill Railroad. As Kenneth Maddox has discovered, this railroad was to be used principally for hauling freight to local tanneries whose owners had for twenty years been clearing the hillsides of hemlock trees to use their bark for tanning leather. By the time Cole settled in Catskill the town was shipping a quarter-million sides of shoe leather and three million feet of lumber. But enterprising local interests saw the new railroad as a means of releasing still more commercial power. The Catskill Association, formed with the declared purpose of 'improving the town of Catskill', envisioned that it would turn the town (then numbering three thousand citizens) into a great centre of inland trade, and they eagerly began to

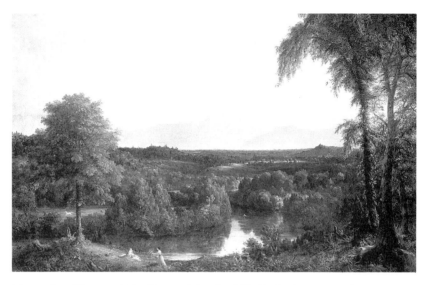

Figure 8 Thomas Cole, *View of the Catskill, Early Autumn*, 1837.
Metropolitan Museum of Art, New York City. Gift in memory of
Jonathan Sturges by his children, 1895

Figure 9 Thomas Cole, *River in the Catskills*, 1843. Museum of Fine Arts,
Boston. Gift of Mrs Maxim Karolik for the Karolik collection of
American paintings, 1815–65

speculate in real estate. Cole was later to recall the tree clearance for the Railroad 'in one year more fatal than the rest' because it removed landmarks with ancient associations, 'that noble grove by Van Vechten's mill ... the ancient grove of cedar, that shadowed the Indian burying-ground'. In his commission for Sturges, Cole wanted to commemorate his valley before it had been desecrated. His client assented: 'I shall be happy to possess a picture showing what the Valley of Catskill was before the art of "modern improvement" found a footing there'. Cole started on the painting late in 1836. His mood had lightened. He had recently completed *The Course of Empire* and also happily married. These were, according to his biographer, the 'golden months' of his life.[33]

View on the Catskill is Cole at his most Claudian. The sun is setting low in the west casting a golden light across the valley. The landscape is heavily but softly wooded, the trees touched with autumn colour. The two trees in the foreground are additions to the view in Cole's sketch of the site, the feathery, framing tree on the right a direct transplant from Claude. Below the tree on the left a mother brings a bouquet of wild flowers to her baby. Below the right-hand tree, approaching a gate, the father returns to his family after hunting, a gun over his shoulder. This domestic scene is completed by a house in the middle distance, embosomed in trees, its chimney smoking gently. The hunter wears the same tall, wide-brimmed hat donned by the figure of the artist on Mount Holyoke in *The Oxbow*. Some have suggested that the domestic scene is a projection of Cole's new marriage; but there are powerful historical currents running through it too.[34]

Although by his dress and demeanour the hunter appears a modern, middle-class figure out for an afternoon's sport, he has a pedigree in contemporary images of America's heroic trailblazer, Daniel Boone. Boone was mythologized as both an empire builder and as a fugitive from civilization, a moral contrast to the character 'induced by the spirit of trade and political ambition'.[35] In portraits Boone is conventionally posed with his rifle next to a felled tree which appears, as a cut stump, on the opposite side of Cole's picture, next to the left-hand tree.[36]

The family may be seen as a genteel version of the pioneer household, the subject of some of Cole's later paintings, but the classical draperies of the mother suggest another cross-reference with the family in *The Pastoral State* (Figure 6) from *The Course of Empire*. Here in the foreground a warrior holding a spear returns to his wife and child. On the other side of the grove of trees is a newly cut stump. There is then nothing languidly timeless about *The Pastoral State*. In his published description of the painting, Cole wrote that it showed 'how the gradual

advance of society has wrought a change in the *Savage State's* aspect'. The 'untracked and rude' has been tamed and softened. 'Shepherds are tending their flocks; the ploughman with his oxen, is upturning the soil, and commerce begins to stretch her wings'. In the painting we see settlement growing by the shore, a ship being built on stocks and sailboats in the bay. Fire, which will destroy the city that has grown here in *Destruction*, is being used purposefully in shipbuilding, if also ominously in what Cole calls 'the smoke of sacrifice' in a Stonehenge-like temple.[37] In the middle distance of *View on the Catskill*, beneath the crag of Kaaterskill High Peak, is an ominous modern sign of fire, the plume of smoke from the town of Palenville, the centre of the local tanning industry. In this scene of modern pastoral, as in that of the ancient, there signs of its historical transmutation.

As it actually turned out in the valley of Catskill Creek, the railroad and the ambitions of its promoters proved short-lived. Floods severely damaged the line and the locomotive never functioned properly. In the financial panic of 1837 land values collapsed and many speculators of the Catskill Association suffered heavy financial losses. It was reported that a group of Albany businessmen still feared the railroad might still secure for Catskill the regional dominance its promoters envisioned and so they purchased the Railroad's stock and allowed the enterprise to fail. In 1842 the rails were torn up.[38]

A year later Cole again painted the valley of Catskill Creek, from a slightly different vantage point compared with the view of 1837. While he had studiously omitted any signs of a railroad in the earlier view when it was built, now, when it was dismantled, he made a point of showing it. It crosses the creek in the middle distance, a smoke spewing locomotive on a bridge pulling a train of freight cars. It is an image which expresses more the aspirations of the Railroad's promoters than the realities of its fitful operation.

In *River in the Catskills* the valley has been denuded of much of the woodland in the earlier view. The Claudian tree on the right has been uprooted, that on the left has been felled, leaving its stump and its trunk cut into logs. The genteel family has been erased, replaced by the sturdier and more homespun figure of an axeman, the flagon of drink by the tree suggestive of the sweat on his brow. Having felled the tree, he surveys the valley. Compared with the earlier view, it is a brighter, fresher, clearer scene. Everywhere there is evidence of improvement of all kinds in all stages. On the far right is a newly reclaimed field with cattle, tree stumps still dotting the ground. The meadow on the left, now flooded with light, is more organized and park-like than formerly. The

railway bridge and locomotive now balance the house as an eyecatcher in the middle distance and would have overpowered it had not tree clearance revealed the dwelling, not as a sweet cottage, but substantial farmhouse, as plain and sturdy as the axeman, the focus, perhaps, of his gaze. Buildings have multiplied along the line of the railroad; the ones near the house look like farm buildings, the one nearer the creek is industrial, perhaps a tannery. In the distance the smoke plume of Palenville is more conspicuous, complementing the smoke of the locomotive.

The structures of the two views differ. In the earlier one the picture space is compressed by the two foreground trees and the spectator's eye funnelled into the distance along a serpentine band of light that recedes from the left-hand tree across the creek, past the house and along a gentle ridge of land beyond. In the later view the picture space is flatter and more horizontal, and movement more lateral. The strongest line is along the railroad and continued in a band of light illuminating the buildings and a sharp ridge to their right. The realignment of the view pivots on the rowing boat. Where before it drifted lazily into the picture, it now is pulled vigorously across it in the direction of the train. Everywhere in *River in the Catskills* energy is, or has been, deployed more powerfully, more efficiently and more productively.

In retrospect *View on the Catskill* seems overburdened with trees and foliage. No feature of improvement which appears in the later view – not the railroad, nor the buildings or the fields – has, from its position in the picture, been newly developed. All could have been in place in the earlier view but obscured by woods. It is as if thinning the trees has released the latent power and meaning of the landscape. This was an axiom of English picturesque theory, and Cole has raised its register for American scenery. If Uvedale Price saw the figure of a picturesque improver as a gentleman roaming his estate lopping boughs with a hacker to 'release the pictures in every tangled wood and thicket',[39] Cole has elided the figure of the artist with that of the axeman felling whole stands of trees and with them, perhaps, the burden of European associations. What are revealed are elements of that vernacular tradition of prospective views (Figure 10) which detail the commercial expansion of localities.[40] Cole has deployed some of the conventions of this tradition, notably in organizing the picture around a bifocal nucleus, uniting agrarian and industrial interests, and in depicting successive zones of farmland, cut-over land and virgin forest.

What are we to make of the relation between Cole's two paintings of Catskill Creek. Is the axeman in *River in the Catskills*, like the stock

Figure 10 Francis Alexander (attrib.), *Globe Village*, c. 1822. Jacob Edwards Memorial Library, Southbridge, Massachusetts

Romantic figure of the sage contemplating the ruins of ancient cities, surveying the ruin of civilization? Or, is he, like the Indians in Cole's early pictures (and whom he follows in frontier versions of American history), witnessing the prospect of his own displacement? In his case by the more advanced forces for which he has cleared a way.

In an essay of 1844 on *Sicilian Scenery and Antiquities* Cole reflected on the collapse of the Canajoharie & Catskill Railroad when contrasting the enduring 'marble piles' built by the Greeks and 'those broken bubbles on which the hopes and fortunes of many of us were suspended'.[41] *River on the Catskills* might then be seen as a record of folly and the landscape a more fragile one than I have suggested. And Cole's style might then appear to parody those vernacular artists who cheerfully endorsed expansionist views. If, by implication, we find Cole's true commitment to the place expressed in the earlier, more domestic *View of the Catskill*, we may use a passage on Cole's *Essay on American Scenery* to gloss a comparison between the mother giving flowers to her baby and the trajectory of the train. In the *Essay* Cole declares that 'in this age when ... what is sometimes called improvement in its march makes us fear that the bright and tender flowers of the imagination, shall all be crushed beneath its iron tramp, it would be well to cultivate the oasis that yet remains to us, and thus preserve the germs of a future and purer system'.[42]

Is this 'future and purer' system in fact realized in the *later* picture? When, in a journal entry of 1836, Cole complained about the felling of trees for the railroad in the valley, it was because they stripped the soil, destroying the agricultural potential of the land, leaving 'herbless rocks to glimmer in the burning sun' – a landscape of mineral sterility reflected in the character of the railroad's promoters, 'copper hearted', suffering from 'barrenness of mind [and] sterile desolation of the soul'.[43] But there are no herbless rocks in *River in the Catskills*; it is a lushly fertile scene. When in 1841 Cole again delivered his *Essay on American Scenery*, this time before the Catskill Lyceum, he added some local remarks to the effect that while the beauty of the banks of the Catskill had been 'shorn away' this was not a necessary accompaniment of the building of railroads. Despite their appalling record in this beauty spot he was hopeful that railroads as an institution 'might even contribute to [nature's] charms by rendering her more accessible'.[44]

RAILROADS AND LANDSCAPE

As the railroad network spread through the north-eastern states, so it played an increasingly prominent role in formulations of American landscape and history.[45] This is evident in a book of engravings and essays dedicated to Cole's memory, and destined for the parlours of polite society, *The Home Book of the Picturesque* published in 1852.[46] In his essay *American and European Scenery Compared*, James Fenimore Cooper set out the conservative case. He considered that 'the lovers of the Picturesque sustain a great loss by means of the numerous lines of railroads that have recently come into existence'. Railroads were an instrument of 'the utilitarian spirit of the day' which, in both a social and topographical sense, 'labours to erase every inequality' from the landscape. Because of 'the necessity of preserving levels, and avoiding the more valuable portions of country, in order to diminish expense ... villages and towns are no longer entered by their finest passages ... the traveller is apt to find his view limited by ranges of sheds, out-houses, and other deformities of that nature'. The experience of rail travel erased those picturesque scenes the train passed through.

> The graceful winding curvatures of the old highways, the acclivities and declivities, the copses, meadows and woods, the half-hidden church, nestling among the leaves of its elms and pines, the neat and secluded hamlet, the farm-house, with all its comforts and sober arrangements, so disposed as to greet the eye of the passenger, will long be hopelessly looked for by him who flies through these scenes, which, like a picture placed in a false light, no longer reflects the genius and skill of the artist.[47]

But Cooper exonerated the whole of the Hudson River Railroad. This did not overpower the great valley but shared in the 'sublimity and grace' through which it passed. And he exempted parts of the Erie Railroad too.[48]

In his essay on the Erie Railroad Bayard Taylor put the progressive case. He was confident that 'with rapid progress and wider development of the great locomotive triumphs of the age, steam travel and steam navigation, the vulgar lament over their introduction is beginning to disappear'. The railroad offered views which surpassed the cramped conventions of European landscape painting, 'a rapidly unrolling panorama of such rural beauty as would have bewildered old Cuyp and Ruysdael'. Taylor transferred the triumphalist rhetoric of the Erie canal to the Erie Railroad, then the longest line in the world and passing

through difficult terrain: 'its course represents, on a small scale, the crossing of a continent'.[49]

THE HUDSON RIVER SCHOOL

Cole's negotiations of a national style influenced a series of followers who made their living in New York, and who became known collectively as the Hudson River School. Some, like Asher Durand, continued to depict the Hudson Valley, others, notably Albert Bierstadt, ventured further west.[50] After the Civil War, the Hudson River Valley was still frequently portrayed in painting, often with an emphasis on its industrial power, but it began to lose its status as an epitome of the nation and its development. The westward trajectory of national identity, symbolized by the building of the transcontinental railroad, focused on the fresher, more magnificent scenery of the Rocky Mountains and Sierra Nevada. The Hudson Valley itself no longer offered a coherent, comprehensive vision. Signs of over-development on one hand, and abandonment on the other, defeated attempts to create pleasingly progressive or nostalgic perspectives.[51]

Late nineteenth-century shifts in artistic fashion spelled a decline in the esteem for Cole's style as well as his subjects. The name Hudson River School was first applied in 1879 and then unflatteringly. Compared to the French-styled, soft-edged apparently spontaneous type of landscape painting then in vogue, Cole and his followers looked embarrassingly regional and reactionary. The market for the Hudson River School collapsed. By the end of the century even Bierstadt's grand canvases of the Rockies and Sierras, which had commanded enormous prices thirty years before, were sold at knock-down prices, sometimes merely as contents in the sale of the great mansions in which they hung.[52]

For most of the twentieth century the revival of Cole's reputation and that of the Hudson River School has been fitful. It rose appreciably in the Depression years along with a distinctive regionalism in painting and writing, and with a taste for the conservationist implications of the pictures.[53] The cultural insularity of the post-war years and the beginnings of the scholarly search for a distinctively 'American mind' also marked a revival. Wolfgang Born's pioneering book of *American Landscape Painting* (1948) upheld Cole's *The Oxbow* as 'unparalleled in European art', a picture expressing 'the influence of the frontier on the aesthetic attitude of America'.[54]

Only from the 1960s did an interest in the Hudson River School, at once popular, academic and financial, escalate. In the Hudson River Valley itself, the paintings were used as conservationist icons, as a reproach both to the threat of new highway development and to the presence of abandoned piers, garbage dumps and decaying industries.[55] There were efforts, in the words of James Flexner's *The Wilder Image* (1962), to restore the Hudson Valley as 'the resplendent main link of the American geographical chain'.[56] In the fine-art world the disappearance of affordable European Old Masters and Moderns sparked a resurgence of the market for American paintings. Works by Cole and Bierstadt once more commanded enormous prices.[57] And not unconnected with this bullish market was a resurgence in scholarship, in the monographs, dissertations and exhibition catalogues from which I have profited in the preparation of this chapter.

NOTES

1 John K. Howat, *The Hudson River and its Painters* (American Legacy Press, New York, 1972); Raymond O'Brien, *American Sublime: Landscape and Scenery of the Lower Hudson Valley* (Columbia University Press, New York, 1981), pp. 3–31.
2 Walter Creese, *The Crowning of the American Landscape* (Princeton University Press, 1985), pp. 45–98; Kenneth W. Maddox, *In Search of the Picturesque: Nineteenth Century Images of Industry along the Hudson River Valley* (Bard College, New York, 1983), pp. 17–70.
3 Ellwood C. Parry III, 'Thomas Cole's early career: 1818–1829' in Edward Nygren, *Views and Visions: American Landscape before 1830* (Corcoran Gallery of Art, Washington D. C., 1988), pp. 161–86, esp. 161–5.
4 William H. Gerdts, 'American landscape painting: critical judgments, 1730–1845', *American Art Journal* (winter 1985), pp. 28–59, esp. 37–8.
5 Parry III, 'Thomas Cole's early career', pp. 167–8.
6 Nicolai Cikovsky Jr, ' "The Ravages of the Axe": the meaning of the tree stump in 19th century American Art', *Art Bulletin* 61 (1979), pp. 611–26; Jay Cantor, 'The New England landscape of change', *Art in America*, Jan./Feb. 1976, pp. 51–4; John R. Stilgoe, *Common Landscape of America, 1580–1845* (Yale University Press, New Haven, 1982), pp. 300–23.
7 Blake Nevis, *Cooper's Landscapes: an Essay on Picturesque Vision* (University of California Press, Berkeley, 1976); Donald A. Ringe, *The Pictorial Mode: Space and Time in the Art of Bryant, Irving and Cooper* (University of Kentucky Press, Lexington, 1971); Henry Nash Smith, *Virgin Land: The American West as Symbol and Myth* (Vintage Books, New York, 1950), pp. 246–60.

8 Quoted in Howat, *The Hudson River and its Painters*, pp. 34, 35.
9 Alan Wallach, 'Thomas Cole and the aristocracy', *Arts Magazine* 56 (1981), pp. 93–106.
10 Louis Noble, *The Course of Empire, Voyage of Life and other Paintings of Thomas Cole* (Cornish, Lamport and Co., New York, 1853), pp. 110–15; Oswaldo Rodriguez Roque, 'The exaltation of American landscape painting', in Metropolitan Museum of Art, *American Paradise: the World of the Hudson River School* (Metropolitan Museum of Art, New York, 1987), pp. 21–48, quotations on pp. 26, 27.
11 Quoted in Roque, 'The exaltation of American landscape painting', p. 29.
12 Metropolitan Museum of Art, *American Paradise*, pp. 125–9.
13 Quoted in Creese, *The Crowning of the American Landscape*, p. 48.
14 Quoted in ibid., p. 48.
15 Stilgoe, *Common Landscape of America*, p. 167.
16 For earlier Claudian views of the Connecticut River Valley, often in estate paintings, see Graham Clarke, 'Landscape painting and domestic typology of post-revolutionary America', in Mick Gidley and Robert Lawson Peebles (eds), *Views of American Landscapes* (Cambridge University Press, 1989), pp. 146–66, esp. 153–63.
17 Maddox, *In Search of the Picturesque*, pp. 27–8.
18 Thomas Cole, 'Essay on American scenery', in John Conron (ed.), *The American Landscape: a Critical Anthology of Prose and Poetry* (Oxford University Press, New York, 1973), pp. 568–78.
19 Uvedale Price, *Essay on the Picturesque*, published in three editions in 1794, 1796–8 and 1810. On Price see Stephen Daniels, 'The political iconography of woodland in later Georgian England' in Denis Cosgrove and Stephen Daniels (eds), *The Iconography of Landscape* (Cambridge University Press, 1988), pp. 43–82, esp. 57–62.
20 Cole, 'Essay on American scenery', pp. 375–6.
21 Ibid., pp. 574–5.
22 Ibid., p. 577. My reading of Cole's *Essay* here and in the next paragraph owes something to Tony Tanner's in *Scenes of Nature, Signs of Men* (Cambridge University Press, 1987), p. 40.
23 Cole, 'Essay on American scenery', p. 577.
24 Ibid., pp. 577–88.
25 Ibid., p. 578.
26 Ibid., p. 575.
27 Alan Wallach, 'Cole, Byron and the course of empire', *Art Bulletin* 50 (1968), pp. 375–9. Elwood Parry III, *Thomas Cole's* The Course of Empire: *a Study of Serial Imagery* (unpublished Ph.D. dissertation, Yale University, 1970).
28 Wallach, 'Thomas Cole and the aristocracy', p. 99.
29 Ibid., p. 102.
30 Ibid., pp. 102–3.
31 Ibid., p. 104.

32 The comparison has been made previously by Kenneth J. LaBudde, 'The rural earth, sylvan bliss', *American Quarterly* 10 (1958), pp. 142–3; Barbara Novak, *Nature and Culture: American Landscape Painting 1825–1875* (Thames & Hudson, London, 1980), pp. 160–75; Kenneth W. Maddox, 'Thomas Cole and the railroad: *Gentle Maledictions*', *Archives of American Art Journal* 25 (1986), pp. 2–9. I have benefited from each of these writings, most especially Maddox's.

33 Maddox, *In Search of the Picturesque*, pp. 49–54. Maddox, 'Thomas Cole and the railroad', quotations on pp. 3–4, 5, 7.

34 Ibid., p.5.

35 Smith, *Virgin Land*, pp. 54–63.

36 Cikovsky, 'The Ravages of the Axe', p. 612.

37 Parry III, *Thomas Cole's* The Course of Empire, pp. 92, 128.

38 Maddox, 'Thomas Cole and the railroad', p. 6.

39 Quoted in Allentuck, 'Sir Uvedale Price and the picturesque garden: the evidence of the Coleorton Papers' in Nikolaus Pevsner (ed.), *The Picturesque Garden and its Influence Outside the British Isles* (Dumbarton Oaks, Washington, D. C., 1974), pp. 59–76 (p. 75).

40 Cantor, 'New England landscape of change'.

41 Quoted in Maddox, 'Thomas Cole and the railroad', p. 6.

42 Cole, 'Essay on American scenery', p. 570.

43 Quoted in Maddox, 'Thomas Cole and the railroad', p. 4.

44 Quoted in ibid., p. 7.

45 Leo Marx, *The Machine in the Garden: Technology and the Pastoral Ideal in America* (Oxford University Press, New York, 1964), pp. 227–353; Susan Danly Walther (ed.), *The Railroad in the American Landscape 1850–1950* (Wellesley College Museum, Wellesley, Mass., 1981); Susan Danly and Leo Marx (eds), *The Railroad in American Art* (Massachusetts Institute of Technology, Cambridge, Mass., 1988).

46 *The Home Book of the Picturesque* (1852) (facsimile reproduction Scholars Facsimiles, Florida, 1967).

47 *The Home Book of the Picturesque*, pp. 65–6.

48 Ibid., p. 69.

49 Ibid., pp. 143, 147, 144. A view of a train of the Erie Railroad crossing the viaduct over the Cascade Ravine forms the title page of the *Home Book of the Picturesque*, the words of the title arched to echo the viaduct's shape. The view of the viaduct echoes those of another nationalist landmark, the Natural Bridge in Virginia, upheld as an American spectacle in Thomas Jefferson's *Notes on the State of Virginia* (1787) and by many subsequent writers and illustrators.

50 Metropolitan Museum of Art, *American Paradise*

51 Creese, *The Crowning of the American Landscape*, pp. 95–8; O'Brien, *American Sublime*, pp. 193–238.

52 Kevin J. Avery, 'A historiography of the Hudson River School' in Metropolitan Museum of Art, *American Paradise*, pp. 3–20, esp. 3–7; Doreen Bolger

and Catherine Hoover Voorsanger, 'The Hudson River School in eclipse' in Metropolitan Museum of Art, *American Paradise*, pp. 71–90.

53 Avery, 'A historiography of the Hudson River School', pp. 12–13.

54 Ibid., pp. 14–16; Wolfgang Born, *American Landscape Paining: an Interpretation* (Yale University Press, New Haven, 1948), pp. 85–6, 80.

55 O'Brien, *American Sublime*, p. 31. David Lowenthal, 'The American scene', *Geographical Review* 58 (1968), pp. 61–8 (p. 78).

56 Quoted in O'Brien, *American Sublime*, p. 31.

57 Avery, 'A historiography of the Hudson River School', pp. 14–16.

6

Frances Palmer and the
Incorporation of the Continent

───❖───

I n *American Landscape Painting* (1948), Wolfgang Born singled out
two pictures which embodied the 'panoramic style' he saw as
expressing 'an innate trend of the American mind': *The Oxbow*
(Chapter 5, Figure 5) by Thomas Cole painted in 1836 and a print by
Frances Palmer (1810–76) *Across the Continent–Westward the Course of
Empire Takes its Way* (Figure 1), published by Currier and Ives in 1868.
Born acknowledged that the panoramic style was not an American
invention and that Cole and Palmer were English-born, but these two
pictures, he maintained, were 'unparalleled' in European art. In con-
trast to the 'cozy but narrow world' of Europe these two panoramas best
expressed 'the influence of the frontier on the aesthetic attitude of
America'. 'Americans began to see their country as the continent really
is, an immense stretch of land over which the imagination could wander
unrestrictedly'. In *The Oxbow*, Cole employed a 'shifting vanishing
point' allowing the spectator's gaze liberty to wander at will through this
view from Mount Holyoke of Connecticut River valley. In *Across the
Continent* Palmer 'did everything in her power to suggest a horizontal
extension of the picture space' to 'express visually the space-feeling of
the American people'. Her subject was no less significant, the transcon-
tinental railroad 'which brought home the vastness of America to the
average American citizen'.[1]

In this chapter I will focus on Palmer's *Across the Continent*. I will
show how it brings together a range of motifs and techniques from a
variety of pictures and texts to construct a corporate version of the
progressive ideology Born saw as an innately American. First I will
describe how Palmer developed her style in England where she first
worked as a professional artist.

Figure 1 Frances Palmer for Currier and Ives, *Across the Continent
 – 'Westward the Course of Empire Takes its Way'*, 1868. Museum
 of the City of New York. The Harry T. Peters Collection

PALMER IN LEICESTER

Until recently little was known about Frances Palmer's life and career in
England, or rather the F. F. Palmer who worked in Leicester as a
draughtswoman and lithographer in the early 1840s was not fully
connected to the Fanny Palmer who became from the 1850s the leading
artist for the largest American printmakers, Currier and Ives.

 Charlotte Streifer Rubinstein's research on Frances Palmer's life in
Leicester reveals an enterprising figure. The daughter of a solicitor, she
was like many middle-class English young women of the time given
some training in drawing. Few such women, as far as we know, went on
like Palmer to become professional artists. From 1839 she did the
drawing and much of the printing for the lithography business adver-
tised in her husband Edmund Palmer's name: 'Views, Architectural and

Botanical Drawings, Maps, Plans and Estates, Railway Sections, Elevations, Law Forms, Invoice Heads, Tickets, Checks, Facsimiles, Circulars and Writings of every description and every character'.[2]

Palmer's major commission was twelve engravings for *The Midland Countries Railway Companion*, published in 1840 to celebrate the opening that year of the line. Despite the depression of the time, or more probably because of it, the handbook was intent to promote the power of its enterprise. For example it compared the 'snail-like pace' of boats on the River Soar at Loughborough with 'the tempestuous speed of the fiery engine and its train' passing them. While pointing out the picturesque character of old landmarks, 'awakening recollections of past occurrences', the Company hoped to afford a 'pleasing comparison between them and the present condition of the Country, in what is justly termed "THE AGE OF IMPROVEMENT" '. Palmer provided views of old landmarks in rustic settings like churches and country houses but also views of features which expressed 'the age of improvement', including the railway station at Leicester, the New Union Workhouse and New County Lunatic Asylum (both institutions viewed with the tracks in the foreground), a viaduct slicing through the village of Sileby and the cast-iron railway bridge over the Trent, 'a handsome structure and we believe the largest bridge of iron used for railway purposes'.[3]

In 1842 Palmer herself published some views of Leicestershire. These were not engravings but more expensive lithographs, sold in six-shilling folios of three, as part of a projected series of twelve folios, *Sketches in Leicestershire*.[4] Again Palmer drew both antiquarian and progressive views. Of particular interest is her view of Loughborough from Cotes Hill (Figure 2). The town of Loughborough is shown to the right of the picture, in the distance, but with signs of prosperity clearly visible: smoking chimneys and centrally the new church built to minister to a growing population. It is an image which fits securely in the optimistic tradition of urban prospects. Specifically it updates the late eighteenth-century view illustrating John Throsby's volume on Leicestershire in which Loughborough is seen as 'a trading town and an industrious people'.[5] Throsby saw the canals and mineral railways of his day as turning Leicestershire into a 'one grand machine, whose movement at this time is smooth and rapid'.[6] Parkland occupies the foreground of Palmer's view, but does not deflect attention from the signs of progress. As we follow the two hunting dogs pursuing their prey so we are taken to the clearing under the bough of the framing tree here to see a train of the Midland Counties Line speeding towards Nottingham. Also in 1842, in a volume illustrated by some of Palmer's Leicestershire sketches,

Figure 2 Frances Palmer, *Loughborough from Cotes Hill*, from *Sketches in Leicestershire*, Part II, August 1842. Loughborough Library

Thomas Potter described a similar prospect of Loughborough from the other side of the Soar Valley on Charnwood Forest over another park-like foreground:

> Loughborough when viewed from the summit of Long Cliff has a noble, city-like appearance. From this point too, the trains of the Midland Countries Line, may be observed, almost uninterruptedly, from Sileby to Derby and form a pleasing object darting across the grand panorama.[7]

The *Leicester Journal* praised Palmer's *Sketches in Leicestershire*, finding a 'boldness and freedom not often exhibited by the female pencil'. 'The view of Loughborough from Cote's Hill ... is characterised by a free and vigorous style of drawing ... The general arrangement and keeping of the landscape also we consider a very creditable proof of Mrs Palmer's skill and judgment in composition'. But the series was not a success. Only eight of the twelve parts were completed, the last in June 1843. The *Leicester Journal* found a 'want of taste and spirit' among potential subscribers. It is probable that the depression of the early 1840s affected the Palmer's business no less than that of many others.

The Midland Counties Railway helped to revive Leicester and its region but not before the Palmers departed. In January 1844 they advertised a lithography business in both their names at an address in New York.[8]

PALMER IN NEW YORK

The Palmers arrived in New York at a time of rising demand for prints of patently American scenes: patriotic tableaux; sites of Republican history; scenes of military engagements; prospects of cities, plains, mountains and forests; maps of the nation and of individual states; perspectives of churches, factories, colleges and banks; depictions of steam ships, river craft and railroads.[9] And they quickly exploited this market. One of their earliest prints was of the homestead on Long Island which housed Washington's Headquarters during the War of Independence. Their most enterprising print was a view of the Battle of Pal-Alto during the Mexican–American War published just twenty days after the event. No eye-witness views were available but the Palmers created a view nevertheless. If the battle actually occurred on a featureless plain, the Palmers framed the battle with tropical plants and temperate trees and deployed the troops according to the traditions of military art.[10]

In the later 1840s Frances Palmer began to work freelance for New York's leading print publisher, Nathaniel Currier. Currier published Palmer's view of Manhattan from the suburb of Brooklyn Heights looking across an East River crowded with gigantic ships, also her view of the High Bridge at Harlem which, the text proudly announced, carried an aqueduct stretching 44 miles from the Croton River, and was built at a cost of 13 million dollars. With her later prints of New York's new penitentiary, workhouse and asylum complex, these views of progressive subjects may be seen as extensions of those Palmer produced in Leicester for the Midlands County Railway.

In 1851 the Palmers' own business failed. Currier bought the stock and Frances Palmer went to work for him full-time. In 1857 Currier took James Ives in partnership and Palmer became the leading artist for the firm. In her thirty years on the payroll Palmer worked on all stages of the production process, including drawing, grinding and colouring and she contributed to advances in the process, such as developing a new lithographic crayon. Palmer produced in her own name over a hundred prints, including many of their most popular, and she had a hand in many hundreds more.[11]

CURRIER AND IVES

It is hard to overestimate the role of Currier and Ives in the pictorial culture of the time. The firm's distribution network was nationwide. They issued mail order catalogues, used regular agents and a variety of retailers including storeowners, stallholders, pushcart vendors and backpack pedlars. The larger, specifically hand-coloured, folios sold for up to three dollars but smaller prints could be had for as little as fifteen cents and were remaindered for less. Currier and Ives prints were displayed in the parlours of many private dwellings and in many public spaces, including schools (to whom the firm sold plain prints cheaply for pupils to colour), offices, banks, bar-rooms, barbershops, boarding houses and hotels. The prints were used to illustrate posters, tradecards, cigar labels and sheet music. It was James Ives as General Manager who was responsible for diffusing his firm's influence so widely. As well as overseeing the development of the distribution system he speeded up production in New York, by streamlining the division of labour, making more use of stock blocks (which could be reground to produce a variety of views from one basic drawing) and freely sampling features for prints from a variety of other pictures, including oil paintings and magazine illustrations. This synthetic technique characterized various forms of production, from quiltmaking to the manufacture of guns.[12]

Currier and Ives produced hundreds of prints on a variety of subjects but it is possible to trace an ideological configuration to their catalogue. The frequent floral compositions, homely scenes of domestic bliss, hunting scenes of weekend sportsmen, improving moral and religious subjects, scenes of pioneer farming and portraits of modern ships and locomotives, project a respectably Protestant, progressive image. These were also frequent subjects of home-made samplers and quilts, and like such needlework Currier and Ives prints adorned respectable homes. They were also displayed on the walls of respectable businesses. The firm also catered for the masculine sphere of Protestant culture, in 'comic' pictures for cigar-labels, bars and barbershops, often degrading Blacks, women or both.

The official political contours of Currier and Ives ideology are explicit in prints of the Civil War. These show battles as stunning Union victories. They project the mid-century Republicanism forged to sustain the Union against the ambitions of the Southern ideologues, particularly ambitions for a slaveholding empire in the Far West. Ives was a captain in the Union Army during the Civil War, and thereafter active in

Republican party policies. Currier was a close friend of the most powerful figure of the Republican Party, Horace Greely, editor of the nationally influential New York *Tribune*, and identified with the phrase he used in a column in 1865: 'Go West, young man, and grow up with the country'. Many of Currier and Ives's prints from the mid-1860s are firmly aligned to the western trajectory of Republican ideology and its rhetoric of continental conquest.[13]

MANIFEST DESTINY

By the mid nineteenth century the United States had annexed the Far West, the lands beyond the Mississippi, and here nationalist visions were now fully released. Anxieties that expansionist ambition would overstretch and weaken the republic were allayed. Fears that American development would repeat the cycle of imperial rise and collapse were dismissed. Progressive ideology triumphed. The United States would develop ever onward and upward. Moreover, according to the doctrine of Manifest Destiny, it had a divine mandate to do so. William Gilpin, the first territorial governor of Colorado, declared in 1846 that 'the untransacted destiny of the American people is to subdue the conti-nent – to rush over this vast field to the Pacific Ocean – to animate the many hundred millions of its people, and then cheer them upward ... to carry the career of mankind to its peak'.[14]

A variety of media, from settler guidebooks to illustrated magazines, from paintings to quilts, broadcast the imagery of Manifest Destiny in settings of vast plains and towering mountains for stories of epic journeys. These scenes served to dramatize this nationalist mission and raise its biblical register. The main vehicles of the doctrine were first the wagon trains which from the 1840s trekked the two thousand miles along the Oregon Trail to the Pacific Coast, followed by the transconti-nental railroad taking the same route and completed in 1869.

The sectional rivalries which culminated in the Civil War only served to heighten the allure of lands beyond the Mississippi. The Far West offered a vision to heal the wounds of the conflict, if this was heavily dosed with Unionist ideology. At the 1864 Sanitary Fair in New York, held to raise money for medical aid to all troops, the outstanding exhibit was a painting by Albert Bierstadt, *The Rocky Mountains – Lander's Peak* (Figure 3). Five years before, Bierstadt had accompanied Colonel Frederick West Lander's expedition to survey an overland passage to California, sketching and photographing the scenery and Indian settle-

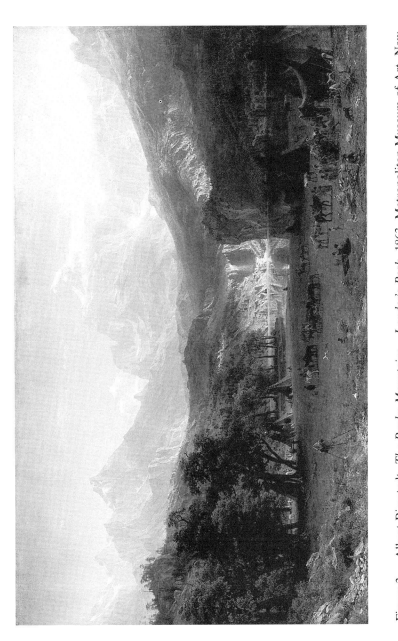

Figure 3 Albert Bierstadt, *The Rocky Mountains – Lander's Peak*, 1863. Metropolitan Museum of Art, New York City. Rogers Fund, 1907

ment. Lander had recently died in the Civil War, a Unionist hero. Bierstadt's painting, measuring twelve feet by six, is a monumental memorial. Centrally it shows the snowy peak named after Lander in the mountains of the Wind River range. Sharply drawn and brilliantly lit, the mountains tower in foreshortened perspective over a Shoshone village in the foreground. Awestruck spectators rushed to subscribe for engravings.[15]

Also in 1864 the West was commandeered in Emmanuel Leutze's colossal, twenty by thirty foot, mural in the US Capitol in Washington DC, *Across the Continent, Westward the Course of Empire Takes its Way* (Figure 4). This shows an emigrant wagon train, shepherded by mountain men, reaching the crest of the Sierra Nevada mountains after the most arduous part of their journey. Here in triumph they behold the lands of the Pacific. Following earlier pictures of families emigrating across the Appalachians, Leutze's painting fuses the Mosaic allusions of the trek to the Promised Land with the Messianic allusions of the Holy Family's Flight into Egypt. While one prairie madonna cradles her infant at the mountain crest, another follows in her wagon. It is a domestic vision. Intrepid individuals give way to courageous families as the main agents of civilization.[16]

Guidebooks and gazetteers domesticated the plains. This involved reclaiming their largely treeless terrain from those who saw them as a barren desert, fit only for nomadic Indians, and thus providing the necessary barrier to expansionist ambition. In contrast promoters of westward expansion projected a garden image across the plains, seeing it as potentially, if not everywhere actually, a great pasturage, or better still, a home for a flourishing population of small farmers. This view was a visible extension of Northern interests; it involved appropriating the plains from Confederate agrarian visions. Along with wild Indians the West would be cleansed of the prospect of feckless slaves and their vicious masters. Initially promoted by conservative Republicans, after the Civil War this agrarian vision was endorsed by Northern ideologues of most persuasions. It became 'a near-consensus ideology, a national rather than partisan crusade'. The West, like the South, would be conquered and reconstructed.[17]

The most powerful weapon of civilization was seen to be the transcontinental railroad. The route finally decided was along the 41st parallel, following the overland trail. Construction began in 1865, the Union Pacific heading west across the plains from Omaha to hook up with the Central Pacific moving east over the Sierras from California. The progress of the line was extensively publicised and documented. A

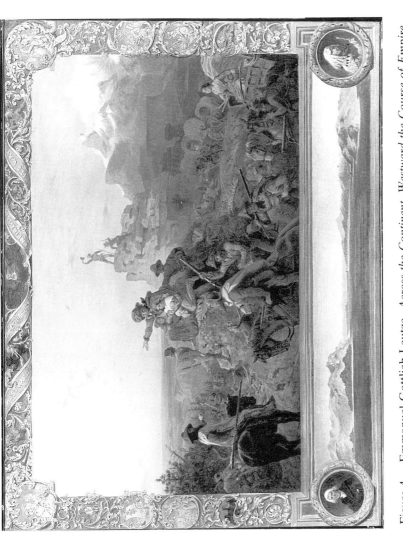

Figure 4 Emmanuel Gottlieb Leutze, *Across the Continent, Westward the Course of Empire Takes its Way*, 1864. Study for Mural, US Capitol. National Museum of American Art, Smithsonian Institution, Washington, DC. Bequest of Sarah Carr Upton

few radical journalists exposed the seamier side of the enterprise, such as the sordid dealings of the consortium who funded supply and construction and the violent protests of Indians against the line, but they were overridden in a campaign of national self-congratulation. The consortium were seen as visionary businessmen, working in partnership with the federal government who provided generous land grants, financial underwriting and low-interest loans as well as military protection from ungrateful Indians. The railroad was a large-scale corporate enterprise with a distinctly military régime. It was appropriate that the ranks of the Union Pacific's presidents and directors should be packed with retired Union Army generals.[18]

The transcontinental railroad redefined the mythology of westward expansion. As it reached rugged terrain beyond the most optimistic limits of cultivation, so it reactivated codes of land appraisal which associated barren terrain with fabulous mineral wealth. There is a hard metallic ring to many promotional images of the railroad set in these places. Photographs of the railroad in Wyoming show the machinery of rails and locomotives as a refinement of the raw terrain, much as painters of lusher landscapes back east had shown farms and sawmills as a refinement of the forest. The verdure of the plains, promoted to sell railroad land to farmers, was seen to be activated by the cutting edge of corporate organization and machine technology. While farmers still figured prominently in the rhetoric of Manifest Destiny, they were upstaged by an enterprise which was exercizing a powerful grip on all aspects of agriculture. The railroad became the primary embodiment of heroic virtue. The main agent of civilization was no longer familial but corporate.[19]

ACROSS THE CONTINENT

Frances Palmer drew a series of pictures for Currier and Ives from the mid-1860s charting the westward course of empire. They focused on various stages of pioneering. Palmer herself never visited the places where pioneering occurred. She drew on a variety of sources for her pictures, from promotional gazateers to oil paintings. Also James Ives applied a strong editorial hand in preparing the lithographs, rearranging parts of Palmer's sketches, adding figures, inserting lettering and deciding on titles.[20]

The Rocky Mountains – Emigrants Crossing the Plains (Figure 5), published in 1866, combines many elements of the mythology of

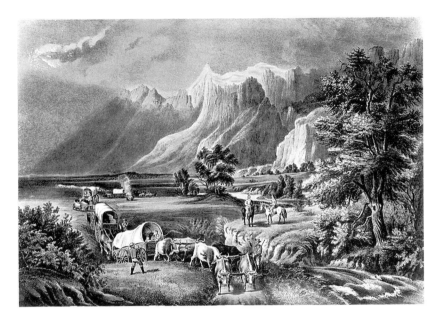

Figure 5 Frances Palmer for Currier and Ives, *The Rocky Mountains –
Emigrants Crossing the Plains*, 1866. Museum of the City of New
York. Harry T. Peters Collection

Manifest Destiny. The Rocky Mountains are rendered in Bierstadt
style. Towering, almost perpendicular, in the background they are
sharply etched and brilliantly lit. Stretching forward across the plains is
a wagon train on the Oregon Trail. A man with a rifle waves the train
ahead, another cracks a whip to startle the oxen. In the front wagon a
prairie madonna cradles her baby. The torrent of water in the
foreground and the narrow, well worn path the leading oxen are
treading, suggest this is the start of a steep ascent. If there are
intimations of hardship ahead, the view of the plains is benign. Writers
and illustrators who encountered wagon trains in the early 1860s noted
how much more prosperous and confident a picture they presented than
those heroic but often careworn, and ill-fated, emigrants described in
the 1840s.[21] No hostile Indians menace this wagon train. On the
opposite bank of the river two plains Indians passively witness the
course of civilization which has superseded them. No carcasses or graves

Figure 6 Frances Palmer for Currier and Ives, *The 'Lightning Express'*
Trains – 'Leaving the Junction', 1863. Museum of the City of New
York. Harry T. Peters Collection

litter a parched earth. The plains are presented as lushly verdant, in the
colouring of the lithograph a brilliant green.

Across the Continent – Westward the Course of Empire Takes its Way
(Figure 1) was published in 1868. It presents a survey of many stages in
the course of empire culminating in the completion of the transconti-
nental railroad.

A locomotive occupies the centre of the composition. For some years
Palmer had been producing portraits of express trains for Currier and
Ives, some of which has been used in advertisements for railway
companies. That in *Across the Continent* has some basis in the black,
brass-trimmed, smoke-belching locomotives in her print *The Lightning
Express' Trains* (1863) (Figure 6). These locomotives race towards the
spectator, their headlights shining. This headlong image became a
standard way of depicting trains on lines of the transcontinental
railroad, the lamp an emblem of trailblazing and civilized enlighten-
ment.[22] The cover by Thomas Nast of the most famous promotional
gazeteer of the railroad, *Beyond the Mississippi* (1867) (Figure 7) by

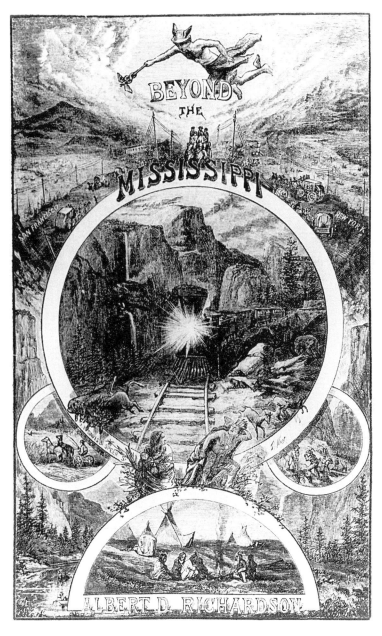

Figure 7 Thomas Nast, title page to Albert D. Richardson,
Beyond the Mississippi, 1867

A. D. Richardson (Horace Creely's crack journalist on the New York *Tribune*) shows a shining locomotive illuminating a path from which it scatters buffalo, deer and Indians. The train in *Across the Continent* face away from us but the brilliantly lit track acts as a beam of projected light.

In *Across the Continent* the locomotive's plume of black smoke trails back to choke two Indians, obscuring even their view of the progress of civilization. It is an altogether more hostile image than the encounter of the two Indians with the wagon train in *The Rocky Mountains*, reflecting the numerous accounts of warfare on the railroad.[23] Carrying weapons, a lance and a rifle, the Indians' demeanour in *Across the Continent* is less reserved, and so is the demeanour of the new vehicle of progress. The locomotive's smokestack resembles the barrel of a canon. It recalls images of attacks not just on Indians but those against the South, like Palmer's 1863 print of *The Mississippi in Time of War*, showing an ironclad Union gunboat shelling Confederate positions, a white-columned plantation mansion bursting into flames.

While the train, emblazoned 'Through Line New York San Francisco', and its track project the completion of the railroad, running parallel to it are earlier episodes of the enterprise, more contemporary with the print. Next to the train a few figures are laying rails and ties; in the distance some are erecting telegraph poles and stringing the wire. These figures, like those of the Indians, were added by Ives to Palmer's original sketches and are drawn from one of the many pictures of the building of railroad. They seem to be taken from A. R. Waud's engraving *Building the Union Pacific Railroad in Nebraska* (Figure 8) from Richardson's gazeteer *Beyond the Mississippi*. Itself redrawn from eye-witness photographs and configured by the rhetoric of Richardson's text, Waud's picture shows gangs of labourers building the railroad along the Platte River Valley, in a setting *Across the Continent* has sampled too, a landscape of flat plain fringed to the right by the hills bordering the river. 'The Platte valley, from six to twenty miles wide, is incomparably the most favourable railway route in the world', declared the gazeteer, 'almost a dead level from the Missouri up to the mountains'. 'For a tangent of forty miles the road is as straight as the track of a rifle-ball. This is a good place for studying perspective'.[24]

If showing whole gangs of labourers, no matter how efficiently they worked, reeked too much of ethnic sweat for Currier and Ives's customers, the telegraph provided a pure image of Republican techno-logy. The telegraph packed a powerful cultural charge. Its inventor Samuel Morse had distinguished himself in politics as president of the

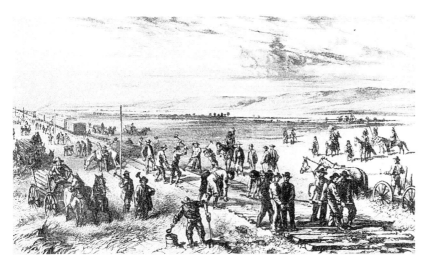

Figure 8 A. R. Waud, *Building the Union Pacific Railroad in Nebraska*,
from Albert D. Richardson, *Beyond the Mississippi*, 1867

American Protestant Union and in art as a painter of republican scenes
like *The Old House of Representatives* (1822) showing the clerk lighting
the brilliant 'lamp of republican promise' watched from the gallery in
shadow by an Indian. Morse's invention flashed news from New Orleans
to New York of success in the Mexican War, and provided a system for
mapping great stretches of terrain through signals tapped out at
fifty-mile intervals.[25] It enabled the contractor of the Union Pacific to
direct the building of the line from New York, pushing the line
westward, wrote Richardson 'with a rapidity never before equalled'.[26]
The cover of *Beyond the Mississippi* shows the wires stretching from
New York to San Francisco, in a scene over which Mercury waves his
wand. The telegraph electrified images of westward expansion. In
Across the Continent, the tracks and telegraph together co-ordinate a
streamlined perspective, projecting not only the speed of the system but
its regular pulse.

On the left side of the tracks is an earlier stage in westward expansion
and, by contrast, a shakier, more rambling one, the path of a wagon
train on the overland trail. Emigrants still set out from a camp on the
edge of the town but they are, in many ways, now marginalized. The
town's focus is now the railroad. Citizens gather at the track side to
embark or wave to passengers. Where in Palmer's print *The Pioneer's*

Home children rush out of a log cabin in the woods to greet their father, here on the plains they rush out of a schoolhouse to greet the train.

There are other signs of corporate ascendancy. In the left corner of the foreground is a scene transplanted from pictures of pioneering in more humid forested regions, of men felling trees and grubbing up stumps. In one of Palmer's sketches for *Across the Continent* this scene is centrally positioned, as a sort of clearing through which we see the locomotive framed on either side by standing trees. Here three of the men are resting from their work, looking down on the train.[27] In the lithograph the scene is pushed to one side to make way for features from another sketch, the institutional buildings of the town, the school and the church. And the men who rest in the sketch are put to work in the print, cutting and shaping the logs which these larger buildings require. One figure remains momentarily at rest. A man leaning on his spade looks across the landscape. As a displaced witness to progress this woodsman assumed the role vacated by the smoke-blinded Indians on the other side of the tracks. He recalls the woodsman in the picture I discussed in the last chapter, Thomas Cole's *River in the Catskills* (Chapter 5, Figure 9), who surveys the path he has helped cut for the railroad, and the urban vision of its promoters.[28]

Figure 9 T. M. Fowler, *Harvard, Nebraska*, 1879. Nebraska State Historical Society

The Union Pacific was promoted in explicitly civic terms. 'In the East, railroads are built for the towns', declared A. D. Richardson in *Beyond the Mississippi*, 'on the border they build the towns'. He documented the vigour of existing settlements the railroad connected and the demise of those it did not. The railroad could make mere hamlets mushroom into great cities. Richardson predicted a great urban civilization on the plains. At the opening of the nineteenth century 'this region was less known than Siberia. Now in its early future, will rise a great city, heart of a dense population, on the grand highway of travel and traffic for the whole globe'. Richardson found Omaha booming, 'the liveliest city in the United States'. A hundred miles out on the plains was Columbus which 'promises to be a future railway focus' and according to the head of the credit company dealing in railway land and stock would be 'a great city, capital of Nebraska, and perhaps of the United States'.[29]

Such inflated claims were central to the rhetoric of urban speculation and lampooned as such in cartoons which contrasted the civic grandeur promised on paper with the shabby settlements redeemed on the ground. Moreover, even promotional journalists depicted railroad towns as picaresque places, with a cosmopolitan, transient and often unruly cast of Black porters, Jewish pedlars, Irish navvies, drunken Indians, gold prospectors and cardsharpers.[30] In contrast the town in *Across the Continent* is solidly respectable, with the institutions to prove it.

To show the town's orderly enterprise, *Across the Continent* deploys the conventions of the promotional urban views. From a raised vantage point such views showed principal civic institutions, thriving sites of commerce and abundant space for expansion. *Across the Continent* uses a standard compositional device of these views, a two-point perspective with vanishing points beyond the horizon, to raise the land into view like a map. Old hunting grounds are transformed into real estate ripe for development. The railroad is always a focus in urban views, in the form of stations, tracks and steaming trains. In lithographs of prairie towns (Figure 9) the tracks strike the dramatic diagonal of those in *Across the Continent*. In Palmer's print the locomotive assumes the pivotal site that in views of cities is reserved for government buildings like State houses.[31]

The tracks in *Across the Continent* divide the picture into two historical arenas. To their left, the story of westward development is funnelled with increasing speed to the horizon. Everywhere there is evidence of industriousness. To the right of the tracks is a slower paced, more expansive scene. A river, fringed with trees, winds gracefully to

the range of low hills. The hills continue the line of sight in a great arc and gently lower the gaze to the horizon. It is an uncultivated, pastoral scene, but not an unresourceful one. There are faint echoes of earlier stages of culture. On the river are two tiny European figures in canoes, perhaps fur trappers, who seem to have paddled in from one of George Caleb Bingham's paintings of river life. Far in the distance below the hills is a buffalo hunt, the sort of scene made famous in George Catlin's paintings of plains Indian life. Gazing across at this scene, and linking the narratives to either side of the tracks, is the woodsman in the lower left corner. His line of sight along the banks of the river acts as countervailing, less rigid, diagonal to that of the tracks. But it does not deflect attention from the railroad; on the contrary it enhances it. The two diagonals intersect at the locomotive, the pivot of the picture, the epicentre of its power. In every way the Far West is revealed as an alluring resource. As Richardson put it in *Beyond the Mississippi*:

> Its mines, forest and prairies await the capitalist. Its dusky races, earth monuments and ancient cities importune the antiquarian. Its cataracts, canyons and crests woo the painter. Its mountains, minerals and stupendous vegetable productions challenge the naturalist.[32]

PULSE OF THE CONTINENT

Across the Continent proved to be one of the last prints Frances Palmer prepared for Currier and Ives, though her style and many of her motifs survived in some of the firm's subsequent output. She died in 1876, the centennial year of the United States. These years between the completion of the transcontinental railroad and the centennial were celebrated as a culmination of the progressive nationalist trajectory Palmer had charted in her work.

The two lines of the transcontinental railroad were joined in May 1869 to an outburst of nationalist rejoicing. In *Passage to India* (1871) Walt Whitman described the railroad as part of a global system which included the Atlantic and Pacific cable and the Suez canal, and in a string of images which evoke Palmer's prints for Currier and Ives:

> I see over my own continent the Pacific Railroad surmounting every barrier,
> I see continual trains of cars winding along the Platte carrying freight and passengers,

> I hear the locomotives rushing and roaring, and the shrill steam-whistle,
> I hear the echoes reverberate throughout the grandest scenery in the
> world ...[33]

In the centennial year of 1876 Whitman published a rousing poem in the
New York *Tribune* to the railroad 'launch'd o'er the prairies wide'. Here
the locomotive assumes the aura of a fetish:

> Thy ponderous side-bars, parallel and connecting rods, gyrating, shuttling
> at thy sides
> Thy metrical, now swelling pant and roar, now tapering in the distance,
> Thy great protruding head-light fixed in front ...
> Thy dense and murky clouds out-belching from thy smokestack ...
> Type of the modern – emblem of motion and power – pulse of the
> continent.[34]

This rhetoric of technological confidence culminated in the 1876 Cen-
tennial Exposition at Philadelphia. Here the main exhibit was a giant
Corliss steam engine powering thirteen acres of machines for various
processes from lithographing wallpaper to sawing logs.[35] Currier and
Ives rushed out centennial prints, principally *The Progress of the
Century* combining a view of a steamboat and steam train with an
interior scene of men operating an electric telegraph and a lightning
steam press.

THE OCTOPUS

Towards the end of the century undercurrents of doubt and criticism
began to surface. The railroad's corporate image became more tarn-
ished. It began to lose its shining pioneer image as a vehicle of national
unity, harmonizing a range of civilized interests, from farming to mining
to wilderness appreciation. It became more explicitly identified with the
exclusive and overbearing power of urban and industrial interests. A
year after the celebrations of the 1876 Centennial Exposition came the
Great Railroad Strike, the first instance of machine smashing and class
violence on a national scale. Farmers began to protest more vocally at
the railroad's economic control and political influence. Reduced in
popular, urban-based imagery, from noble yeoman to comic hicks,
farmers and their representatives mounted a wide-ranging programme
of cultural resistance.[36] Cartoons show sturdy yeomen slaying

locomotive-like monsters coiled around the US capitol building in Washington (Figure 10).

Frank Norris's novel *The Octopus* (1901) dramatizes this renewed agrarianism. It is based on a conflict which erupted twenty years before in the San Joachim Valley, California between the Southern Pacific Railroad and the settlers the railroad had enticed to farm the lands but now wished to eject.[37] In the novel, Presley, a young visitor from the East, wants to write an epic, Whitman-like, 'poem of the West'. He finally finds his vantage point on the summit of one of the hills overlooking the valley which had just yielded a bountiful harvest. It is a view which expands in Presley's imagination to a vast vision of fertile earth, 'beyond the fine line of the horizon, over the curve of the globe ... the nourisher of nations, the feeder of an entire world'. Descending from the summit his vision is smashed. A locomotive shoots by 'in a sudden crash of confused thunder', slaughtering a herd of sheep which had strayed on to the line, 'a massacre of the innocents':

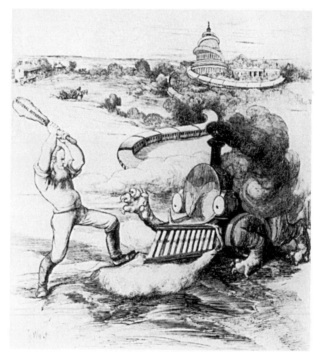

Figure 10 Thomas Nast, *Railroads and Farmers*, from *Harpers Weekly*, 14 August 1873

Presley saw again, in his imagination, the galloping monster, the terror of steel and steam with his single eye, cyclopean, red, shooting from horizon to horizon; but saw it now as a symbol of vast power, huge, terrible, flinging the echo of its thunder all over the reaches of the valley, leaving blood and destruction in its path; the leviathan with tentacles of steel clutching into the soil, the soulless force, the ironhearted power, the monster, the colossus, the octopus.[38]

THE FINAL FRONTIER

The 1893 World's Fair in Chicago, held to celebrate the four hundredth anniversary of Columbus's discovery, and designed to cement a corporate alliance between culture, business and the State, opened its gates 'almost at the exact moment when banks and factories closed theirs in the worst financial panic in the nation's history'. Here Frederick Jackson Turner rewrote the doctrine of Manifest Destiny, not as prophecy but as elegy, in a seminal address to the American Historical Association on 'The Significance of the Frontier in American History'. Turner offered a 'connected and unified account' of American development and national character when the nation seemed anything but. Turner reaffirmed the power and virtue of a pioneering, Protestant, Anglo-Saxon culture but largely in the past tense.[39]

The beginning of Turner's address establishes that the significance of the frontier is its closure, announced in 1890 by the Superintendent of the Census whose 'brief official statement marks the end of a great historic movement'. After telling the story of this movement, in its various stages from exploration to city building, as they occur in various sites across the continent, Turner concludes with a sentence for the occasion of address: 'And now, four centuries from the discovery of America, at the end of a hundred years of life under the Constitution, the frontier has gone, and with its going has closed the first period of American history'. Turner urged his fellow historians to recover this period, excavating the evidence of various frontiers, as 'the geologist traces patiently the shores of ancient seas'.[40] In contrast to the prospective, dynamic, optimistic rhetoric epitomized in *Across the Continent*, Turner's essay is largely retrospective, reflective, enclosed. It is also largely agrarian. There is hardly a mention of minerals or extractive industry, and little acknowledgement of railroads. Turner reinstates the sturdy pioneer farmer and the fecundity of the once forested soil.[41]

Settlement may have now reached from coast to coast but it was not the final frontier. While Turner was charting the containment of

America, elsewhere entrepreneurs were developing a new mode of regenerative movement, the automobile. Like the railroad before it, the car and the highway became vehicles for renewing and reforming the prophetic rhetoric of landscape and national identity.[42]

GENUS AMERICANUS

As a business Currier and Ives scarcely survived the nineteenth century. Their last-known print is dated 1898. From 1902 the firm was liquidated. Stock and equipment was sold off in the remainder sale of 1907, lithographic stones going by the pound. The firm's decline was signalled even before Nathaniel Currier retired in 1880. They did not convert to more efficiently mechanical processes of print making, and lithography anyway was being overtaken by new forms of pictorial reproduction like photo-engraving.[43]

By the 1930s, as the taste for scenes of old America sharpened, so Currier and Ives prints became highly valued as antiques. Folio prints fetched three thousand dollars. In his 1929 book on the firm, based on his unrivalled collection of their prints, Harry T. Peters struck the note of nostalgia: 'All [the prints] are homely in the best sense; simple, sincere representations of an era that is past. They belong to the genus Americanus ...'. He recognized Frances Palmer's work, if he rendered it simple and genteel. Peters's labels of 'charm' and 'homeliness' may have been influenced by his belief that Palmer was born of 'gentlefolk' and attended a 'very select private school in London' as well as by the conventional tendency to stereotype women's art as an extension of a domestic or refining role in society.[44] Recently scholars like Mary Bartlett Cowdrey and Charlotte Streifer Rubinstein have laid the groundwork for recognizing Palmer as a more capable figure producing more complex work.[45] What makes a picture like *Across the Continent* so compelling is that it projects, with measured power, a heroic view of American land and development.[46]

NOTES

1 Wolfgang Born, *American Landscape Painting: an Interpretation* (Yale University Press, New Haven, 1948), pp. 80, 86, 88.

2 Charlotte Streifer Rubinstein, 'The early career of Frances Flora Bond Palmer (1812–1876)', *The American Art Journal* 17 (1985), pp. 71–88, quotation from advertisement on p. 72.

3 *The Midland Counties Railway Companion* (Midland Counties Railway, Nottingham and Leicester, 1840), pp. 62, 1, 44, 60–1; *Guide to the North Midland, Midland Counties and London and Birmingham Railway* (R. Tebutt, Leicester, 1841), p. 22.

4 Rubinstein, 'The early career of Frances Palmer', pp. 75–9.

5 John Throsby, *Select views in Leicestershire* (Leicester, J. Brown for the author, 1789).

6 John Throsby, *The History and Antiquity of the Ancient Town of Leicester* (Leicester, J. Brown for the author, 1791), p. 401.

7 T. R. Potter, *The History and Antiquities of Charnwood Forest* (Hamilton, Adams and Co., London, 1842), p. 187.

8 Rubinstein, 'The early career of Frances Palmer', p. 82.

9 John W. Reps, *Views and Viewmakers of Urban America* (University of Missouri Press, Columbia, Mo., 1984), p. 3.

10 Rubinstein, 'The early career of Frances Palmer', p. 82.

11 Ibid., p. 86. Mary Bartlett Cowdrey, 'Frances Palmer, an American lithographer' in Carl Zigrosser (ed.), *Prints* (Holt, Rhinehart & Winston, New York, 1962), pp. 217–34.

12 Harry T. Peters, *Currier and Ives, Printmakers to the American People* (Doubleday, Doran & Co., Garden City, NY, 1942); Martin Cronin, 'Currier and Ives, a content analysis', *American Quarterly* 4 (1952), pp. 317–30; Karen Peterson and J. J. Wilson, *Women Artists* (Harper Calophon Books, New York, 1976), pp. 68–73.

13 Peters, *Currier and Ives*, p. 9; Rozsika Parker and Griselda Pollock, *Old Mistresses: Women, Art and Ideology* (Routledge & Kegan Paul, London, 1981), pp. 75–81; Walton Rawls, *The Great Book of Currier and Ives America* (Abbeville Press, New York, 1979), pp. 281–91.

14 Dawn Glanz, *How the West was Drawn: American Art and the Settling of the Frontier* (UMI Research Press, Ann Arbor, 1982), esp. pp. 55–83; Patricia Hills, *The American Frontier: Images and Myths* (Whitney Museum of Art, New York, 1978), quotation on pp. 7–8.

15 William H. Goetzmann and William N. Goetzmann, *The West of the Imagination* (W. W. Norton & Co., New York, 1984), pp. 145–57. Elizabeth Lindquist-Cook, *The Influence of Photography on American Landscape Painting, 1839–1880* (Garland Inc., New York, 1977), pp. 69–80.

16 Goetzmann and Goetzmann, *The West of the Imagination*, pp. 114–15; Glanz, *How the West was Drawn*, pp. 77–9.

17 David M. Emmons, 'The influence of ideology on changing environmental images: the case of six gazeteers' in Brian W. Blouet and Merlin P. Lawson (eds), *Images of the Plains* (University of Nebraska Press, Lincoln, 1975), pp. 125–36.

18 Richard Slotkin, *That Fatal Environment: the Myth of the Frontier in the Age of Industrialisation, 1800–1890* (Connecticut University Press, Middleton, Conn., 1985), pp. 211–26; Susan Danly Walther (ed.), *The Railroad in the American Landscape 1850–1950* (Wellesley College Museum, Wellesley, Mass., 1981), pp. 39–40. Alan Trachtenberg, *The Incorporation of America* (Hill & Wang, New York, 1982), pp. 17–24.

19 John R. Stilgoe, 'Far fields and blasted rock: American land classification systems and landscape aesthetics', *American Studies* 22 (1981), pp. 21–34; Danly Walther (ed.), *The Railroad in the American Landscape*, pp. 37–50, 99–105. Susan Danly, 'Andrew Joseph Russell's The Great West Illustrated' in Susan Danly and Leo Marx (eds), *The Railroad in American Art* (Massachussetts Institute of Technology, Cambridge, Mass., 1988), pp. 93–112; Ann Farrar Hyde, *An American Vision: Far Western Landscape and National Culture, 1870–1920* (New York University Press, 1990), pp. 53–106; Glanz, *How the West was Drawn*, pp. 82–4.

20 Cowdrey, 'Fanny Palmer', p. 225.

21 Ron Tyler, *Visions of America: Pioneer Artists in a New Land* (Thames & Hudson, London, 1983), pp. 152–3.

22 Danly Walther (ed.), *The Railroad in the American Landscape*, p. 92. Susan Danly, 'Introduction' to Danly and Marx (eds), *The Railroad in American Art*, pp. 17–21.

23 Danly Walther (ed.), *The Railroad in the American Landscape*, p. 94.

24 Albert D. Richardson, *Beyond the Mississippi* (American Publishing Co., Hartford, Conn., 1867), pp. 567, 566. On A. R. Waud see Robert Taft, *Artists and Illustrators of the Old West 1850–1900* (Princeton University Press, 1953), pp. 58–62.

25 Goetzmann and Goetzmann, *The West of the Imagination*, p. 91.

26 Richardson, *Beyond the Mississippi*, p. 567.

27 Peters, *Currier and Ives*, p. 114. Palmer's sketches for *Across the Continent* are reproduced on pp. 18–19.

28 I do not know whether Palmer could have known Cole's painting. It was not to my knowledge engraved.

29 Richardson, *Beyond the Mississippi*, pp. 571, 566.

30 John Reps, *The Making of Urban America* (Princeton University Press, 1965), pp. 392–402.

31 Reps, *Views and Viewmakers*.

32 Richardson, *Beyond the Mississippi*, p. i.

33 Walt Whitman, *Leaves of Grass*, ed. Scalley Bradley and Harold W. Blodgett (W. W. Norton & Co., New York, 1973), p. 413.

34 Ibid., p. 472.

35 John F. Kasson, *Civilising the Machine: Technology and Republican Values in America, 1776–1900* (Penguin, Harmondsworth, 1977), pp. 139–80.

36 Trachtenberg, *The Incorporation of America*, pp. 38–69. Brian Lee and Robert Reinders, 'The loss of innocence, 1880–1914', in Malcolm Bradbury

and Howard Temperley (eds), *Introduction to American Studies* (Longmans, London, 1981), pp. 176–94.

37 Frank Norris, *The Octopus* (New American Library, New York, 1981), afterword by Oscar Cargill, pp. 459–69.

38 Ibid., quotations on pp. 41, 42.

39 Trachtenberg, *The Incorporation of America*, pp. 211, 11–17.

40 Frederick Jackson Turner, *The Frontier in American History* (Henry Holt & Co., New York, 1953), pp. 1, 38, 10.

41 Henry Nash Smith, *Virgin Land: the American West in Symbol and Myth* (Vintage Books, New York, 1950), pp. 291–305; William Coleman, 'Science and symbol in the Turner frontier hypothesis', *American Historical Review* 72 (1966–7), pp. 22–49.

42 Warren Belasco, 'Motivatin' with Chuck Berry and Frederick Jackson Turner', in David L. Lewis and Lawrence Goldstein (eds), *The Automobile and American Culture* (Michigan University Press, Ann Arbor, 1980), pp. 262–79.

43 Peters, *Currier and Ives*, pp. 16–17; Rawls, *The Great Book of Currier and Ives America*, p. 63.

44 Peters, *Currier and Ives*, pp. 3, 26–9.

45 Cowdrey, 'Frances Palmer'; Rubinstein, 'The early career of Frances Palmer'.

46 This is sometimes seen as an exclusively masculine view, for example in Annette Kolodny, *The Lay of the Land* (University of North Carolina Press, Chapel Hill, 1975).

7

John Constable and the Making of Constable Country

J ohn Constable (1776–1837) is the most popular English painter. His works are frequently reproduced and in a variety of ways: as framed prints and tapestries, on greetings cards, calendars, table mats, tea trays and chocolate boxes. Constable's paintings are used as publicity images, harnessing the twin virtues of nature and nation, recently to advertize beer, cheese, mineral water and breakfast cereal, and to protest against chemical pollution, property development, oil drilling and nuclear missiles.[1] The places Constable painted have become as famous as the paintings themselves. The stretch of the Stour Valley on the Suffolk–Essex border is a prime tourist area, now officially designated an Area of Outstanding Natural Beauty. Its focus, managed by the National Trust, is the short reach of the river around Flatford Mill where the sites of some of Constable's most famous paintings are found.[2]

The place of Constable in English culture perhaps seems secure and stable, like the rural scenes he painted. In this chapter I will offer a less settled view, both of Constable's painting and of his cultural position. I will examine the often dramatic shifts in Constable's reputation, and its changing terms. Constable has been esteemed for his life and words as well as for his pictures and places. He has been attributed a range of personae: the natural painter, the national painter, the quintessentially English painter, the founder of French painting, the nostalgic reactionary, the progressive modernist, the innocent eye who painted only what he saw, the manipulator who painted only what he wished to be seen. The whereabouts and character of Constable Country have been constantly disputed. Claims have been made for Hampstead, even Wiltshire, as well as Suffolk. Such disputes are not merely local or

documentary. They reflect shifting views of the 'country' at large, the nation. Constable Country, both as an area Constable painted and as an area of enquiry across which his pictures are discussed, has been a terrain of contending interests. This chapter charts some of the principal manoeuvres.

THE NATURAL PAINTER

There is a myth, cultivated by the painter himself and his posthumous admirers, that Constable was an isolated figure, overlooked in his own lifetime. It is true that the public then were aware of only a small fraction, and a restricted range, of Constable's output. That is in some measure a reflection of Constable's reluctance to part with his work. Most of the works to which he attached major importance remained unsold. Cushioned by an income from his family's business in Suffolk, Constable could afford to adopt an unprofessional attitude. He seems to have taken a perverse pride in *not* being recognized, perhaps as a calculated bid for future fame. Recent scholars who have trawled through the art journalism of the period have discovered that Constable's pictures were in fact noticed regularly, and apportioned no less praise than those of many other painters of the time, indeed sometimes more. Characteristics of Constable's style, like oil sketching and chiaroscuro, and of his subjects, like riverside and canal scenes, can be found in the work of his contemporaries. Other painters, notably Turner, also sought to raise the moral seriousness of landscape art. Constable's reputation was well established by the 1820s. In 1827 *The Times* was calling him 'unquestionably the finest landscape painter of the day'. And from the mid-1820s critics begin to find his work 'emphatically', 'peculiarly', 'essentially' English. This is often couched in terms of the naturalism of his style, 'fresh', 'green', 'clear', 'healthy' and so on. But the critical vocabulary seldom goes beyond such terse phrases. What the reviewers did not consider, what they would have throught it inappropriate to consider, was Constable's concern with the range and depth of observation and feeling in his work and his personal bond with the places he painted. The Stour Valley may have meant much to Constable, but it was not a place other artists, art journalists or urban tourists frequented. If Constable was not overlooked, he was not understood in the terms he demanded; but in this he was not exceptional.[3]

Towards the end of his life Constable attempted to extend his public, and to explain his artistic project, by issuing a set of twenty-two engravings of a range of his work. *Various Subjects of Landscape Characteristic of English Scenery* (hereafter *English Landscape Scenery*), issued in 1830, and with text in 1833, presented a representative sample of the places Constable painted. Over half of the pictures were of scenes in his home region of the Stour Valley in Suffolk. Among the rest were pictures of Hampstead Heath, Salisbury Cathedral, Old Sarum and Brighton Beach. Like earlier albums of engraved views, notably those produced by Turner, *English Landscape Scenery* surveyed the topographic, climatic and historical features which expressed the nation's character. The prospectus said it was 'to increase the interest for and promote the study of the Rural Scenery of England, with all its endearing associations, its amenities, and even in its most simple localities'. The tone is nostalgic. The frontispiece is a view of Constable's birthplace in East Bergholt, the house and grounds of his late father. The text recalls a spot 'fraught with every endearing recollection' and goes on to evoke the scenes in the Stour Valley 'where once his careless childhood strayed' and which inspired him to be a landscape painter.

> the gentle declivities, the luxuriant meadow flats sprinkled with flocks and herds, and well cultivated uplands, the woods and rivers, the numerous scattered villages and churches, with farms and picturesque cottages, all impart to this particular spot an amenity and elegance hardly anywhere else to be found.[4]

But despite Constable's aspirations *English Landscape Scenery* did little to extend his reputation. Constable's own vacillations – continually changing his mind about details, revising compositions, altering effects – were largely responsible for the rarity of good sets. Estimates of the number of sets disposed of, either by sale or gift, vary between about forty and less than a hundred.[5]

It was left to Constable's friend, C. R. Leslie, to reconstruct the artist's reputation after Constable's death in 1837. First, as a national memorial, he managed the presentation of the first of Constable's paintings to a national collection. *The Cornfield* (Figure 1) was purchased through private subscription by a group of Constable's admirers and presented to the National Gallery. Constable himself had considered *Salisbury Cathedral from the Meadows* would probably in future be considered his greatest work, and this was mooted as the picture to purchase for the National Gallery. But this dark, tumultuous,

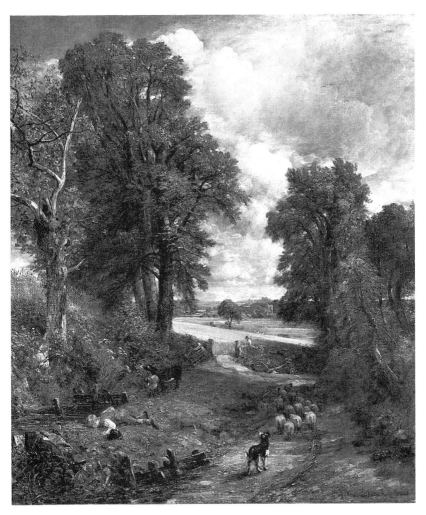

Figure 1 John Constable, *The Cornfield*, 1826. Reproduced by courtesy of the Trustees, The National Gallery, London

scene, showing a bolt of lightning striking the Cathedral spire, and resonant with personal, religious and political turmoil, was considered inappropriate, too bold, probably too disquieting. In contrast, *The Cornfield* is a peaceful rustic scene, set in a Suffolk lane. It was already known through an engraving and Constable had exhibited it a number of times, although it did not, in his lifetime, find a buyer.[6] This was not

from want of trying. Constable said he had deliberately given *The Cornfield* more 'eye-salve' than was usual with his Suffolk pictures, to make it appeal to public taste for the Picturesque. Various features which would have irritated local countrymen – a dead tree, a broken gate, a neglected flock of sheep, – were designed to soothe urban tourist tastes.[7]

Leslie's most enduring memorial to Constable was his book *Memoirs of the Life of John Constable*. This was first published in 1843, then again two years later in an expanded but cheaper version which has remained, through a number of editions, in print ever since. For the rest of the nineteenth century Leslie's book was virtually the only one on Constable, and until 1960 the most complete biographical account.[8] The book is largely made up from passages from Constable's letters and papers, carefully edited to promote a particular view of the painter. Constable emerges as a martyr for naturalism, struggling manfully against an uncomprehending public. Leslie highlights a series of naturalistic qualities in Constable – local knowledge, close observation, deep feeling, originality, independence – which were at the time part of a self-consciously Protestant, Anglo-Saxon cultural package with which other English critics, notably Ruskin, were defending English landscape and genre art. English artists were, or were to be, rugged individuals rooted in nature, free from the pedantry, mystery and mannerism critics found in Continental culture.[9]

A series of memorable anecdotes and phrases in Leslie's *Life* articulated Constable's naturalism. Constable does not just feel for nature, he knows it factually and functionally as a miller's son should: 'When I look at a mill painted by John, I see that it will *go round*', his brother Abram is quoted as saying, 'which is not always the case with those by other artists'. Constable's localism is established by the story of Constable travelling in a coach with two strangers to London from Suffolk: 'In passing the vale of Dedham, one of them remarked, on my saying it was beautiful, "Yes, sir, this is Constable's Country" '. Leslie reports on his own excursion to Suffolk three years after the painter's death:

> We found the scenery of eight or ten of our late friend's most important subjects might be enclosed by a few hundred yards at Flatford ... so startling was the resemblance of some of these scenes to the pictures of them, which we knew so well, that we could hardly believe we were for the first time standing on the ground from which they were painted.

Of other pictures, Leslie recognized that Constable 'had rather combined and varied the materials, than given exact views' but usually to improving effect, increasing the width of the river, introducing the tower of Dedham Church, and showing the waterwheel of Dedham Mill 'which in reality is hidden'. Constable's own thoughts and feelings are captured in ringing maxims:

> There is room enough for a natural painter ... I should paint my own places best; painting is with me but another word for feeling, and I associate 'my careless boyhood' with all that lies on the banks of the Stour; those scenes made me a painter ... Londoners with all their ingenuity as artists, know nothing of the feelings of a country life, the essence of landscape ... I never had a desire to see sights, and a gentleman's park is my aversion ... we see nothing truly till we understand it ... painting is a science and should be pursued as an inquiry into the laws of nature ... I am doomed never to see the living scenes [in Italy] that inspired the landscape of Wilson and Claude ... I was born to paint a happier land, my own dear old England.[10]

Leslie narrates Constable's neglect in England in his lifetime with the early history of *The Hay-wain* (Figure 2) documented in correspondence between Constable and his friend John Fisher. Failing to find a buyer upon exhibition at the Royal Academy in 1821 *The Hay-wain* is purchased by an Anglo-French dealer who exhibits it in Paris, where it is reputed to cause a sensation, and to be about to be purchased for the French nation: 'The stupid English public, which has no judgment of its own, will begin to think there is something in you if the French make your works national property', Fisher tells Constable. Constable is amused to 'think of the lovely valleys and peaceful farmhouses of Suffolk forming part of an exhibition to amuse the gay Parisians' but he is not tempted out of England himself: 'all this is amusing enough, but they cannot get at me on this side of the water, and I shall not go there'. Leslie is keen not to confine Constable as a painter of local topography. It is the painter's attention to atmosphere, weather, and climate, then seen as one of the keys to national character, which releases him from purely regional considerations. The picture Leslie spends most time describing, and which he finds unsurpassed in establishing Constable as 'the most genuine painter of the English landscape', is one of Hampstead Heath (Figure 3). This is valued not for its rendering of topography, but for its atmosphere: 'The sky is the blue of an English summer day, with large, but not threatening, clouds of silvery whiteness'.[11]

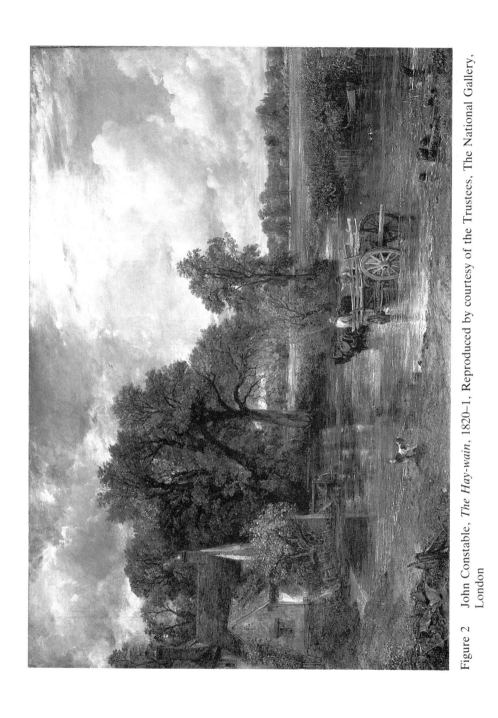

Figure 2 John Constable, *The Hay-wain*, 1820–1, Reproduced by courtesy of the Trustees, The National Gallery, London

Leslie edited out much of Constable's rancour from the correspondence and he was reticent about the painter's problems of conceptualizing his naturalism. Apart from his description of the Hampstead painting Leslie remained largely silent about the look of the pictures. Indeed the popular 1845 edition included only three illustrations, two of them portraits of Constable. At a time when there were few places Constable's paintings could be viewed, Constable, the man, his heart and mind, became, through Leslie's book, better known than his pictures.[12] But Leslie's book provided a rich resource for interpreting Constable's pictures when they did become better known. The third edition of 1896 was fully illustrated, as have been all editions since.

FORSAKEN NOOKS AND RUDE HEATHS

From the later 1840s Constable's pictures began to appear more frequently in the sale rooms, at more substantial prices, and to reach a wider audience through loan exhibitions and permanent acquisitions by national collections. After returning from France, *The Hay-wain* reappeared at Christie's in 1846, then again in 1853 and 1866. In 1866 it fetched £1,365. If major Turners and Landseers were fetching three times that figure, Constable's stock had risen appreciably since the knock-down prices for his work in the sale immediately after his death.[13]

Writings on Constable were published more frequently. The first extended account of his paintings was a chapter in Richard and Samuel Redgrave's *A Century of Painters of the English School* first published in 1866. This was largely based on the exhibition of Constable's pictures at the International Exhibition at the South Kensington Museum in 1862. A few years earlier Delacroix had claimed Constable as the 'father' of French painting and the Redgraves were intent to repatriate Constable. They did so by emphasizing his subjects, rather than (as had Delacroix) his style. Constable, the Redgraves maintained, 'was entirely English in the subjects he chose, locally English no doubt, but still purely English'. And, in contrast to the aggressive agricultural and industrial expansion of their own time, they saw Constable's works as picturesquely unproductive:

> Look at any or all his pictures and see how England rises before us – England in all her wealth of picturesque beauty – not 'trimmed and frounced', not clipped and cropped as the corn-manufacturers disfigure her; but English nature as it holds its own in our rude heaths and commons, and it reasserts itself in every forsaken nook and corner.[14]

Figure 3 John Constable, *Hampstead Heath, the House Called 'The Salt Box' in the distance*, c. 1820. The Tate Gallery, London

While the Redgraves admired the forsaken nook shown in *The Hay-wain*, they were more impressed by the rude commons shown in the pictures of Hampstead Heath. The heathland around London was then being threatened by what the Redgraves called 'the monster city'.[15] The Commons Preservation Society had been founded in 1865 with the object of securing 'for the use and enjoyment of the public open spaces, situated in the neighbourhood of towns, and especially of London'. Its first campaign was to resist the attempted enclosure of Hampstead Heath. Against the actual law of commons, they successfully promoted a myth of ancient rights and public access which, said one CPS official, had 'something of the attributes of ancient Saxon Folk-Land' and which was thought to have existed in England before the Industrial Revolution or the Enclosure Movement or the Reformation or the Norman Conquest, or whenever England's Fall from Grace was deemed to have begun. The campaign to secure Hampstead Heath for the public went on twenty years, as did the popularity of Constable's Heath pictures. In 1889, the 260 acres of Parliament Hill fields were added to this urban park.[16] That year Constable's *Hampstead Heath with Harrow in the Distance* was easily the most copied Constable in the National Gallery, second only in the entire collection, and only just, to Landseer's animal picture, *Dignity and Impudence*.[17]

THE SOUTH COUNTRY

In the last two decades of the nineteenth century interest in Constable quickened on a variety of fronts. His children released hundreds of oil paintings, oil sketches, drawings and watercolours, revealing a hitherto unknown range of subjects and styles. They had agreed that 'the most important examples' of their father's work 'should eventually become national property'. Isabel Constable made a number of gifts and bequests to national institutions: drawings and watercolours to the British Museum, oil studies, mainly of Hampstead and Brighton, to the Royal Academy, oil sketches and drawings showing Constable's development, including the watercolours of Stonehenge and Old Sarum, to the South Kensington Museum, which had a pronounced educational role, and to the National Gallery finished oils.

If for years Constable's reputation had run ahead of actual knowledge of his pictures, by the end of the century, in the original, or in the many prints and illustrations, his work was widely seen. A new edition of C. R. Leslie's *Life*, edited by his son G. D. Leslie, was published fully

illustrated in 1896, and in an article on Constable in the *Art Journal* seven years later, G. D. Leslie announced that 'Constable's pictures are now so well known and appreciated that there is no need here to dwell on their merits'.[18] Some in less familiar style did need a defence, and with it the portrayal of a less amiable figure than the nature lover of Leslie's biography. The palette knife sketches would not appeal to 'effeminate weaklings' announced James Orrock in 1895, being the work of a 'coarse and violent' man, 'masculine and muscular', 'a fighting, fearless man'.[19]

Prices for Constable's oil paintings escalated, and by the end of the century they were in the same league as those for Turner's. The £8,925 paid by the banker Sir Samuel Montagu for *Stratford Mill* was probably a record for an English landscape. When, the previous year, the American banker J. Pierpont Morgan purchased another six-footer, *The White Horse*, he started an export of major Constables to the United States. English collectors could not compete and were forced to fight over the market for smaller oils, watercolours, mezzotints, and the flood of imitations and forgeries.[20]

The new market for Constable helped to assuage later nineteenth-century fears about British art and culture. An editorial entitled 'Patriotism' in the *Art Journal* for 1888 noted that the reluctance of British citizens to buy British goods extended to pictures. They cheerfully subsidized the nation's foreign competitors, especially the new military-industrial might of Germany, by purchasing their pictures, along with their cheese and butter, even giving artistic awards to 'gentleman bearing foreign names'. Commodity patriotism was perhaps 'advancing slowly in the metropolis', 'but in the provinces patriotism in this form has not spread, and amongst the working class it has not been thought of'. Constable's pictures might provide a focus for a new patriotic consensus.[21]

After Henry Vaughan presented *The Hay-wain* to the National Gallery in 1886 it swiftly rose in popularity. By the turn of the century it seems to have become Constable's best-known picture, and well on its way to becoming a national icon.[22] In 1906 Herbert Tomkins, author of two popular books on Constable, noted that *The Hay-wain* was the largest Constable in the National Gallery, occupying a 'central position' and 'recently lingering before it, noticed how much earnest attention it elicited'. 'You cannot ramble long in London without seeing cheap prints, some good, some exceedingly bad and misleading, in shop windows'. *The Hay-wain* was biblical in its appeal:

On brightly coloured picture cards *The Hay-wain*, as I well know, is pored upon by tiny folk; the 'angel of the house' places it in her album of treasured views; the student copies it, or would fain to do so; I have even heard the 'unlettered hind' praise its fidelity to Nature. The pleasure created and distributed by such a picture as *The Hay-wain* is perhaps greater than that derived from any other human source, except perhaps only the book which is at once great and popular.[23]

Lewis Hind's 1909 book on Constable found *The Hay-wain* 'looks a little old fashioned ... a little solid, a little laboured' but this was its merit. Constable 'had worked with John Bull conscientiousness over every inch of the canvas'. 'Constable does not thrill. Roast beef does not thrill but it is wholesome and life-communicating'.[24]

The flood of Constable pictures, both real and imitation, in good prints and bad, prompted the first systematic attempt to catalogue Constable's work and assess his merits in terms of the history of European art. Charles Holmes's *Constable and his Influence on Land-scape Painting* (1902) became a standard text for over half a century.[25] Holmes was keen to criticize the vulgarization of Constable in prints 'a shade of warm brown' which made Constable look just like all his bland imitators. Holmes chided Constable himself for his reputation, for providing 'recipes' for 'artisans' to paint routine 'rustic landscape with figures', to decorate the villas of a middle class 'resting complacently after the strain of the Napoleonic wars'. And Holmes criticized too topographical a reading of Constable, one which put him in terms of the places English people liked to dote on, not the great tradition of European landscape art. Again Holmes chided Constable, for approaching his work like the ramblers Holmes despised:

His attitude to his work is like that of the average British traveller as opposed to the more methodical researches of the German savant. He plunges boldly enough into the unknown, notes an interesting fact here, another there, and by his very audacity, his carelessness, and his self-reliance covers more ground and collects more specimens than his more deliberate rival. The published account of his travels is thus sure to be entertaining reading, full of adventure, failures and successes, but as a lasting contribution to knowledge it will probably have less permanent value than the duller and narrower, but better arranged, more concen-trated, and more thorough work of the Teuton.

The Hay-wain was a case in point.

What is the main thing that the picture is intended to emphasize? Is it Willy Lot's cottage and the trees by it? If so we might cut off the right hand half of the picture. The incident in the foreground, from which the work takes its present name, is carefully painted, but would show to better advantage if treated with less importunate facts all around it. Consider the picture carefully, and you will recognize that it emphasizes nothing at all. It is merely an aggregate of circumstances suggesting fine weather.[26]

Holmes's connoisseurship carried great authority but it was sometimes resented by Constable's populist admirers.[27] If Constable's pictures fell apart under Holmes's scrutiny, they knew what held them together, their resemblance to the places they depicted and places like them, places which beckoned those in search of rural England. Constable's popular admirers were interested not so much in painting as in scenery.

It took over half a century for a precise locational appreciation of Constable to develop. Even Constable's admirers had been a little hazy about the whereabouts of the country he painted. In his popular handbooks for the 1857 Art Treasures exhibition at Manchester and the 1862 International Exhibition at South Kensington, Tom Taylor made much of Constable's intense feelings for his native scenes but located them in Sussex.[28] James Orrock's 'coarse and violent' Constable was a native of the Midlands.[29] An article on the Wiltshire Avon in the *Art Journal* of 1888 claimed that this was as much Constable Country as the Stour because it flowed in the foreground of the paintings of Salisbury Cathedral and, if not in the pictures of Stonehenge or Old Sarum, was not in actuality too far away. After all, the article ended, the Stour is the Avon's greatest tributary, which is true, though this River Stour is two hundred miles from the one where Constable painted.[30]

By the 1890s there were coach tours to Constable Country in the genuine Stour Valley organized by Thomas Cook and the Great Eastern Railway.[31] A vague knowledge of Constable's art could prove an advantage here. The Great Eastern Guidebook declared that 'to enjoy it you need not be a collector – a single picture runs into thousands – or even an admirer of Constable, although there are few cooler spots in London on a summer's day, than in front of one of his pictures at the National Gallery or South Kensington Museum'.[32] But precision was expected of what were now called 'pilgrims'. In his book on Constable Country of 1906 Herbert Tomkins reported that you could buy photographs of Constable paintings in Dedham to match with their sites. At the viewpoint for *The Hay-wain*, 'the most important spot on my rambles', Tomkins stood glancing from the reproduction to the 'origi-

nal' (that is the site) and back. If Constable had increased the width of the river, by Tomkins's time the trees to the right of the millstream had grown to obscure the meadow, funnelling the view to the left, creating one of those picturesque riverside scenes so popular in this period. What struck Tomkins was not the specificity of *The Hay-wain* but its typicality: 'Here is a small house beside a mill-stream, overshadowed by trees – a stream to which the farm men at times lead horses to drink. The scene does not differ from many such in England'. Looking at the original in London had the same effect:

> Go into the National Gallery, view that landscape steadily and sympathetically from a sufficient distance, and presently the frame, the wall, the gallery itself is gone, and you are looking, not upon *The Hay-wain* by Constable, but upon a scene by a riverside in the full light of noonday, a scene typical of the England you know so well.

A visit to Constable Country could both bring his pictures into tight, local focus and disperse them into a more typical image of the nation at large.[33]

The Hay-wain was sufficiently typical in 1916 to illustrate a piece in *Country Life* on the love that makes men die for 'England's Green and Pleasant Land', a selection of 'noble things' from Shakespeare, Spenser, Keats and Wordsworth 'written of our "little world" '.[34] Languid little England pastoral was a central ingredient of wartime patriotism. In a 1918 essay on 'Patriotism in literature' Quiller-Couch considered that the Englishman found less satisfaction in loudmouthing 'Rule Britannia' in the style of 'Deutschland über Alles' than in meditating on the 'green nook of his youth ... where the folk are slow, but where there is seed-time and harvest', whether this green nook was in Yorkshire or Derbyshire or in softer southern counties like Devon and Kent.[35] This was not just official propaganda. The experience and memory of the trenches enhanced the allure of pastoral England as a refuge from the absurd theatre of Flanders, that boundless, discomposed land, a no man's land, an anti-landscape. At the front Ford Madox Ford had dreamed of this English pastoral, 'not quite a landscape, a nook rather ... the closed end of a valley; closed up by trees ... a sanctuary'.[36]

Views of *The Hay-wain* along the millstream focused on the farmhouse known as Willy Lot's House or Cottage. Leslie's biography had mentioned it as 'a principal object in many of Constable's pictures', 'the most exact view' occuring in the engraving entitled 'A Mill Stream' for *English Landscape Scenery*.[37] Here, from the forecourt of Flatford Mill,

more of the house is seen than in *The Hay-wain* and it dominates the view. The house was also well known from the mid nineteenth century, in an upstream view, as the subject of *The Valley Farm*, the second of Constable's pictures donated to the National Gallery in 1847, and popular as an engraving.[38] What gave Willy Lot's house its symbolic gravity was Leslie's assertion, repeated in almost every mention of the house, that 'its possessor was born in it; and, it is said, has passed more than eighty years without having spent four whole days away from it'.[39] Here was an emblem of the sturdy English yeoman. *The Valley Farm* was reproduced in an 1877 book, *Home Life in England*, which saw the Willy Lots of rural England as ideal breeding stock for the colonies. Such houses as his would have a 'mystic interest' 'when in distant ages the triumphant spread of the English race was a subject of antiquarian enquiry'.[40]

The way Constable depicted Willy Lot's house in *The Hay-wain* made it available to two versions of domestic pastoral. It could be seen as a sturdy farmhouse, neatly tiled and plastered, as plain and durable as the farmer who inhabited it. Ot it could be seen as a pretty cottage, by focusing on the creeping foliage, the puff of hearth smoke, and the woman washing or drawing water from the stream.[41] Such are the illustrations, from Surrey, in Helen Allingham's *Cottage Homes of England* (1909), which claimed *The Hay-wain* as a cottage picture and Constable as a cottage painter. 'Constable painted these homely subjects in a way which has never been surpassed'. The Old English cottage was 'the most typical thing in England': unlike noble mansions or modern houses 'the old cottage prefers to nestle snugly in shady valleys. The trees grow closely about it in an intimate familiar way'.[42]

Constable Country, in the form of *The Hay-wain*, pictures the metaphor of 'the South Country' as the essential England, a metaphor which became compelling across the whole political spectrum from the later nineteenth century. The South Country was, as Alun Howkins has pointed out, not so much a coherent region (parts of the Midlands and northern England were included, parts of eastern and south-western England left out) as 'a set of yardsticks of rurality'.[43] A number of social and economic developments can be held to account for the allure of the South Country. These include the loss of industrial supremacy to Germany and the United States, and with it the displacement of a 'north country' metaphor of England as the workshop of the world. It is from the 1880s that the industrial revolution became seen as an unEnglish aberration, 'a spread over a green and pleasant land of dark satanic mills

that ground down their inmates ... an image sharpened by the contemporary growth of industrial discontent and social criticism'.[44] Also the South Country can be seen as a projection of growing imperial and financial power centred on London, a suburban little place in the country which compensated for aggression and alienation overseas or in the metropolis itself.[45] The economic decline and depopulation of agricultural counties like Suffolk, the deflation of the cultural pressure they still exerted in Constable's time, certainly made it easier for metropolitan interests to remake them in their own image.[46]

But rural weakness could undermine the very image it made possible. From the turn of the century the rhetoric of Constable Country is more urgently informed by a sense of vulnerability, to invasive rashes of modern development or to slow internal decay. There were warning signs at the end of the century. In an article of 1891 in the *Magazine of Art*, C. L. Burns found Dedham Mill 'improved ... into hideousness', land in East Bergholt newly built over and the sites of old buildings there reverting to grass. But Flatford seemed to be in good shape. The site of *The Hay-wain* was animated, beyond anything in Constable's pictures, and shown as such by Burns (Figures 4, 5):

> The milltail is used as a thoroughfare, up which the hay is carted from the meadows on the opposite bank of the river ... Down this backwater in July the heavy cart-horses drag the sweet-scented haywains knee deep and axle deep in water, leaving feathery wisps of hay hanging from the willows, and clinging to the tail rushes upon either hand, the waggoner bravely astride the leader, while haymakers and children are seated on the top of the load, not a little nervous in mid-stream, and clinging tightly when the horses are struggling up the descent into the stack yard.

For the rest of the year 'solitude ... reigns supreme in the silent, currentless backwater', wonderful for weeds and wildflowers but intimating rural decay. The working world beyond the millstream provided a measure of reassurance:

> The silence would become oppressive were it not for an indistinct murmur from the working world, which forms a fitful background to the prevailing stillness; the distant roar of a train as it rushes on its journey to the palpitating heart of London, the faint sound of a mowing machine in the meadows, or the crack of a whip from the tow path as a barge moves up to the primitive lock, add a touch of human interest without disturbing the sense of restfulness from the eager hurry of the nineteenth century.[47]

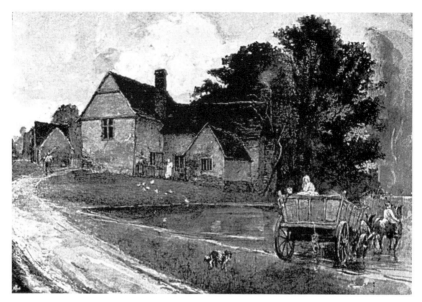

Figure 4 C. L. Burns, *Willy Lot's House at Flatford*, from *Magazine of Art*, 1891

Figure 5 C. L. Burns, *The Blackwater at Flatford*, from *Magazine of Art*, 1891

A NEW CENTURY CRUSADE

By the twentieth century the condition of Flatford seemed more disturbing. In 1924 E. V. Lucas reported a 'tall chimney' at Flatford which 'indicates that water power has a rival' and the dereliction of Willy Lot's Cottage, 'empty on its road to ruin'.[48] Steam power could not save Flatford Mill and soon it fell silent. A campaign was mounted to save the whole site. After the successful purchase and restoration of the land and buildings and conversion to a public trust, Flatford Mill Estate, the warden, Herbert Cornish, told the story of the rescue in his book *The Constable Country* and in a way which projected a modernist version of preservation.

In 1925 'pilgrims' to the painter's native scenes turned from the 'roaring highway' of the London Road and 'vanished from the new century scene into the green and russet mysteries of Constable Country'. They went from East Berhgolt down into the 'sleepy hollow' at Flatford. Here they took the old cart road to Willy Lot's house. It was imperative to rescue the house from 'ruin or the perils of pseudo-restoration'. With that resolve the reverie in the stagnant air of the nineteenth century was abruptly ended: 'our pilgrims awoke from the perfect daydream to find themselves arrayed ... in the panoply of a new century crusade'.[49]

While the National Trust and Society for the Protection of Ancient Buildings fussed about money for repair and maintenance in stepped a strong figure of cultural renewal to finance the work. After studying at the Ipswich School of Art in the 1870s, A. L. Parkington made his fortune designing and improving gold mining equipment in South Africa and after his return was, in Cornish's words, 'largely employed in developing estates at home, in executing public works, including many of the more modern halls of public assembly and educational institutions in the four counties of East Anglia'. Moreover 'he anticipated public action in acknowledgment of a national responsibility, by building, immediately after the War, fifty houses for occupation by ex-soldiers and their families'.[50] Willy Lot's house would symbolize those homes fit for heroes, with a modernist aesthetic of clear order and truth to materials. When we compare the photograph of the house in decay (Figure 6) in Cornish's book with the line drawing of restoration (Figure 7) we can see the force of the modernist aesthetic: 'Neat, calm and light' writes Alex Potts. it 'could signify ideas of order and health appropriate to a rationally modernized society emerging from the

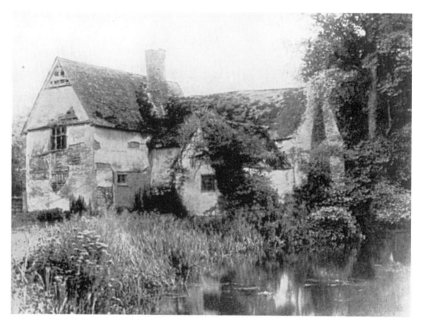

Figure 6 *Willy Lot's Cottage as Found by the Restorers, September 1926*, from Herbert Cornish, *The Constable Country*, 1932

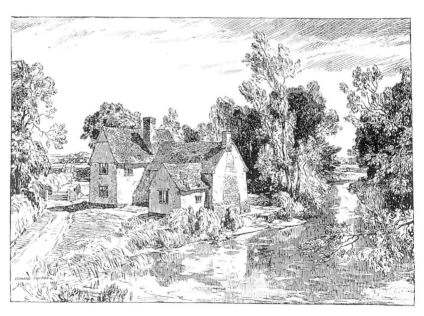

Figure 7 Leonard Squirrell, *Willy Lot's Cottage, from a window of Flatford Mill*, July 1928. From Herbert Cornish, *The Constable Country*, 1932

gloom, disorder and dirt of Victorianism – both new and organically related to the past at the same time'.[51]

Order and health were the key issue throughout the area. 'The Constable Country, to the enlightened mind', declared Cornish, 'is one living organism: of which the heart is Flatford.'

> And in such a living organism the heart is vital. While the heart is strong in its own health, well guarded from assault, untoward accident or overstrain, and well preserved against degenerative agencies, then throughout the organism there is action and reaction of self-renewing life.

On the accompanying map, the living organism of Constable Country stretches, well beyond the places Constable painted, from Lavenham in the west to Felixstowe in the east, from Colchester in the south to Woodbridge in the north. The industrial town of Ipswich is singled out, illustrated by a little-known view by Constable of the port there, lined with warehouses and plied by river traffic, and a series of modern aerial photographs of the docks and the town centre, 'the heart of the town'. While marked by 'these hundred years of industrial rush and ravage', Ipswich was still in its civic pride 'very human and intensely English'. Despite, or perhaps because of, its commercial vigour, it had never 'lost hold of the essential threads of vitalizing intercourse between her present and past; between them both and the future; between the town life and the country life ...'.

> For growth and change are not the natural enemies of preservation. It is when they are deforming and incongruous that they disfigure and destroy. The Constable Country is the Constable Country after a hundred years, not because a condition merely or mainly static, but rather because it has grown while it stood ... So that its past and present and, we may hope, its future, grow onwards together in continuous organic unity.[52]

Haphazard, ramshackle developments might threaten Constable Country but not those which were well planned and securely built. The reconstruction of Flatford Lock promised a change from the site of an 'occasional horse drawn barge' to the 'prospect of some revival of that moribund commerce'. Road improvements were invigorating. The London road from the City, the heart of the Empire, 'the vortex that whirls before ... Mansion House', was now a symbol of the power of Great Highways. These not only protected byways, 'the blessed state of bywayhood', at Flatford, but were arteries of energy for lesser veins.

From year to year, its makers and re-makers have advanced in zeal of
seeking, and of learning, how they may reconcile their straightenings and
broadenings, their by-passing and re-gradienting, with the laws of natural
growth and the gracious orderings of enlightened acts of change, the
virtuous observance of which orderings makes growth and change rather
the helpers than the enemies of preservation.

'The great minds among our projectors and engineers of ways and
waters, of power and light' brought 'an enlarging dimension of the
breadth of mind that is able to comprehend the vital need of preserva-
tion in the self-same largeness of embracing thought'.[53]

This modernist vision – panoramic, lucid, vigorous, functional,
forward-looking – can be found in much of the writing on, and depic-
tion of, rural England in the inter-war years. As David Matless has
shown, this vision was not predicated on an opposition between new and
old, town and country, but between order and disorder. The dirt and
darkness of Victorian times, as well as the sham restoration and
muddled commercial development of modern times, would be cleansed
and illuminated by the power of synoptic planning and preservation, as
exemplified by the national grid, arterial roads and national parks. The
new order would recall the freshly planned, properly managed, country-
side of Georgian England. An orderly England would replace decay and
chaos with sweetness and light.[54]

This vision of order is the basis of the 1929 pastiche of *The Hay-wain*
(Figure 8) by the *Daily Express* cartoonist, Sydney Strube. The *Daily
Express* was in the vanguard of modernist patriotism, promoting an
all-electric society of clean, efficient domesticity for its suburban,
middle-class readership. In Strube's cartoons the new, flourishing
English home and garden, often cultivated by a clerk-like man and his
wife, is contrasted to the violence and confusion of foreign national-
ism.[55] In Strube's *Hay-wain* cartoon the violence and confusion are the
product of brash, unbridled commercial development, then often seen
as patently American. Huge billboards advertizing beer, tobacco and
tyres have been erected in the meadow and on the stream bank. The
cart now carries 'Coals'. The cart track has been converted to a motor
road. A petrol station occupies the foreground. A sign on the roof of
Willy Lot's house announces 'Teas'. This is precisely the kind of
disorderly development the new Council for the Protection of Rural
England wished to eradicate. They exhibited Strube's cartoon as a
poster at their travelling 'Save-the-Countryside' exhibition of 1929
(alongside a reproduction of the original painting) and issued a postcard
of it too. Another postcard issued for the exhibition shows orderly

Figure 8 Sydney Strube, *Had John Constable Lived Today*, from *Daily Express*, 2 March 1929. Reproduced by permission of the *Daily Express*

England fighting back, St George, in medieval armour but sporting a 1920s haircut, slaying a dragon marked 'cigarettes, petrol, tyres' emerging from a chaotic, polluted landscape, the knight defending a neat, hygienic English village, a wife and two children.[56]

In the 1930s a modernist Constable emerged in the writings of art critics and connoisseurs. The large sketch for *Hadleigh Castle*, purchased by the National Gallery in 1935, was proof, said Charles Holmes, of Constable's 'modernity' and 'power', that the artist had broken free of a 'staid, static' tradition.[57] Constable's centenary year of 1937 was a further occasion for modernist re-visioning. An exhibition of his works in London charted Constable as a forerunner of all styles of *avant-garde* painting, culminating in that of Cezanne.[58] In an article that year for the *Architectural Review* John Piper concentrated on the energy and abstraction of Constable's sketches and drawings. Constable 'made the Impressionist movement, and ultimately the whole of the modern movement, possible and necessary'.[59] A centenary volume on Constable's art summarized Constable's modernism:

> Today the art of Constable satisfies the nostalgia of ill-urbanized men, but it was not created out of nostalgia: it was created out of acceptance. He celebrated the world he belonged to, as his counterpart today must celebrate pylons and aeroplanes and concrete.[60]

REACH FOR THE SKY

The threat of invasion in the Second World War prompted an outpouring of patriotic works on British land and life, environment and character, which echoed that during the Napoleonic Wars. If Constable himself had volunteered patriotic scenes during hostilities against Napoleonic France, he was enlisted a century later in the struggle against Nazi Germany. In a 1942 volume in Batsford's *Face of Britain* series, S. P. Mais looked across the Stour Valley where 'Constable has set down for all time ... the countryside which it is our privilege to defend against the gates of hell infernal itself'.[61]

Contemporaries saw in Constable's pictures the sturdy, vernacular culture, rooted in Tudor England, which, more than any other, was seen to epitomize the nation. But it was difficult to pretend that modern Suffolk fulfilled this vision. Julian Tennyson's *Suffolk Scene*, written in 1938 and reprinted in every year of the war, acknowledged that with prices of farms tumbling since the 1920s 'the smallholder is in a bad way'. 'A really well kept building is a surprising sight in Suffolk'. But while Suffolk was 'poor in purse, in spirit it is strong, solid and persevering'. This spirit was symbolized by the best-kept farmbuilding in Suffolk, although no longer a functioning one: Willy Lot's house. Here was 'the true spirit of England'. 'Sitting here, I imagined old Willy poking his whiskered face out of the cottage window at dinner-time with a hunk of bread in his hand ... He looks across the pool: "What be yew a doin' on, John boy? Be a paintin' the 'ould farm again, hey?"'[62]

Willy Lot's house appeared frequently and prominently in publications on English art, landscape and architecture. Since Flatford Mill had opened as an arts and field studies centre, it had arguably become the best-known farmhouse in England. In 1943–4 Willy Lot's house was presented (with Flatford Mill) to the National Trust. In a 1945 volume issued by the National Trust to commemorate their Diamond Jubilee, the portion of *The Hay-wain* showing Willy Lot's house was reproduced as the frontispiece; a passage on the house included in a chapter on 'historic shrines' declared that 'no building in England is more surely a national trust'.[63] The *English Cottages and Farmhouses* volume of Collins's *Britain in Pictures* series gave Willy Lot's house pride of place in a passage which upheld East Anglia as the heartland of yeoman independence, its Tudor farmhouses 'ample in proportion, without ostentation, and comely in design'.[64] In his 1945 booklet on *The Hay-wain*, Kenneth Clark found Willy Lot's house the 'subject' of the

picture, 'a symbol of rustic peace'. This involved qualifying the modernist, pan-European reputation Constable had been attributed before the war. Those 'whose eyes have been dilated by half a century of impressionism' had come to prefer the less finished full-scale oil sketch of *The Hay-wain*; but it was, Clark maintained, in the final picture that its 'enduring qualities' showed, that it took on its atmosphere of 'calm and happiness'. *The Hay-wain* was the turning point in Constable's 'long, stubborn, independent struggle', and his 'obstinate provinciality and hatred of foreigners, though using language of stupidity, was probably the expression of a wise instinct'.[65]

Constable's skies were commandered for the war effort. They feature prominently in the *British Weather* volume of the *Britain in Pictures* series, a volume which upholds the English sky not just as a reflection of national character but, no less than the sea, a 'natural advantage' in times of war.[66] The war in the air was largely launched from the eastern counties and seen to protect the landscape there. An essay in a 1946 volume on *Countryside Character* described how 'from the midst of these wheatlands and meadows, from among the centuries of old cottages, with their straw thatch and oak beams, the huge bomber fleets were airborne which pulped the heart of Hitler's Reich'.[67] A series of paintings, which Pyrs Gruffudd has termed 'RAF Pastoral', show the vapour-trailing Spitfires swooping among the clouds above Constable-style countryside. But there was always some ambivalence about the spectacle of air-power. Horses and carts in these paintings are sometimes startled by the machines overhead. It was Rex Warner's wartime novel *The Aerodrome* which juxtaposed the archaic quaintness of an English village with the modernity of the neighbouring fascist airbase. The speed, power and modernity of aeroplanes had always been part of a right-wing ideology it was no longer patriotic to endorse.[68]

ENGLAND OF THE BOMBING RANGE

The close relation between rural preservation and town and country planning which had subsisted before the war, and which had sustained a modernist aesthetics of landscape, began to break apart after it. Planning was added to the litany of forces despoiling rural England.[69] Landscape became defined more clearly in anti-modernist terms. The last chapter of W. G. Hoskins's *The Making of the English Landscape* (1955) declared that since 1914 'every single change in the English landscape has either uglified it or destroyed its meaning, or both'. A

ravaged English countryside was being carved up by bureaucrats Hoskins called 'the atom men'.

> England of the Nissen hut, the 'pre-fab', and the electric fence. England of the arterial by-pass, treeless and stinking of diesel oil, murderous with lorries ... England of the bombing range ... of high explosive ... Barbaric England of the scientists, the military men, and the politicians.

Development in East Anglia epitomized the destruction of England. Bulldozers rammed old hedges 'for the machines of the new ranch farming', airfields 'have flayed it bare', and 'over them drones, day after day, the obscene shape of the atom bomber, laying a trail like a filthy slug upon Constable's and Gainsborough's sky'.[70]

The 1960 *Shell Guide to Suffolk* found the county 'threatened by forces more potentially devastating than anything realized or rumoured since the Romans departed': ' "outline planning permission" ... to build all over East Anglia and West Suffolk' for London 'overspill' (a word, according to W. G. Hoskins, 'as beastly as the thing it describes'). So now after long suffering decay and dereliction, Suffolk was threatened, through rising population as well as modern farming, with growth. Proposals to build 450 new houses in Constable's home village of East Bergholt were only defeated after a two-day enquiry, after which 'the struggle was transferred to Stratford St. Mary – in the middle of Dedham Vale – whose water-mill still attracts young anglers as it did when Constable made it a subject of one of his six-foot canvasses'.[71] A Dedham Vale Society kept up pressure against the threats to the area, which now included insensitive water-management and large-scale leisure facilities as well as the traditional bugbears of billboards, electric wires and modern farming techniques. And they were successful. In 1970 Dedham Vale was designated an Area of Outstanding Natural Beauty. Even those who had not been there, or even been moved by Constable, declared a writer for *Country Life*, 'will recognize the Vale as the physical realization of the ideal rural scene of every Englishman's dreams'.[72]

THE 'FEILD OF WATERLOO'

As Constable Country on the ground was being conserved as a rustic retreat, the Constable Country of academic enquiry was being opened up to vigorous, sometimes brash developments. Graham Reynolds's

1965 book on Constable, the first full account since Leslie's *Life*, opened by stating that 'it is hardly an exaggeration to call him an industrial landscape painter'. This was not just because of the intense productivity of the land Constable painted but because of the 'vital modern factor' of the canalization of the Stour, 'the visible basis for Constable's art', with its locks, sluices, bridges, cuts and dams.[73] A 1971 exhibition on Constable at the Tate Gallery challenged the received image of the natural painter, who 'loved nature and painted it without affection'. It presented Constable as a sharper, more complicated artist, concerned with the problems of conceptualizing his art. 'The art of seeing nature is a thing almost as much to be acquired as the art of reading the Egyptian hieroglyphics' runs the quotation from Constable which prefaces the catalogue. Constable is also seen grappling with a changeful, sometimes turbulent countryside.

> The English countryside, commonly seen (at least by historians of landscape painting) as a place of eternal calm and contentment, in Constable's day underwent considerable change. Reorganization of agriculture – more efficient planning and mechanization – could be a very mixed blessing. While some profited, many suffered and there was widespread uncertainty.[74]

In the scholarly literature on Constable from the 1970s the pictures emerge once more as powerful, monumental images, engaging with the forces and relations of rural production if only to subdue their impact. In discussions of *The Hay-wain* the focus shifts from the homely nook around Willy Lot's house out to the hay meadow where reapers are working and another haycart being filled (a part of the picture which had rarely been noticed, indeed was often cropped in reproduction). *The Hay-wain* is seen as a managerial survey of harvesting, the very fragmentation of work into isolated segments pointing to 'a contemporary model of alienated labour ... workers' actions on an assembly line'.[75]

This sociological perspective on Constable reflected a new English cultural history, epitomized by John Berger's *Ways of Seeing* (1972) and Raymond Williams's *The Country and the City* (1973), which explored the social construction of rural imagery, probing the social tensions such imagery often masked.[76] The Tate Gallery's 'Landscape in Britain' exhibition of 1973 situated Constable in a complex genealogy of rural representation, including works which challenged any comforting picture of the Georgian countryside.[77] The catalogue to the Bicentenary

Constable Exhibition at the Tate in 1976 opened with a review of the social and political manouevres of the art scene in Constable's time prefaced by the painter's comment: 'The feild of Waterloo is a feild of mercy to ours'.[78] The exhibition provoked a powerful and complex interest in the politics of Constable's art.

Showing also in 1976, across the Thames at the Hayward Gallery, and in many ways prefiguring the Constable show, was an exhibition on another painter of iconic rural scenes: Jean-François Millet. The prominence of figures in Millet's paintings and the social issues they raised – of the formulae of relating land and labour, of the respective gazes in and around the paintings – shaped many reviews and previews of the Constable show. In highly animated reviews, art journalists for the Sunday papers and weeklies went out of their way to discuss, from a variety of ideological positions, the figures in Constable's paintings and their role, if only *in absentia*, in the meaning of the pictures.[79] Other columns took up the issue.

In his *Times* column Bernard Levin compared Millet and Constable. He found 'many, perhaps most, of Constable's landscapes devoid of figures ... with Millet the exact opposite is true; only a handful are of nature without man, and in almost all of the rest humanity rules'. 'And yet it is Constable who provides the more intensely human experience'. This, for Levin, had less to do with what he called Millet's 'didacticism', or the difference between Suffolk and the Auvergne, than the fact that 'Constable is more English than Millet is French'. 'The English spirit at its finest suffuses Constable's work; I quite astonished myself at the feeling of rootedness I had by the time I left the Tate'. Constable had none of 'the torments of Turner, none of the social ambiguity of Gainsborough, none of the disturbing passion of Blake ... He takes us gently by the hand and leads us before the scenes he loved'. The show, in Levin's eyes, redeemed the Tate's reputation after the affair of Carl André's brick sculpture, the occasion for one of Levin's familiar assaults on what he saw as an unholy alliance between the modern art establishment and the ailing Labour government's Arts ministry under Hugh Jenkins.[80] Three months later Levin's pastoral reverie in Constable Country was rudely disturbed by a correspondent to the *Guardian* ('Alas, where else?' he sighed). The letter found Constable 'firmly on the side of the ruling classes'. It complained that Constable never showed agricultural workers burning ricks, that 'his family possessed the land, that Constable took possession of its visual appearance', that Constable's 'obsession with the sky' was part of his 'desire to avert his eyes from the real social conditions'. 'Well, the filthy Fascist sod',

exclaimed Levin in a piece which turned into one of his familiar tirades against leftist cultural politics and which was illustrated by a photograph of Hitler and Mussolini in an open car entitled '*The Hay-wain*'.[81]

Now, as 1976 recedes into the past that is another country, we might speculate more widely on why it was so difficult then to sustain a settled view of Constable, why his art seemed socially troubling, his landscapes to have a darker side. It was more than a matter of Millet or an influential new social history undermining the calm of Georgian England. Social relations then were sharper, more bitter. Racial tension, culminating in the urban riots of the summer of 1976, was at the centre of debates on English national identity.[82] Labour disputes were frequent; Britain was, in the phrase of the time, 'strike bound'. And the labour unrest of the mid-1970s was not confined to industry. There was the last ripple of organized protest from farmworkers. The countryside has not become the plush, gentrified commuter-land we see now throughout southern England.

GREENHAM PLEASANT LAND

By the early 1980s the pastoral version of Constable Country was, under the shadow of nuclear war, being reclaimed by radical patriots. Peter Kennard's photomontage *Haywain–Cruise Missiles* (Figure 9) became the most famous image of the Campaign for Nuclear Disarmament. It first appeared in the radical photographic journal *Camerawork* overlain by three quotations: one from the *Daily Telegraph* assuring its readers that 'The Cruise Missile makes no noise, and the only inconvenience the local population will experience is the occasional sight of the missile launchers on the roads', another from John Selwyn Gummer, MP for Eye in Suffolk, asserting that 'we shall not be led astray by all kinds of populist comments ... the people of Suffolk are proud to help in the defence of Britain' and, in banner headlines, Constable's declaration 'There never has been an age, however rude and uncultivated, in which the love of landscape has not in some way been manifested'. Kennard's montage prefaced an extract on Cruise Missiles from an essay by E. P. Thompson, *The State of the Nation*.

> These missiles ... can be dragged around our country lanes on trans-
> porters carrying three at a time. They are not to be kept together, but will
> be dotted individually around the place. The enemy ... must obliterate all
> East Anglia and south and central England to find them out. So, so far

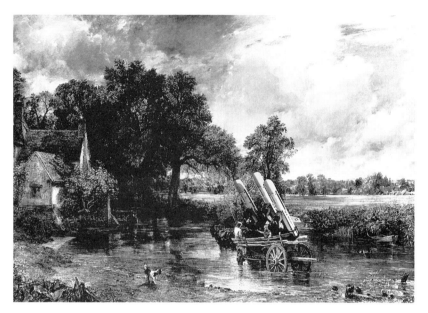

Figure 9 Peter Kennard, *The Hay-wain, Constable (1821) Cruise Missiles, USA (1981)*, 1983. Reproduced by kind permission of Peter Kennard

from 'deterring' the 'enemy', the presence of these missiles here will provoke and draw down upon us these strikes. Civil Liberties and Cruise missiles cannot coexist in this island together. East Anglia is not the Nevada desert'.[83]

A long history of Little-English rhetoric is packed into this anti-nuclear pastoral. Specific to the 1980s was a feminist inflection, the discourse of the Greenham Common Peace Camp, Cruise Missiles as rampant masculinist weapons despoiling, in the words of another CND poster, 'England's Greenham Pleasant Land'.[84]

We can chart the pastoral reclamation of Constable in the writings of Peter Fuller. In his review of the 1976 bicentenary exhibition Fuller lists the oppressions of the rural labourers: 'we look in vain for any of this' in Constable's art, he observes.[85] Five years later in a 1981 essay on Kennard's montage Fuller counterpoints the 'absolute despair' symbolized by Cruise Missiles to the 'aesthetic wholeness' of Constable's painting. 'the fuller realization of human sensual and perceptual potentialities within a world transformed'. The 'aesthetically satisfying world

view' of *The Hay-wain* is mapped on to 'our green and pleasant land'. 'We should do our part in helping to ensure that *The Hay-wain* carries no alien cargo into East Anglia'.[86] In a 1986 essay yoking Constable's vision of Suffolk with that of the Australian painter Arthur Boyd, the aliens include agribusiness, the Sizewell B nuclear reprocessing plant, American warplanes heading for Tripoli and the 'ugly breeze blocks which the "National Trust", of all organizations, is using to erect new public conveniences' at Flatford.[87] Constable was incorporated in an anti-modernist English pastoral which both radical and conservative patriots used to reproach the American style of the Thatcher government.[88]

THE 'GREAT LONDON'

The 1991 Constable exhibition at the Tate Gallery was organized geographically rather than chronologically, in terms of the various places Constable painted, rather than the periods when he painted them. This had the effect of settling down the image of Constable, indeed of discovering a conservationist version of the natural painter. The *Times* reviewer was relieved:

> The 1976 show achieved some notoriety – perhaps appropriate to its era – for taking a strongly political line on Constable ... Today this faint aura of disapproval has been banished. If anything, we are invited to see Constable rather as a caring man, concerned for the environment and conservative only in wanting to preserve continuity with nature and the good things of the past.[89]

Many of the 1991 catalogue entries were intent to straighten out interpretative controversies over Constable, if only by refusing the legitimacy of many readings of the pictures which were not grounded in (what were confidently presented as) physical facts about the places painted or the painted canvas itself. Constable's Suffolk in this catalogue was no longer a tense or complicated place but an agreeable one 'in which much remains comparatively unchanged'.[90] It is as if the affluence of the 1980s, which gentrified so much of East Anglia, restoring the most remote of rural buildings, had helped to congeal Constable's countryside.[91] The moral force of historic and nature conservation, increasingly seen as a condition of the enterprise culture, not a barrier to it, recommended the countryside to a range of interests, not least to the Bank which sponsored the Constable exhibition:

'Constable Country' is an especially evocative phrase to all who know and love England and the English countryside. Barclays' roots in that part of the world are particularly deep. Our modern world of high finance and international banking shows a proper concern for all aspects of our environment, but especially for the countryside.[92]

If the geographical organization of the exhibition had had the effect of closing down Suffolk, it opened up other Constable countries – Salisbury, Brighton, Hampstead, London – which have largely been overlooked in the twentieth century. Indeed a paradox of the exhibition was how Constable stood out less as a rustic painter than as a civic one. Seen together the Brighton pictures chart the development boom of the 1820s under the patronage of the Prince Regent and much of its bustle: the new houses, hotels, bathing machines, the Chain Pier, the collier brigs unloading coal, 'Piccadilly ... by the seaside' Constable called it. The Hampstead pictures emerge as an album of metropolitan culture, in the gravel-digging for building, the groups of promenaders, the panoramic views of the London region, the prospects of the City and Westminster. The six pictures in the evolution of *The Opening of Waterloo Bridge*, the 'great London', Constable called it, present varying versions of a great piece of civic theatre set in central London on the Thames.[93]

Traditionally writers on Constable have quoted the maxims from Leslie's *Life* which sum up Constable's hostility to London:

> I am hardly yet got reconciled to brick walls and dirty streets after leaving the endearing scenes of Suffolk ... in London nothing is to be seen, worth seeing, in the natural way ... Londoners with all their ingenuity as artists know nothing of the feeling of country life ... the essence of Landscape.[94]

But the very force of these phrases show that Constable was addressing the issue of London, not turning his back on it. London was where the power lay, not least the power of the art establishment represented by the Royal Academy, and Constable made the city his home. Constable's house in Charlotte Street may have been too surrounded by brick walls and dirty streets for him to appreciate London as landscape. But, as Peter Bishop has pointed out, when, from 1827, Constable makes Hampstead his permanent home (rather than just a summer retreat), and seldom visits Suffolk, London ceases to be just the shadow side of the Stour Valley.[95] Arguably it was the heights of Hampstead which gave Constable pictorial purchase on the capital's power, even as he was conscious of its ominous implications. The 1991 catalogue entry for a view from Constable's back window in Well Walk quotes Constable's declaration to Fisher in 1827 that it

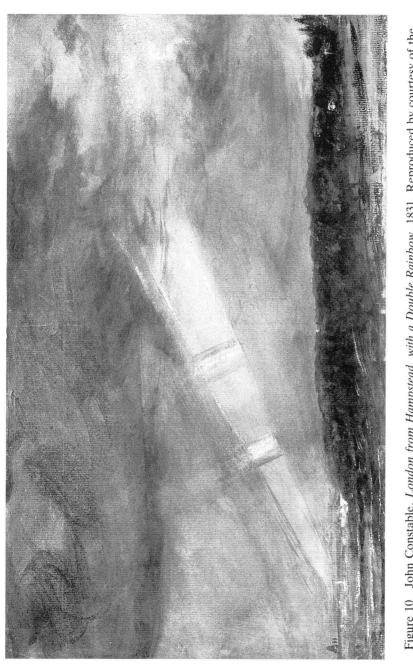

Figure 10 John Constable, *London from Hampstead, with a Double Rainbow*, 1831. Reproduced by courtesy of the Trustees, The British Museum, London.

> commands a view unequalled in Europe – from Westminster Abbey to
> Gravesend – the doom [*sic*] of St Paul's in the Air – realizes Michael
> Angelo's Idea on seeing that of the Pantheon – 'I will build such a thing in
> the Sky'.[96]

On the same page of the catalogue is another view over London from
Constable's house showing a great pillar of light, with a double rainbow,
radiating from the dome of St Paul's (Figure 10).[97] The Cathedral was at
this time established not just as a national shrine for war heroes but as a
radiant focus of imperial power.[98] In many of Constable's views of
London St Paul's Cathedral plays the pivotal role that Dedham Church
plays in his views of Suffolk.

Constable was never a categorically anti-urban painter. Many of his
Suffolk scenes have intimations of the metropolis to which the prosper-
ity of the region was closely connected. The canal scenes, the views of
the mouth of the Stour showing the ports of Harwich and Mistley, depict
a dynamic system of circulation which exported grain to London and
imported the night-soil which helped to keep the fields fertile. And
Constable's very attempt to give historical grandeur to the Stour Valley
echoes the established iconography of the Thames Valley.[99] Constable's
English Landscape Scenery includes views with urban implications. The
text to *A Sea-Beach – Brighton* declares:

> there is perhaps no spot in Europe where so many circumstances
> conducive to health and enjoyment are to be found combined; and being
> situated as it is within so short a distance of the largest Metropolis in the
> world, will account at once for its extraordinary rise, its vast extent and
> population: and the almost countless numbers who visit it during the
> season.

The text to *Stoke By Neyland, Suffolk*, showing a once flourishing wool
town, charts the urban decay in the present scene of rustic seclusion, the
grand church tower now 'surrounded by a few poor dwellings'.

> These spots were once the seats of the clothing manufacturers, so long
> established in these counties, and which were so flourishing during the
> reigns of Henry VII and VIII, being greatly increased by the continual
> arrival of the Flemings, bringing with them the bay trade, who found here
> a refuge from the cruel persecutions of their own Country.

The church tower evoked an era when commercial enterprise, royal
patronage and the Protestant Church formed a powerful urban blend.

The view of Old Sarum, shown as a desolate moorland scene, 'contrasts strongly with its former greatness ... this once proud and populous city':

> This proud and 'towered city', once giving laws to the whole king-dom – for it was here that our earliest parliaments on record were convened – can now be traced but by vast embankments and ditches, tracked only by sheep-walks.[100]

At the time of the Reform Bill agitation (which greatly alarmed Constable's Tory sensibilities), such frank nostalgia for the city of Old Sarum confirmed the conservatism of Constable's urban politics. To Reformers Old Sarum was the very symbol of old corruption, a place, with a population of seven, returning two members of Parliament, while the booming industrial cities of the north remained unrepresented.

Like Robert Southey, that 'friend of the establishment' as Constable called him, Constable may have considered it unrealistic to find a Tory vision in a depressed and disaffected countryside after the Napoleonic Wars.[101] While urban, commercial enterprise, especially that of provincial cities, was being rhetorically appropriated by Reformers, there might still be scope for Constable's Toryism in a view of London in which commerce and industry could still be framed by monuments of established aristocratic and religious power. For his 'great London', Constable chose as his subject the opening in 1817 of Waterloo Bridge by the Prince Regent. He sketched the scene on the day and worked on the idea over the next fifteen years, with numerous drawings and oil sketches, finally submitting a finished painting to the Royal Academy in 1832.

The Opening of Waterloo Bridge (Figure 11) has, as the title indicates, a highly patriotic subject. It shows the occasion when the Prince Regent, escorted by the Dukes of York and Wellington, embarks in the State barge from the foot of Whitehall Stairs for Rennie's new bridge lined with Waterloo veterans. Soldiers line the wall of the house in the left foreground, the home of the Prime Minister Lord Liverpool. Waterloo Bridge is picked out by beams of light. A puff of smoke on the bridge indicates the firing of a salute. On the right of the bridge are belching chimneys of factories on the south bank. On the left is the artistic power house of London, Somerset House, home to the Royal Academy. Towering over the bridge, and finely delineated, is St Paul's Cathedral. Overhead the sky echoes the activity and energy on the river.[102]

The composition and subject matter of *Waterloo Bridge* owes much to Canaletto's views of the Thames a century earlier, especially his 1746

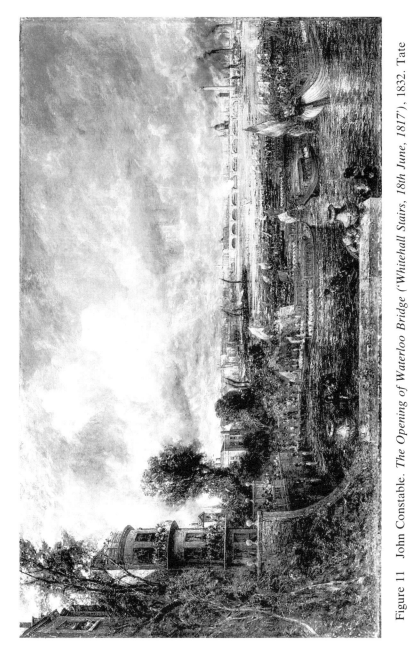

Figure 11 John Constable. *The Opening of Waterloo Bridge ('Whitehall Stairs, 18th June, 1817')*, 1832. Tate Gallery, London

view of a newly completed Westminster Bridge and ceremonial flotilla. (Chapter 4, Figure 9).[103] And it is part of an established tradition of Thamesside view-making which emphasized the grandeur of metropolitan improvements, from fine buildings to civil engineering structures, enhancing the bustle of the river.[104] As the composition evolved, so the specific event of the bridge's opening in 1817 was incorporated in a more general scene of civic theatre. Indeed some reviewers at the exhibition of the final painting in 1832 thought the scene showed the opening the previous year of the new London Bridge by William IV, the subject of two other paintings at the exhibition, and perhaps the occasion for prompting Constable finally to complete his 'great London'.[105]

Why should a civic, London Constable, stand out in 1991? As I showed in the first chapter of this book, the cultural power of London has impressed itself on the last decade, in various issues from high finance to heritage to homelessness. It has been one of those moments when London has epitomized the nation, when the capital became in the words of a seventeenth-century writer, 'our England of England, and our landskip and representation of the whole island'.[106] It is perhaps not incidental that Constable's *Opening of Waterloo Bridge* has been exhibited three times in 1980s exhibitions on British art and cultural heritage, in London, Japan and New York.[107] And the painting featured prominently in the Prince of Wales's influential *Vision of Britain* (1989) as a reproach to Thamesside scenery today. There it is positioned, in glorious colour, over a grim monochrome photograph of the National Theatre, which 'seems like a clever way of building a nuclear power station in the middle of London'.[108]

1992

A few rustic-minded reviewers of the 1991 Constable exhibition suggested that the show represented a defensive stand against European integration, in particular to the Single Market of 1992.[109] They might ponder a recent essay entitled 'Constable Country' by Ronald Blythe, author of *Akenfield* (1969), that shrewd, unsentimental portrait of rural Suffolk.

> These counties are currently bracing themselves for 1992, not forgetting that it is to Europe that they have looked ever since Edward I encouraged the Flemish weavers to settle in them. The Reformation blew into them from Holland long before Henry VIII's divorce. Gainsborough and

Constable were led into art by Dutch masters. The names on the Continental juggernauts lumbering inland from Felixtowe strike a chord here ... The East Anglians can be a touch north European still, even at this late date. The future could suit them. Their land is littered with artefacts and with a poetry which suggests a broader scene.[110]

NOTES

1 This publicity is discussed in Sarah Cooper, *The Changing Reputation of John Constable and the Changing Reputation of his Art* (unpublished BA dissertation, Department of Geography, University of Nottingham, 1985); Peter Bishop, *Consuming Constable: Diet, Utopian Landscape and National Identity*, University of Nottingham, Department of Geography, Working Paper 5 (1990); Richard Cork, 'A horse and cart among our souvenirs', *The Times Saturday Review*, 8 June 1991.

2 Recent guide books to Constable Country on sale at Flatford include James T. Pawsey, *Constable Country* (F. W. Pawsey & Son, Ipswich, 1983); Celia Jennings, *John Constable in Constable Country*, second edition (Barbara Hopkins Books, Norwich, 1987). The National Trust publish a pack of postcards of Constable's paintings around Flatford with a guide to the sites.

3 Judy Crosby Ivy, *Constable and the Critics 1802–1837* (Boydell Press, Woodbridge, Suffolk, 1991); Michael Rosenthal, *Constable* (Thames & Hudson, London, 1987), pp. 200–9, quotation on p. 203.

4 Andrew Wilton, *Constable's 'English Landscape Scenery'* (Colonnade, London, 1979), pp. 24, 26.

5 Ian Fleming-Williams and Leslie Parris, *The Discovery of Constable* (Hamish Hamilton, London, 1984), p. 7. The first part of this chapter is much indebted to this book.

6 Ibid., pp. 9–11.

7 Michael Rosenthal, *Constable: the Painter and his Landscape* (Yale University Press, New Haven and London, 1983), pp. 172–9. Elizabeth Helsinger, 'Constable: the making of a national painter', *Critical Inquiry* 15 (1989), pp. 253–79, esp. pp. 273–9.

8 Fleming-Williams and Parris, *Discovery of Constable*, pp. 27–37.

9 William Vaughan, 'Constable's England', lecture at Constable symposium, Tate Gallery, London, 12 July 1991. William Vaughan, 'The Englishness of British art', *Oxford Art Journal* 13 (1990), pp. 11–23.

10 C. R. Leslie, *Memoirs of the Life of John Constable* (Phaidon, Oxford, 1951), quotations on pp. 4, 213, 285, 285–6, 15, 86, 80, 93, 318, 323, 101.

11 Ibid., quotations on pp. 119, 121, 127, 72.

12 Fleming-Williams and Parris, *Discovery of Constable*, p. 36. The one rural scene of Constable's to be reproduced in the 1845 edition of Leslie's *Life* is a picture of a windmill from *English Landscape Scenery*.

13 Ibid., pp. 55–80.
14 Richard and Samuel Redgrave, *A Century of Painters of the English School* (2 vols, Smith & Elder, London, 1866), vol. 2, pp. 387–8.
15 Ibid., p. 387.
16 Jan Marsh, *Back to the Land: the Pastoral Impulse in Victorian England from 1880 to 1914* (Quartet, Melbourne, 1982), pp. 39–59, esp. pp. 41–2.
17 Fleming-Williams and Parris, *Discovery of Constable*, p. 86.
18 G. D. Leslie and Fred Eaton, 'John Constable, RA', *Art Journal* (1903) pp. 5–9, quotation on p. 5.
19 James Orrock, 'Constable', *Art Journal* (1895), pp. 367–72, quotations on p. 368.
20 Fleming-Williams and Parris, *Discovery of Constable*, pp. 87–93.
21 Editorial, 'Patriotism', *Art Journal* (1888), p. 1.
22 Fleming-Williams and Parris, *Discovery of Constable*, p. 85.
23 H. W. Tomkins, *In Constable's Country* (J. M. Dent, London, 1906), pp. 44–5.
24 C. Lewis Hind, *Constable* (T. C. & E. C. Jack, London, 1909), pp. 18, 52.
25 Charles Holmes, *Constable and his Influence on Landscape Painting* (Archibald, London, 1902); Fleming-Williams and Parris, *Discovery of Constable*, pp. 106–7.
26 Holmes, *Constable and his Influence*, p. 174.
27 Herbert Cornish, *The Constable Country* (Heath Cranton, London, 1932), vol. 1, pp. 18–19 (only one volume published).
28 Fleming-Williams and Parris, *Discovery of Constable*, p. 46.
29 Orrock, 'Constable', p. 370.
30 Frances Watt, 'The Wiltshire Avon', *Art Journal* (1888), pp. 293–7.
31 Fleming-Williams and Parris, *Discovery of Constable*, p. 112.
32 Percy Lindley, *A Drive Through Constable Country* (Great Eastern Railway, London, 1902), n.p., proof copy, Tate Gallery, London.
33 Tomkins, *In Constable's Country*, pp. 45, 44. Peter Howard's research on Royal Academy Summer Exhibitions reveals that scenes of pastoral rivers in lowland England rose significantly in popularity towards the end of the nineteenth century. Peter Howard, 'Painters' preferred places', *Journal of Historical Geography* 11 (1985), pp. 138–54.
34 Sylvanus, 'England's Green and Pleasant Land', *Country Life*, 9 December 1916.
35 Quoted in Peter Brooker and Peter Widdowson, 'A literature for England', in Robert Colls and Philip Dodd (eds), *Englishness: Politics and Culture 1880–1920* (Croom Helm, London, 1986), pp. 116–63, quotation on p. 117.
36 Quoted in Ian Jeffrey, *The British Landscape 1920–50* (Thames and Hudson, London, 1984), p. 10.
37 Leslie, *Life of Constable*, p. 45.
38 Fleming-Williams and Parris, *Discovery of Constable*, pp. 46–7. Helsinger, 'Constable', pp. 273–99.
39 Leslie, *Life of Constable*, p. 45.

40 Olive Mount Wavertree, *Home Life in England* (Virtue & Co., London, 1877), p. 77.

41 Marsh, *Back to the Land*, pp. 171–83.

42 Helen Allingham and Stewart Dick, *The Cottage Homes of England* (1909), republished (Bracken Books, London, 1984), pp. 270–1, 11.

43 Alun Howkins, 'The discovery of rural England' in Colls and Dodd (eds), *Englishness*, pp. 62–88, quotation on p. 64.

44 Martin J. Wiener, *English Culture and the Decline of the Industrial Spirit 1850–1980* (Cambridge University Press, 1981), pp. 41–6, 81–8, quotation on p. 83.

45 Howkins, 'The discovery of rural England', p. 64; Raymond Williams, *The Country and the City* (Chatto & Windus, London, 1973), pp. 281–2.

46 Wiener, *English Culture*, pp. 48–9. See also p. 53 on the making of 'Hardy Country' which has some parallels with my discussion of Constable Country at this time.

47 C. L. Burns, 'Constable's Country', *Magazine of Art* (1891), pp. 282–8, quotation on p. 286.

48 E. V. Lucas, *John Constable the Painter* (Halton & Truscott, London, 1924), p. 14.

49 Cornish, *The Constable Country*, p. 47. The account of the saving of Flatford is largely transcribed from Westeanaue East, *The Saving of Flatford Mill* (Westenaue East, Ipswich, 1928).

50 Cornish, *The Constable Country*, p. 47.

51 Alex Potts, ' "Constable Country" between the wars' in *Patriotism*, ed. Raphael Samuel, vol. 3, *National Fictions* (Routledge, London, 1989), pp. 160–88, quotation on p. 175.

52 Cornish, *The Constable Country*, pp. 45, 42–3.

53 Ibid., pp. 56, 25, 33, 47, 28–9.

54 David Matless, 'Ages of English design: preservation, modernism and tales of their history', *Journal of Design History* 3 (1990), pp. 203–12; David Matless, 'Definitions of England, 1928–1989: preservation, modernism and the nature of the nation', *Environment and Planning* 16 (1990), pp. 179–91. These issues are discussed more fully in David Matless, *'Ordering the Land': the Preservation of the English Countryside* (unpublished Ph.D. dissertation, University of Nottingham, 1991). See also Bill Luckin, *Questions of Power: Electricity and Environment in Inter-War Britain* (Manchester University Press, 1990); Jeffrey, *The British Landscape*, p. 15 and Ian Jeffrey, 'Public problems and private experience in British art and literature' in Arts Council, *Landscape in Britain 1850–1950* (Arts Council, London, 1983).

55 Rod Brookes, 'Everything in the garden is lovely: the representation of national identity in Sydney Strube's *Daily Express* cartoons in the 1930s', *Oxford Art Journal* 13 (1990), pp. 31–43.

56 Matless, 'Ordering the Land', pp. 230–53.

57 Fleming-Williams and Parris, *Discovery of Constable*, p. 125.

58 Ibid., p. 127.

59 John Piper, ' "Died April 1st, 1837", John Constable', *Architectural Review*, April 1937, pp. 149–51.

60 World's Masters Series, *John Constable 1776–1837* (Studio Ltd, London, 1937), quoted in Pyrs Gruffudd, *Reach for the Sky: the Air and English Cultural Nationalism*, University of Nottingham, Department of Geography Working Paper 7 (1990), p. 5.

61 S. P. Mais, *The Home Counties* (B. T. Batsford, London, 1942–3), p. 132.

62 Julian Tennyson, *Suffolk Scene* (Alastair Press, Bury St Edmunds, Suffolk, 1973), pp. 289–90, 30.

63 James Lees-Milne (ed.), *The National Trust: a Record of Fifty Years Achievement* (B. T. Batsford, London, 1945), p. 112.

64 C. Henry Warren, *English Cottages and Farm Houses* (Collins, London, 1948), p. 25.

65 Kenneth Clark, *John Constable, The Hay-wain* (Lund Humphries, London, 1945), pp. 9, 8, 11.

66 Stephen Bone, *British Weather* (Collins, London, 1946).

67 Peter Howard, 'American uncles', in Richard Harman (ed.), *Countryside Character* (Blandford Press, London, 1946), pp. 137–47, 136, quoted in Gruffudd, *Reach for the Sky*, p. 15.

68 Gruffudd, *Reach for the Sky*, p. 5.

69 Matless, 'Definitions of England'.

70 W. G. Hoskins, *The Making of the English Landscape* (Penguin, Harmondsworth, 1970), pp. 298, 299.

71 Norman Scarfe, *Suffolk, a Shell Guide* (Faber & Faber, London, 1960), p. 115.

72 Michael Wright, 'Constable Country in the balance', *Country Life*, 2 July 1970, pp. 24–6. There are now plans to extend the 23 square miles of the Dedham Vale AONB another 6.5 square miles upriver, in part to take the pressure off the more crowded areas (*Essex County Standard*, 7 September 1990), p. 5.

73 Graham Reynolds, *Constable: the Natural Painter* (Panther Books, London, 1976), p. 22.

74 Tate Gallery, *Constable: the Art of Nature* (Tate Gallery, London, 1971), pp. 7, 11.

75 Ann Bermingham, *Landscape and Ideology: the English Rustic Tradition, 1740–1860* (University of California Press, Berkeley, 1986), quotation on p. 142; See also John Barrell, *The Dark Side of the Landscape: the Rural Poor in English Painting 1730–1840* (Cambridge University Press, 1980), pp. 146–9; Rosenthal, *Constable: the Painter and His Landscape*, pp. 124–32; *The Great Artists, No. 1, Constable* (Marshall Cavendish, London, 1985), p. 12. The view towards the hay meadow was opened up in art criticism by Richard E. Tyler, 'Rubens and "The Hay-wain" ', *Connoisseur* 189 (1975), pp. 271–5 who drew attention to the compositional parallels with Rubens's *Chateau de Steen*. This view is endorsed in Alistair

Smart and Attfield Books, *Constable and his Country* (Elek Books, London, 1976), p. 47, although in an appendix Brooks questions whether the hay cart is in fact crossing a ford in the mill stream towards the meadow. It may be in the stream to cool the horses' fetlocks or to soak the rims of the cartwheels to prevent them from shrinking.

76 John Berger, *Ways of Seeing* (Penguin, Harmondsworth, 1972); Raymond Williams, *The Country and the City* (Chatto & Windus, London, 1972). These two books were very influential in a number of academic diciplines. I discuss them in Stephen Daniels, 'Marxism, culture and the duplicity of landscape' in Richard Peet and Nigel Thrift (eds), *New Models in Geography* (2 vols, Unwin Hyman, London, 1989), vol 2, pp. 196–220.

77 Leslie Parris, *Landscape in Britain c. 1750–1850* (Tate Gallery, London, 1973).

78 Leslie Parris, Ian Fleming-Williams and Conal Shields, *Constable: Paintings, Watercolours and Drawings* (Tate Gallery, London, 1976).

79 Barrell, *Dark Side of the Landscape*, pp. 131–4.

80 Bernard Levin, 'Gently, gently through Constable Country', *The Times*, 4 March 1976, p. 10. On the affair of Carl André's brick sculpture see Bernard Levin, 'Art may come and art may go but a brick is a brick forever', *The Times*, 18 February 1976, p. 16.

81 Bernard Levin, 'We are all Old Masters now', *The Times*, 18 June 1976, p. 14.

82 Paul Gilroy, *There Aint No Black in the Union Jack: the Cultural Politics of Race and Nation* (Hutchinson, London, 1987), pp. 43–71.

83 'The State of the nation', *Camerawork*, July 1980, pp. 7–10.

84 Ken Sprague, 'Jerusalem', Leeds Postcards, *c.* 1981. At the time Alun Howkins noted a CND poster showing 'a village church, with a spire, peeping through hedges, and over thatched roofs. In the foreground is a missile launcher. The slogan is simply "America Rules OK" ': 'The discovery of rural England', p. 62. On the women's peace camp at Greenham Common see the article by Leonie Caldecott in *Sanity* 6, Dec.–Jan. 1981, pp. 10–11.

85 Peter Fuller, 'Constable Country', *New Society*, 26 February 1976, p. 462.

86 Peter Fuller, 'Aesthetics and nuclear anaesthesia', reprinted in *The Naked Artist* (Writers & Readers, London, 1983), pp. 35–45.

87 Peter Fuller, 'The Suffolk outback', *Art Monthly*, January 1986, pp. 6–11.

88 Peter Fuller, 'Neo-romanticism: a defence of English pastoralism', reprinted in *Images of God: the Consolation of Lost Illusion*s (Tigerstripe, London, 1985), pp. 83–91.

89 John Russell Taylor, 'Enchantment in the vales', *The Times*, 11 June 1991. The 1991 exhibition was often reviewed in parallel with the exhibition of the environmentally friendly art of Richard Long showing at the Hayward Gallery. Two of the more critical reviews of both shows are Margaret Drabble, 'What do we know about Willy Lot', *Modern Painters* 4 (2) (1991), pp. 40–5 and James Hall, 'Endless industry', *New Statesman and*

Society, 14 June 1991, p. 28, the latter written in an unreconstructed spirit of 1976.

90 Leslie Parris and Ian Fleming-Williams, *Constable* (Tate Gallery, London, 1991), quotation on p. 54. Among the most stringent empiricist revisions of recent Constable scholarship is the entry for *The Cornfield*, pp. 301–5. I voiced my own criticisms of the catalogue in a paper 'The feild of Waterloo' to the Constable symposium at the Tate Gallery, 12 July 1991, now published in *Rural History* 3(1) (1992), pp. 139–45. So did Michael Rosenthal in a paper 'Constable revisited', some of which is published in a review of the exhibition 'Constable at the Tate: the bright side of the landscape', *Apollo*, August 1991, pp. 77–84. See also the review by John Barrell, 'Constable's plenty', *London Review of Books*, 13 August 1991.

91 There is a shrewd observation of this gentrification in Steve Lohr, 'Constable Country', *TWA Ambassador Magazine*, April 1989, pp. 74–8.

92 Parris and Fleming-Williams, *Constable*, p. 9. On heritage and the enterprise culture see Stephen Daniels and David Matless, 'The new nostalgia', *New Statesman and Society*, 19 May 1989, pp. 40–1.

93 Parris and Fleming-Williams, *Constable*, pp. 206–43, 267–81, quotation on p. 267.

94 Leslie, *Life of Constable*, pp. 51, 80.

95 Peter Bishop, 'An archetypal Constable', lecture at the Tate Gallery, London, 21 June 1991.

96 Quoted in Parris and Fleming-Williams, *Constable*, p. 473.

97 Ibid., p. 473.

98 Humphrey Jennings, *Pandaemonium 1660–1886: the Coming of the Machine as seen by Contemporary Observers* (Picador, London, 1987), pp. 124–5, 167; Ralph Hyde, *Panoramania!* (Trefoil, London, 1988), pp. 79–94.

99 Rosenthal, *Constable: the Painter and his Landscape*, p. 56.

100 Wilton, *Constable's 'English Landscape Scenery'*, pp. 42, 38, 44–6.

101 Leslie, *Life of Constable*, p. 115. Passages from Southey are reprinted in B. I. Coleman (ed.), *The Idea of the City in Nineteenth Century Britain* (Routledge & Kegan Paul, London, 1973), pp. 58–61 followed by some of Southey's Whig opponents. On Constable's despair at the condition of the countryside later in his life see Rosenthal, *Constable: the Painter and His Landscape*, pp. 214–37.

102 Parris and Fleming-Williams, *Constable*, pp. 369–72.

103 Brian Allen, 'Topography or art: Canaletto in London' in Barbican Art Gallery, *The Image of London*, pp. 29–48, esp. pp. 33–6.

104 Alex Potts, 'Picturing the modern metropolis: images of London in the 19th century', *History Workshop Journal* 26 (1988) pp. 28–56, esp. pp. 34–43.

105 Parris and Fleming-Williams, *Constable*, p. 372.

106 Quoted in James Turner, 'Landscape and "Arts Prospective" in England, 1584–1660', *Journal of the Warburg and Courtauld Institutes* 42 (1979), pp. 290–3, quotation on p. 290.

107 Parris and Fleming-Williams, *Constable*, p. 369.

108 HRH The Prince of Wales, *A Vision of Britain* (Doubleday, London, 1989), p. 45.

109 A. N. Wilson, *Evening Standard*, 14 June 1991; Philip Dodd on *Kaleidoscope*, BBC Radio 4, 15 June 1991.

110 Ronald Blythe, 'Constable Country', *Independent Magazine*, 25 August 1990, pp. 40–1, quotation on p. 40. On developments since this chapter was written see Stephen Daniels. 'Reconstructing Constable Country', *Geographical Magazine*, October 1992, pp. 10–14.

Conclusion

I n this book I have shown the power of landscape as an idiom for representing national identity in England and the United States. A variety of styles of landscape, from sweeping prospects to secluded nooks, of subjects, from industrial cities to ancient woodland, in various media, from painting to photography, offer a range of political views on these nations and their history. I have concentrated on particular landscape images which yield many fields of vision, in their own time and since, in their making and re-making, in their mobilization by many social interests. Such landscape images achieve the status of national icons. And I have attempted to situate such landscape icons in terms of other imaginitive geographies: maps, regional surveys, topographical verse, travel books. I hope to have shown not just the connection between the imaginitive geography of landscape and the imagined community of the nation, but the implication of the aesthetics of space in the culture of modernity.[1]

As itself an exercise in the geographical imagination, this book partakes in the cultural history it describes. In trying to make stylistic sense of the book as a whole I fastened on a genre which is inherently geographical, if by no means the preserve, or even now much the practice of professional geographers: travel writing.[2]

This book is the product of many journeys, between many archives, libraries, and galleries in England and the United States and between most of the sites shown in the pictures, from St Paul's Cathedral to the Hudson River, from Willy Lot's cottage to Catskill Creek. Exploring the cultural field of a landscape image, following the trails of its associations, involved its own kind of journeying, tracking back and forth between disparate sources on a variety of practices. Researching

Loutherbourg's *Coalbrookdale*, for example, ranged from poking around ruined furnaces to poring over occult texts. Plotting the meaning of such images is a kind of mapping.[3]

The itinerary of this fieldwork is not that set out in the book. The book starts and ends in London, beginning with the Prince of Wales's 1989 vision of Britain focused on St Paul's Cathedral and ending with Constable's vision of Britain, as shown in the 1991 exhibition, focused on Waterloo Bridge. In between, the text traverses various fields of vision around St Paul's and Constable's pictures and ranges further, in space and time, from the Great Plains in Nebraska in 1860s as represented in the print culture of New York to Derbyshire's Derwent Valley a century before as represented in Derby's culture of natural philosophy. While the chapters describe the varying contexts of diverse landscape images, and in ways which question prevailing meanings, they do so from the perspectives of English culture in the 1980s. The themes of this book – heritage, patriotism, consumerism, imagery, money, mobility – and its translantic focus characterize the period in which it was researched and written.

The momentum of the book has been guided by its sources. Many of the landscape images I discuss are themselves not just the product of travel, but about it. Great rivers and railroads run through the book, streams and footpaths too. The Prince of Wales makes his Royal Progress down the Thames, Joseph Wright orbits the sun, Repton picks his way through the decline of rural England, Turner rides the waves of British imperialism, Thomas Cole charts America's destiny along Catskill Creek, Frances Palmer does so across the Great Plains, Constable and his critics tread the footpaths enfolded in Dedham Vale. These journeys are not just descriptions of places and their national significance but necessarily narrations too. Describing them from the perspective of the late twentieth century has involved re-narrating them, plotting their significance now.[4] Travel writing is always story telling. I have tried to tell, or at least allude to, many stories, or to shuttle back and forth in my own narrative, precisely to evoke the many images and myths which gather in certain sites and scenery.

Tracing the connections and transformations of landscape images involves travelling of a sort. It is a procedure which, in Peter Bishop's words, 'moves slowly around an image ... circular rather than linear'.[5] This is not to say it is without direction. The narrative drive of this book has been geared to realizing the historical momentum of images, to specifying those episodes when pictures, texts or designs condense a

range of social forces and relations, when images assume a high specific gravity.[6]

Authors who have revived an interest in the geographical imagination have emphasized the importance of combining aesthetic with social theoretic perspectives. In the same breath some have told cautionary tales about the glamour of landscape images, their power to deflect scholarly attention from the concrete conditions of time and place.[7] The project of combining the aesthetic with the social has often amounted to fixing images to literal conditions, translating them into concepts, reducing them to 'signifiers' of social forces and relations. The very fascination with visual imagery and visual perception in a variety of academic disciplines is being driven by an earnest desire to purge it.[8] In this book I have attended to the social history of landscape images to unfold their range and subtlety, to amplify their eloquence. It is not so much a procedure of unmasking images, to disclose their real identity, as of re-visioning images, of showing their many faces, from many, shifting, perspectives.[9]

NOTES

1 Stephen Daniels and Denis Cosgrove, 'Iconography and landscape' in Denis Cosgrove and Stephen Daniels (eds), *The Iconography of Landscape* (Cambridge University Press, 1988), pp. 1–10; Felix Driver, 'Geography's empire: histories of geographical knowledge', *Society and Space* 10 (1992), pp. 23–40.

2 On travel writing, and its imaginative and intellectual possibilities, see Peter Bishop, *The Myth of Shangri La: Tibet, Travel Writing and the Western Creation of Sacred Landscape* (Athlone, London, 1989); Paul Fussell, *Abroad: British Literary Travelling between the Wars* (Oxford University Press, 1980), esp. pp. 37–50; Paul Carter, *The Road to Botany Bay* (Faber & Faber, London, 1987); Mona Domosh, 'Towards a feminist historiography of geography', *Transactions of the Institute of British Geographers* 16 (1991), pp. 95–104; David Matless, 'Nature, the modern and the mystic: tales from early twentieth century geography', *Transactions of the Institute of British Geographers* 16 (1991), pp. 273–86.

3 Graham Huggan, 'Decolonizing the map: post-colonialism, post-structuralism and the cartographic connection', *Ariel* 20 (1989), pp. 115–31.

4 On the integrity of narrative to geographical description see Stephen Daniels, 'Arguments for a humanistic geography' in R. J. Johnston (ed.), *The Future*

of Geography (Methuen, London, 1985), pp. 143–58 esp. pp. 152–5; J. Nicholas Entrikin, *The Betweenness of Place: Towards a Geography of Modernity* (Macmillan, London, 1991).

5 Bishop, *Myth of Shangri La*, p. 23.

6 The procedure recalls an alchemical itinerary, the speculative working of symbolic field. James Hillman, *Re-visioning Psychology* (Harper & Row, New York, 1977).

7 David Harvey, 'Between space and time: reflections on the geographical imagination', *Annals of the Association of American Geographers* 80 (1990), pp. 418–34; Yi Fu Tuan 'Realism and fantasy in art, history and geography', *Annals of the Association of American Geographers* 80 (1990), pp. 435–46.

8 On this issue, from a variety of positions, see Stephen Daniels, 'Marxism, culture and the duplicity of landscape' in Richard Peet and Nigel Thrift, *New Models in Geography* (2 vols, Unwin Hyman, London, 1989), vol. 2 pp. 196–220; Peter Bishop, 'Rhetoric, memory and power: depth psychology and postmodern geography', *Society and Space* 10 (1992), pp. 5–22; R. Deutsche, 'Boys town', *Society and Space* 9 (1991), pp. 5–30; James L. Westcoat Jr, Michael Brand and Naem Mir, 'Gardens, roads and legendary tunnels', *Journal of Historical Geography* 17 (1991), pp. 1–17; Stephen Daniels and Denis Cosgrove, 'Spectacle and text: landscape metaphors in cultural geography' in James Duncan and David Ley (eds), *Place/Culture/Representation* (Routledge, London, 1993), pp. 57–77.

9 This is not to surrender social description or theory to aesthetic contemplation, but to revive the visual and theatrical connotations of theory and description. On this see Bishop, 'Rhetoric, memory and power' and Hillman, *Re-visioning Psychology*.

Index

NOTE: Page references in **bold** indicate illustrations

Abstract Expressionists, 139
advertizing, 13, 26–7, 200
aeroplanes, 221–4, 229
agriculture
 and estate management, 80–1, 113
 flax, 114–15
 haymaking, 215–16, 225
 pasture, 88, 92, 182
 wheat, 91–4, 147, 194, 207
agricultural revolution, 225
agricultural workers, 182, 193–5, 226
alchemy, 53, 60, 69
Alexander, Francis, *Globe Village*, **166**
Allingham, Helen, *Cottage Homes of England*, 214
American Academy of Art, 151
American Civil War, 179, 180–2
American Centennial, 192–3
American Revolution, 50, 52–3
American War of Independence, 148, 178
Anglican Church, 21, 29
Anne, Queen, 19–20, 22
Antarctic, 6

apocalypse, 69–72
Apollo, 2
architecture, 11–37, 101, 102–7, 140–1, 158–9, 214
Architectural Journal, 36
Architectural Review, 34, 221
Arctic, 6
aristocracy
 English, 2, 7, 49, 62, 67, 101–7, 113, 126–7
 federalist, 151
Arkwright, Richard, the elder, 57, 62–8, **64**
Arkwright, Richard, the younger, 98
Armley, 85–9, 122
Armley Mill, 85–9, **87**
Art Journal, 210, 212
Art Treasures Exhibition, Manchester, 124, 212
axeman, 150–1, 163
axis mundi, 15
Aylsham, 91
Aysgarth, 67

Baldwin, Stanley, 32
Barclays Bank, 229–330
Barker, Paul, 140–1
Battle of Palo Alto, 178

Battle of the Nile, 48, 69
Beaven, Arthur, *Imperial London*, 29
Beeston Hill, Leeds, 117–19
Bedlam Furnaces, 68–70, **69**
Betjeman, John, 36, 139
Berger, John, *Ways of Seeing*, 225
Berkley, Bishop, 158
Bible, The, 71, 91, 182, 210–11
Bierstadt, Albert, 169, 170, 182, 185
 The Rocky Mountains – Lander's Peak, 180–1, **181**
Big Bang, 36
Bingham, George Caleb, 192
Binney, Marcus, 106
Bishop, Peter, 244
Blacks, American, 179, 181, 190
Blake, William, 34, 72
 Jerusalem, 34
Blitz, The, 32, **33,** 36
Blythe, Ronald, 235
Bonaparte, Napoleon, 49, 83, 89, 114
Booker, Christopher, 36
Boone, Daniel, 163
Born, Wolfgang, *American Landscape Painting*, 169, 174
Boorstin, Daniel, 2
Boulton, Matthew, 49, 55
Bourne, J. C., *Maidenhead Railway Bridge*, 128, **129**
Brecon Beacons, 7
Brewer, John, 49
Bridport, 115, **116,** 121
Brighton, 113, 232
Britain, 11–17, 32–4, 66–7, 68–73, 114–16, 121–4, 126–8
British Museum, 209
 Library, 28
Brontë, Charlotte, *Villette*, 23–4
Brown, Lancelot 'Capability', 82–3, 106
Brunel, Isambard Kingdom, 127–9
Buck, Samuel, *East Prospect of the Town of Leedes*, 119, **121**

Bull, John, 49, 63, 211
Bunkśe, Edmunds, 7
Burdett, Peter Perez, 55
Burke, Edmund, 16, 53, 72, 80–1, 84
Burns, C. L., 215–16
 The Backwater at Flatford, **216**
 Willy Lot's House at Flatford, **216**
Butler, Samuel, 25
Byrne, Dymphnia, 141–2

Campaign for Nuclear Disarmament, 227–8
Canajoharie & Catskill Railroad, 161, 167
Canaletto, 12–13, 38 n.5
 The Thames from the Terrace of Somerset House, **12**, 12–13, 15, 19, 36
 Westminster Bridge, London, 134, **135**, 233–4
canals, 13, 113, 146, 168, 219, 225, 232
Cannadine, David, 104
Carthage, 115, 122, 152
Catksill, 161
 Association, 161, 164
 Creek, 161–7, **162**
 Lyceum, 167
 Mountains, 155
Catlin, George, 192
Charles, Prince of Wales, 11–17, 36–7, 106, 107, 140, 244
 Vision of Britain, 11–17, 235
Chatsworth, 46, 59, 62, 68
Chesterton, G. K., 16
Chicago World's Fair, 195
Churchill, Sir Winston, 32
circulation, 23–7, 82, 98, 113, 123
 see also commerce, finance
Clark, Kenneth, 222–3
class *see* aristocracy; middle class; working class
classicism, 17
Claude Lorrain, 151–2, 163, 171, 205 n.16

Clore, Charles, 140
Clore Gallery, 140, **140**
Coalbrookdale, 46–7, 68–70, **69**
Cobbett, William, 73, 98–9
Coke, Daniel Parker, 65
Cole, Thomas, 146–70, 174, 190, 244
 Course of Empire, The, 158–61,
 159
 Essay on American Scenery, 155–8,
 167
 Falls of Kaaterskill, 152, **153**
 Landscape with Figures and a Mill,
 149–51, **150**
 Oxbow, The, 152–5, **154**, 157, 163,
 174
 River in the Catskills, 161–7, **162**,
 190
 View of the Catskills, Early
 Autumn, 161–7, **162**
Coleridge, Nicholas, 105
Colman, Samuel, *Storm King on the*
 Hudson, **147**
Colosseum, Regent's Park, 23, 28
Columbus, Nebraska, 191
commerce, 3, 23–7, 45–51, 80–6,
 112–42, 146–7, 151–5, 161–7,
 184, 217–19, 232
 see also circulation; finance;
 improvement; industry
Commons Preservation Society, 209
Confederacy, 182, 188
Connecticut River valley, 152–7, **154**,
 174
conservation, 15, 101–2, 107, 170,
 209, 217–20, 229–30
conservatism, 1, 11–17, 96–9, 151–2,
 158–67, 200, 233–5
Conservative Party, 16
Constable, Abram, 204
Constable, Isabel, 209
Constable, John, 2, 17, 36, 73, 152,
 200–36, 244
 Cornfield, The, 202–4, 203
 East Bergholt, 202
 Hadleigh Castle, 221

Hampstead Heath, the House
 Called 'The Salt Box' in the
 distance, 205, **208**
Hampstead Heath with Harrow in
 the distance, 209
Hay-wain, The, 6, 205, **206**, 207,
 210–16, 220–3, 225, 227–9
London from Hampstead, 230–2,
 231
Old Sarum, 233
Opening of Waterloo Bridge, 230,
 233–5, **235**
Salisbury Cathedral, 212
Sea Beach, Brighton, 232
Stoke-by-Neyland, 232
Stratford Mill, 210
Valley Farm, The, 214
Various Subjects of Landscape
 Characteristic of English
 Scenery, 202, 232–3
White Horse, The, 210
Constable Country, 31, 200–36
consumer culture, 25, 46–9, 200, 244
Continental Blockade, 115, 121
Cook, Thomas, 212
Coolidge, Ellen Randolph, 154–5
Cooper, James Fenimore, 151, 168
Cooper's Journal, 28
Cork, Richard, 140
Cornish, Herbert, *The Constable*
 Country, 217
Cotes Hill, Loughborough, 176–7
cottages, 6, 202, 214, 223–5
Country Life, 101, 107, 213, 224
coursing, 92, 176
Cowdrey, Mary Bartlett, 196
Cowper, William, 73, 83
Cromford, 46, 63–6
Crosby, Theo, 36, 141
Cruikshank, George, 128
Cruise Missiles, 227–9
Crystal Palace, 144 n. 49
cultural diplomacy, 2–3
Currier and Ives, 175, 179–83, 196
Currier, Nathaniel, 178, 196

Daily Express, 220–1
Daily Mail, 32
Daily Telegraph, 2, 104, 227
Darwin, Erasmus, 50, 55, 57
 The Botanic Garden, 61–2, 67
Dedham
 Church, 205, 232
 Mill, 205, 215
 Vale, 224
Delacroix, Eugene, 207
Derby, 43–4, 46, 55, 61, 65
Derby Mercury, 66
Derbyshire, 57–68
Derwent River, valley, 57–9, 61–2,
 65–8
Diana, Princess of Wales, 37, 106
Dickens, Charles, *Dombey and Son*,
 136
Docklands, 141
Doré, Gustave, *London*, 25, 29
 Ludgate Hill, 25, **26**
 The New Zealander, 25, **26**
Drury Lane Theatre, 59, 60
Dwight, Timothy, 154
Dyer, John, *The Fleece*, 121–2

East Bergholt, 202, 217, 224
Egremont, Lord, 113
Eiffel Tower, 31, 34
Elizabeth I, Queen, 6
Elizabeth II, Queen, 146
 Silver Jubilee, 36
Elizabeth age, 31
Elton, Arthur, 46
empire, 5–6, 11–37, 68–72, 112–42,
 158–70, 174–96, 209–16
 see also imperialism
enclosure, 95
engineering, 31, 124–30
England, 2–3, 6–8, 28, 68, 72, 80–4,
 88–9, 99, 101–7, 124, 174–5,
 200–34
English Heritage, 46, 105
 see also railways

enlightenment, 28, 34, 50–1, 61,
 68–72, 74 n. 12
Erie Canal, 146, 147
Erie Railroad, 168
European integration, 3, 235
exhibitions, 3, 15, 43, 44, 107, 124,
 170, 207, 212, 221, 225, 229–30,
 235

Falklands War, 2, 4, 16
federalists, 151, 160
female (feminine), 29, 37, 163,
 175–7, 185, 196, 224
Ferrers, Lord, 55
finance, 13, 36, 83–4, 92, 96–8, 113
 see also commerce
Flatford Lock, 219
Flatford Mill, 31, 200, 213–17, 219
Fletcher, John, 70
Flexner, James, *The Wilder Image*,
 170
Flower, Cook, 94–5
Fowler, T. M., *Harvard, Nebraska*,
 190, 191
France, 5–6, 49, 205
 Napoleonic, 20, 50
 Second Empire, 5
 Third Republic, 31
Francis, John, *History of the English
 Railway*, 126–7, 128
Franklin expedition, 6
freemasonry, 49–51, 61, 71
French Revolution, 20–1, 44, 49, 53,
 72
frontier
 American, 5, 169–195–6
 Russian, 5
Fuller, Peter, 228–9

Gainsborough, Thomas, *Mr and Mrs
 Robert Andrews*, **81**, 103, 105
gardenesque, 99
gender *see* female; male
geo-political theory, 31

geography, 5, 243–5
geology, 19, 55–61
George III, King, 21, 29, 63, 66
Georgian age, 15, 80–4, 101–2
Germany, 214
 Nazi, 222–3
Gibraltar, 66–7
Gilpin, William, governor of
 Colorado, 180
Gilpin, William, writer on the
 Picturesque, 119
Glens Falls, 146, 148, **148**
gothic, 17, 20, 101
Gott, Benjamin, 85–9, 119, 122
Great Eastern Railway, 212
Great Fire of 1666, 11, 17, 134
Great Gale of 1987, 107
Great Plains, 180–92
Great Western Railway, 124–9, **125,
 129**
Greely, Horace, 180, 188
Greenham Common, 228
Greenwich
 naval hospital, 25
 Prime Meridian, 6
Guardian, 2, 226
Gulf War, 2
Gummer, John Selwyn, 227

Hall, Jerry, 37
Hamerton, P. J. *Life of Turner*, 139
Hampstead, 230
 Heath, 205–9, **208**
Hare Street, 99, **100**
Harvard, Nebraska, **190**
Hawksmoor, 37
Haydon, B. R., 24
Hayley, William, *Ode to Joseph
 Wright*, 67
Hayward Gallery, 226
heritage, 2–4, 141, 244
 industry, 15, 46–7, 200–1
Hewison, Robert, 104
Hind, Lewis, 211

history, 2, 5
 cyclical theory, 114–16, 136–8,
 155–67
 linear theory, 138, 157, 180–93
Hitler, Adolf, 223, 227
Holford, William, *Plan for precinct
 of St. Paul's Cathedral,* 34, **35,**
 107
Holmes, Charles, *Constable and his
 Influence on Landscape
 Painting,* 211–12, 221
Home Book of the Picturesque,
 168–9
Home Counties, 29, 31, 214–15
Hoskins, W. G. *The Making of the
 English Landscape,* 223–4
Houses of Parliament, 131–6
Howard, Peter, 237 n. 23
Hudson River, valley, 146–9, **147,
 148**, 152–4, 158, 169
 Railroad, 168
 School, 169–70
Hunloke, Sir Windsor, 85, 86
Hussey, Christopher, 101, 103, 107

iconoclasm, 8, 72–3, 245
illuminations, 21, 48, 66, 89
 see also spectacle
Illustrated London News, 29–30
imperialism, 5–6, 29–32, 32–7,
 124–38, 146, 158–70, 174–96,
 209–16
 see also empire
Impressionists, 139, 223
improvement, 80–2, 95–99, 157,
 163–7, 176
Independent, 37, 141
Indians, Native American, 151–2,
 184–8, 191–2
industrial revolution, 34, 43–6, 159,
 214–15
industry
 cotton, 67–8
 flax, 114–15, 121

industry (*cont'd*)
 iron, 68–72, 85, 155
 mining, 49–51
 pottery, 48–9
 tanning, 161–7
 wool, 85–9, 116–22
Inge, W. R., 32
International Exhibition, South
 Kensington, 207, 212
Ipswich, 219
Iron Bridge, 48, 70
Ives, James, 178, 184

Jackson, Andrew, 160
Jacksonian democracy, 151
Jacobs, Jane, 15
Jeffries, Richard, 31
Jennings, Humphrey,
 Pandaemonium, 34
Jerrold, Blanchard, *London*, 25

Kennard, Peter, *The Haywain,
 Constable (1821), Cruise
 Missiles, USA (1981)*, 227–8, **228**
Klingender, Francis, *Art and the
 Industrial Revolution*, 44–6

Labour government, 103, 226
Lander, Colonel Frederick West,
 180–2
landownership, 2, 7, 62, 80–108,
 126–7, 151, 190–2, 217–24
Landscape, 106, 107–8
landscape gardens, 34, 80–108
landscape imagery, study of, 8, 243–5
Landseer, Sir Edwin, 207
 Dignity and Impudence, 209
 Man Proposes, God Disposes, 6
Latvia, 7
Leeds, 85–9, 91, 116–24, **118, 120**
Leicester, 175–8
Leicester Journal, 177–8
Leicestershire, 176–7

Leslie, C. R., 202
 *Memoirs of the Life of John
 Constable*, 204–7, 209, 213
Leslie, G. D., 209–10
Leutze, Emmanuel, *Across the
 Continent, Westward the Course
 of Empire Takes its Way*, 182,
 183
Levin, Bernard, 226
lithography, 175–6, 178–80, 196
London, 11–37, **12, 14, 24, 27**, 98,
 117, 123–4, 130–8, **135**, 210, 215,
 219, 230–5, **231**, 234
Lot, Willy, 222
 house, 212, 213–18, **216, 218**,
 222–3
Loudon, J. C., 99
Loughborough, 176–7, **177**
Loutherbourg, Philippe Jacques,
 Battle of the Nile, 69
 Coalbrookdale by Night, 68–72,
 69, 244
 Eidophusikon, 71
 Headpiece to Isaiah, 71, **71**
 Vision of the White Horse, 71
 Wonders of Derbyshire, 59–60
Lowenthal, David, 8, 34
Lucas, E. V., 29, 31, 217
Ludgate Hill, 25, **26**, 37
Lunar Society, 55, 61
Lund, Niels, M., *The Heart of the
 Empire*, 13, **14**, 15, 31
Lutyens, Sir Edwin, 32

Mackinder, H. J., 31
Maddox, Kenneth, 161
Madonna, 37
Magazine of Art, 215
magic, 49–51, 60–1
 see also alchemy; Rosicrucianism
Maidenhead Bridge, 126–9, **129**, 132,
 136
Mais, S. P., 222

Malapeau, C. and Miger, C.,
 *Voltaire's Remains Transported
 to the Panthéon*, **21**
male, masculine, 16, 163, 189–90,
 199 n. 46, 210, 228
Manchester Guardian, 124
Manifest Destiny, 180–5
Mansion House, 13, 15, 31, 141, 219
Marshall, John, 123
masonry *see* freemasonry
Matless, David, 220
Matlock High Tor, 57–8, **58**, 60, **60**
mechanics, 53
Mexican–American War, 178, 189
middle class, 17, 49–51, 67, 99, 175
Midlands Counties Railway, 176–8
millenialism, 70–2, 157
Millet, Jean-François, 226
Milton, John, 25, 28, 70
mining *see* industry
modernism, 15–17, 34, 217–25, 229
modernity, 136, 242
money, 13, 36, 83–4, 92, 96–8, 113
Montagu, Sir Samuel, 210
Montgomery-Massingbird, Hugh, 104
Moore, Henry, 139
moorland, 7
morality, (moral decline), 11–13, 45,
 96–101, 116, 123, 154–67, 223–4
Morgan, J. Pierpont, 210
Morning Chronicle, 22
Morning Post, 129
Morse, Samuel, 188–9
 The Old House of Representatives,
 189
Mount Holyoke, 152, 174
Mundy, F. N. C., *Address to the
 River Derwent*, 57, 62
museums, 28, 46

Napoleonic Wars, 70, 94, 99, 114,
 132, 142, 211, 222, 233

narration, 5, 8, 148–9, 244
 see also history
Nast, Thomas
 Beyond the Mississippi, 186, **187**
 Railroads and Farmers, **194**
Nat West Tower, 13
national anthem, British, 3, 22, 131
National Gallery, London, 6, 22,
 106, 139, 141, 202, 209, 210,
 213, 214, 221
national identity, conceptualization
 of, 4–7
National Museum of American Art, 1
National Theatre, 235
National Trust, 101, 103, 107, 200,
 217, 222
nationalism *see* patriotism
Natural Bridge, 53, 172 n. 49
natural philosophy, 81–2, 205
 see also science
naturalism, 204–7
Nelson, Horatio, 22, 48, 94–5
Nelson Trust, 95
Nelson's column, 22
New Poor Law, 134
New York, 13, 127, 149, 151, 166,
 178, 189
 Lyceum, 155
 Sanitary Fair, 180
 Tribune, 180, 188, 193
Newton, Sir Isaac, 28, 56
Newtonian ideas, 51, 57
Niagara Falls, 53, 156
Nicolson, Benedict, *Joseph Wright of
 Derby*, 44–5
Noble, Louis, 152
Norris, Frank, *The Octopus*, 194–5
North Africa, 5
nuclear power, 235
nuclear war, 227–9

Old Sarum, 233
Omaha, 191

Oregon Trail, 180, 185, 185
orreries, 51, **52**, 53
Orrock, James, 210, 212

painting
 and conservation, heritage, 1–4,
 43–7, 103–5, 139–5, 139–42,
 169–70, 200–1, 207–17, 228–30
 and federalism, 151–2, 160–1
 and pottery, 48–9
Palenville, 164–5
Palmer, Frances, 174–92, 196, 244
 *Across the Continent, Westward the
 Course of Empire Takes its
 Way*, 174, **175**, 186–93
 Battle of Palo Alto, 178
 *'Lightning Express' Trains –
 'Leaving the Junction'*, 186,
 186
 Loughborough from Cotes Hill,
 176–7, **177**
 Mississippi in Times of War, 188
 Pioneer's Home, 189–90
 *Rocky Mountains – Emigrants
 Crossing the Plains*, 184–6,
 185
 Sketches in Leicestershire, 176–7
panoramas, 23, 92, 117, 168, 174
Panthéon, Paris, 20, **21**
Paris, 20, 205
Paternoster Square, 34, **35**, 37
patriotism, 3–4, 16, 20, 48, 73,
 114–16, 146, 178
Pearce, David, 106
Pennsylvania Academy of Art, 149
perspective, 98, 181, 188, 191–2, 245
Peter, Harry T., 196
Petworth, 112
Picturesque, The, 68, 107, 114, 119,
 155, 159, 165, 168, 204, 207
Pilkington, James, *View of the
 Present State of Derbyshire*, 57
Piper, John, 221
planning, 11–13, 224

Platte River, valley, 188
pneumatics, 53
Pollard, Ingrid, 7
post-modernism, 17, 46, 140
pottery, 48–9, 62
Potts, Alex, 217–18
Price, Richard, 72
Price, Uvedale, 68, 83, 155, 165
Priestley, Joseph, 53
Prince, Hugh C., 34
Prince Regent, 230, 233
Protestantism, 179, 204, 232
provincialism, 42–7
 see also regions
Pugin, A. W. *Catholic Town in 1440,
 The Same Town in 1840*, 101,
 102
Punch, 27

Quiller-Couch, Sir Arthur, 213
quilt making; quilts, 180

race; racist, 5–6, 139, 179, 181, 211,
 214
railways; railroads, 25, 124–9, 146–7,
 161–8, 176–8, 182, 186–9, 215
Recording Britain project, 101
Redgrave, Richard and Samuel, 207,
 209
Reed, Luman, 160–1
Reform Bill, 132, 142, 233
region; regionalism, 29, 43–6,
 169–70, 201–2, 205, 209–23,
 235–6
Repton, Humphry, 80–101, 107–8,
 122, 244
 Armley Mill from Kirkstall Road,
 86–8, **87**
 commission for Armley, 55–9,
 122–3
 commission for Sheringham, 89–96
 commission for Wingerworth, 85
 *Coursing on the Sea Shore at
 Sheringham*, 92, **93**

Improvements, 96–8, **97**
Main view from proposed new house at Sheringham, 92–3, **93**
Main vista from Armley House, 86–8, **87**
View from Repton's house at Hare Street, 99, **100**
View of proposed new house at Sheringham, 89–91, **90**
Repton, William, 94–5
Republican Party, 179–81, 181
Reynolds, Graham, 224–5
Reynolds, William, 68–9
Rhine, River, valley of, 146, 158
Richardson, Albert D., *Beyond the Mississippi*, 187–8, 191, 192
Rittenhouse, David, 53
rivers, 12, 57–9, 61–2, 65, 67–9, 123, 125–6, 129–36, 141–2, 146–9, 152–7, 158, 174, 188, 200–3, 212, 232–5, 237 n. 33
roads, 31, 117, 119, 217–8, 219–20
Rocky Mountains, 169, 180–2, **181**, 185, **185**
Rogers, Richard, 17
Rome, 17, 20, 55, 127, 156
Rosicrucianism, 50–3, 60–1
Rotherhithe, 132, 141
routeways, 113, 244
 see also canals, railways, rivers, roads, sea power
Royal Academy, 32, 34, 36, 69, 137, 139, 205, 209, 230, 233
Royal Exchange, 13
royalty, 11–22, 29–31, 50, 66, 233–5
Rubinstein, Charlotte Streiffer, 175, 197
rural development, decline, 55–70, 80–111, 113, 146–70, 193–4, 200–29, 235–6
Ruskin, John, 124, 204
 Modern Painters, 138–9
Russia, 5

Saint Paul's Cathedral, 11–37, **14, 24, 27, 33, 35,** 62, **63,** 107, 138, 141, 232, 233, 243
 Great Model, 17, **18**
Saint Peter's, Rome, 17
Salvator Rosa, 151–2
Samuel, Raphael, 15
San Joachim valley, 194
Sargent, John, *The Mine*, 60–1
science, 51–62, 127–8, 188–9, 205, 219–20
Scott expedition, 6
Scott, Sir Giles Gilbert, 32
sea; sea power, 13, 19, 63, 66–7, 114–38
Sheerness, 130
Shell Guide to Suffolk, 224
Sheringham, 89–95
Shields, 116
Ship of State, 13, 19, 138
Siberia, 5
Sierra Nevada, 169, 182, 183
Signac, Paul, 139
Smithsonian Institution, 1
Snowe, Lucy, 23–4
socialism, 22, 32, 34, 44, 225–6
Society for the Protection of Ancient Buildings, 217
South, American, 182, 188
South Country, English, 214
South Kensington Museum, 209
Southey, Robert, 233
Soviet Union, 4, 26–7, 29, 44, 106
spectacle, 44, 46–8, 51, 71–3, 106, 132–6
Squirrell, Leonard, *Willy Lot's Cottage,* **218**
State; state power, 4–6, 20–2, 51–3, 80–2, 114–38, 180–4, 232–5
Stilgoe, John, 153
Stirling, James, 140–1
Stoke-by-Neyland, 232
Stonehenge, 20, 37, 212
Stour, River, valley, 200–2, 212

Strong, Roy, 104
Strube, Sydney, 220–1
 Had John Constable Lived Today,
 220, **221**
Sturges, Jonathan, 161–3

Tate Gallery, 2, 43, 45, 141, 225,
 226, 229
Taylor, Bayard, 168–9
telegraph, 188–9
Tennyson, Julian, *Suffolk Scene*, 222
Thackeray, William Makepeace, 132
Thames, River, valley, 12, 123,
 125–6, 129–36, 141–2, 146, 232–5
Thatcher, Margaret, 16, 37, 105, 106
 government, 16, 229
Thatcherism, 16, 104
theatricality, 13, 47, 50–1, 55, 72–3,
 134, 230
 see also illuminations; spectacle
Thompson, E. P., 70
 The State of the Nation, 227–8
Thomson, James, *The Seasons*, 130
Throsby, John, 176
Times, The, 28, 201, 226–7, 229
Tomkins, Herbert, 210–11, 212–13
topography, 114–16, 149
Torrington, Viscount, 66, 67
Toryism, 233
tourism, 46–8, 66, 147, 200, 211, 224
Trafalgar, Battle of, 94, 132, 142
Trafalgar Square, 22
travel writing, 243–5
Treloar, Sir William, 31
Tribune, New York, 180, 188, 193
Turner, Frederick Jackson, *The
 Significance of the Frontier in
 American History*, 195–6
Turner, J. M. W., 112–42, 152, 155,
 158, 201, 207, 210, 244
 Bridport, 114–15, **116**
 *Burning of the Houses of
 Parliament, The*, 130, 132–6,
 133

*Decline of the Carthaginian
 Empire, The*, 122
Dido Building Carthage, 122
Fallacies of Hope, 115–16
Fighting 'Temeraire', The 130–2,
 131
*Keelmen Heaving in Coals by
 Night*, 116
Leeds, 112, 117–18, **118**, 126
London, 36, 123, 141
*Petworth Park: Tillingham Church
 in the Distance*, 113
*Rain, Steam and Speed – the Great
 Western Railway*, 124–38, **125**,
 139
Sun of Venice Going to Sea, The
 137–8, **137**
Venice, 116
Turner Bequest, 114, 140–1
Turner Society, 139, 141

Union Army, 180–2, 184, 188
Union Pacific Railroad, 182, 184,
 189, **189**, 191
United States, 1–2, 3–4, 13, 32, 51–2,
 146–70, 174, 178–96
Upcher, Abbot, 89–96
urban development, decline, 11–37,
 99–101, 116–47, 161–7, 191, 209,
 229–35

Vaughan, Henry, 210
Venice, 11–13, 19, 20, 116, 137–8
Vesuvius, 55–7
Victoria and Albert Museum, 16
Victoria, Queen, 29–30, **30**, 127
 Diamond Jubilee, 29–30, **30**
Victorian age, 15, 99–101, 220
Vietnam War, 1, 3
vitalism, 219–20

Walker, George, *The Costume of
 Yorkshire*, 119, 123
Wall, William Guy, *Glens Falls*, **148**

Wallach, Alan, 151, 158, 160
Warner, Rex, *The Aerodrome*, 223
wars, 2, 4, 6, 11, 16, 32, 70, 94, 99,
 101, 114, 132, 142, 178, 180–2,
 189, 211, 213, 222–3, 227–9
warships, 66, 121, 130–2
Washington Post, 2
Waterloo Bridge, 134–6, 233–5, **234**
Waud, A. R., *Building the Union
 Pacific Railroad in Nebraska*,
 188, **189**
Waugh, Evelyn, *Brideshead
 Revisited*, 101, 103
weather, 205, 223
Wedgwood, Josiah, 48–9, 50, 56, 63,
 63
 vase, 47
 works, 61
Wein, Al, 141˙
West, American, 1–2, 174, 180–96
Westminster, 130–5, 233–5
 Abbey, 21, 134
 Bridge, 134–5, **133, 135**, 235
 Hall, 134–6
Whitaker, T. D., 117, 123
Whitehurst, John, 56, **59**
 *An Inquiry into the Original State
 and Formation of the Earth*,
 57–61
 *A Section of Strata at Matlock
 High Tor*, **60**
Whitman, Walt, 192–3
 Passage to India, 192

William Hunter's Museum, 28
Williams, Raymond, *The Country
 and the City*, 225
Wilson, Richard, 2, 205
woodland, 7, 91, 98, 155–8, 190
Wordsworth, William, 17, 129
 The Excursion, 68
workhouses, 91–2, 176
working class, 22, 123, 134
World War One, 6, 32, 213
World War Two, 11, 32, 101, 222–3
Wingerworth, 85, 88
Wright, James, *Phoenix Paulina*, 19
Wright, Joseph, 43–73, 244
 Alchymist, The, 50, 55, **56**,
 Arkwright's Mills by Night, 43, 44,
 45, **45**, 62–8, 69
 Corinthian Maid, The, 48
 *Experiment on a Bird in the Air
 Pump, An*, 43, 50, 53, **54**, 55
 John Whitehurst FRS, 57, **59**
 Matlock Tor, Moonlight, 57, **58**
 Mine, The, 60–1
 *Philosopher giving that lecture on
 the Orrery*, 43, 51, **52**, 55
 Richard Arkwright, Sir, 57, 63, **64**
 View of Gibraltar, 66–7
Wright, Patrick, 36
Wren, Sir Christopher, 13, 17,
 19–20, 25, 27, 28–9

Yates, Frances, 50